Roger Simon and
Dr. Lydia Bayne

THE LIBRARY FOUNDATION

Serving the People of Multnomah County

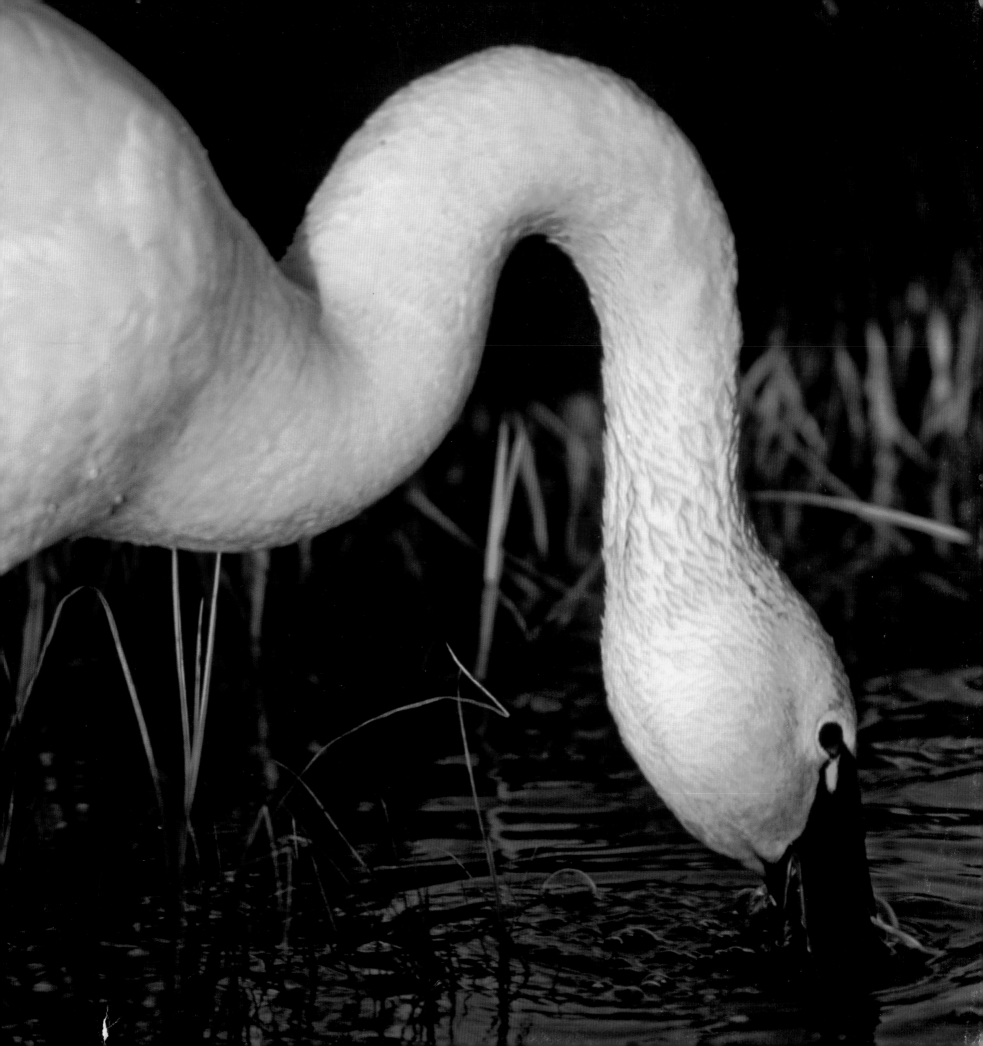

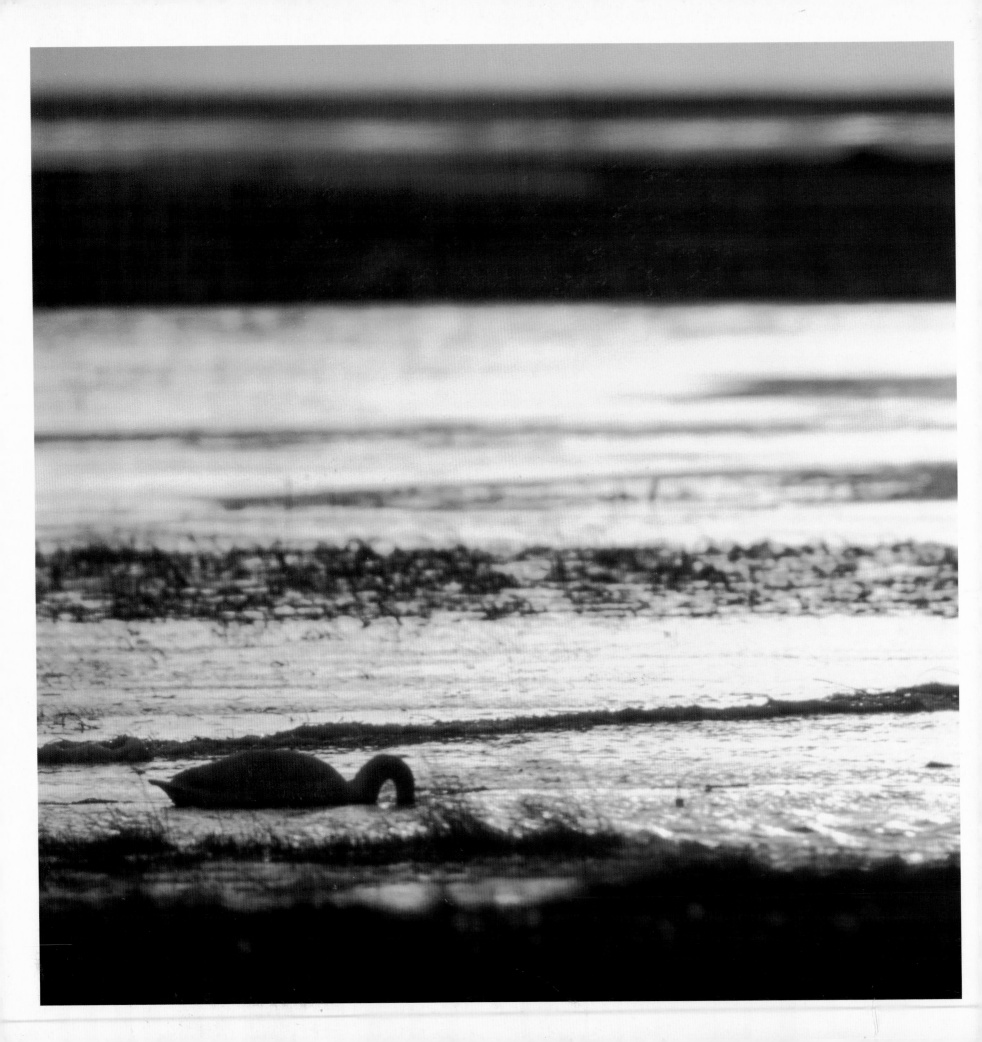

SUBHANKAR BANERJEE STEVEN KAZLOWSKI HUGH ROSE MICHIO HOSHINO ARTHUR MORRIS

BIRDS *of the* ARCTIC NATIONAL WILDLIFE REFUGE

ARCTIC WINGS

Edited by STEPHEN BROWN *Foreword* JIMMY CARTER *Introduction* DAVID ALLEN SIBLEY

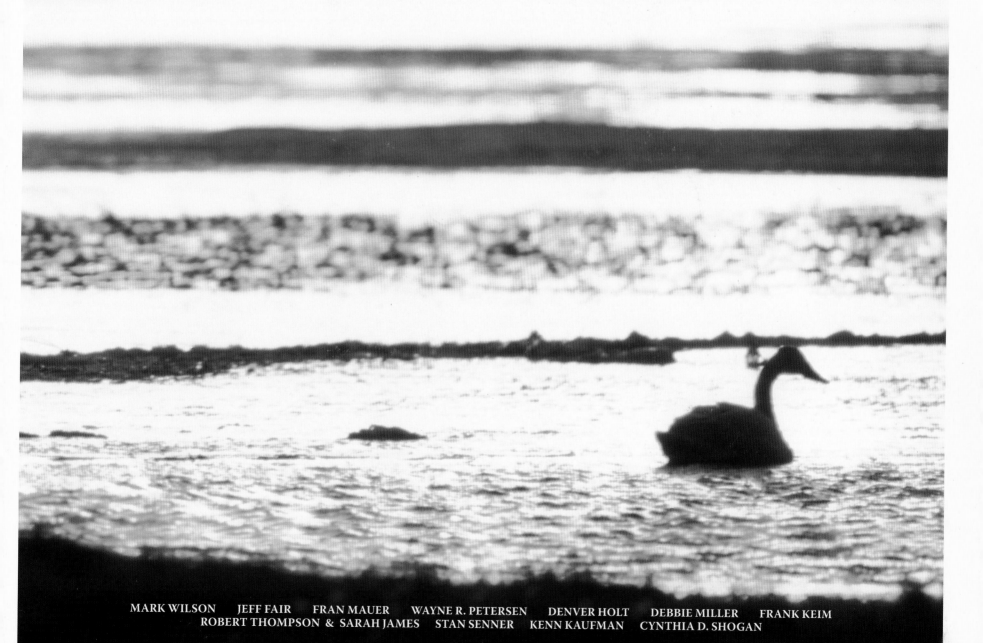

MARK WILSON JEFF FAIR FRAN MAUER WAYNE R. PETERSEN DENVER HOLT DEBBIE MILLER FRANK KEIM
ROBERT THOMPSON & SARAH JAMES STAN SENNER KENN KAUFMAN CYNTHIA D. SHOGAN

THE MOUNTAINEERS BOOKS, SEATTLE ■ **MANOMET CENTER FOR CONSERVATION SCIENCES**

 The Mountaineers Books is the nonprofit publishing arm of The Mountaineers Club, an organization founded in 1906 and dedicated to the exploration, preservation, and enjoyment of outdoor and wilderness areas.

 Manomet Center for Conservation Sciences' mission is to conserve natural resources for the benefit of wildlife and human populations. Through research and collaboration, Manomet builds science-based, cooperative solutions to environmental problems.

Editor: Christine Clifton-Thornton
Acquiring Editor: Helen Cherullo
Director of Editorial and Production: Kathleen Cubley
Designer: Ani Rucki
Map design: Rose Michelle Tavernitti
Map relief: Dee Molenar
Proofreaders: Elizabeth J. Mathews, Karen Parkin

Cover photograph: *Snowy Owl and chicks* © Michio Hoshino/Minden Pictures
Back cover: *Long-billed Dowitcher,* Subhankar Banerjee
Half title and title pages: *Tundra Swans,* Steven Kazlowski
Page 4: *Snow Geese,* Hugh Rose
Page 7: *Long-tailed Jaeger,* Steven Kazlowski

The Mountaineers Books and Manomet Center for Conservation Sciences

gratefully acknowledge the generosity of Bev Reitz,

who worked for the Arctic National Wildlife Refuge.

Reitz, who was an enthusiastic advocate for wilderness,

left a bequest to Subhankar Banerjee for his work on behalf

of the refuge. Banerjee, in turn, elected to contribute these

funds to the production of **Arctic Wings** in her honor.

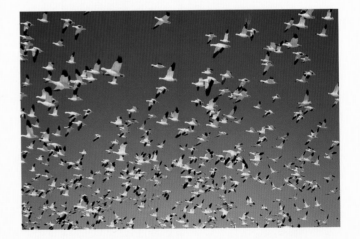

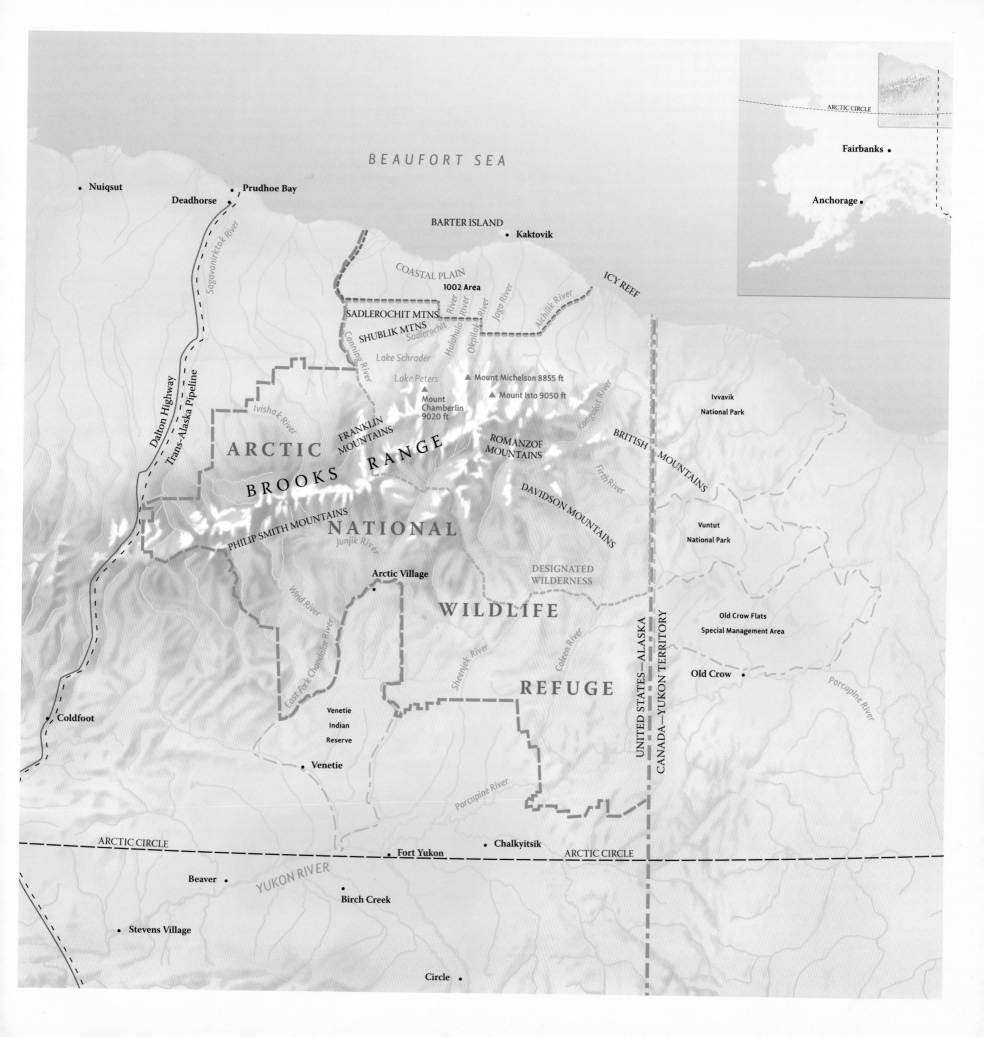

BEAUFORT SEA

Nuiqsut

Deadhorse • Prudhoe Bay

Sagavanirktok River

BARTER ISLAND

• Kaktovik

COASTAL PLAIN

ICY REEF

1002 Area

Aichilik River

SADLEROCHIT MTNS

Canning River

SHUBLIK MTNS

Sadlerochit River

Hulahula River

Okpilak River

Jago River

Lake Schrader

Lake Peters

▲ Mount Michelson 8855 ft

▲ Mount Isto 9050 ft

Ivvavik

National Park

Ivishak River

▲ Mount
Chamberlin
9020 ft

Kongakut River

ARCTIC

FRANKLIN
MOUNTAINS

ROMANZOF
MOUNTAINS

BRITISH

BROOKS RANGE

Firth River

MOUNTAINS

Vuntut

National Park

PHILIP SMITH MOUNTAINS

NATIONAL

DAVIDSON MOUNTAINS

Dalton Highway

Trans-Alaska Pipeline

Junjik River

DESIGNATED
WILDERNESS

Arctic Village

WILDLIFE

Old Crow Flats
Special Management Area

Wind River

Sheenjek River

Coleen River

East Fork Chandalar River

REFUGE

Old Crow •

Porcupine River

Coldfoot

Venetie
Indian
Reserve

UNITED STATES—ALASKA

CANADA—YUKON TERRITORY

• Venetie

Porcupine River

ARCTIC CIRCLE

• Fort Yukon

Chalkyitsik •

ARCTIC CIRCLE

Beaver •

YUKON RIVER

• Birch Creek

• Stevens Village

• Circle

ACKNOWLEDGMENTS

A project of this magnitude requires the commitment of countless people, and this book is an excellent example of what can be accomplished by a community working collaboratively toward a shared goal. Everyone involved deserves credit for its successful completion. As editor, I have the opportunity to thank those with whom I've worked most closely, but there are many more who contributed to this book as well. Our deepest thanks to all of you.

First, I would like to thank my colleagues at Manomet Center for Conservation Sciences who supported me throughout the project, particularly Rob Kluin and Karen Grey, who helped conceive, develop, and support the book; and Linda Damon, who finds so many ways to support our work. I also thank Manomet's president, Linda Leddy, as well as other staff who have given so much to help this work over the years, including Sue Chamberlin and Jennie Robbins, and my colleagues—Brian Harrington, Charles Duncan, Trevor Llyod-Evans, and especially Robin Hunnewell, who deserves special credit for her untiring support and hard work both in the field and with the manuscript. I thank Peter Alden and Manomet's Shorebird Friends Group for all their support.

I would also like to thank the incredible staff at The Mountaineers Books—publisher Helen Cherullo, whose cheerful support and positive attitude carried us all forward; Ani Rucki, whose capable design and layout work made the book so beautiful; and Rose Michelle Taverniti, whose wonderful maps help us visualize the scale of bird migration. Most of all, I want to thank Christine Clifton-Thornton for her mastery as editor of the project, for her exquisite skill at gently but firmly organizing the contributors, and for being a superb collaborator and colleague throughout.

We could not have completed the project without the generous support of our donors, including the Chase Wildlife Foundation, the Seabreeze Foundation, Eagle Optics, and a number of anonymous supporters.

I would like to give special thanks to Subhankar Banerjee, whose artistry and previous work have raised awareness about the Arctic Refuge with such beauty and grace, and without whom this project never would have been launched. Subhankar and David Sibley initially conceived the idea that became this book. I am especially grateful to all our coauthors and photographers for their spectacular and inspirational work, for transporting us so vividly to the refuge and telling us the stories of its inhabitants, and for fitting this project into their already busy lives of dedication to the cause of conservation. In particular, Debbie Miller found so many ways to contribute in addition to her essay, and we are all grateful for her input. Thanks also to Martyn Stewart for the wonderful CD of Arctic Refuge birdsongs that accompanies the book.

Special thanks are also due to our colleagues in the field, including Rick Lanctot, Steve Kendall, Dave Payer, and Jon Bart, and all of those who have volunteered in field camps under beautiful but also challenging conditions. I particularly want to thank Brad Winn, who used his vacation time to work on the project and helped tremendously with both photography and field work.

Finally, I want to thank my wife, Metta McGarvey, for sharing the challenges and rewards of field projects with me, for her skills as a writer and organizer, and for always supporting my dream of trying to make a difference despite the personal cost; and thanks also to my children, Claire and Ethan, who did without me so often when projects like this one took me on long journeys, and for whose generation we hope to preserve this last great wilderness.

—*Stephen Brown*

CONTENTS

PREFACE *Subhankar Banerjee* 9

FOREWORD *Jimmy Carter* 11

INTRODUCTION *David Allen Sibley* 12

WHERE THE RIVERS FLOW NORTH *Mark Wilson* 16

Spring Bird Research in the Arctic Refuge 23

Loons and Waterfowl
ANGELS IN THE MIST *Jeff Fair* 26

Hawks, Eagles, and Falcons
HUNTERS OF THE ARCTIC SKY *Fran Mauer* 58

Shorebirds
IMPERILED ARCTIC AMBASSADORS *Stephen Brown* 72

Gulls, Terns, and Jaegers
OCEAN MARINERS *Wayne R. Petersen* 94

Owls
THROUGH ARCTIC EYES *Denver Holt* 112

Land Birds
SONGS FROM AROUND THE WORLD *Debbie Miller* 130

Winter Birds
WINGS OVER WINTER SNOW *Frank Keim* 150

Autumn Bird Research in the Arctic Refuge 167

CULTURAL REFLECTIONS *Robert Thompson / Sarah James* 168 / 170

LANDSCAPE OF THE FUTURE? *Stan Senner* 172

AFTER AN ARCTIC SEASON *Kenn Kaufman* 178

BIRDERS IN THE SCOPE *Cynthia D. Shogan* 180

ADVOCACY RESOURCES 184 SELECTED REFERENCES 185 ABOUT the PHOTOGRAPHERS 186 BIRDS of the ARCTIC NATIONAL WILDLIFE REFUGE 188
BIRD INDEX 189 GENERAL INDEX 190 ABOUT the CD 192 THE CD: BIRDS of the ARCTIC NATIONAL WILDLIFE REFUGE inside back cover

On a mid-April day in Kaktovik, a small Inupiat village on the northeast coast of Alaska, I step out of Robert Thompson's house onto the snow-covered ground. It is cold, and the snow will not melt for another month or so. The Snow Buntings have just arrived. They seem cheerful as they sing their hearts out. Jane Thompson, Robert's wife, is very happy to see them, and so is the rest of the village. She tells me about all the different places they are going to be nesting. Buntings have brought a promise with them: "Winter is over, and spring is just around the corner." This is an important promise to a town that has been blanketed in snow for months, with blizzards and darkness for much of the time. Buntings have never broken their promise.

As I reminisce about my first sighting of Snow Buntings, I think about Terry Tempest Williams and her mother watching two white birds with black on their backs in the Great Salt Lake. Terry writes in her classic memoir, *Refuge: An Unnatural History of Family and Place*, "'I found them! Here they are . . . snow buntings! . . . I can't believe it! These are rare to the Refuge. I have never seen them before.' Mother watches the birds carefully. 'Tell me, Terry, are these birds Tolstoy may have known?'"

Robert is talking about duck hunting. In less than a month, he says, millions of ducks and geese will be migrating along the icy coast. "It is beautiful to watch them migrate in lines and formations over the ice, close to the ground," he says. Like clockwork, the pregnant females of the Porcupine caribou herd will have ended their epic annual spring migration, arriving on the coastal plain of the Arctic Refuge in time for calving. At least 157 species of birds from around the planet will come to the coastal plain, and at least 56 species will stay to nest and rear their young. Another 20 species are probably nesting here, but their nests are secrets yet to be discovered. It is a springtime flurry of activity: songbirds sing, tiny sandpipers intensely engage in courtship to attract mates quickly, Gyrfalcons hunt ptarmigans to convince potential mates that they are good hunters, Smith's Longspurs look for nesting sites . . . the drama is unfolding with intensity on the vast tundra.

Debbie Miller has told me stories of the songbirds. Few people have walked the Arctic Refuge and listened to the tundra as extensively as Debbie and her husband, Dennis. To a casual observer, the tundra may seem empty and ugly. One needs to kneel down and put ears and eyes close to the ground to see and hear these little creatures engaged in life's drama. I wasn't a birder before I went to the refuge. I knew little about their lives, but I was enthralled when I saw all these events unfolding in front of me. I made a promise to myself to give a voice to their ways of life.

In June 2001, I camped out in Sarah James's backyard in Arctic Village to attend an emergency Gwich'in gathering. The loons were calling from out on the lake. I went down to look for them; yes, they were there. Later that summer, Cindy Shogan invited me to go to Washington, D.C., where I met Stan Senner. I showed Stan my bird photographs from the Arctic Refuge. That fall, Stan produced a beautiful report, "Birds and Oil Development in the Arctic Refuge,"

which was widely distributed to congressional members and activists who were working to preserve the coastal plain from oil and gas drilling.

Summer of 2002 was remarkable. Robert and I had the good fortune to spend time with Peter Matthiessen and David Allen Sibley on the Arctic tundra. They taught us much about birds and how to appreciate their lives. Peter was thrilled to see the Buff-breasted Sandpiper; David was elated to see all these birds in their nesting habitat, species that he has been painting so eloquently for years.

Semipalmated Sandpipers arrive on the coastal plain and almost immediately start building nests. When the nest-building process is successful, the males depart for their southern wintering grounds. After the eggs hatch and the chicks are able to feed on their own, the females depart, too; now the chicks have to

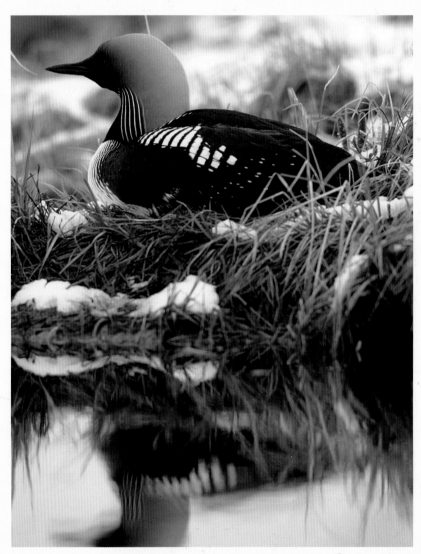

Opposite ■ *Birds over coastal lagoon, Brooks Range in the background* / *Pacific Loon on nest*

make it on their own to reach their wintering grounds in South America. Science has yet to explain how they do this.

Poet Rainer Maria Rilke wrote in *Letters to a Young Poet*, " . . . be patient toward all that is unsolved in your heart and try to love the *questions themselves* like locked rooms and like books that are written in a very foreign tongue. Do not now seek the answers, which cannot be given you because you would not be able to live them. And the point is, to live everything. *Live* the questions now." The Arctic Refuge gives us the opportunity to live with such questions.

I found it difficult to sleep on the open tundra of the Arctic Refuge during spring and summer because of the twenty-four-hour sun and the constant noise from the cranes, swans, and loons. But there are other times when snow falls on the ground, the wind blows, and the tundra goes silent, and we all conserve energy. Then the snow melts, the sun comes out, and swans glide effortlessly on the glassy water of the Aichilik River. This river defines the eastern boundary of Section 1002, where Congress is proposing to drill for oil. The swans are unaware that they are gliding on yet another artificial boundary.

In the fall of 2002 I supported an event with Peter Matthiessen for the Manomet Center for Conservation Sciences in Plymouth, Massachusetts. Early in the day, Stephen Brown, Wayne Petersen, Metta McGarvey, and other good friends took us out birding on Plymouth Beach. That day we saw American Golden-Plover, Ruddy Turnstone, Dunlin, Semipalmated Sandpiper, and Semipalmated Plover, species that Peter and I had seen only a couple of months before in the Arctic Refuge. Everyone was amused by my boyish enthusiasm; Mark Wilson wrote that up in the *Boston Globe.*

Stephen had been conducting extensive shorebird research on the Arctic Refuge coastal plain. He tells me how important it is to preserve the nesting habitat and all the stopover points for these birds during their long migrations. We put our heads together on how to bring the story of the birds of the Arctic Refuge to inspire birders and the general public so that they might participate in the preservation of this magnificent place. We talk about a book, and Stephen comes up with the title, *Arctic Wings.* We propose it to Helen Cherullo, my friend and publisher of The Mountaineers Books. Helen had already launched her vision of "mission publishing," to bring amazing conservation stories through books to a larger audience. She said, "Let's get to work," like she did in 2001 when I proposed to her the idea of my first book, *Seasons of Life and Land.*

I immediately call my friend and fellow photographer Steven Kazlowski, with whom I had camped out on the Arctic Refuge. Over the past decade, Steven has dedicated his photography almost entirely to Alaskan wildlife. And early in my Arctic work I was fortunate to have befriended Fran Mauer. Whenever I had a question about the ecology of the Arctic Refuge I would reach out to him for the most authentic explanation; no one knows the wildlife of the Arctic Refuge like Fran. Over dinner at their home, Fran and his wife, Yoriko, showed me a series of books published in Japanese by their dear friend, late Japanese photographer Michio Hoshino. Michio fell in love with the Arctic Refuge, and one of his photographs graces the cover of this book.

Stephen Brown and I, with the assistance of the wonderful team at The Mountaineers Books, reached out to other contributors who would lend their voices through words and images. The result is this book that you are holding in your hands, a labor of love from a community of many who deeply believe we must preserve the Arctic Refuge coastal plain for the birds, for the caribou, and for all life that is yet to come.

Through the migrations of birds, the Arctic National Wildlife Refuge is connected to every citizen of our planet. I believe it is wrong to destroy that connection by putting oil rigs, pipelines, gravel roads, and buildings on the coastal plain. By introducing helicopter noise, pollution, and the inevitable oil spills and loss of habitat that come with this development, we may very well harm many species struggling to maintain their place on the planet. When a bird dies, its migration stops, and one more song disappears. We might lose the wisdom of one more indigenous culture; the world will become a little more fragmented; and, unheeded, progress will continue as if nothing has happened.

As I contemplate the potential loss of species and biodiversity that occurs all around us, I think about Albert Pinkham Ryder, who was perhaps the most original painter America has produced. He was a painter of dreams, a painter of imagination. Ryder painted *The Dead Bird* in the late 1870s. It is a rather small painting, and one of his best-loved and most-affecting paintings. No work of art has ever affected me like *The Dead Bird.* It is imagination combined with emotion, distilling pathos into art of the highest order.

Imagine making a trip to a village in Patagonia, a village in Papua New Guinea, a village in India, and telling your new-found friends, "Did you know that hungry and skinny bird you saw yesterday has just arrived from the Arctic Refuge after thousands of miles of flying?" They will be amused with your story, and you will become closer as friends.

 SUBHANKAR BANERJEE's *photographic career stemmed from his childhood passion for painting, coupled with a deep love and concern for the wilderness and disappearing indigenous cultures. Since the publication of his first book,* Arctic National Wildlife Refuge: Seasons of Life and Land *(The Mountaineers Books, 2003), Banerjee has worked closely with the public, conservation and Native American organizations, and members of the U.S. Senate and House of Representatives to tell the story of the Arctic Refuge, its importance in our society, and the urgent need to protect the coastal plain from oil and gas drilling. Banerjee is the first recipient of the Cultural Freedom Fellowship from the Lannan Foundation, the Green Leaf Award for Photography at the 2005 United Nations World Environment Day in San Francisco, a National Conservation Achievement Award from the National Wildlife Federation, a Special Achievement Award from the Sierra Club, and the Daniel Housberg Award from the Alaska Conservation Foundation.* ■

Northern Wheatear juvenile

ach spring millions of birds from six continents begin their incredible migrations to the Arctic National Wildlife Refuge. They cross oceans and mountain ranges, deserts and glaciers, forests and tundra. Following ragged coastlines and winding rivers, they wing their way across Alaska's vast wilderness. These extraordinary creatures have made annual journeys since the beginning of time.

When Rosalynn and I first visited the Arctic Refuge in 1990, we marveled at the diversity of migrants that we discovered. As we hiked across the tundra we spotted breeding shorebirds such as the American Golden-Plover, a regal bird that conducts an amazing 18,000-mile round trip between the pampas of Argentina and the Arctic. We felt lucky to see nesting activity and fluffy plover chicks as they teetered on the tundra.

With twenty-four-hour daylight, the music of birds constantly filled the air. Lapland Longspurs sang their cheerful melodies. In the willow thickets we caught glimpses of bright Yellow Warblers and chattering redpolls. Along the braided rivers we watched Semipalmated Plovers scurry on the sandbars. I have also seen these plovers during the winter along the Georgia coast in the Savannah National Wildlife Refuge.

I first became an avid birder after climbing Mount Kilimanjaro with my family in 1988. It's stunning to think that one of the thrush species that we saw there, the Northern Wheatear, migrates thousands of miles across Siberia to nest in Alaska's Arctic. Imagine this remarkable insect-eating bird perched next to elephants on the savannah in the winter, and then standing near caribou on the tundra in the summer.

This book gives readers a fascinating look at many of the 194 bird species known to visit or reside in the Arctic Refuge: from migratory birds such as the Red-throated Loon, Golden Eagle, and Eastern Yellow Wagtail, to year-round residents like the Willow Ptarmigan, American Dipper, and Black-capped Chickadee. Through the eyes of well-known authors and photographers, *Arctic Wings* reveals how all of us, no matter where we live, are connected to these northernmost breeders. A bird perched in your backyard during the winter, or a flock passing overhead, may represent some of these amazing Arctic travelers.

Arctic Wings also deepens our appreciation and understanding of some of the most interesting and well-adapted species on Earth. Every bird finds its special niche on our planet, whether it be in the tropics, in the Arctic, or on the grasslands. These widespread and diverse families of birds contribute to the environment by controlling insect populations and spreading seeds, and producing some of the Earth's most beautiful music.

The fact that millions of our planet's migratory birds depend on these northern latitudes makes us more fully realize the importance of protecting the Arctic National Wildlife Refuge as a unique birthplace and home. Whether in my backyard or on the savannah in Africa, whenever I see a beautiful bird heading north in the spring, it's reassuring to know there are protected areas such as the Arctic Refuge where these winged creatures can safely nest to create future generations. May their northern birthplace always remain truly wild and free.

Photo: Rick Diamond

JIMMY CARTER, *the thirty-ninth president of the United States (1977–1981), advocated and signed the Alaska National Interest Lands Conservation Act, which celebrated its twenty-fifth anniversary in 2005. Carter has consistently opposed drilling for oil in the Arctic National Wildlife Refuge as fundamentally incompatible with wilderness. In 1982 he founded The Carter Center, a nongovernmental organization guided by a commitment to human rights and the alleviation of human suffering. He won the Nobel Peace Prize in 2002 for his decades of effort in finding peaceful solutions to international conflicts, advancing democracy and human rights, and promoting economic and social development. He is the recipient of numerous other awards, including the highest awards of the National Wildlife Federation, The Wilderness Society, the National Audubon Society, and the National Parks Conservation Association.* ◼

For most of the year, the Arctic is a beautiful but harsh environment with temperatures well below zero, months of mostly darkness, and almost no visible signs of life. Amazingly, a few birds do spend the winter here—Snowy Owls, ptarmigans, ravens, and even redpolls somehow find enough food to sustain themselves in the bitter cold. But beneath the snow and ice, even within the ice itself, a profusion of life lies dormant, waiting for spring.

Tundra plants respond to the slight warming in spring with new growth under the snow. In June, as soon as the ground is free of snow, the tundra suddenly is teeming with life that will provide food for birds: Flies, mosquitoes, spiders, insect larvae, and other invertebrates thrive among the plants, and rodents are more available. But perhaps the most dramatic and visible change is the millions of birds that arrive here from all over the globe to take advantage of this abundant food and claim the Arctic as their summer home.

Although the winter landscape is barren, the summer landscape is its polar opposite, as all living things here try to squeeze the activities of spring, summer, and fall into about three months' time. In the short Arctic summer, life is intense. For the birds, it's "get in, nest, get out." The sun is up twenty-four hours a day, and bird activity continues around the clock. Some birds that arrived in June as the snow was beginning to melt have already built nests, laid eggs, and raised young by July, and they're ready to head south.

When I was in the Arctic National Wildlife Refuge in July several years ago with Subhankar Banerjee and Robert Thompson, they would often point to a particular species and ask, "Where does that bird come from?" Each time the question caught me off guard, and I thought to myself, "What do they mean?

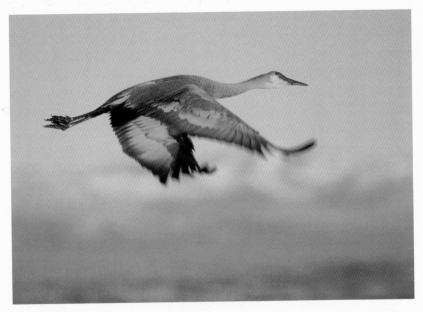

Sandhill Crane

We're looking at a nest; that bird comes from right here." From my southern perspective, I went to the Arctic to see these birds on their breeding grounds—to see where they came from. But from an Arctic perspective, these birds are just brief visitors; some are in Alaska for only a few weeks. They may be born in the Arctic Refuge, but most of them don't really have a permanent home; they're always moving, and, in that sense, they don't come from anywhere.

Even during their weeks in the Arctic, the birds are constantly in motion—competing for territories and mates, building nests, feeding young, and feeding themselves. At the same time they must prepare for the migration south. The need for food, for fuel, is so great that even as a bird defends its nest by scolding an intruder, it will pause compulsively to grab an insect out of the grass.

The payoff for this intense lifestyle must outweigh the hardships and the dangers of the long migration, because so many birds do it. The ones that make the longest journeys have adapted physically with a very streamlined shape—long, pointed wings and tapered body—and the ability to carry large amounts of fat for fuel. And each species has developed a different strategy for migration.

One of the most amazing and well-known migratory birds is the four-ounce Arctic Tern, which makes the longest annual migration of any bird. They fly a minimum of 24,000 miles a year, essentially from the north polar areas to the south polar areas and back. They might spend three months during the Arctic summer nesting and raising their young in the north, and then take three months to make the long journey down the Pacific Coast to the Antarctic. They'll spend three months in the southern summer and then make another three months' journey back to their northern summer home in the Arctic. They spend most of their lives on the wing and in daylight. But this migration, as long as it is, is not as dramatic as the migration of some of the sandpipers.

The one-ounce Semipalmated Sandpipers arrive in the Arctic in early June, spend only four to six weeks in the Arctic National Wildlife Refuge, and then leave before their young are fully grown. They migrate southeast across Canada, heading for the rich tidal flats of the Bay of Fundy, where they gather in large numbers, building up fat. They are preparing for a nonstop flight from Nova Scotia to South America, traveling 2400 miles in seventy-two hours and burning fat equal to about half their body weight. Adults make the trip in July; the young birds follow instinctively on the same path a few weeks later.

Even though they "come from" the Arctic, the coastal mudflats of northern South America could be called their primary home. This is where they spend at least six months of the year. The Bay of Fundy, which provides fuel for their long nonstop flight, as well as other stopping points along the way, are equally important.

Sandpipers are the fastest migrants, among the last to arrive and first to leave the Arctic. Other species, such as geese and Sandhill Cranes, stay longer in the Arctic. Pectoral Sandpipers nest in the Arctic Refuge, arriving in early June and departing from mid-July to mid-August. When the first southbound adult

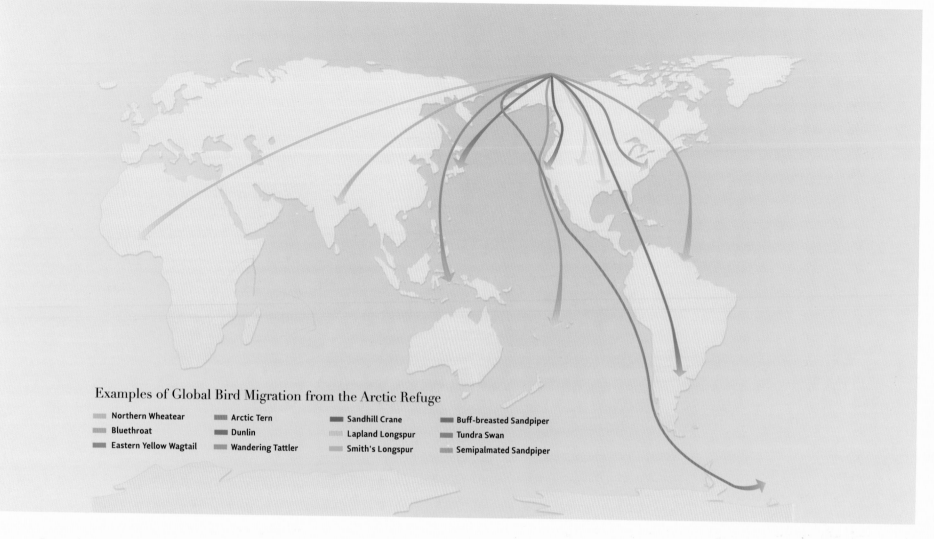

Examples of Global Bird Migration from the Arctic Refuge

- Northern Wheatear
- Bluethroat
- Eastern Yellow Wagtail
- Arctic Tern
- Dunlin
- Wandering Tattler
- Sandhill Crane
- Lapland Longspur
- Smith's Longspur
- Buff-breasted Sandpiper
- Tundra Swan
- Semipalmated Sandpiper

Pectoral Sandpipers reach the southern United States in July, young geese have just hatched from eggs on the tundra. By August, while the geese are still six weeks away from beginning their southward migration, the adult sandpipers already are half a world away on their wintering grounds in southern South America, and the intrepid young sandpipers are just beginning their journey south.

While the sandpipers are migrating south, geese and ducks gather at traditional molting places in the Arctic. Many species actually migrate north in late summer to molt at large wetlands where their species has gone for centuries. Some waterfowl leave the refuge to go elsewhere in Alaska and Canada; others, such as Long-tailed Ducks, come northwest out of Canada by the hundreds of thousands in late summer to rest and feed and molt in the lagoons along the Arctic coast of Alaska before flying south in late fall to winter along the coasts of the United States.

Small songbirds finish nesting by early August, and while the waterfowl are pouring into the coastal lagoons, sparrows, warblers, longspurs, and others wander the tundra, finding food and shelter in the grasses and willow thickets. Those that gather into small flocks over the course of the summer and fall, moving across the Arctic coastal plain in search of prime feeding areas, are like an unruly sea of birds sloshing back and forth at the top of the continent. Becoming more and more restless as the days shorten late in the season, first

the sandpipers, then the terns and sparrows, then the geese and longspurs all start moving south.

As autumn storms come in and crisp, cold air sweeps down across the coastal plain, north winds bring a few snow squalls and a skim of ice that edges the ponds. This triggers an exodus that sends birds southward. Like ripples on a pond that spread out from the source, the waves of birds travel south, rolling, mixing, dispersing, and converging. Some birds move quickly, others slowly, but all move inexorably south, pushed by the arctic air, each traveling according to the plan of their ancestors.

While all of this has been going on in the Arctic, the birds of the southern United States have been relatively relaxed. The climate is mild enough that many species—White-breasted Nuthatch, Canada Goose, and others—can be resident. They stay on familiar grounds for the entire year and face none of the risks and uncertainties of migration. Migratory species such as the Rose-breasted Grosbeak spend only the summer in the forests of the eastern United States and migrate south to Mexico or the West Indies for the winter. But unlike the birds that migrate to the Arctic, the grosbeaks spend many months on their breeding territories in the long, mild summer.

Some early morning in late July, a male Rose-breasted Grosbeak pauses in its singing atop a sugar maple to glance up into the blue sky. A flock of Pectoral

Examples of Bird Migration Routes of North America

Birds from the Arctic Refuge migrate along many different routes, and different species can be found wintering or passing through most of the Lower 48 states. Along with many other species, the birds listed here as examples breed in the Arctic Refuge, then migrate along major flyways to the conterminous United States.

Brant

Golden Eagle

Tundra Swan

Smith's Longspur

PACIFIC FLYWAY
Pacific Loon
Pacific (Black) Brant
Sandhill Crane
Surfbird
Red-necked Phalarope

CENTRAL FLYWAY
Rough-legged Hawk
Golden Eagle
Baird's Sandpiper
Northern Shrike
Lapland Longspur

MISSISSIPPI FLYWAY
Pectoral Sandpiper
Northern Flicker
American Pipit
Yellow-rumped Warbler
Smith's Longspur

ATLANTIC FLYWAY
Red-throated Loon
Tundra Swan
Long-tailed Duck
Peregrine Falcon
American Golden-Plover

Sandpipers, flying fast and straight, is barely visible as they migrate south high overhead, traveling a thousand miles in a single hop. Between the time that the grosbeak arrives on its nesting territory in Ohio in April and the time it leaves in September to fly to Mexico, the Pectoral Sandpipers have flown from Argentina to the Arctic, nested, and flown back to Argentina.

This grand dance is passed on instinctively from generation to generation, shaped by climate, geography, tradition, and evolution, and choreographed by weather. Birds pass us by, mysterious and seemingly without effort; one day they appear and the next day they are gone. It is easy to see why early naturalists thought that birds spent the winter on the moon or hibernating in mud at the bottom of ponds.

Now that we know the routes and patterns of the birds, they can give us a sense of place, of our location on the globe. We watch them trace a line across the sky and can imagine extending the line back to where they came from and ahead to where they are going. It may be hot and sunny in the Lower 48 in July, but the migrating sandpipers bring a touch of the Arctic with them. They may have seen snowflakes and icebergs just a few days before, and consorted with eiders and Arctic Terns and longspurs. Then they come south to take advantage of the wetlands, warmth, and easy prey that they instinctively know are there.

As we imagine the migratory paths and patterns being honed over millennia, it also gives us a sense of time and history. Hearing the Sandhill Cranes migrating overhead on a cold north wind, we can imagine the same sounds filtering down from the clouds on a similar day 5000 years ago. We can imagine generations of humans before us watching the arrival of migrating birds and saying to their children, "The cranes are passing; winter will be close behind." We may not sense what the birds sense, but their finely tuned wisdom provides guidance for the observer and clues to the changing seasons.

The migration of birds such as the Pectoral Sandpiper goes back beyond ice ages. Their ancestors flew over giant sloths and rested at watering holes alongside woolly mammoths. Even the 500-year history of European settlement in North America cannot compare to the migratory history of the Pectoral Sandpiper. Our oldest cities are just a few concrete boxes that have recently appeared along their route from the Arctic to Argentina. Even though the migrating birds seem like a temporary and transient thing, and their migration a fragile thread over the land, they are as constant and predictable as the seasons.

There is a kind of music in the patterns of bird migrations, a delicate rhythm that plays over the slow cycles of seasons, the orbits of planets, the raising of mountains. It is the rhythm of the earth made plainly visible.

In many places, our modern lifestyle—with its time clocks and computers and automobiles and insulated, air-conditioned buildings and processed food— has isolated us from this rhythm. The ancient rhythms are there; they are a part of all of us. We understand them and follow them subconsciously, but too much of our lives now are separate from them, and we only hear them when we know what to listen for. It's easier in a place without automobiles and buildings and other modern technology. Sanctuaries like the Arctic National Wildlife Refuge are among the few places on earth where we can hear the natural rhythms

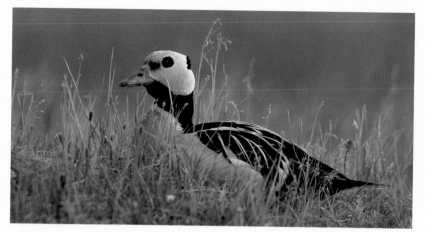

Steller's Eider

clearly, and where some humans still live in harmony with those rhythms.

But the rhythm of bird migrations also reminds us that even in the most urban settings, we do not really control nature; we live in constant interaction with it. Even in the heart of a city like Paris or Los Angeles, birds migrate, seasons change, trees grow, rocks erode. Natural processes are there, and a flock of migrating birds can transport us to the Arctic, to South America, to our childhood, to our ancestors. We are all connected to the earth. It responds to us, and we to it.

Nobody knows what drove the Labrador Duck to extinction in the 1800s, and nobody can predict what will happen with increased human activity in the Arctic. Oil exploration could be enough to tip already-threatened birds such as the Steller's Eider and the Buff-breasted Sandpiper into extinction. Helicopters and drilling equipment will disturb nesting birds. Pipeline and road construction will alter the delicate balance of tundra plants and ponds. Garbage that often comes along with modern human settlements could lead to an increased population of scavenging arctic foxes, ravens, and Glaucous Gulls, which will then eat the eggs and young of nesting birds, potentially leading to declines of many species. Whatever the results of development may be, it is certain that migrating birds will make those effects, small or large, visible all around the world.

DAVID ALLEN SIBLEY *began seriously watching and drawing birds in 1969, at the age of seven. He is the renowned artist and author of the extremely successful books* The Sibley Guide to Birds *and* The Sibley Guide to Bird Life and Behavior, *which set a new standard for both artistic beauty and detailed bird identification. Since 1980 Sibley has traveled throughout North America in search of birds, both on his own and as a leader of bird watching tours, and it was this intensive travel and bird study that culminated in the publication of his comprehensive guides.* ∎

Where the Rivers Flow North by Mark Wilson

One doesn't come to this forbidding place lightly.

To even know about the Arctic National Wildlife Refuge, the crown jewel of refuges, one must have paid attention to a small voice in a world where myriad media scream for ears and eyes. Most Americans, I suspect, know little of this place despite yearly spirited congressional battles over whether to allow oil drilling on the coastal plain. Few people—even those interested in exploring spectacular natural places—make the effort to get here. After all, a birder looking to jolt his or her North American lifelist would find many more wayward Asian species on Attu, at the tip of the Aleutian Islands chain, and might spend less money doing it. A mountaineer would find many higher and tougher peaks to climb in other parks of Alaska. Rafters will find better boat-eating white water on rivers outside the Arctic Refuge, and fishermen can cast more productive waters than the silty, braided, north-flowing rivers of the refuge's coastal plain.

If you nurture a deep sense of natural history or wilderness, then you will find the Arctic Refuge a moving place. Understanding any land from afar is at best a loose approximation. But consider the numbers: The refuge contains 19.5 million acres, with 1.5 million of those acres in the coastal plain and 8 million acres designated as wilderness. There are 194 species of birds that have been recorded in the refuge, with the majority—157 species—found north of the Brooks Range, on the coastal plain. Thirty-seven species of land mammals and 36 species of fish live in the refuge for at least part of the year, and more than 400 species of plants grow on Alaska's North Slope. Numbers, however, merely quantify the place; they cannot express how it looks at midnight when the sweet light lingers for hours; how sleet feels in a July blizzard when the shorebirds are brooding chicks; or how glorious the tundra smells in the morning.

The weather in the Brooks and northward is fickle and tough. Bush pilots die finding this out. Save for the tiny, isolated village of Kaktovik, roads and services don't exist. This is called *wilder*ness for a reason. Topographic maps for the Arctic Refuge most often have a road legend that reads, "No roads or trails in this area." If you come to the Arctic Refuge, you're on your own.

■ ■ ■

I and my wife, Marcia, decided to explore the refuge by canoe in search of some of the sexiest bird species a naturalist can lay binoculars on—Yellow-billed Loons, Gray-headed Chickadees, Gyrfalcons, Eastern Yellow Wagtails, Wandering Tattlers, Bluethroats, three species of jaegers, Buff-breasted Sandpipers, and thirty-five species of shorebirds. We also hoped to see Golden Eagles, American Dippers, Northern Wheatears, Peregrine Falcons, Common Redpolls, and Snowy Owls. Some of these are rare species; a few are hard to observe outside of breeding season and come to the tundra only to nest before going back to the sea for a pelagic existence.

The birds really were just an excuse to visit the refuge. More important, we came to the Arctic Refuge to gain a sense of place, to see and feel what the land was about—a place replete with predators, no roads, and few people. We came to see for ourselves what is at stake, for we, like you, are shareholders in the refuge.

Our drop-off would be almost exactly sixty-nine degrees north latitude, near the heart of the Brooks Range. Only a few refuge rivers on the North Slope offer a trip that starts in the mountains, descends to the foothills, and traverses the coastal plain with the mileage that could make for an extended trip. The Hulahula River, near the middle of the refuge's coastal plain, was one. The Canning River, on the northwestern side of the refuge, was another.

The Canning River seemed to draw us, perhaps because it cuts a symbolic course northward between development to the west and wilderness to the east. On it we would pass through three of the refuge's six ecological zones: the Brooks Range, the Arctic foothills, and the coastal plain.

We could expect to find different birds in each of the three zones. In most mountain ranges, the color of the mountains tells us what type of rock forms them. In the Brooks, limestone gives them a gray, barren presence. Sandstone and conglomerate color the ridges greenish brown. Shale can form gray or black crumbling slopes. Schist looks bluish from afar, and basalt stains the mountain a reddish brown. Plants on the mountains are scant—lichens, heather, saxifrages, ferns, grasses, shrubs. Above 4500 feet, little other than lichen and a handful of flowering plants can survive. We expected to find few birds in the mountains, although we hoped for falcons, Golden Eagles, and perhaps a Northern Wheatear.

The Arctic foothills range from near sea level to roughly 2500 feet. More plants grow here than in the mountains because the climate is less severe. The foothills get more sun than does the coastal plain, which is sheathed in fog or overcast about three-quarters of the time in summer. Tufted cottongrass, which forms fields of tussocked growth, is perhaps the most common plant found in the foothills. We hoped to see Eastern Yellow Wagtails, Bluethroats, raptors, and maybe terns and jaegers in the foothills. The foothills also are home to moose, caribou, wolverines, arctic foxes, and wolves.

As the Canning flows north, leaving the foothills for the coastal plain, it becomes the western boundary of the refuge. To the east of the river stretches the refuge's contested Section 1002 in all its complexity, a mosaic of dry tundra, wet sedge tussock tundra, and wet sedge willow tundra. Here we hoped to find nesting shorebirds and Arctic specialties such as the Yellow-billed Loon and perhaps some waterfowl. Muskox, caribou, moose, and wolverines would also be possibilities here.

To the west of the river, State of Alaska oil lease lands stretch seventy miles to the Dalton Highway, also known as the Haul Road. Built to create the oil town of Deadhorse and the Alaska pipeline, and to service large oilfields on the coastal plain and offshore, under the Beaufort Sea, the Dalton Highway

is open to public travel. A week before setting out for the Canning River, we drove the hundreds of miles of the dusty Haul Road from outside of Fairbanks to Deadhorse, where we stayed for two nights in the Arctic Oilfield Hotel. We wanted to touch the warm pipeline at its source and to see for ourselves the sprawl of working oilfields, the footprint that oil extraction makes on the tundra—to see what supplying petroleum to consumers like us entails. Blink your eyes and pretend the frozen Beaufort Sea isn't there, and you might think you are in Texas. The difference in Alaska is that the oilfields are an industrial city in the middle of a wilderness.

We saw a list of "problem" bears, each named and numbered, which was held at a gatehouse to a section of oilfield closed to the public. Dumpster-diving was among the bears' crimes. For all its industrial grit, Deadhorse proved to be relatively litter- and garbage-free. The bears weren't a problem until oil was discovered; now they're criminals in their own land. Texas, on the other hand, killed off its last grizzly bear, in the Davis Mountains, in 1890.

On a late June day, Marcia and I flew north out of Arctic Village into the Arctic National Wildlife Refuge, over the Philip Smith Mountains, and on to the Franklin Mountains. Our cargo included a seventeen-foot Pakcanoe, an amazing collapsible boat that packs into a medium-size duffle and fits easily into a Cessna. Give a photographer a canoe and he considers it the world's biggest camera bag—a floating camera bag. The canoe would allow me to bring an array of lenses, a carbon-fiber tripod, three 35mm camera bodies, a 35mm panoramic camera, a lot of spare batteries, and 100 rolls of film. For a photographer, canoeing is the ultimate way to travel, the perfect compromise between load limit and mobility. Along with the usual range of camping gear associated with isolated northern destinations, we brought Gore-Tex dry suits to prevent potentially fatal hypothermia, should either of us go for an inadvertent swim in the frigid waters of the Canning River. Our final piece of equipment was an aviation band radio, which we could use to talk to any plane in sight, be it a local bush pilot buzzing past or an international jet headed for Seoul at 35,000 feet. In an emergency, we could radio out for help or advice.

JUNE 28. I wonder if migrating birds can feel awe, fear, and excitement, all at the same time. It's what I feel as I peer from the passenger window of Kirk Sweetsir's Cessna 185, a tail-dragger equipped with balloon tundra tires. Below—and at times not that far below—are some of the harshest limestone mountains I've ever encountered. As we fly over fields of unnamed peaks in the Brooks Range, the land looks big, new, and raw. No evidence of human doings marks these mountains. Most of the peaks support little vegetation that is visible from a plane. Botanists call parts of the Brooks "rock desert," a place inhospitable to plants and birds.

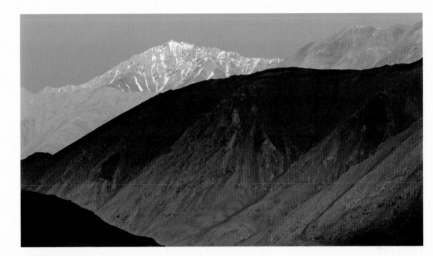
Franklin Mountains

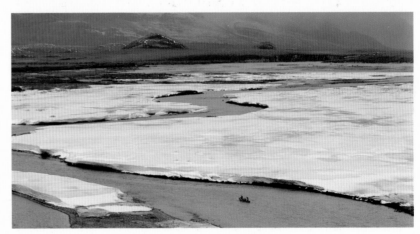
Mark and Marcia Wilson in canoe with aufeis on Canning River

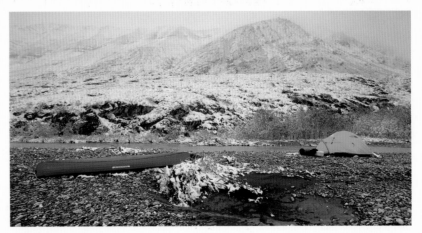
July snowstorm, Canning River

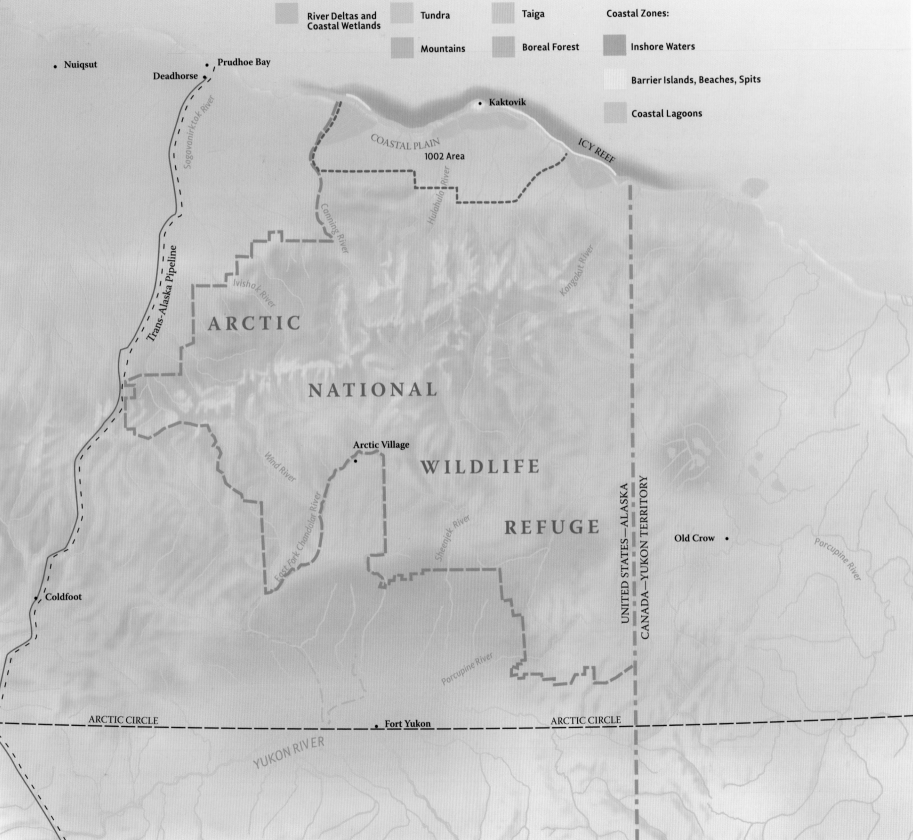

Arctic Refuge Ecological Zones

River Deltas and Coastal Wetlands

Tundra

Taiga

Mountains

Boreal Forest

Coastal Zones:

Inshore Waters

Barrier Islands, Beaches, Spits

Coastal Lagoons

Nuiqsut

Prudhoe Bay

Deadhorse

Kaktovik

COASTAL PLAIN

1002 Area

ICY REEF

Sagavanirktok River

Canning River

Hulahula River

Kongakut River

Trans-Alaska Pipeline

Ivishak River

ARCTIC

NATIONAL

Wind River

Arctic Village

WILDLIFE

East Fork Chandalar River

Sheenjek River

REFUGE

Old Crow

Porcupine River

UNITED STATES—ALASKA

CANADA—YUKON TERRITORY

Porcupine River

Coldfoot

ARCTIC CIRCLE

Fort Yukon

ARCTIC CIRCLE

YUKON RIVER

We clear another nameless mountain pass, and suddenly the Canning River is below. With no apparent landing strip in sight, Kirk banks the Cessna between steep, austere mountains, setting up for a landing in the narrow valley. What looks like a footpath through the gravel and willows is, in fact, Kirk's intended runway. Moments later we bounce down a rutted track that couldn't have been 700 feet long.

Unloading is a no-nonsense exercise. We say our good-byes and then Kirk is off, circling once to eye us a last time. We'd arranged for him to pick us up about seventy river miles and nineteen days downriver at a gravel strip, which we marked with GPS coordinates.

As the plane becomes a speck in the distance, rain starts to fall, and our pile of gear suddenly begins to look small. We move our belongings through the willows and the rain to a camping spot a few hundred yards from the strip and set up camp.

We spend two nights here—where nighttime is a daylight event—assembling our canoe, unpacking and repacking gear to find the right fit, and getting our first taste of refuge birds, mammals, and landscapes. A rafting group (two guides and a family of six from Florida) arrives by bush plane; they unload and go ahead of us down the river.

Birds around the landing strip camp are mostly passerines—White-crowned Sparrows, American Tree Sparrows, American Robins, Common Ravens, Northern Shrikes, Gray Jays, Common Redpolls. A few others are those associated with the river: Mew Gulls, Semipalmated Plovers, and Spotted Sandpipers. While hardly the species of Arctic birding dreams, these birds are a comforting mix of the familiar in a land where life clings tenuously, and tenaciously.

■ ■ ■

JULY 1. Marcia has never run white water in a canoe; I've run a lot of quick rivers, but never in a canoe with 500 pounds of gear. This is learning in the frying pan for both of us. Maneuvering and navigating the shallow channels proves to be strenuous in the fast waters of the upper Canning. If Marcia was fearful of the speeding, snaking river, she didn't show it, perhaps because she was so busy snapping the canoe bow right and then left under my urgent calls from the stern.

■ ■ ■

The first few miles are bump-and-grind canoeing. We often line or drag the canoe. The braided channels require constant attention. The scenery sweeps past, sometimes with nary a glance from us. At other times we steal peeks from the racing canoe at a Wandering Tattler we flush bank side, at Mew Gulls calling in alarm overhead. We opt not to stop and look for their nests. Perhaps the highlight of the day (other than the successful navigation of this speedy little river) is when Marcia spots a foraging dipper just after we'd gone aground in a riffle. The dipper walks a shallow bit of river, peering underwater and pecking the bottom. Water beads and rolls from its back, looking like drops of falling quicksilver; at no time does the bird appear wet. The dipper flies to a riverside cliff, landing under a small overhang. The food-begging calls of baby dippers, a high, whistling refrain, come from a grapefruit-size moss nest tucked back in a crack in the wall perhaps ten feet above the river. Two adults feed the young. One parent leaves the nest

Calf and cow moose tracks

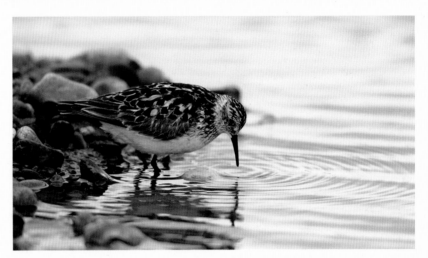

Baird's Sandpiper

carrying a fecal sac; the other flies to a puddle and splash-lands.

We camp a short distance downriver from the dipper's nest. Birds on this stretch of the Canning River are sparse. Redpolls, robins, White-crowned Sparrows, and American Tree Sparrows frequent the willows. We have yet to see an eagle or a falcon. A hike up along a creek that tumbles out of the forbidding Franklin Mountains yields no new species of birds, but a large, fresh, black pile of grizzly bear dung brings me up short. This pile and two others I encounter are laced with the fibrous remains of a vegetable diet, despite the scattered sounds of Arctic ground squirrels. There are no ground squirrel fur or bones in the scat, but craters in the tundra mark where a griz has dug squirrels out of their burrows.

JULY 2. Last night was quiet, with little wind. I found myself on the edge of sleep, listening back into the willows to catch any sounds—not that a bear would make much sound. We tent only a few feet from thickets of willow that the redpolls and White-crowned Sparrows favor. Our site is just north of a dry creek bed that fingers down out of the mountains. In the fine alluvial mud at the creek's mouth, a string of sharp tracks attests to where a moose mother and

calf have walked. We lounge riverside, watching occasional Arctic Terns work upriver against a backdrop of lupines on the mountain flanks.

JULY 3. Late in the day, Marcia and I ferry across the river and then hike upriver to observe the dipper nest again. On a dryas river terrace, a Baird's Sandpiper seems to be in the vicinity of a nest. From another terrace I catch a fleeting, distant view of a flushing Upland Sandpiper. To see the birds we must first see the habitat, and that means looking along the river in the dryas, grasses, and willows. The surrounding mountains are proving to be spectacular to ogle but nearly fruitless for birds. The river is where the action is.

JULY 4. We break camp and are soon engulfed in the fireworks of a thunderstorm. We get off the river and find a shallow gully to squat in while lightning strikes around us. Back on the water, a north wind conspires with the river to make canoe handling difficult. During a lull in the rain we pick a campsite on a low gravel bar, partly sheltered from a thirty-mile-an-hour wind. We hurry to set up the tent and then tumble into the vestibule to get out of clammy dry suits and into warmer clothes.

10:30 PM. Back home, the fireworks over Boston's Charles River will have ended. We lie in the tent, cozy but concerned about the rain and wind lashing our camp. The cloud ceiling has lowered and we hunker down, waiting for better weather so we can dash downstream. We wonder how the Baird's Sandpiper is faring, probably incubating four eggs or downy chicks, shaking off hypothermia.

JULY 5. Overnight, a sound like tiny bugs dancing on leaf litter should have been our first clue that the rain had turned to snow. We awake to four or five inches of snow blanketing our camp and the surrounding mountains, from what little we can see of them. We sit tight for the day, hemmed in by low clouds and high wind on a very gray stretch of river. Even the Wandering Tattlers we briefly see look gray, their eerie flight-songs drifting over the river bars. Back in the eight-foot-high willows we hear a cold recital from an American Tree Sparrow; add to that the alarm notes of a couple of robins, two American Pipits foraging insects on the gravel bar as I watch from the tent door, and a few redpolls dodging around—except for these, it's a quiet bird camp. In the night, the river

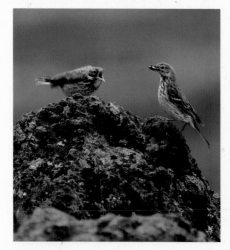

American Pipit

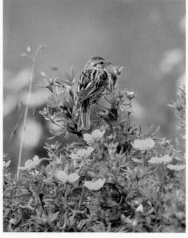

Savannah Sparrow

has risen to within a few feet of our hastily erected tent.

JULY 6. The Marsh Fork of the Canning River joins the Canning in early afternoon. A tattler forages on the west bank just downstream from the confluence. On the east bank an agitated Lesser Yellowlegs flies along with the canoe, and soon a second bird joins in. Both birds act as if a nest might be nearby, perhaps back in the willows. A Long-tailed Jaeger breezes past, the first we've seen on the trip.

The mountains have stepped back from the river. The valley seems to be widening as we paddle north. Dryas plateaus along the Canning offer better camping places, and we pick one near Plunge Creek, hoping to hike in the morning to balsam poplars in search of cavity-nesting Gray-headed Chickadees we had heard about on a tip. This is perhaps the rarest nesting bird one could find in the Canning drainage. As we descend in elevation on the river, we start to see trees in the sheltered ravines and draws. Poplars can grow to thirty feet tall and a foot in diameter in the Canning drainage. Feltleaf willow and green alder can grow here too, although alder is rare.

JULY 7. With today's gray skies and cold wind, Marcia and I lose all ambition to ferry across the river and hike up Plunge Creek. Instead we loll around camp, sleeping late, writing, and puttering. The lack of bird variety and other animals in the mountains has us looking downriver more and more. Sun tantalizes us from the foothills, but the mountains seem stuck in clouds. American Robins have been a constant at every campsite. At this camp, a robin ferries food to a low willow near a backwater. These are hardy robins—big, dark, and richly colored.

JULY 8. The patch of whitewash on the cliff was evident from upriver. We had studied the patch in the spotting scope, hoping to find bird movement, but we were too far away. Not until our little red canoe is barely abreast of the whitewash spot do we simultaneously see the youngster, both of us blurting out, "Gyrfalcon!" We quickly pull to the gravel bar across the river and drink in the single, nearly fledged chick as he eyes us from his eyrie some thirty feet above the river. Plumes of down still cling to his back and neck. We revel in the scene. Had the nest held a Rough-legged Hawk or Peregrine Falcon chick it would have been no less remarkable, but to any birder, the rare gyr chick makes the cliff an instantly recognizable place of Arctic magic. A colony of Cliff Swallows lends energy as they hawk mosquitoes over the river and bluff; a pair of Say's Phoebes commutes to a nest hidden fifteen feet above the Gyrfalcon's ledge. The nest of the gyr is not much more than a whitewashed ledge; no sticks denote this as an old Rough-legged Hawk's nest.

From the foot of the cliff we scrounge for leftover signs of previous Gyrfalcon meals. Under a perch twenty-five feet upriver, a single white ptarmigan wing marks a probable plucking perch.

Reluctantly we push downriver, but not before watching as a Rough-legged Hawk harries a Golden Eagle, the hawk working to gain altitude on the eagle before sweeping down in swift sorties.

We leave the mountains farther behind each day. Finding our fifth campsite proves problematic as we thread small channels in the area of Eagle Creek. The

flood plain of low willows and cobbles makes good campsites scarce, so we settle for a sandy break in the willows a few feet above a side channel. The sand turns out to be quite dusty, and, with a bit of wind, the sand quickly finds its way into everything. The camp has its charms, however. An alarmed Eastern Yellow Wagtail, an American Tree Sparrow, and a redpoll greet us upon landing. Nearby, tracks in the river mud show a wolf had recently shadowed a muskox adult with a calf. Having drinking water so close by is luxurious.

JULY 9. A section of the Canning looms large today. We expect the river could be thick with overflow ice or aufeis. We'd heard that a few weeks earlier, a rafting group rounded a river bend to find the channel blocked by aufeis. They'd had to lift their rafts up and out of the six- to eight-foot ice canyons—not a scene we wanted to repeat. We scout ahead from a hill and see an open channel. If the easy channel passage through the aufeis is a relief, the Rough-legged Hawks (at least two pairs, maybe three) we find nesting on riverside bluffs are a delight. One pair in particular was not wary. Marcia sprawls on a gravel bar and watches the female return to her nest. A nearby pair of Say's Phoebes rallies to harry the rough-legs.

Farther downriver, a wolf pauses to watch our approach on the river. We scramble to haul out binoculars. The wolf moves on in the wind, stopping twice to look back at us. The wildness and enormity of the Arctic Refuge come into focus with this one wind-buffeted predator on the move, wary and watchful.

JULY 10. We camp near Ignek Creek so we'll have a short hike to an exploratory oil well on state oil lease land on the west side of the Canning. After ferrying the river, we stash the canoe and change into hiking boots. Hiking north through the willows and then up through a steep gully to higher ground brings us to tundra thick with mosquitoes. Earlier in the day we had watched from across the river as seven bull muskox walked this same draw. At the head of the willow gully, a pair of Bluethroats, both carrying food, scolds us. We slog across the dry, tussocky tundra, and on the plateau I flush a male Smith's Longspur.

The drill pad is in view for most of the hike, and as we draw near, it proves to be three acres or more of cobbles and gravel dug from nearby tundra and fashioned into a working lot. Borrow pits that once held the gravel now hold water and foraging Red-necked Phalaropes. Eastern Yellow Wagtails and Savannah Sparrows panic over our presence at the pond edges. A Northern Harrier stops by to check on the excitement. Later, a Short-eared Owl hunts the edges of the manmade wetland. The setting highlights the tenuousness of oil in proximity to ponds and wetlands: The water attracts birds; if the well ever leaks, the wetlands would become a fatal magnet for birds.

The exploratory oil well, a large pipe sprouting from the ground, tapers to a swedge and is capped by a two-inch valve. Welded to the well pipe is a smaller pipe that sticks up eight or ten feet. That's where a welder had brazed an Exxon tiger and the words, "Exxon Company USA # A-1 Canning River Unit." Partly buried in the edges of the gravel pad are two fifty-five–gallon drums. We can't help but wonder about the contents of the drums and why they might be buried there. Are there others buried deeper—and more importantly, is it possible that their unknown contents are leaking? It's an unpleasant thought.

JULY 11. After our eight-hour foray to the exploratory well, we take a rest day at camp. We share this sandbar with another paddler, the only one we've seen since parting with the rafting group at the beginning of our trip. He says he's an oil geologist from Oklahoma, and he's against drilling in the refuge for oil. He's just returned from a hike up Ignek Creek where he reports having seen eight moose in the willows along the creek.

JULY 12. We're on the river by seven in the morning, but the wind soon rises and forces us to shore in the early afternoon. We set a hasty tent with no fly, and the wind roars. I watch a Golden Eagle trying to work his way along a series of low bluffs behind us, away from the river. Even he seems forced to hug the ground. Three times he lands in the relentless wind. A Peregrine Falcon whips past, riding an updraft from the bluff where we are hunkered.

JULY 13. By 2:30 AM the wind subsides. We strike camp and are on the river by six o'clock. We get in a few hours of paddling before the roaring headwind starts up again. Our first caribou of the trip—nearly fifty animals—shimmer in the distance. A few hard-won miles on the river bring more caribou. We camp

Exxon test well on state lease land near Section 1002

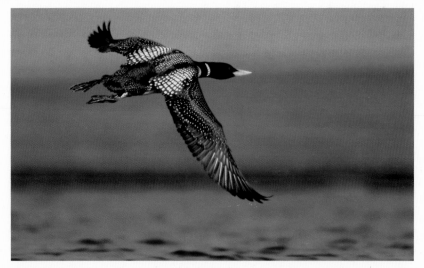

Yellow-billed Loon

on a twenty-five–foot bluff on the western shore overlooking a view of caribou hanging out on a remnant snowdrift on the opposite shore. Suddenly fifteen caribou are running; a wolf is hard on their heels. The caribou bolt for the river and plunge in, the largest bull leading the way. The wolf comes up empty.

We are on the coastal plain now, though it's difficult to say where the foothills ended and the plain began. Our campsite proves to be on a flight line for birds. The north wind deflected off the steep bank creates an updraft for the birds to sail along. Glaucous Gulls, Long-tailed Jaegers, and a peregrine sail past, hardly flapping, sometimes at eye level. The mosquitoes are grounded.

JULY 14. "I have a wolverine," says Marcia as she peers over the tundra through her spotting scope. I get on the distant galloping animal with my binoculars. His gait is part weasel, part bear, and he's hunting. Over the next forty-five minutes the wolverine pounces, lopes, and stares at caribou. They stare back. 'Rine, as we come to call him, takes an extended snow bath in the same bank where the caribou stand to avoid mosquitoes. 'Rine rubs his butt with an exaggerated sweep in the granular snow. He seems to be ecstatic with pleasure. "Happy birthday," says Marcia. The wolverine is her gift to me.

JULY 15. We break camp early to get on the river before the wind picks up. The rigors of paddling and pulling a heavy canoe have been taking a toll the last few days, and a quick four miles of paddling to the pullout leaves us with time to nurse our river wounds. I ice a sore heel with snow gathered from a bank. Our hands have slowly become chapped to the point of bleeding when we move our fingers.

From the high plateau at the pick-up strip we glass the river and see our first Yellow-billed Loon of the trip.

JULY 16. Had I planned for more time, I'd be tempted to push farther onto the coastal plain and the Canning River delta, where few paddlers venture and where, undoubtedly, we'd see more diversity of nesting shorebirds. Perhaps the delta will be the goal of a return trip. We while away the hot day reading and napping, camped not far from a ground squirrel colony, waiting for the drone

of Kirk's Cessna. Mosquitoes queue by the hundreds on our tent's netting. Somewhere nearby another Yellow-billed Loon is wailing.

■ ■ ■

POSTLOGUE: A birder visiting the Arctic will soon realize that the distribution of birds and mammals is lumpy. Large areas of—to human eyes—appropriate habitat can be bereft of birds or signs of mammals. Other seemingly identical areas can support a dense, exciting mix of shorebirds, jaegers, waterfowl, owls, arctic foxes, and wolves. In the Arctic Refuge this lumped density of life most often occurs in the grasses and tussocks of the coastal plain, with its perceived aesthetic monotony; in contrast, the spectacular landscape of the Brooks Range is a place of grand views but relatively few birds and mammals. We tallied forty-three species of birds on our nineteen-day river trip, and few of the sightings came from the mountains; our best bird and mammal sightings came from the foothills northward toward the coastal plain. Had we pressed farther into the plain and delta of the Canning, we likely would have added at least twenty-five species of birds to our list.

For Marcia and me, the refuge's influence was deep and continues to mold our thinking. Soon after returning from the refuge we replaced a thirty-mile-per-gallon car with a sixty-mile-per-gallon hybrid car. We tightened up our home's weather-stripping to save heating oil, and we started running the thermostat at lower temperatures in winter and wearing sweaters to compensate. We started paying attention to what could happen in the refuge.

For the average American who will never visit the Arctic Refuge, the closest he or she may come to the tundra is to sit behind a Toyota Tundra pickup in midtown traffic. Yet the habits and preferences of mainstream America have great impact on the very biological heart of the refuge's North Slope—the Section 1002 area. If the American public remains uninformed and indifferent, the refuge's coastal plain will be destroyed. It seems not too much to ask that we, a powerful, wealthy nation, spare the very last remnant of Alaskan Arctic coastal plain that is so terribly crucial to millions of nesting birds.

Photo: Marcia Wilson

MARK WILSON *brings a degree in biology and a love of natural history to his work as a wildlife photographer, photojournalist, writer, lecturer, and avid birder. His writing includes a biweekly birding column, "The Backyard Birder," and a weekly photography column, "Camera," which appeared in the* Boston Globe *for four and nine years respectively. He is a staff photographer at the* Globe. *His work has appeared in* National Geographic, National Wildlife, Canadian Wildlife, Yankee, Orion, *and many other magazines and books. He and his wife, teacher naturalist Marcia Wilson, often camp, canoe, and hike to study birds, wildlife, and ecosystems. The two run Eyes on Owls, an educational company that offers live owl programs.* ■

Spring Bird Research in the Arctic Refuge by Metta McGarvey

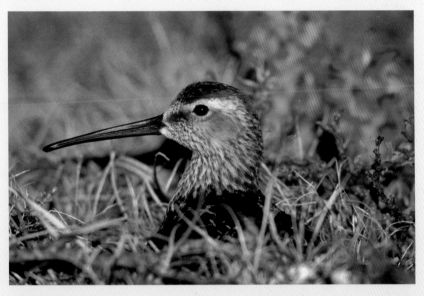

Stilt Sandpiper on nest

*O*ur group from Manomet Center for Conservation Sciences arrived on the Jago River on May 31, excited to begin documenting the distribution and density of breeding shorebirds throughout the coastal plain. The weather ranges from freezing fog with gale-force winds to glorious, sunny days in the fifties.

Today starts at 6:30 AM with the lovely woo-woo-woo-woo-woo of a male Pectoral Sandpiper. Shorebirds produce a spectacular symphony of breeding and territorial calls during the twenty-four–hour daylight in June. It's thirty-eight degrees and foggy. By 8:30 we've had breakfast and loaded data sheets and equipment into our daypacks, together with twenty pounds of survival gear, GPS units, field glasses, water, and food. We carry twelve-gauge shotguns for bear protection.

Four team members are transported by helicopter to conduct rapid surveys of randomly selected, forty-acre sites across this 1.5-million-acre region—110 sites in total—while I and three others rotate among eight intensively studied sites within walking distance of camp. A surprising range of habitats makes walking an adventure. Shallow bogs, with slick permafrost underneath, suck hard on our hip boots, making each step a slurping test of determination. Upland areas of tussock tundra transform walking into a fatiguing, comical wobble across a field of stubbly softballs.

Two long miles from camp I begin recording breeding-bird displays. Observing a Semipalmated Sandpiper and Stilt Sandpiper as they forage, I track each back to its nest. On past visits to this site we documented one Red-necked Phalarope nest and two Pectoral Sandpiper nests, along with the nests of two Lapland Longspurs and one Long-tailed Duck. I carefully recheck these to make sure they have not been destroyed by predators. The birds sit tight for a remarkably long time, flushing only when I'm about fifteen yards away.

Around 7:30 PM, after surveying my second site, I hike back to camp. Changing from hip boots to hiking boots and fresh socks is a welcome relief. During dinner, the floor of the tent undulates: A lemming is making its home beneath the temporary shelter. At 10:45 PM we write up data and finish with our camp chores. The mountains are stunningly clear, and in the long light of the midnight sun, birds sing like it is morning. We hear the dee-dee-dee-dee-dee-burr of a Long-billed Dowitcher; a Stilt Sandpiper calls high above, ending with the braying sound of a donkey.

Lying on camp pads nestled between tussocks, we listen. Two Red-necked Phalaropes softly coo as they forage in the pond just feet from our tent. We hear the wild calls and gentle mewing of many pairs of Pacific Loons on ponds near and far. Their powerful voices, found only in wilderness, fall on too many deaf ears. This research is how we can help them be heard, help protect this one last precious piece of undeveloped Arctic coastal wilderness and the millions of birds and animals whose lives depend on it. Long days and sore feet are a small price for the privilege of being in this place that needs more than anything for us to simply let it be. ■

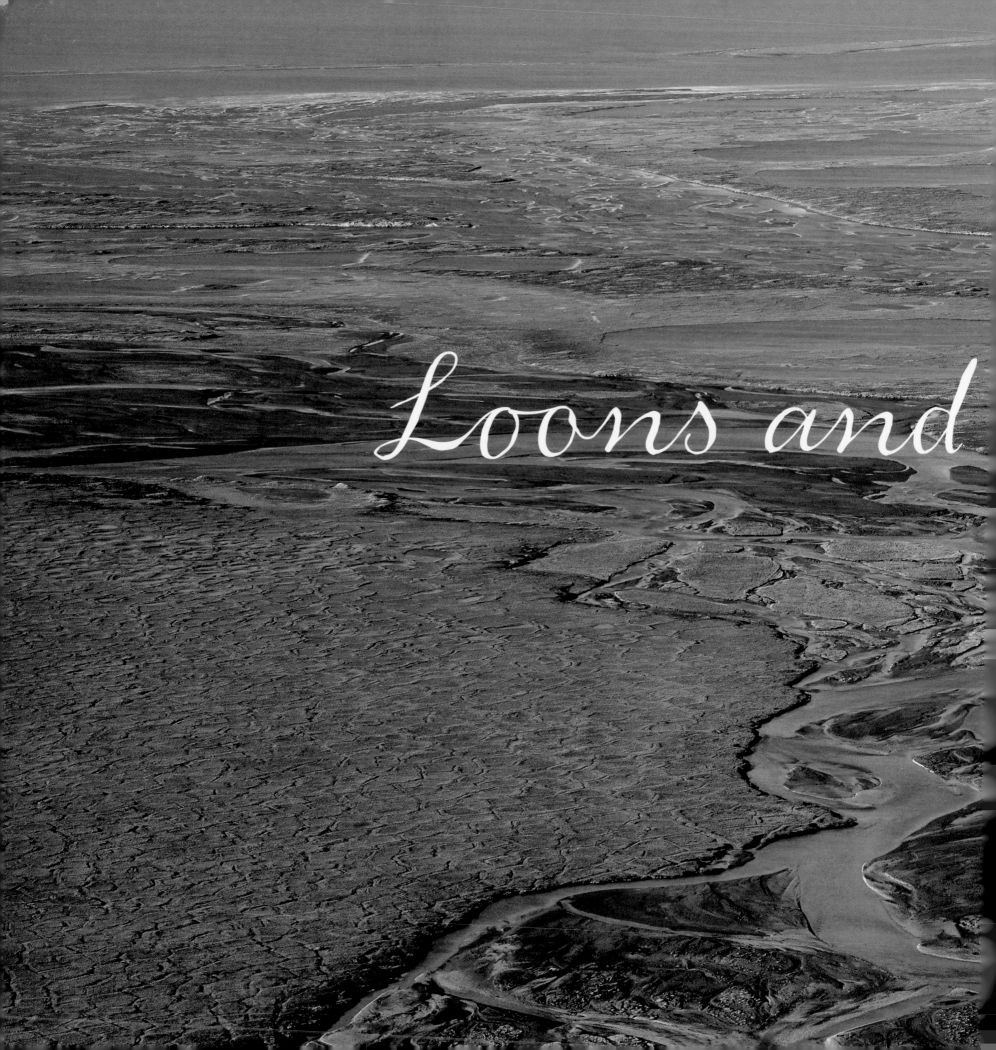

Loons and

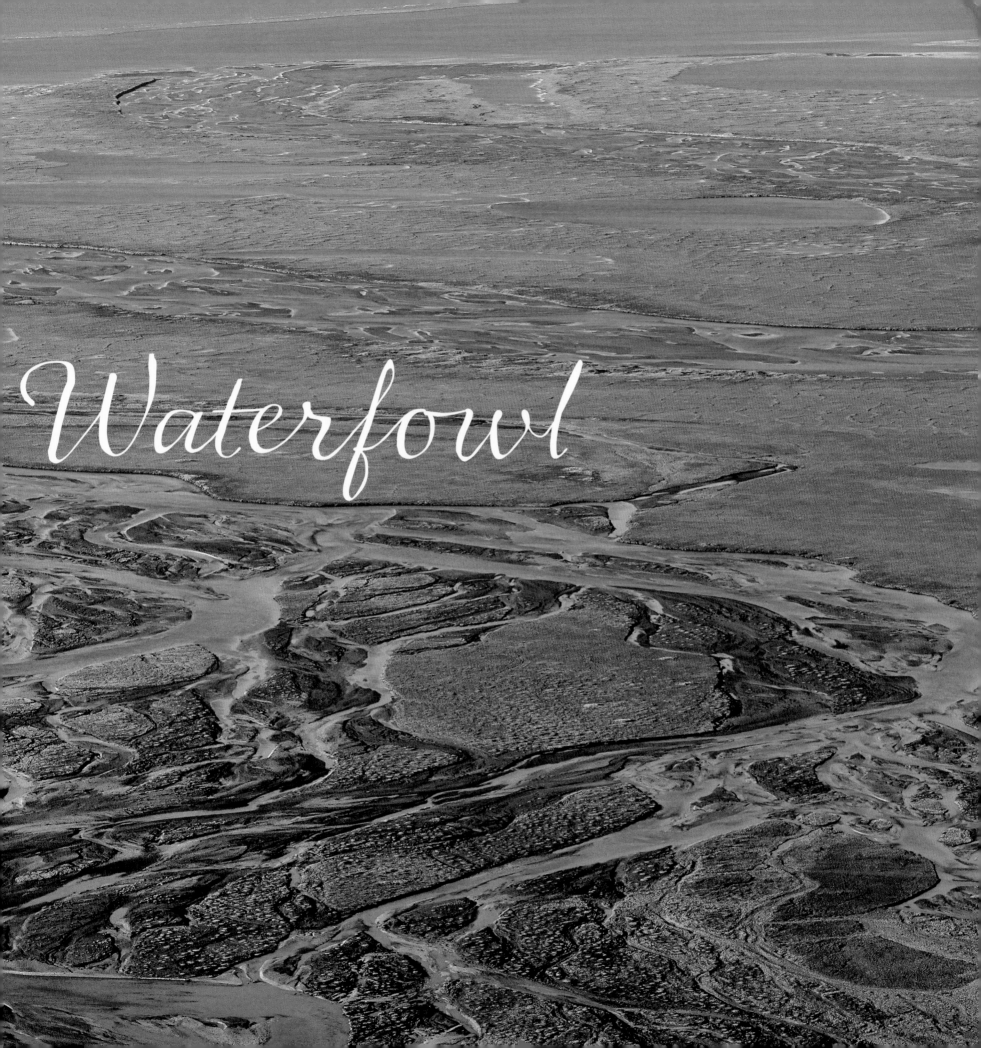

Waterfowl

JEFF FAIR *is a wildlife*

biologist with four books to

his credit, including Moose

for Kids *and* The Great American Bear. *His*

essays have appeared in Alaska Magazine, The

Christian Science Monitor, *the* Boston Globe,

Equinox, Ranger Rick, Audubon Magazine,

and Appalachia, *where he is a contributing*

editor. In 1998 he received the National Wildlife

Federation's Farrand/Strohm Writing Award,

and in 2001 he was selected for the Alaska State

Council on the Arts' first Tumblewords roster.

Overleaf ■ *Hulahula River and Okpilak River delta*

THE CANNING RIVER DELTA, ARCTIC NATIONAL WILDLIFE REFUGE
JUNE 4, 1:07 AM

All night long under the midnight sun, the Arctic sings its spring song. Floating in from somewhere behind the wind are the voices of this land: the various musics of Greater White-fronted and Canada Geese, Pacific and Red-throated Loons, and Long-tailed Ducks (we used to call them Oldsquaws), along with a few quieter fowl I cannot name. Nestled in the candlelike glow inside my yellow tent, I lie awake, listening. The temperature hovers below freezing, half the tundra remains covered in snow, the lakes are still frozen over—but these water birds, eternal optimists of the Arctic plains, are arriving 'round the clock, en masse and in voice, for their summer ventures. Off to the north I hear the excited chatter of Tundra Swans. A few hours ago, outside my tent I looked up and watched seven of them materialize out of the mist: elegant, slow-winged creatures pure as snow, passing closely above with the grace of angels.

Bowing into the morning fog on a raw northeast wind, I make my way to the cook tent to build a mug of boreal coffee. Six of us have established a temporary research camp here on the northern fringe of the delta, in the very northwestern corner of the refuge. I've joined the others as a volunteer biologist for a study of the nesting success of the local birdlife.

We arrived by bush plane over the past two days, as weather allowed, and set up our bivouac: six identical sleeping tents crowd together like a clutch of eggs, and fifty yards off stands a cooking tent and a warming tent with a wood stove. Farther yet our tiny, makeshift latrine enjoys a holy and priceless view. The tents are staked against the arctic wind with foot-long pieces of rebar hammered into the frozen ground. Yesterday we used ice chisels and sledges to pound larger holes to erect two separate three-wire bear fences, one around our sleeping quarters and one around the food tents. There are a few griz about, and we hope to see them, but they are not welcome inside. The fences are electrified by solar panels—powered by the sun like the living tundra itself.

Angels in the Mist by Jeff Fair

*Abandon, as in love or sleep, holds
the ancient faith: what we need is here.*

"The Wild Geese," from *The Selected Poems of Wendell Berry*

Around us stretches the vast Arctic prairie, now a mosaic of white snow and golden brown cottongrass and sedges. When the ocean fog lifts (camp is only two miles from the shore of the Beaufort Sea), we can see thirty miles south to the Sadlerochits, last mountains before the North Pole, and beyond them to the massive Brooks Range, blue and infinite in the distance.

Out of the fog and that infinity, the feathered tribe continues to arrive. More Tundra Swans wing in from their winter waters on the Chesapeake Bay; White-fronted geese appear, with their high-pitched laughter, up from the Texas coast. The loons have come all the way from the Yellow Sea off China. We see two long lines of Black Brant—a subspecies of Brant—fifty or more in each, flying eastward, low over the whitened tundra along the coast, nearing the end of their jaunt from Mexico. Must be something about this place, something attractive and valuable that draws them here. Otherwise, why would so many species come from so many distant places for the most important function of life—reproduction? And I don't mean only water birds. Arctic Terns and many of the shorebirds return here from even more distant places. Caribou and polar bears choose to give birth here. What some have blindly called a barren wasteland appears to me more like a coral reef of the north, a huge sponge of productivity.

Ten Snow Geese, then twenty more, fly across, white as alabaster under a cerulean blue sky. Pintails, Common Eiders, and King Eiders arc overhead in pairs and small groups. The commons are more likely to move out to the coastal barrier islands to breed. A drake King Eider flies close by at eye level. His body is black and white, but his head is the marvel: red bill, orange forehead, green cheek, blue crown and nape—nearly the full spectrum from the neck forward. The Harlequin Ducks are nearly as audacious, but we won't see them here. They nest up in the mountains, where they walk underwater along the stream bottoms, foraging into the current in the fashion that the water ouzel made famous.

Of all the birds that nest in the refuge, I consider the Pacific Loon the most elegant. With its velvet gray hood, splendid black-and-white collar and cape, and polished poise on the water, it embodies a reserved handsomeness, dignity,

and grace. I say this without bias, although my work has focused on loons for nearly three decades. In truth, I haven't studied Pacific and Red-throated Loons much at all and still have a difficult time separating their voices.

Today we make our first formal visit to two of the twenty research plots established three years ago when the study began. My compatriots take a primary, focused interest in the shorebirds, our most numerous clients on the swaths of tundra. I'm keeping an eye out for loons and waterfowl—the larger feathered spirits. There's something about how a swan can raise its cygnets from eggs to fifteen pounds over a short Arctic summer by eating cold vegetables that seems magic to me. The local Inupiat still hunt these creatures, and their knowledge of them is based upon the oldest research ever undertaken in these parts: the science of survival.

▪ ▪ ▪

Swans float about like icebergs on the river in front of camp. A single Red-throated Loon rockets downriver. One minute later: cacophony at the river bend. She's found some friends—or maybe antagonists. It's hard to tell, given the caterwauling. Either way, it resounds with excitement.

As my colleagues pointed out, the racket these two species make can hardly be called a song at all. And by strict definition they are correct. Any ornithological text or field guide will tell you that neither loons nor waterfowl sing songs; they utter *calls.* In the absolute scientific sense, this is true. Problem is, I'm not an absolute scientist; romantic biologist might be a better description. I cherish these voices because they symbolize the north lands that I love. And if, as the bioacousticians suggest, these voices are tuned to carry through misty winds and above the white sound of driven waters, then they are tuned by the landscape—they are voices of the land, much as their very bodies are built of and powered by local stickleback and blackfish. Even the Red-throated Loon's cry, compared by some to the sound of a cat in despair, rings eerily melodic if you happen to carry an affinity for loons as I do. To my ear all these voices, in their innocent melancholy and exuberance, reach to that place where laughter

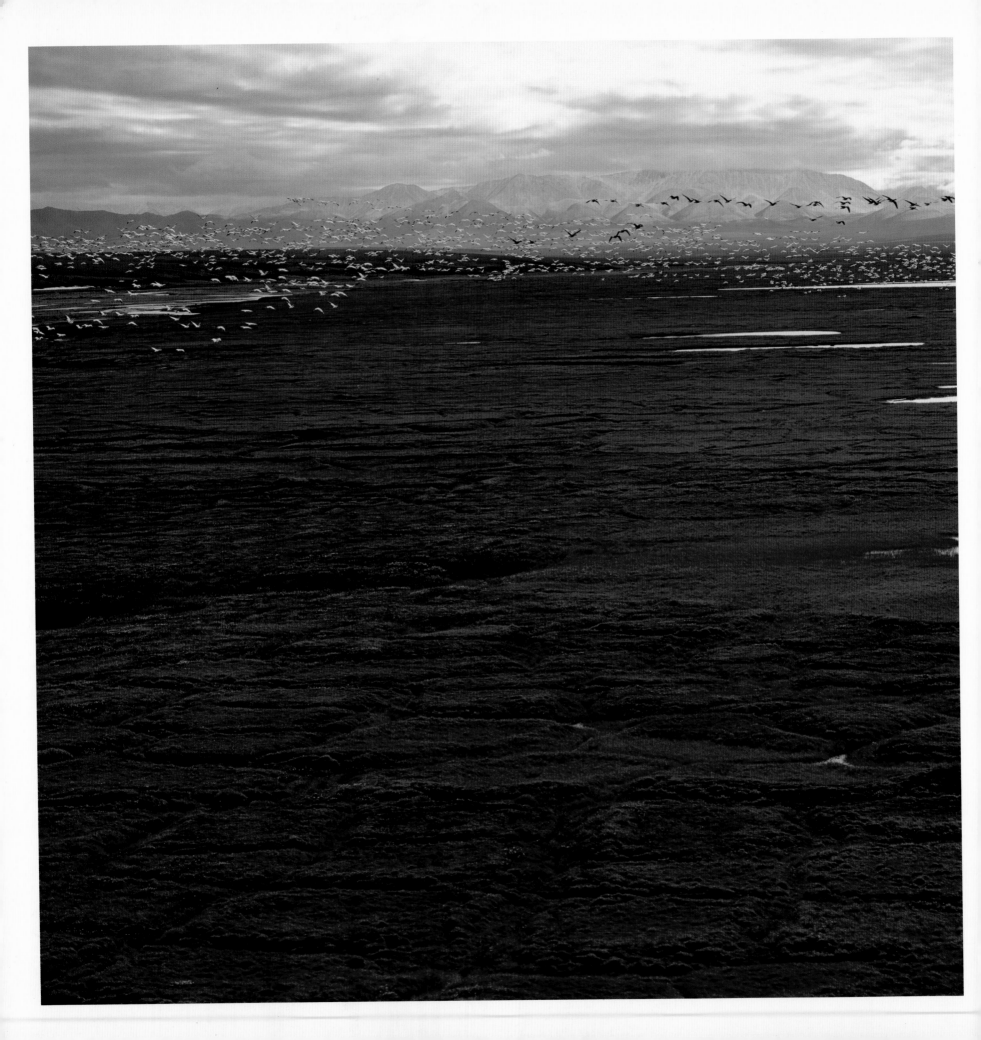

and tears meld, and life celebrates itself upon the land. It is music to me.

The wind whips up again in the evening, rattling and wrestling with the tents, another night of wild percussion drummed into our delicate human spirits. The wind, too, is a voice of the land—that same wind that lifts the wings of Tundra Swans and carries the yodels of loons.

■ ■ ■

Every day we walk the plots. Lapland Longspurs and a few sandpipers have already begun nesting in tiny alcoves in the sun-warmed and hay-scented tundra. The snowfields are disappearing by the acre despite the biting cold of the wind. Ice water collects in the polygons, fills the ponds, and seeps in slow, cold currents through the grasses and sedges into the river and down toward the sea. On average, only seven inches of precipitation fall here each year, but it's hard to think of this place as a "polar desert" when we're marching through water up to our knees. Unable to soak very deeply into the soil due to the solid barrier of permafrost, the snowmelt remains on the surface, available to wildlife and irrigating the grasses and sedges. Often we wade across ponds filled with a layer of water above ankle-deep muck, our soles treading upon the concrete hardpan of ice—the permafrost.

Purple saxifrage, first of the Arctic blooms, flowers around us from its low cushions on the drier soils. East of camp I found a broad scatter of swan feathers, a few bone fragments. Over by the river we stumbled onto the skull and rib cage of an arctic fox. A few miles to the north lies the entire skeleton of a muskox, its flesh eaten and the long bones gnawed apart. Here and there on the tundra we find the shells of Long-tailed Duck eggs, the antlers and ribs of caribou. We watch for the droppings of foxes and wolves, deposited on the peat mounds and often twisted with the hair of lemmings and occasionally caribou, sometimes containing the tips of feather shafts. There's a grizzly track frozen into last year's mud near my tent. On the riverbank we see many tracks—all sizes and makes of waterfowl—along with those of fox and weasel, and now and then a burst of feathers. All the chapters of life here lie open to the sky. Every walk is a treasure hunt.

■ ■ ■

Cold again; windy as usual. My crew finds the first Canada Goose nest today near study plot 4B: four eggs nestled in gray down upon a grassy bowl on a small island. The Tundra Swans, first of the waterfowl to nest, are incubating too, down on the lower delta.

Loons of both species, often singly, fly overhead almost constantly now, in different directions, reconnoitering the melt waters, one might assume. Loons are, of course, not waterfowl at all. According to current theory, they are more closely related to penguins and frigatebirds. Adapted to diving, they navigate poorly on land and require stretches of open water for take-offs and landings. Because of this, they will be among the last to alight upon the lakes as they thaw.

More and more waterfowl arrive. Red-breasted Mergansers have appeared, as well as a pair of Northern Shovelers. Someone has seen a pair of Spectacled Eiders, a threatened species listed formally under the Endangered Species Act

and a rare nester here. Most of the United States Arctic population nests farther west, where oil leases are likely to be developed. But this was a pair, male and female, and they are known to prefer river deltas, so we are hopeful.

The Long-tailed Ducks would make an interesting study. Tens of thousands of them molt and gather into large groups to stage on the lagoons behind the barrier islands before fall migration. We see them floating, almost always in pairs, on the coldest-looking little ponds among chunks of ice. Common breeders on the coastal plain, they are unusual in two ways. Unlike the other waterfowl, Long-tailed Ducks utter sentence-long calls and molt continually in a sequence of phases from spring through fall, rendering a long series of ephemeral appearances far too numerous and variable to be represented in any field guide. Though ornately beautiful in earthen tones, for half the year it is impossible to match their color patterns with any page in a field guide.

Off the corner of plot 4A I spot a Peregrine Falcon sitting dark and quiet upon a low peat mound, waiting patiently. There's a reason the Peregrine was once called a "duck hawk," but this hunter is more likely watching for the rustle of a sandpiper or a nice, warm lemming. (There are a lot of lemmings about this year, which might take some of the predation pressure off of the birdlife.) We honor the peregrine's presence by pausing our survey so as not to scare up any study birds, duck or Dunlin, for its dinner. I carry no prejudice against predators, myself. After all, I belong to that league, and so does the cute little arctic fox, and the loon. We're all part of the balance.

The wind howls, coating my spectacles with droplets of fog, burning color into the skin of my cheeks. A harsh land? Some would say so. Who could deny it? But it is this very harshness that illuminates by contrast the abundant and exuberant life here—song and sex and celebration, bloom and productivity. The harshness of winter here drastically reduces the numbers of predators. And the

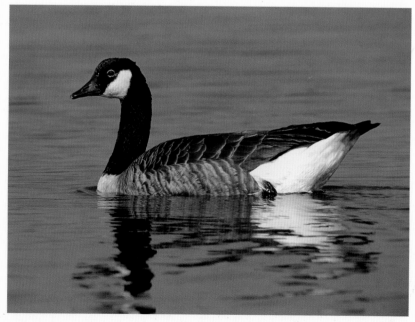

Opposite ■ *Snow Geese over the coastal plain, Brooks Range in the background* / *Canada Goose*

same latitude that creates the long, dark season also creates a summer with twenty-four-hour-a-day sunshine that swells the lowly cottongrass and sedge with solar energy, which in turn becomes goose feather and swan song.

I wonder if the wind tires the goose in the same manner that it soaks away my energy. If so, she doesn't show it. Down puffed out against the chill, contour feathers preened with oil to shed the mist, that goose out there by 4B nestles down on five eggs tonight, facing the wind and keeping alert for the wrong kind of company.

■ ■ ■

Out on the plots the tundra is greening up. I find the single flower, bright and cheery, of a buttercup, second one I've seen this week. Who can call it a barren wasteland where the innocent buttercup blooms?

The loons are largely gone from the river now. We see them, as well as many of the waterfowl, in pairs on the ponds. One of the characteristics of loons, swans, and geese that seems to pique a certain human wistfulness is the fidelity of these mated pairs. They are said to mate for life, and scientific studies have illustrated that this is for the most part true. Some of them, the loons especially, hold a strong landscape fidelity as well. If Pacific and Red-throated Loons follow the behaviors of Common and Yellow-billed Loons, as we assume they do, they will return to the same lake or pond, and sometimes the same nest site, year after year.

Polygon ponds formed by freezing and thawing cycles

Ducks are a different clan, with a different strategy. Most of them appear to flirt about each year, courting new mates and breaking up shortly after intentions are spent. Interestingly, it is the ducks that show different plumages between the sexes, males strutting about in bright breeding colors designed (by the great evolutionary stylist) to attract females, a necessary requirement every spring. The females are usually drab, giving the benefit of camouflage to the nest sitter. The loons, geese, and swans, which generally mate for life, have no need of such dress-up; plumages are identical (at least to the human eye) between genders.

Pair fidelity appears linked to brooding and rearing strategy as well. After breeding, most of the drake ducks have fulfilled their ecological responsibilities and disappear to the molting areas and an early start south. But both male and female loons, geese, and swans share in the raising of their young at least to fledgling (flying) age. Among them, only the loons share equally in incubation duties.

■ ■ ■

No loon nests yet. The Yellow-billed Loons I've studied in the western Arctic would be on eggs by now, secreted down by the narrow open margin of a larger frozen lake. But they are not known to nest on the coastal plain of the refuge, perhaps due to a relative paucity of larger lakes here. They seem to be social creatures, preferring the juxtaposition of many larger lakes in the western Arctic, where the plain is wider. But they migrate through here, and the local Natives know them well. A hunter from Kaktovik told me that he remembered a single *Tuullik* feeding thirteen people around his father's table. And how did it taste? About a five, he said. On a scale of ten? No, he said, once every five years would be often enough.

Clearest hour of the season so far, tonight. We stare out across the green-gold prairies to the Sadlerochits, snow-veined and purple in their Arctic majesty. Above and beyond them, the rarefied pinnacles of Mounts Chamberlin and Michelson in the Brooks reach toward a three-quarter moon. The first little longspurs hatched today; I've seen the tiny miracles in their little grass caves. More of the geese are hunkered down laying eggs. The Pacific Loons are yodeling, defining and defending their territories, a behavior penultimate to breeding. But I hear another music beyond them, more a feeling than a sound: the subtle chords of exultation from the land itself. Or perhaps my own heart.

■ ■ ■

Today is a day off for me, and I plan to mosey overland to a distant set of ponds where I'll scout for loon nests. We haven't found one yet. I pack my field notebook, lunch, binoculars, and shotgun (in descending order of importance), and set out before noon. The gun is loaded with slugs for the rare case of a grizzly threat. Every team or individual from our crew venturing afield is required to carry one. Wouldn't want to lose one of us; we have enough paperwork to do already.

I walk north in a set of parallel ruts that runs clear to the coast. Made decades ago by a vehicle driving on the tundra, they remain scars in the earth today and will for a long time to come. This may be a harsh land, but it is delicate, too. Its wounds heal slowly or not at all.

The water birds up here are the wariest I've ever seen. As I crest a low hill, a pair of Canada Geese a hundred yards away lifts off in fright, discussing it in counterpoint:

Gaak

Leek

Gaak

Leek

GaakLeek

GaakLeek

LeekGaak

Leek

Gaak

Leek

GaakLeek. . . . Polite, graceful, but intolerant of me, they disappear, still conversant, behind a low roll of tundra.

We already know many of the effects of industrial invasion on these timid creatures from studies conducted west of here, where oil and gas exploration and development have occurred. Obviously, a spill anywhere, particularly during staging or migration, would be catastrophic. Nesting and feeding habitat losses; disturbance of these wary and retiring creatures at critical times; changes in hydrological schemes and lake levels; and the usual increase in opportunistic predators, which feed on refuse and find shelter at developed sites. These include bears, foxes, ravens, and gulls, which also keep a hungry eye out for wild eggs and nestlings. All are factors either proven or considered likely to add to the challenges of breeding and survival of the waterfowl and loons here as well as shorebirds and other members of the feathered tribes.

The very study I am part of has been undertaken to better understand the significance of these factors, although the National Academy of Sciences has already reported them as part of the cumulative environmental effects of oil development. Although this Section 1002 area does not support a preponderance of nesting water birds, it is the refuge's heart of production for waterfowl and loons, and includes critical migration habitats. Our site on the Canning River delta is important to the study because here there is no development. It serves as a "control" or "benchmark" area against which the effects at developed sites may be compared. The refuge's coastal plain is the last part of our Arctic coastal plain that is *not* available for leasing—the last benchmark area. Everything from Point Thomson to Barrow is open for leasing or already developed. And, ironically, the Canning River delta could be the first spot in the refuge affected by industrial changes. This is the entry point from the existing oil fields to the west; the Alaska State government hopes to build a road nearly to the refuge boundary, just a few miles from here, if the oil companies don't get to it first.

The value of this area as the final wild comparison was not missed in the argument for protecting these refuge lands the first time around. Lowell Sumner himself suggested that this is a place where the land could still have the "freedom to continue, unhindered and forever, if we are willing, the particular story of planet Earth unfolding here. . . . "

If we are willing.

Don't think about it, I'm thinking. We came here to celebrate, not to fret and mourn. The northeast wind whistles through the grass. The nesting geese hunker low, facing into it. A veil of down and breast feathers stretches off behind each one in the downwind, southwesterly direction, eroded from the thick, blanketlike covering that insulates their eggs. As I approach the ponds, one of them flops off her nest, calling in consternation.

So far I've been referring simply to the Canada Goose, or "CAGO" in the birders' shorthand that I use in my field notes. But someone working the far opposite extreme of my field of wildlife science has been peeking into the genes of these geese and has decided that they ought to be divided into *two* species, Lesser Canada Goose (actually the larger of the two) and Cackling Goose. Because the Canadas here in the Arctic are of intermediate and differing sizes, the scientists aren't certain what to call them, and so we have promised to collect a few feathers from each nest for DNA analysis.

Interesting work, but there is a danger, I think, as we divide and categorize life. Focus down too fine, and you lose the big picture. The poets recognize this: "Erase the lines:" wrote Robinson Jeffers, "I pray you not to love classifications. / The thing is like a river, from source to sea mouth / One flowing life."

Amen to that. Nevertheless, biologist that I am, I wade out on the slick permafrost pond bed toward the nest. The goose flushed at my approach, and I have a responsibility now. I collect a dozen breast feathers from the veil into a plastic baggie and then reach down to close the downy nest liner over the clutch like a purse—field etiquette to minimize heat loss and camoflage the nest from predators until the goose returns. When I lean over the eggs, their radiant heat warms my face with remarkable intensity: six hot little globes of sunlight recycled and resurrected into life, cooking along embryologically at 100 degrees F out here upon the open prairie, eighteen inches above the ice age.

■ ■ ■

I walk the shoreline of another pond with a pair of Pacific Loons on it, and here I find what may be the very beginnings of nest construction—a rude circle of soggy grass pulled together on a shoal just offshore. The pair acts nervous and I leave

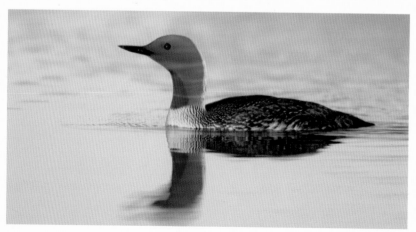

Red-throated Loon

quickly, but not before observing a pair of Spectacled Eiders nearby and a nesting Canada Goose with a pair of King Eiders hauled up and dozing against her nest, male on one side, female on the other. Relating these wondrous sightings to my colleagues over dinner, I hear of their own remarkable observations: Camp hit a record high of 39.5 degrees F today, three caribou appeared across the river, and someone collected the first mosquito (deceased).

SUMMER SOLSTICE

We find a skiff of snow on our tents this morning. The Arctic summer arrives, and I must fly out tomorrow. I'll miss the loons and the eiders laying their eggs, their newly hatched broods, the griz following the caribou in. Generously, I leave all that to my colleagues.

In the evening I take a seat on the saxifrage and look out over the complex of ponds on the lower delta. Geese, swans, gulls, loons, all varieties of ducks—Lord, everything I've been seeing seems to be out there in a huge array and concentration, and all of them are singing and shouting at once in so many tongues. Exuberant, self-willed, so full of life. I pause a long time here with my notebook on my knees, scribbling my thoughts and prayers beneath a warm Arctic sun. Biologists are concerned about the status of Northern Pintail and Long-tailed Duck populations. The Spectacled Eiders are threatened, and the King Eiders seem to be disappearing. Across a few decades, Alaska's Red-throated Loon population declined by half. There is much to do, much to defend. But for now, and for a long time into the evening, I will tarry here and listen. It is enough that the night is magic, and down on the delta the angels are singing.

KAKTOVIK, BARTER ISLAND
SEPTEMBER 13

Dropping out of the clouds over the Hulahula River, my first impression of the landscape is how *red* it appears. The tundra as far as I can see appears cloaked in rusty rubescence, not the tawny green I'd left behind nearly three months ago and fifty miles to the west. Autumn by the Beaufort Sea: season of the aurora borealis, the Inupiat whale hunt, the arrival of polar bears. And the final upshot of the water-bird season: the great migratory gatherings, the final exodus.

■ ■ ■

I walk south of town and onto the tundra. The sedges have turned to gold and the cottongrass is fading, too, its mop-tops looking a bit wind stressed. Along the edges of standing water, which is just about everywhere, the *Arctophila* grass has gone red (carotenes over chlorophyll)—the rouge I'd seen from the air.

Near a small freshwater lake, I come upon several hundred Greater White-fronted Geese hunkered down in the lee of the wind. They appear to be a congregation of family groups. Occasionally one or two of these short strings will take flight—laughing like schoolgirls. A significant number of white-fronts stage on the refuge coastal plain prior to fall migration, primarily in August, stripping the sedges to boost fat reserves for transit out of here. I suspect these may be among the last waves to fuel up on the local pasturage.

Scanning the lake I find to my delight a pair of Pacific Loons with a chick that still is not quite adult size. At my approach they utter a catlike *MAAA-AAaaaaaaaw* and move away. The pair has foregone the exodus of their conspecifics, remaining behind to fledge this chick. Given the late nesting dates over on the Canning, I imagine that such families throughout the area are right now challenging their deadlines in an ages-old drama in which the tooth of the arctic fox, the sharp eye of the peregrine, and the bite of autumn freeze-up contribute to the loons' grace and survival by removing the slow, the inept, from their reproductive gene pool.

Walking the shoreline I find the tracks of a grizzly sow and cub, strolling the opposite way. On the horizon above the far shore, half a mile away, I see the griz herself, perched atop a peat mound like a circus elephant balanced on a barrel. I deduce from her movements that she is digging for lemmings. We peer at each other for a moment, across the distance. No threat for now, we're both thinking, but we'll keep an eye out.

A pair of swans with three blue-necked cygnets flutters in from somewhere, perhaps driven by my approach. The young are fledged but not yet as tall as their parents—another family pushing the deadline. Good luck to them, too. They swim together nonchalantly but directly to the south shore to continue on foot into the wetlands there. At a mile away they stop and begin to feed again, among numerous families of pintails I hadn't noticed.

One of the loons takes off, flies above the bear uttering a phrase I hadn't heard before, circles the lake, and disappears. Several white-fronts lift, fly off, but circle about and return. Excitement fills the air: *die Zugunruhe*, the behavior biologists used to call it—"unrest before the journey." A hard chill rides in that same air, and my hands are growing stiff. The grizzlies remain occupied with their lemmings, the swans have disappeared in the marsh, and the loon adult and chick have moved to the center of the lake, safe from two-legged intruders. I sneak off to leave them all in peace, walking in the tracks of bears back toward town.

■ ■ ■

The wind has changed overnight and blows jauntily from the west now, under clearing skies. The fog has lifted, disappeared.

Out by the lake, and across all the tundra I cover, there are only a few geese to be seen. The pintail families are reduced to singles hunkered down in the ditches, lifting only at my immediate approach. Juveniles, I assume. A pair of scaup has appeared on the lake, en route eastward. They seem to prefer the company of Glaucous Gulls. Safety in numbers, perhaps. The loon chick floats beside one remaining adult. And with the swans I count only two cygnets. A Peregrine Falcon passes overhead; I'd seen it dive on a pintail earlier, narrowly missing. The bears have disappeared.

Through the rarefied air I can now gaze out past the island, across the mainland tundra, up the Sadlerochit River to the golden foothills and all the way to the mighty blue-and-white Brooks beyond. Somewhere out there, scattered across the refuge coastal plain, 300,000 Snow Geese may be feeding. They move in from western Canada to these rich prairies in mid-August to fuel up on cottongrass stems and horsetail shoots for their autumn migration. In three weeks they may

consume as much as 4600 tons of cottongrass alone, biologists calculate. It may take years for the cottongrass stands to regenerate after an intensive harvest, so the geese require an extensive foraging area. For them and the Greater White-fronted Geese, these limited feeding areas across the entire coastal plain are crucial; loss of habitat or even disturbance there at this time of year could diminish their survival rates, particularly for juveniles. Aircraft disturbance is the primary concern. Disruption of feeding here could reduce their migration fat reserves by up to 50 percent, reducing their chances for survival along the way to their wintering grounds.

I scan the far-off tundra hard through the binoculars—10x42s, excellent glass—hoping for some distant waggling line of white against the burnished tundra, before the golden foothills, but see no sign of them. Perhaps they, too, have already left for the Sacramento Valley, Bosque del Apache, Chihuahua.

An air of anticlimax: On the saltwater in the lagoons I see only a few small groups of eiders (females and young; the males left a long time ago, avoiding all reproductive chores beyond conception), a pintail here and there, a few Red-breasted Mergansers, several bands of White-winged Scoters, and one solitary Surf Scoter, bouncing in the waves. Several larger flocks of twenty to fifty Long-tailed Ducks float about, but tens of thousands of them that had staged in the lagoons between here and Canada have left. The last of them that I see stream in before the pink twilight in nervous flights from the sea, coming in low over the barrier islands into the safety of the lagoons for the night.

■ ■ ■

On my final day of maneuvers, I walk a few miles west to a set of ponds where a local says he's seen hundreds of waterfowl recently. The tundra around the ponds is littered with the feathers and droppings of geese, but the ponds are perfectly quiet and empty of birdlife. Only a family of Short-eared Owls remains in residence. They flap about and perch on the peat mounds, watching me from beneath Groucho Marx eyebrows.

A telling silence. As those spirits arrive with the spring snowmelt, so do they disappear on the autumn winds. The white-fronts, the pintails, and the rest of the swans wing eastward; the Brants, the eiders and Long-tailed Ducks, and the loons disappear into the west. The four-month burst of life under the all-night sun is over; only the stragglers remain. Even the whales are migrating past us toward warmer seas. The Kaktovik whalers beached their third bowhead last night, and the polar bears have swum a hundred miles from the pack ice to clean its bones. Time to leave this place to them, the Gyrfalcons and ptarmigan and other spirits who will keep watch on the place over winter. Among the latter is Cygnus, the swan, my celestial talisman. I saw her three nights ago, high in the sky with the aurora playing through her outstretched wings. The same constellation is also known as the Northern Cross. Cygnus, head down in the sky, becomes the crucifix, heads-up. "Anticipate resurrection," wrote Terry Tempest Williams.

Of course. That age-old story of the cycle of life: departure and return—and then revival. Here we find it rendered by both the swans and the stars, the ecological texts and the Gospel (one a metaphor of the other). We are not at

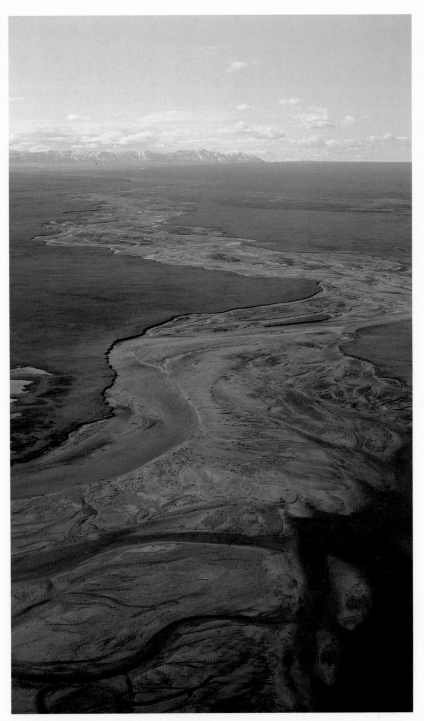

Sadlerochit Mountains and refuge coastal plain

the end of a cycle after all, but rather a beginning—an embarkation. *Here,* those anxious voices have been crying all along—*here* is where it all begins.

I march eastward again, across the quiet and empty tundra toward my dinner, the big silver bird, and that other world down below. Nearly back to camp I hear, startlingly close above me but invisible in the mist, the excited laughter of geese. ■

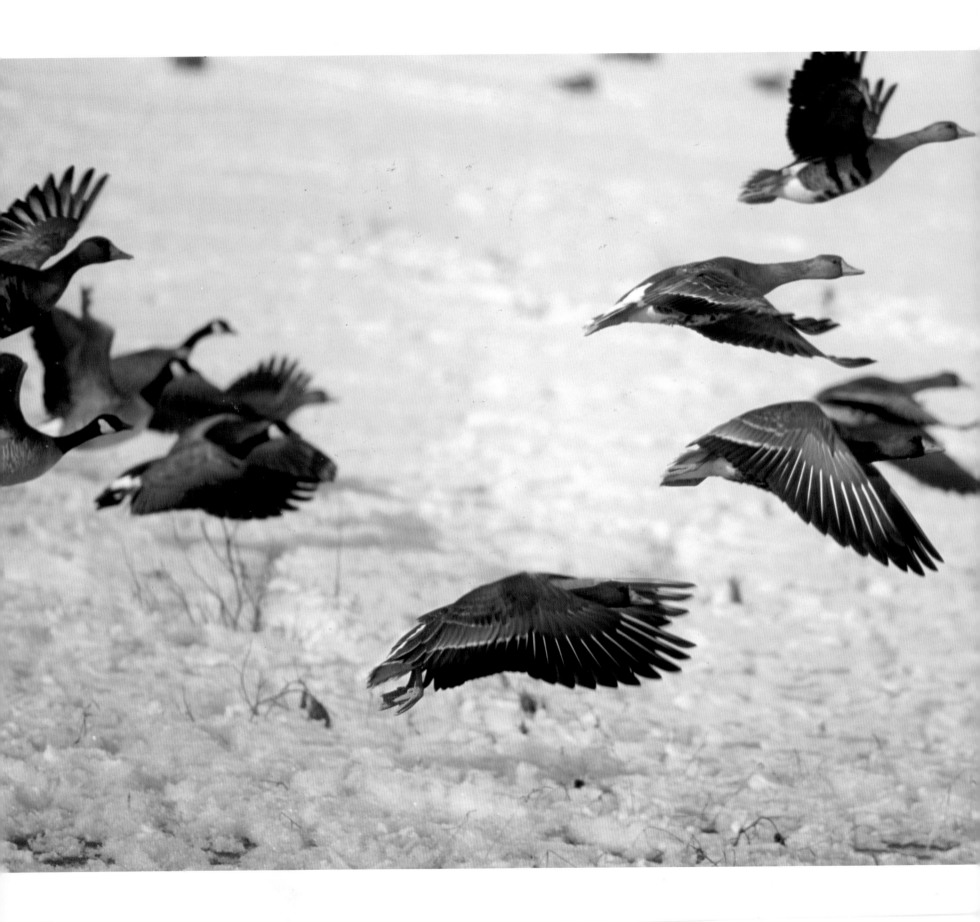

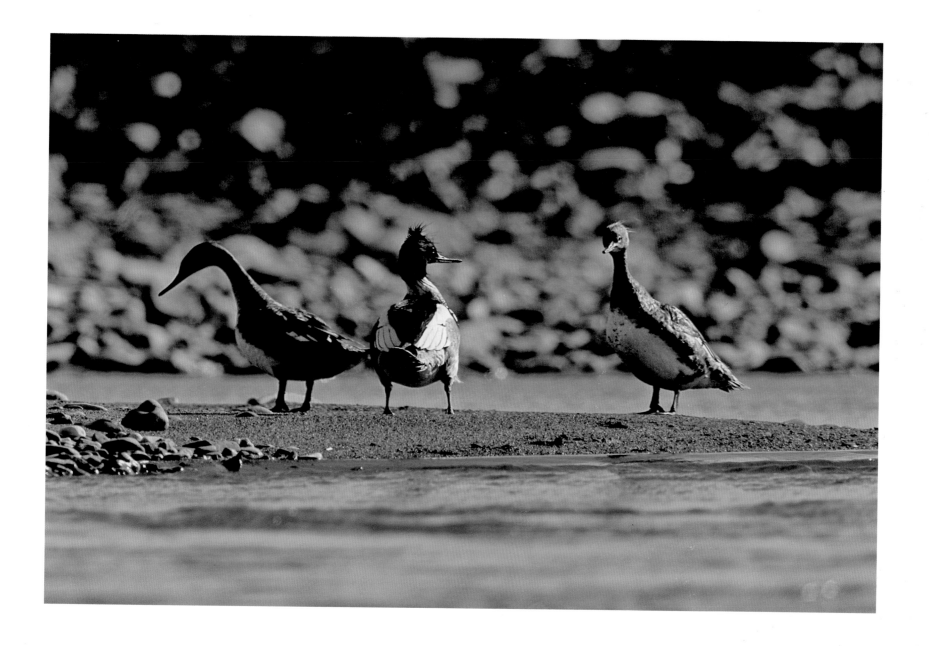

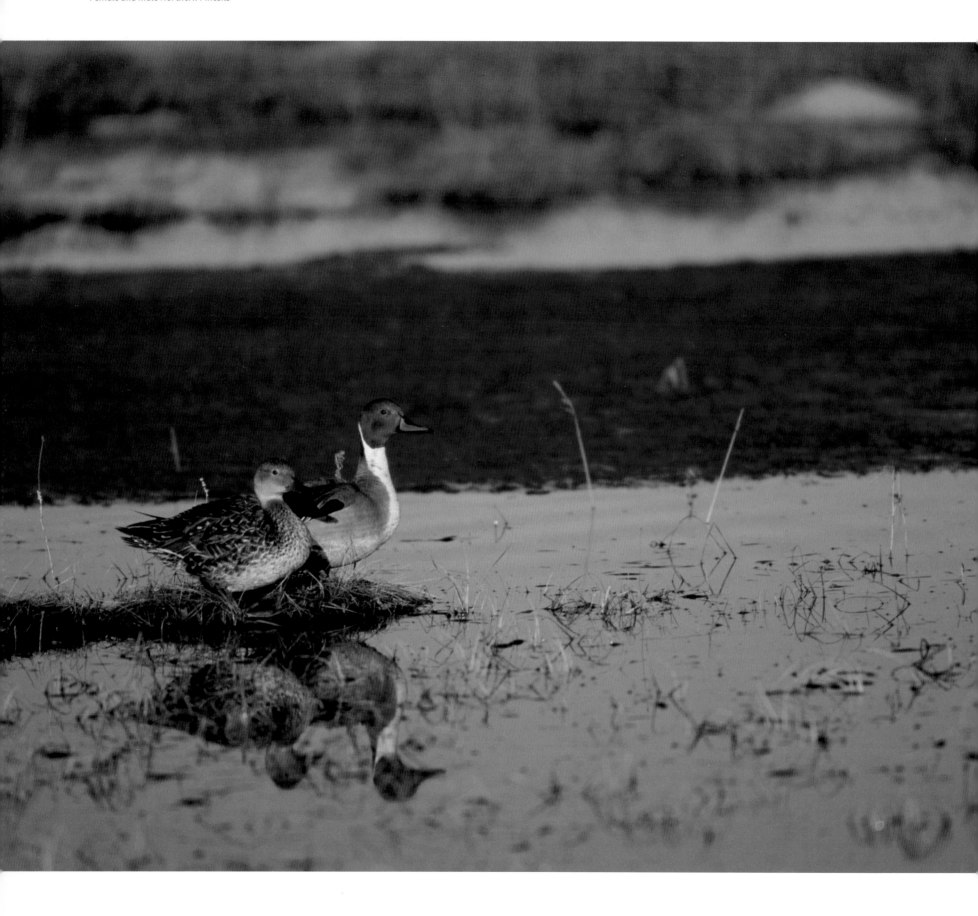

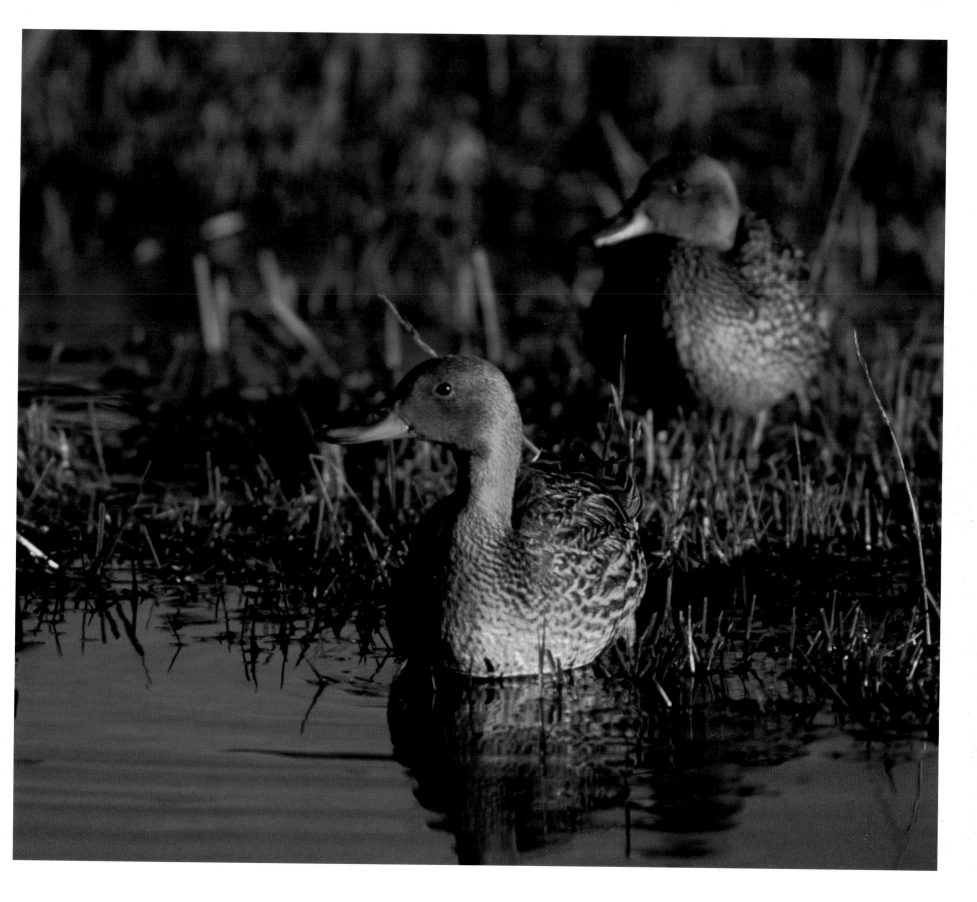

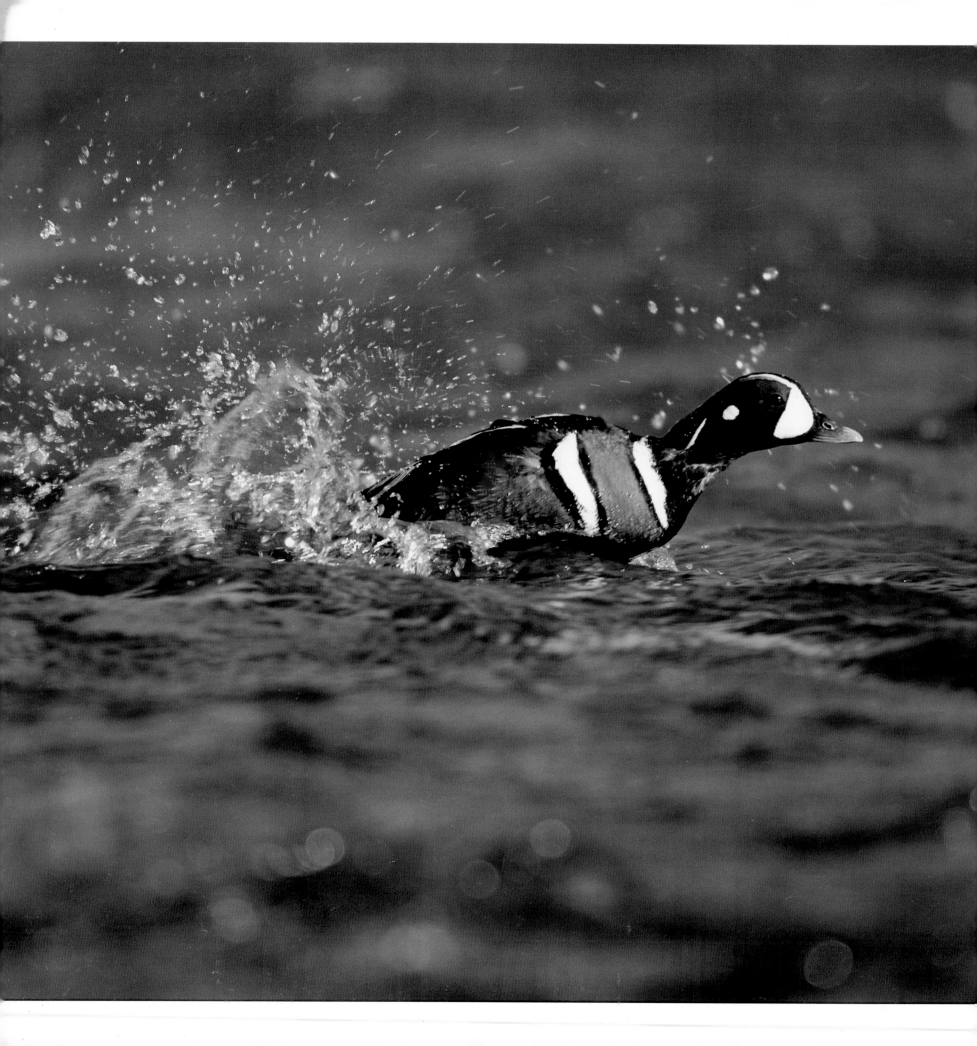

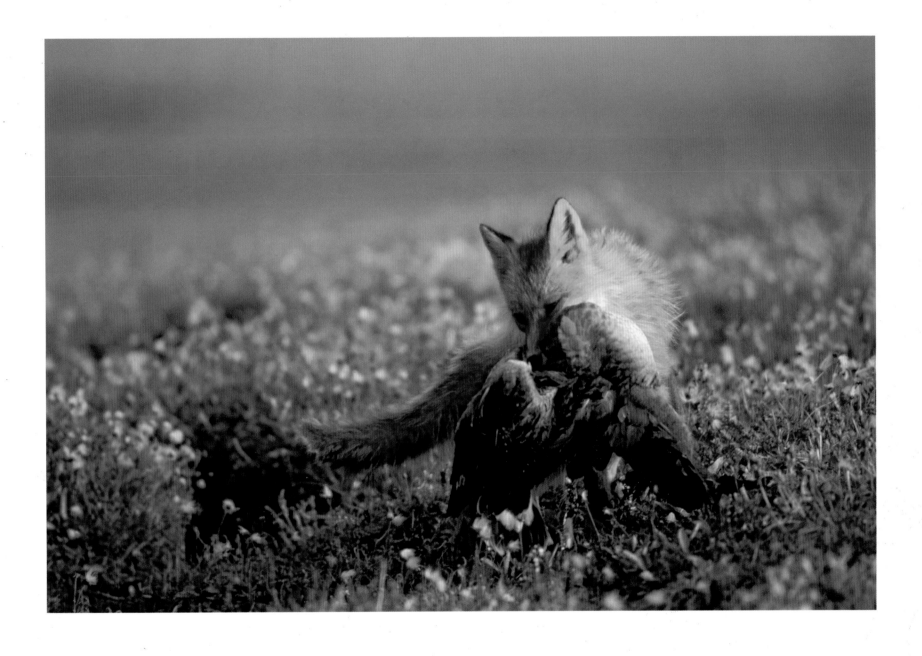

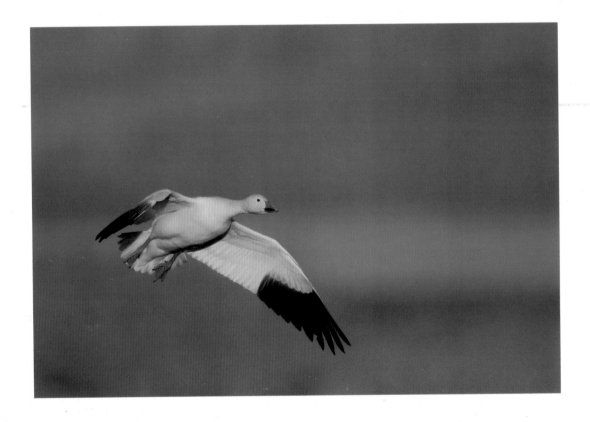

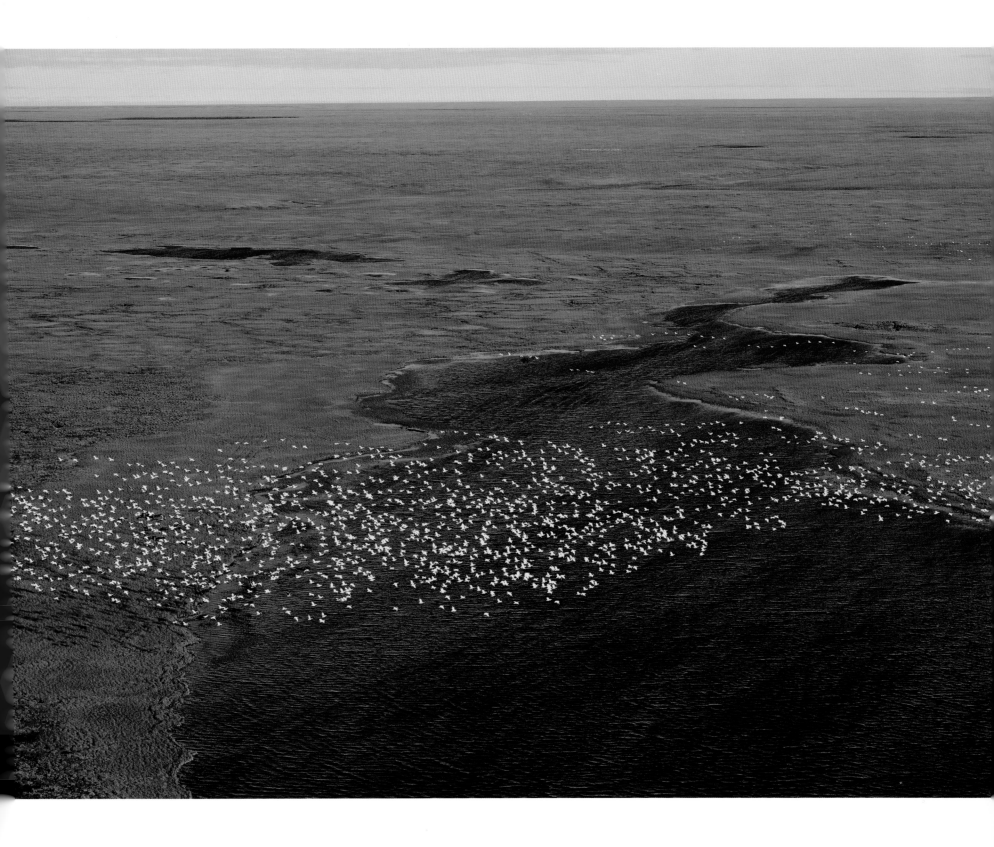

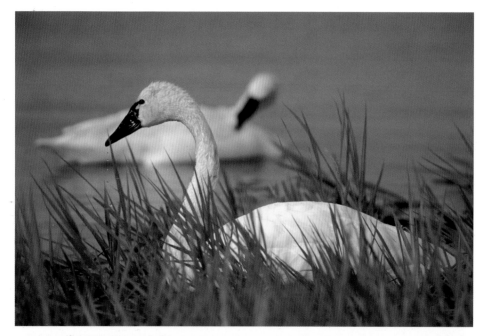

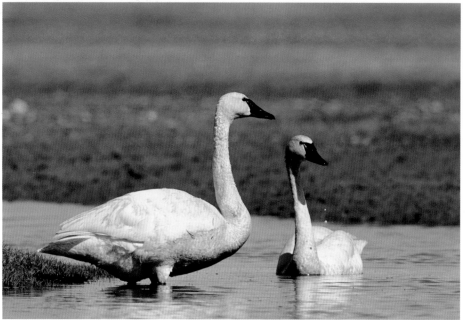

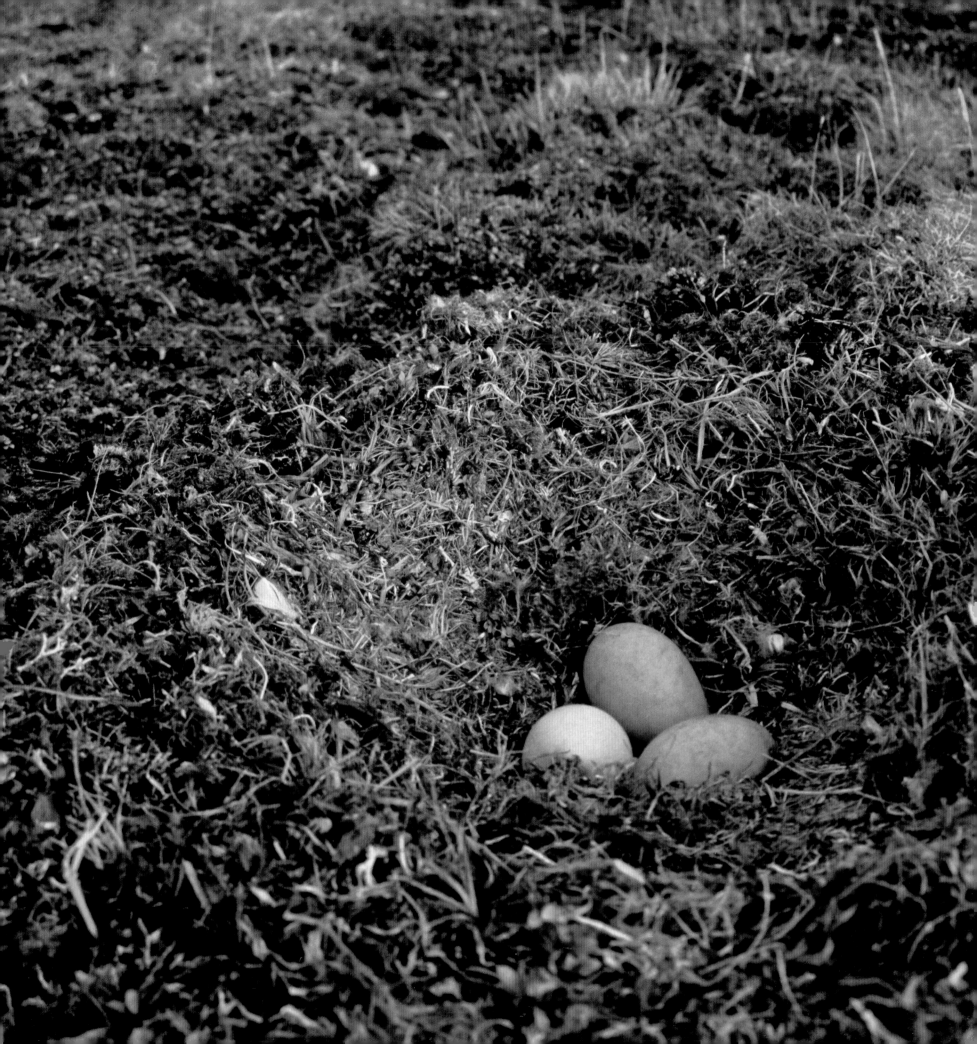

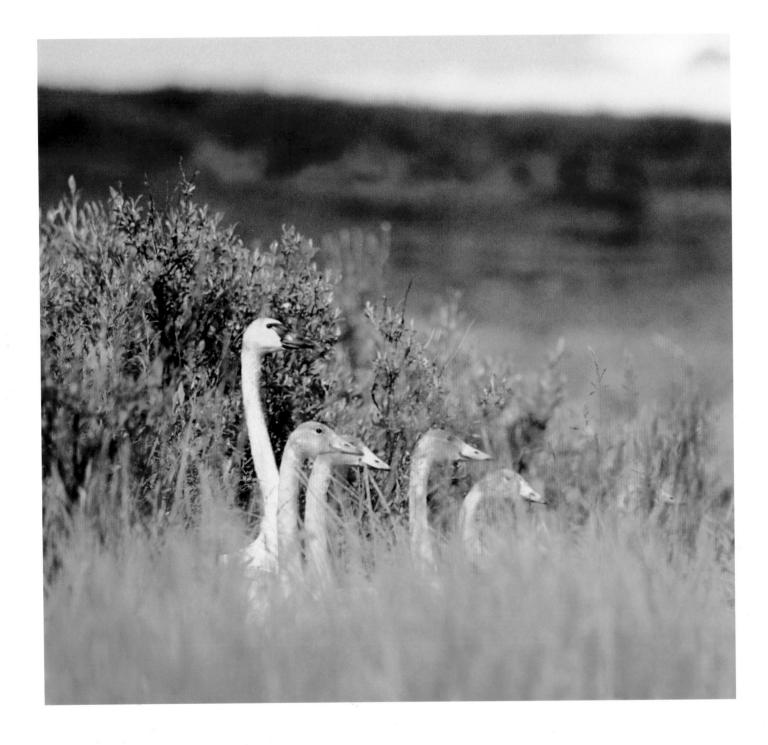

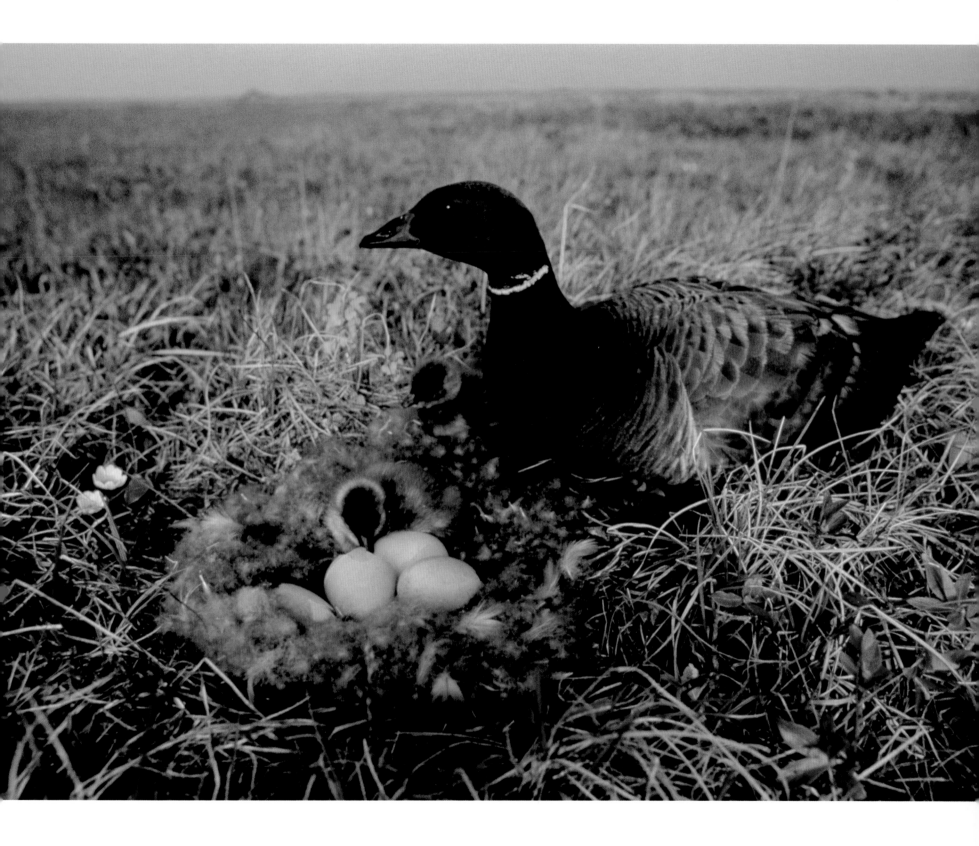

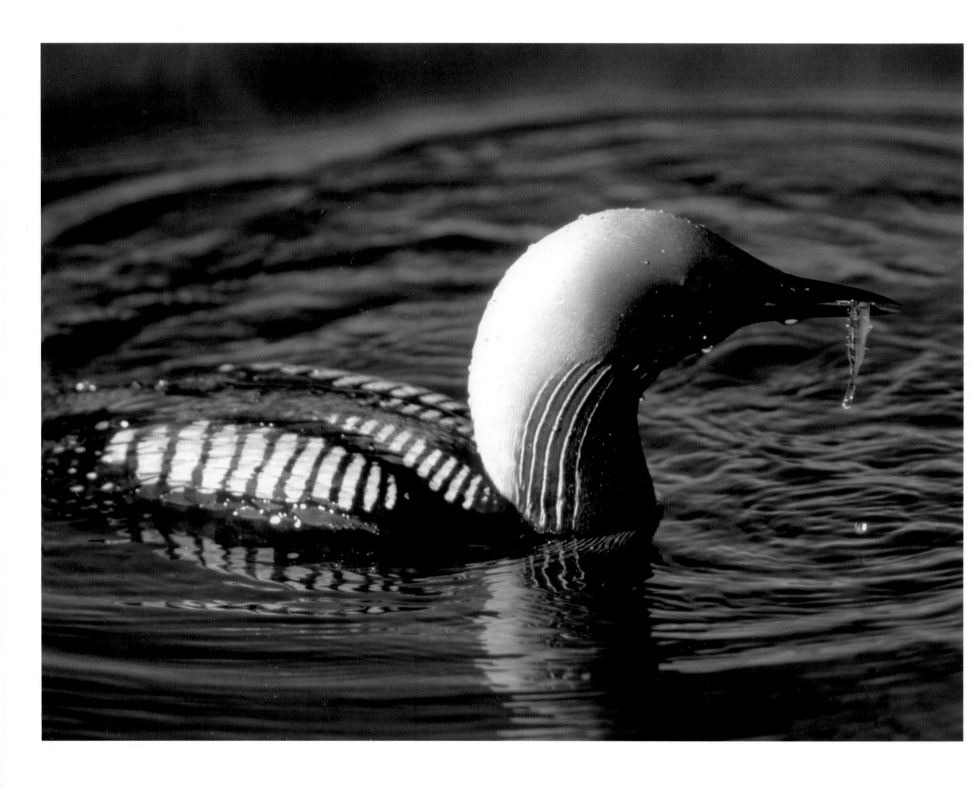

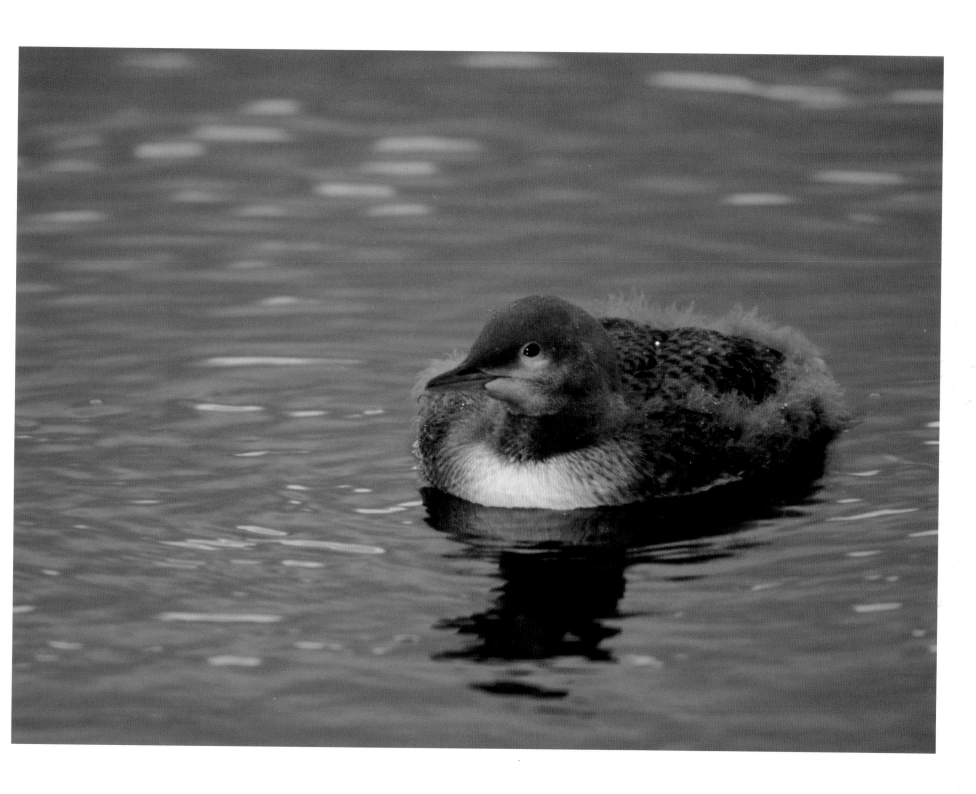

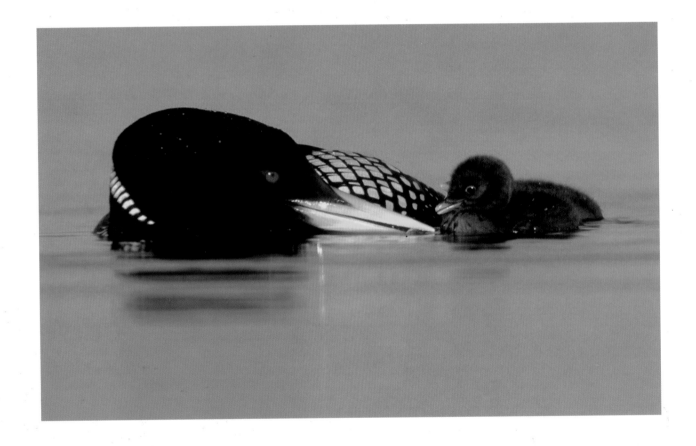

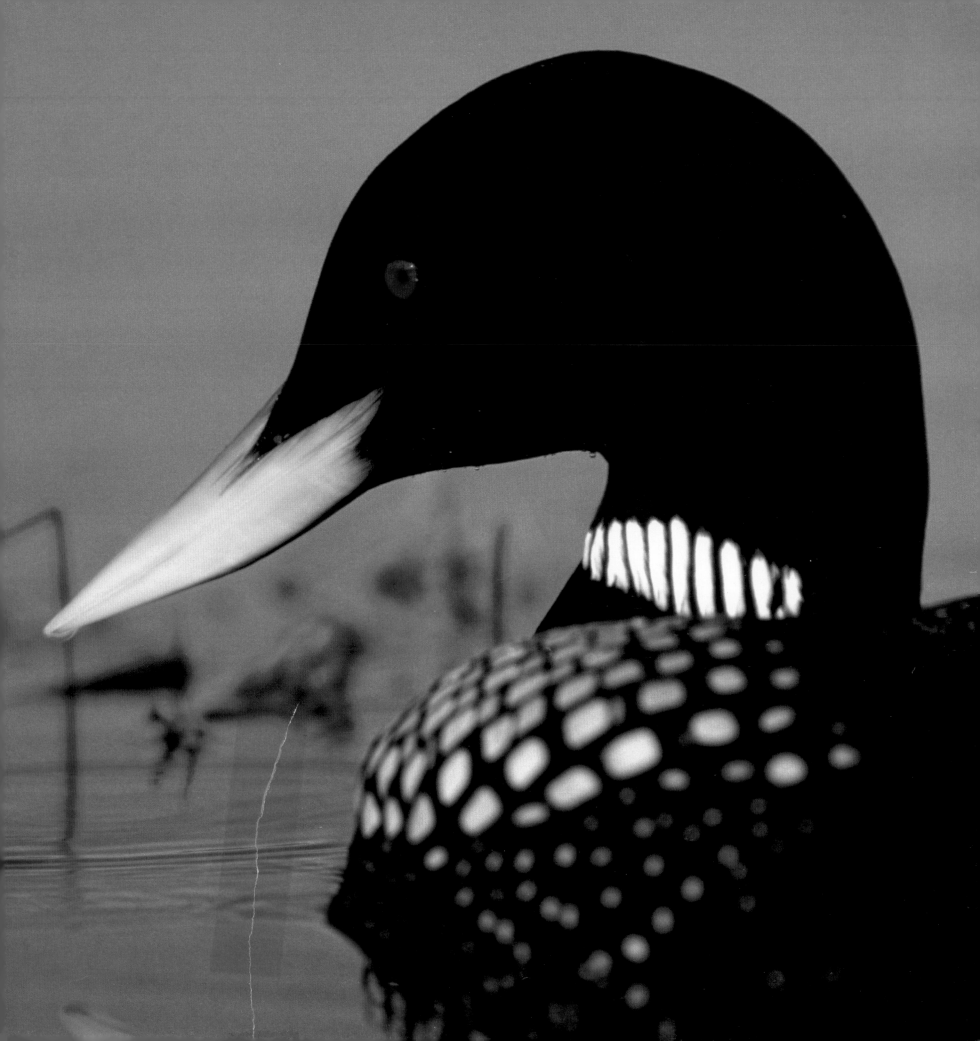

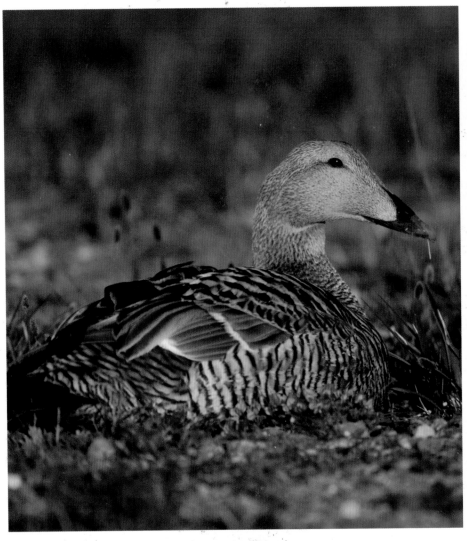

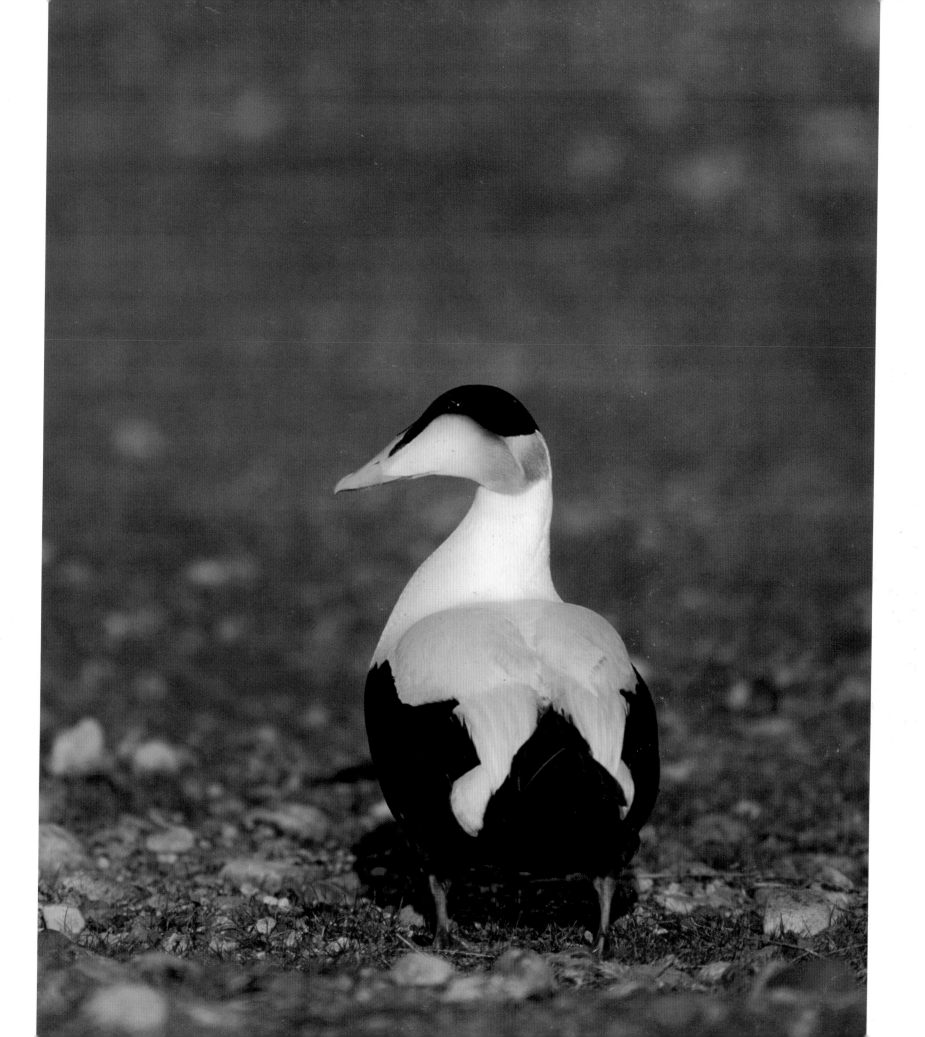

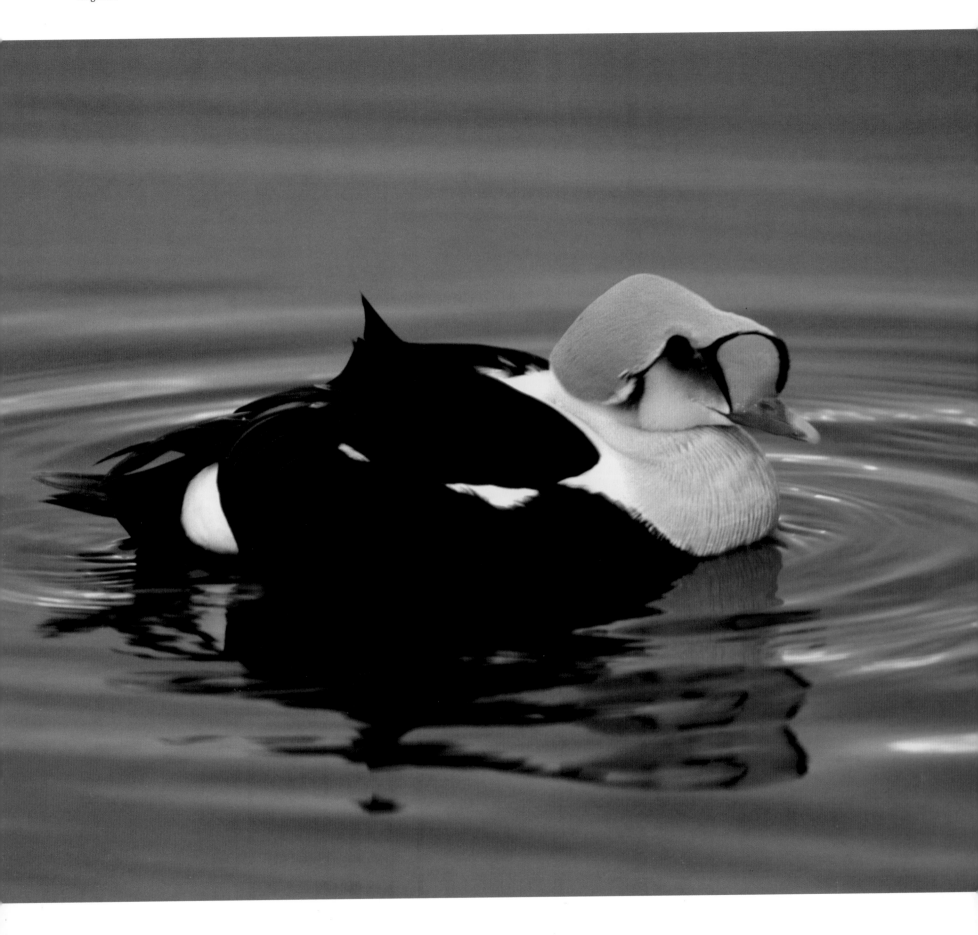

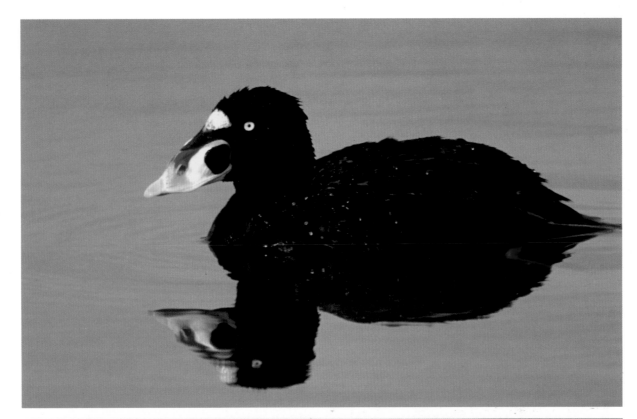

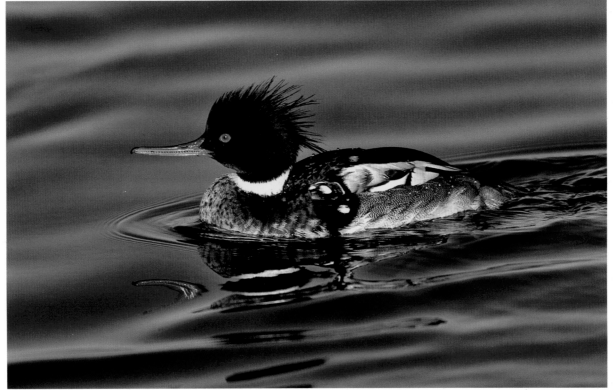

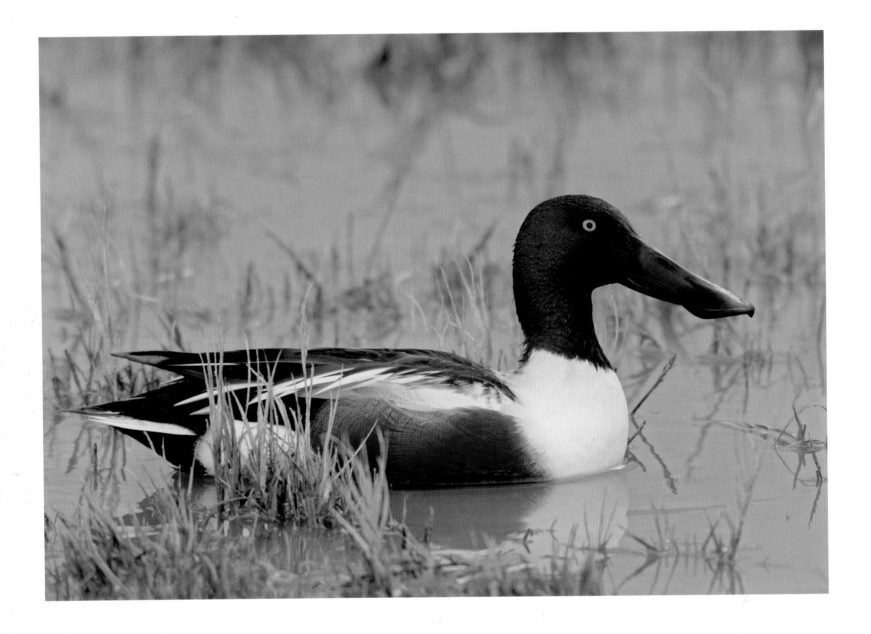

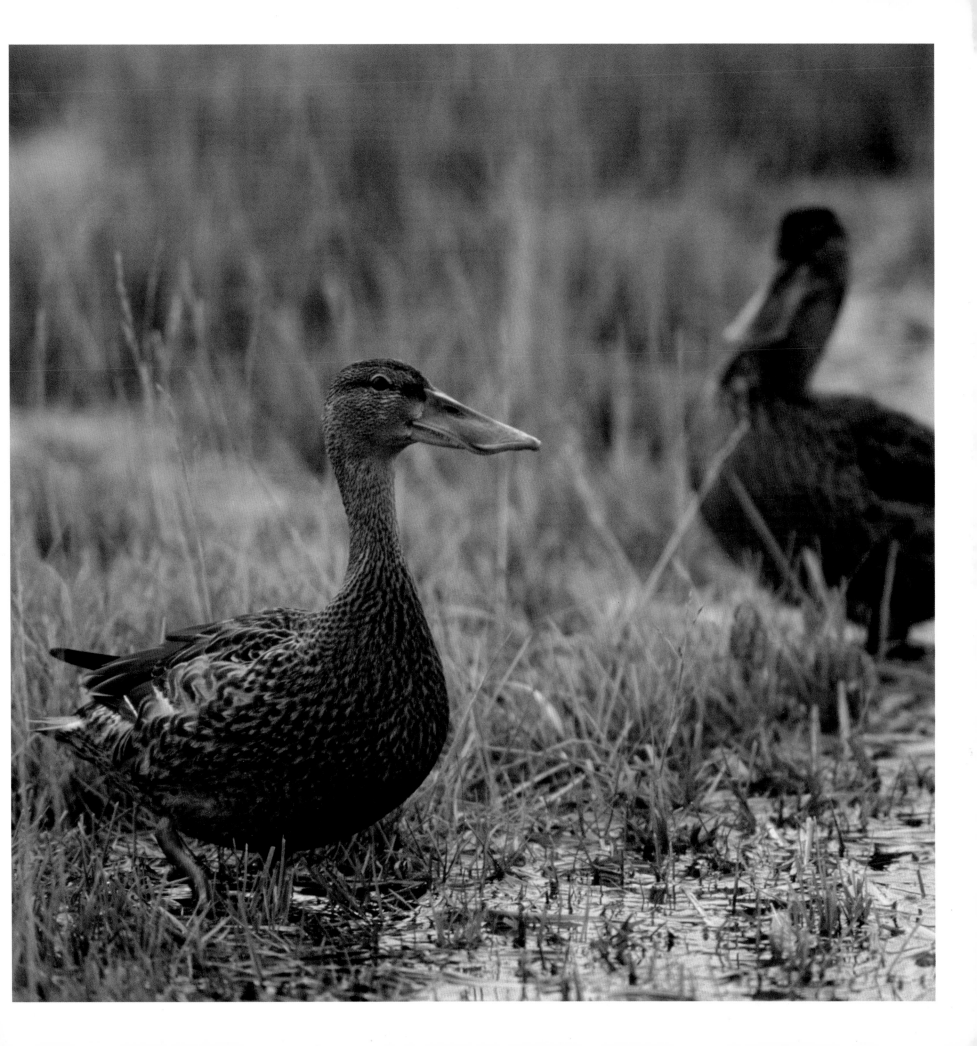

Hawks, Eagles,

and Falcons

Photo: Mike Emers

FRAN MAUER *is a retired*

wildlife biologist who

provided resource data

and analysis in support of the proposed Alaska

National Interest Lands Conservation Act

(ANILCA), which ultimately established new

national parks, wildlife refuges, wilderness

areas, and wild rivers in Alaska. He worked in

the Arctic National Wildlife Refuge for twenty-

one years, where he conducted field surveys

of Peregrine Falcons and Golden Eagles, and

studied interactions between caribou and

Golden Eagles on the calving grounds of the

Porcupine caribou herd. He was a contributing

essayist for Arctic National Wildlife Refuge:

Seasons of Life and Land.

Overleaf ■ *Kongakut River valley*

The Andes and Rocky Mountain cordillera, the longest mountain system on Earth, reaches its northernmost apex in the Arctic National Wildlife Refuge of northeast Alaska. Here the great mountain chain arches to the west after some 10,000 miles of generally north-to-south alignment. In doing so, a unique array of landscapes is compressed into the relatively small space of approximately 100 miles. It is here that the mountains reach their closest point to the Arctic Ocean, bringing barrier islands, coastal lagoons, river deltas, tundra plains, foothills, mountains, taiga, and boreal forest into close proximity. The Arctic Refuge, which straddles the mountain chain and extends from boreal forest in the south to the polar sea in the north, is the only protected area in the entire circumpolar region that embraces such diversity of landscapes, vegetation, and wildlife.

The varied land forms and corresponding tapestry of plant life found in the refuge are in turn home to a uniquely diverse assemblage of invertebrates, fish, mammals, and birds, which provide an abundance of prey for the eagles, hawks, and falcons that inhabit the refuge. Also critical for these birds of prey are the abundant nesting habitats, such as river bluffs, canyon and mountain cliffs, and precipitous rock outcrops that are found throughout the refuge, as well as the numerous cottonwood and white spruce nest trees that occur in the southern part of the refuge. All combined, the refuge is a unique habitat for the birds of prey that live here.

EAGLES

It is in mid-March, the period of rapidly increasing daylight hours, when the first Golden Eagles arrive in the Arctic Refuge. They have recently traveled up the flanks of the great mountain chain from their winter range in the mountain states and western Great Plains, as far south as west Texas and northern Mexico. In spite of the lengthening daylight, winter conditions often prevail for two more months. At first the new arrivals may rely on scavenging at sites where wolves have killed caribou, muskox, moose, or Dall sheep. In years when

important place in the great scheme of things, whole world would be impoverished and dulled.

G. H. Thayer, *Bird Lore*

Willow and Rock Ptarmigan populations are high in the region north of the mountains, or when the hare cycle is at its peak in the region south of the mountains, there is abundant food for Golden Eagles. However, in years when food is scarce during late winter, Golden Eagles have been known to prey on healthy adult caribou and Dall sheep. This is a relatively rare situation that lasts for a short period, because soon after Golden Eagles arrive, Arctic ground squirrels begin to emerge from their dens, providing a more convenient source of food.

During this time, prey abundance is critical in determining how many pairs of adult eagles will successfully breed and raise young. For example, in the canyon country of the Porcupine River at the southern end of the refuge, the number of productive Golden Eagle pairs is highest in years when the hare cycle is at its peak. In lean years when hares, ptarmigan, and ground squirrels are scarce, most pairs of adult eagles fail to produce young.

Courtship begins soon after adult Golden Eagles arrive at their traditional nest territories. This includes interactive flight displays and addition of new sticks and branches to the nest sites. Nests are located on river bluffs, precipitous rock outcrops, and mountain cliffs. Usually there are two or more nests located within a pair's nesting territory. Use of the nests within a territory often alternates between years. Most Golden Eagle nests are very large; some may exceed ten feet in diameter. These large nests represent many years of use, growing in size as more branches and sticks are added during each year of use.

Egg laying seems to vary with annual changes in the timing of snowmelt. In the northern part of the refuge, Golden Eagles start laying eggs as early as late March and as late as mid-May. Only one or two eggs are laid. Since the incubation period for Golden Eagles is quite long (about forty-five days), much of this period occurs when winter conditions are still prevalent. While flying on caribou surveys over the northern mountains bordering the calving grounds, I saw adult eagles faithfully hunkered down on nests, keeping their eggs warm,

with their backs dusted white with snow from swirling squalls, which are common up to early June.

When the season comes for caribou of the Porcupine herd to give birth on their traditional calving grounds on the coastal plain, an interesting association between caribou and Golden Eagles begins. During studies of calf mortality on the Porcupine herd's calving grounds, it was discovered that predation of young calves by Golden Eagles was greater than that of either wolves or grizzly bears. Apparently eagle predation has been a significant influence on caribou for a very long time. Calves will run under their mothers when they sense movement overhead in the form of a shadow. I have seen young calves react in this manner when the shadow of the survey aircraft I was flying in passed over them.

As larger groups of caribou begin forming during the post-calving period in

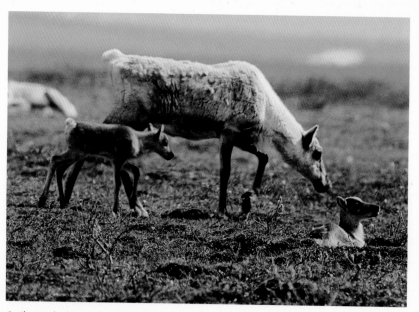

Caribou and calves on the coastal plain

late June, greater numbers of Golden Eagles are observed in close association with the caribou. With caribou herds numbering in the tens of thousands, Golden Eagles are commonly seen scavenging on caribou that have died of causes other than predation by eagles. I once counted thirteen eagles feeding on a caribou carcass in late June. With many thousands of caribou in the vicinity, the scene reminded me of images from the African grasslands, where vultures and buzzards commonly gather to feed on animal carcasses. Eagles are known to prey on calves as late as the third week in July, when the calves weigh as much as forty-five pounds. Nearly all of the Golden Eagles that were observed near caribou during the calving and post-calving period were subadults. Since

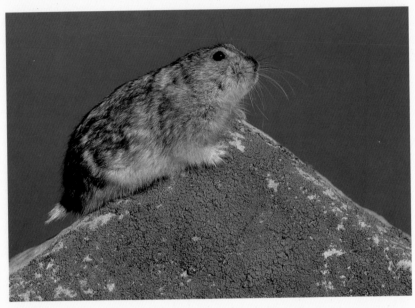

Collared lemming

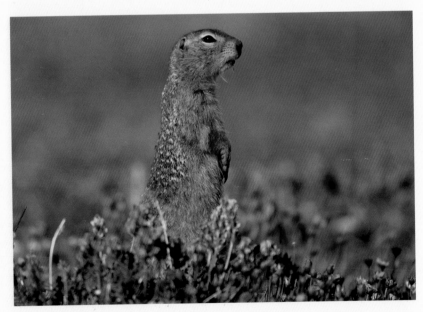

Arctic ground squirrel

adult eagles occupy nest sites located in the mountains south of the calving grounds at this time, they are less able to travel out onto the coastal plain where the caribou are. The subadult segment of the eagle population, on the other hand, is not tied to nest territories and is free to travel more widely to exploit seasonally abundant prey such as caribou calves, and to scavenge on adult caribou that die of other causes.

If calving caribou of the Porcupine herd were displaced from their traditional calving grounds on the coastal plain due to oil drilling and production activities (as portions of the Central Arctic herd have been displaced by oilfields elsewhere on the North Slope of Alaska), then predation of young calves by Golden Eagles would be greater because the displaced caribou would be in closer proximity to the nesting adults and yet still be vulnerable to the subadult eagles as well.

More subadult eagles are found on the calving grounds than are produced from adjacent nest territories in the mountains, thus the origin of these subadult eagles has been a question biologists have pondered for some time. Research using lightweight satellite transmitters placed on Golden Eagle fledglings in Denali National Park has recently provided some insight. Of the tagged subadult eagles that survived the winter and still had working transmitters, about 30 percent migrated north in the spring to the vicinity of the Porcupine caribou herd's calving grounds. This suggests that some of the subadults that congregate on the caribou calving grounds originate from nests quite distant from the area. It also demonstrates the value of having a network of conservation areas where natural conditions provide essential habitat for such a wide-ranging species as the Golden Eagle.

Bald Eagles are also found in the Arctic Refuge, which is the northernmost part of their distribution. They are known to nest in the southern part of the refuge in areas where there are shallow lakes with abundant fish populations. A few adult Bald Eagles are commonly seen each summer in the northern edge of the mountains along rivers having abundant runs of Arctic char. These birds apparently are non-breeding transients, as no observations of nesting have been confirmed in the northern portion of the refuge.

HAWKS

The diverse habitats of the Arctic Refuge support several species of voles and lemmings, which in turn are food for birds of prey and mammalian predators such as foxes, weasels, mink, and pine martens. Populations of these small rodents tend to cycle about every four years and spell boom and bust for all those who prey on them. When brown and collared lemmings are abundant on the tundra of the coastal plain, nesting success of Rough-legged Hawks is high. When northern red-backed voles are at the peak of their cycle, Harlan's Hawks (a subspecies of Red-tailed Hawk) nesting in the southern forest region of the refuge are also abundant. One year when voles were abundant along the Porcupine River in the southern part of the refuge, a pair of dark-phase Swainson's Hawks was observed at a nest site. This was probably a rare occurrence, although Swainson's Hawks are fairly common in neighboring

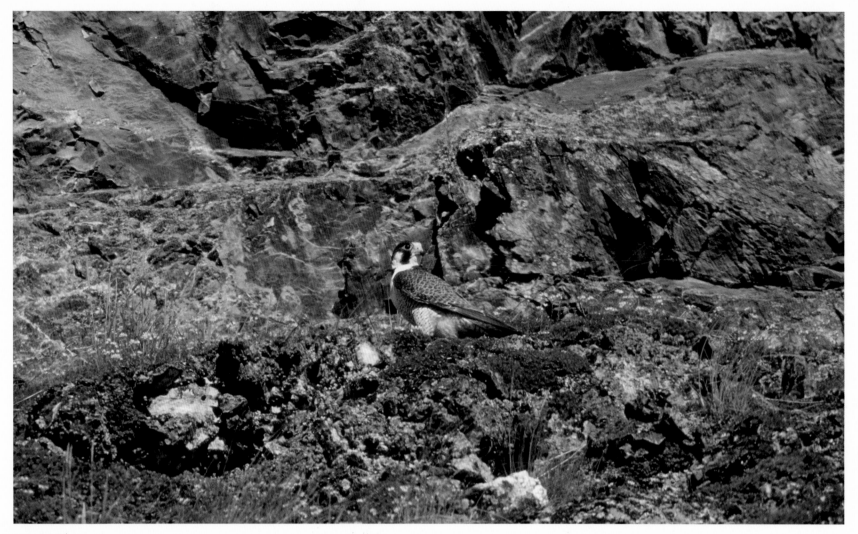

Peregrine Falcon

central Yukon Territory. Tundra voles, yellow-cheeked voles, meadow voles, singing voles, and northern red-backed voles are actively sought by Northern Harriers that hunt both the northern tundra and boreal forest meadows of the refuge. The arrival of hawks migrating to the refuge in spring corresponds closely with the melting of snow, which floods the tunnels of lemmings and voles with water, forcing the occupants to the surface where they become easy targets for these aerial hunters.

The Northern Goshawk, a powerful hunter of small mammals, hares, grouse, and some small birds, remains year round in the boreal forest. Food items for the goshawk change with the seasons: For example, fewer species of small birds are available during winter, and the presence of snow influences availability of the small mammals that spend much of their winter under the snow cover. Swift flight and skillful maneuvering through the forest gives the goshawk a distinct advantage over its prey. The smaller Sharp-shinned Hawk, a seasonal migrant to the boreal forest, hunts in a similar manner and preys heavily on small birds.

Rough-legged Hawks raised in the refuge migrate down to the western Great Plains, as far south as Texas. Harlan's Hawks migrate to the central United States for the winter. Northern Harriers winter in the central and southern states and Mexico. Swainson's Hawks migrate to South America, where they winter as far south as Argentina.

FALCONS

Okiotak, or One Who Remains in Winter, is the Inupiaq name for the Gyrfalcon. This large falcon is found primarily in the northern tundra and mountains of the Arctic Refuge, where it preys largely on ptarmigan during the winter and small mammals, ptarmigan, and other birds during summer. Individuals of both color phases—gray in varying degrees of intensity and white—occur in the refuge. Although most Gyrfalcons remain in the Arctic year round, some individuals are known to move as far south as central South Dakota during winter. Resident Gyrfalcons breed and nest earlier than the migratory birds of prey that come to the refuge. This gives the Gyrfalcon first pick of the prime

cliff-nesting habitats. Like other species of predators, Gyrfalcon populations rise and fall in response to ptarmigan population cycles. Because these birds are resident in the Arctic and are at the top of the food chain, monitoring of their populations may help to track accumulation of contaminants in the Arctic environment.

The Peregrine Falcon, perhaps the best known of the falcon species, nests in the Arctic Refuge on river bluffs and rock outcrops on the south side of the Brooks Range, and from the northern margin of the mountains to the Arctic coast. The peregrines that nest in the northern part of the refuge are referred to as the Arctic Peregrine Falcon (*Falco peregrinus tundrius*), and the peregrines that nest south of the Brooks Range are known as the American Peregrine Falcon (*Falco peregrinus anatum*).

Olaus Murie was the first to band young Peregrine Falcons in what is now part of the Arctic Refuge. He did so in the summer of 1926 while traveling with his wife, Margaret; their one-year-old son, Martin; and Jesse Rust, up the Porcupine River on their way to Old Crow Flats, where they also banded flightless geese. At that time they found "duck hawks"—a common name for peregrines at the time—to be common along the canyon cliffs of the Porcupine River. Thirty years later, Olaus and Margaret would lead an expedition to the Sheenjek River, which began a campaign to establish the Arctic National Wildlife Range, a 1960 precursor to the Arctic Refuge.

Peregrine Falcon populations throughout North America declined to dangerously low levels in the 1960s. The cause of the decline, it was later learned, was the accumulation of pesticide metabolites, especially from DDT, in the fat tissue of Peregrine Falcons. High levels of these pesticides resulted in thinning of peregrine eggshells and consequently much lower reproductive success. Eventually the Peregrine Falcon was placed on the endangered species list. Much of the credit for saving the Peregrine Falcon from extinction, and many other species for that matter, goes to a true heroine of our times, Rachel

Carson. She detected scattered shreds of evidence that pointed to the negative influences of pesticides and other chemical pollutants in our environment. Rachel, a writer and editor for the U.S. Fish and Wildlife Service, labored with the data collection for several years before finally drawing public attention to the problem in 1962 with her now-classic book, *Silent Spring*. It was through Carson's courageous determination to publish her findings and defend the evidence she compiled against critics from the chemical industry that made the difference. Responding to an alarmed public, Congress finally passed a law in the early 1970s banning DDT and some other dangerous pesticides from use in the United States.

Peregrine Falcon populations remained at very low levels for several years following the pesticide ban. Populations along the Porcupine River of the refuge began to show signs of increasing in the early 1980s. On the north side of the mountains, peregrine numbers did not increase until the early 1990s. When I began conducting annual Peregrine Falcon surveys on the Porcupine River in 1988, the number of pairs had just increased to sixteen pairs with thirty-eight young, up from a low of six pairs and thirteen young in 1976. During the next five years the number of pairs more than doubled, to thirty-three. On the north side of the refuge, peregrine numbers were extremely low. In the mid-1980s, only a few pairs were found during extensive surveys. Their numbers began to slowly increase, and by the mid-1990s there were at least twelve pairs present. One of the most gratifying aspects of my work during those years was to document the recovery of a species at a time when so many others were declining around the world. It was a thrill each time I discovered a new pair of peregrines occupying a site where there were no previous records. I remember wishing that Rachel Carson could share in the excitement of finding each new pair. Unfortunately, Rachel died before the peregrines began to increase. The recovery of North America's Peregrine Falcon populations is, however, a fitting confirmation of her heroic efforts.

The value of long-term studies in advancing our understanding of complex ecological relationships cannot be overemphasized. One example is the annual survey data for cliff-nesting raptors on the Porcupine River in the Arctic Refuge. Data has been consistently collected each year from 1979 to the present. As the Peregrine Falcon population recovered, it was possible to observe an interesting interaction between hare cycles and the annual total of nesting peregrines in the Porcupine River survey area. Seventeen Golden Eagle nest territories have also been identified in the survey area. As the multiyear data set grew, patterns of Golden Eagle nesting success were noted. When the hare cycle was at its peak, the highest number of Golden Eagle nests produced young. When the hare cycle was at its lowest ebb, few if any Golden Eagle nests held young. Since peregrines do not prey on hares, one would infer that there would be no change in peregrine numbers during variations of the hare cycle. Long-term data for the Porcupine River, however, showed that when hare cycles were high, the total number of peregrine pairs present decreased. Examining the data more closely, it was found that specific peregrine eyries in close proximity to Golden Eagle nest territories were often vacant when Golden Eagles occupied their nests.

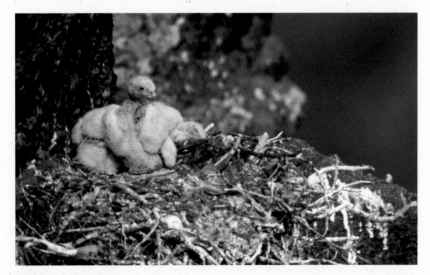

Gyrfalcon chicks and nest

Since Golden Eagles arrive in spring before peregrines, they are apparently successful in displacing neighboring peregrines from their traditional eyries. In addition, other predators such as red foxes and Great Horned Owls become more numerous during a high in the hare cycle. Some peregrine eyries are accessible by foxes, and young peregrines in others are preyed upon by Great Horned Owls. Thus, while many species of predators prosper during hare cycle highs, there is often a dip in nesting success of Peregrine Falcons on the Porcupine River.

Much has been written about the great speed that Peregrine Falcons can attain when they dive at prey and about their aerial agility in catching birds. At several locations on the Porcupine River, peregrine eyries occur in close proximity to nesting colonies of Cliff Swallows. Early in my career studying the peregrines of the Porcupine River, I sat at one of these colonies during a lunch break, watching an exuberant swarm of swallows flying over the river catching insects. I wondered if peregrines could catch a bird as swift and agile as the swallow. As I continued watching, a pair of peregrines arrived on the scene and soared above the swarm of swallows. One swallow wandered away from the rest and for a moment was isolated from the other swallows. Suddenly, both peregrines dove toward the isolated swallow, one peregrine ahead of the other by about twenty feet. The first peregrine attempted to catch the swallow, but the swallow successfully dodged it. In doing so, the swallow moved directly into the path of the second peregrine and was instantly caught. I have subsequently observed single peregrines pursue and catch swallows.

■ ■ ■

The undisturbed condition of the Arctic Refuge has allowed us to learn something of how the natural world works, how the ancient relationships between species and their environment have developed over eons of time. The lives of the eagles, hawks, and falcons of the refuge are only part of the splendid tapestry of life found here. And there is still much more to learn if we are willing.

The original purpose for establishing the Arctic Refuge was to protect for all time this rich, diverse, wild place, where natural processes have continued unaltered by modern humans since the beginning of time. Or, as Olaus Murie once said, it is "a little portion of our planet left alone." The Arctic Refuge was to remain untouched, to be used as a scientific control that could help us to understand the changes brought elsewhere to Arctic Alaska at the hand of modern humans.

Will the white Gyrfalcon continue to hunt the snow-white ptarmigan in the wild whiteness of winter? Will Golden Eagles continue to follow the great herds of caribou as they flow across the land in the sacred light of summer at midnight? Will Peregrine Falcons continue to bring food, freshly plucked from the sky, for their young? Will these wild birds of prey and all of life in the Arctic Refuge be allowed to live free of disturbance and alteration of their habitats? As Margaret Murie once asked, "Will our society, our modern society, realize the value of keeping such an area, at least, empty of technology and full of life?" ■

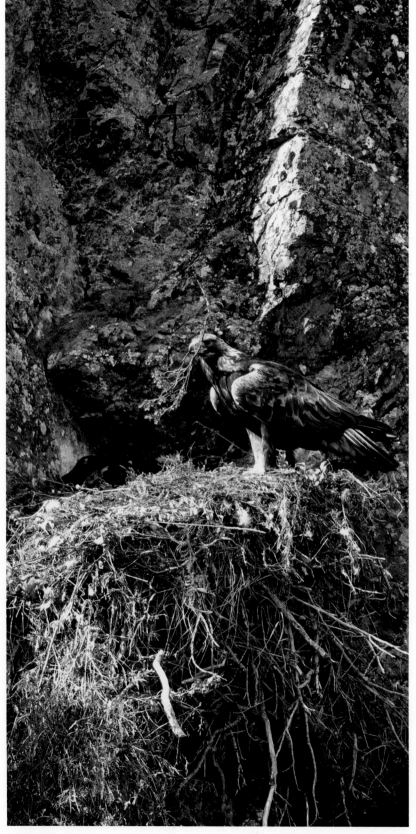

Golden Eagle and nest

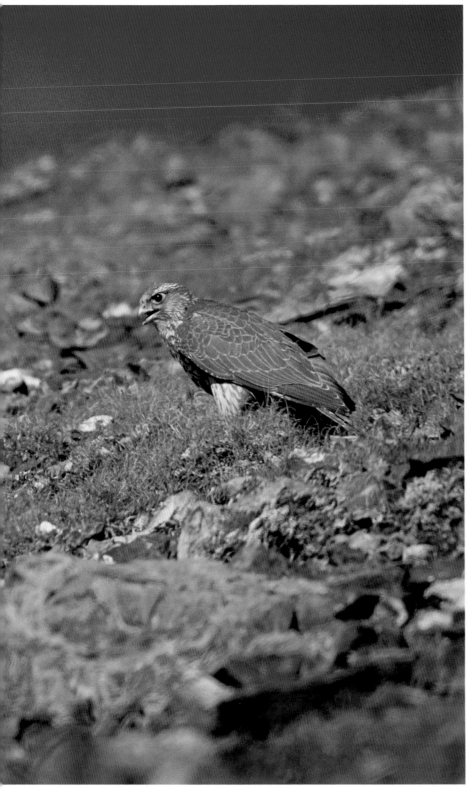

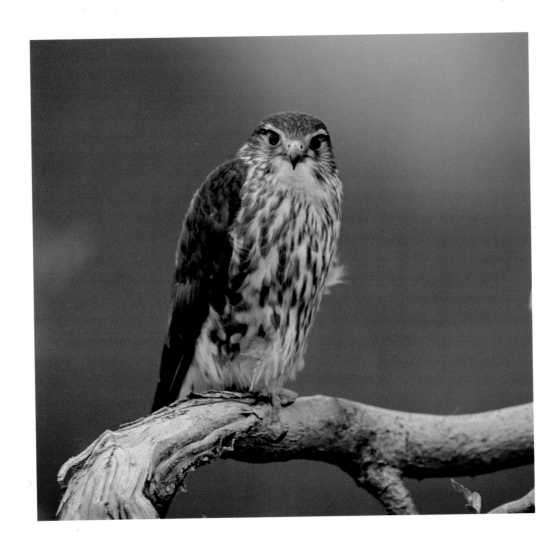

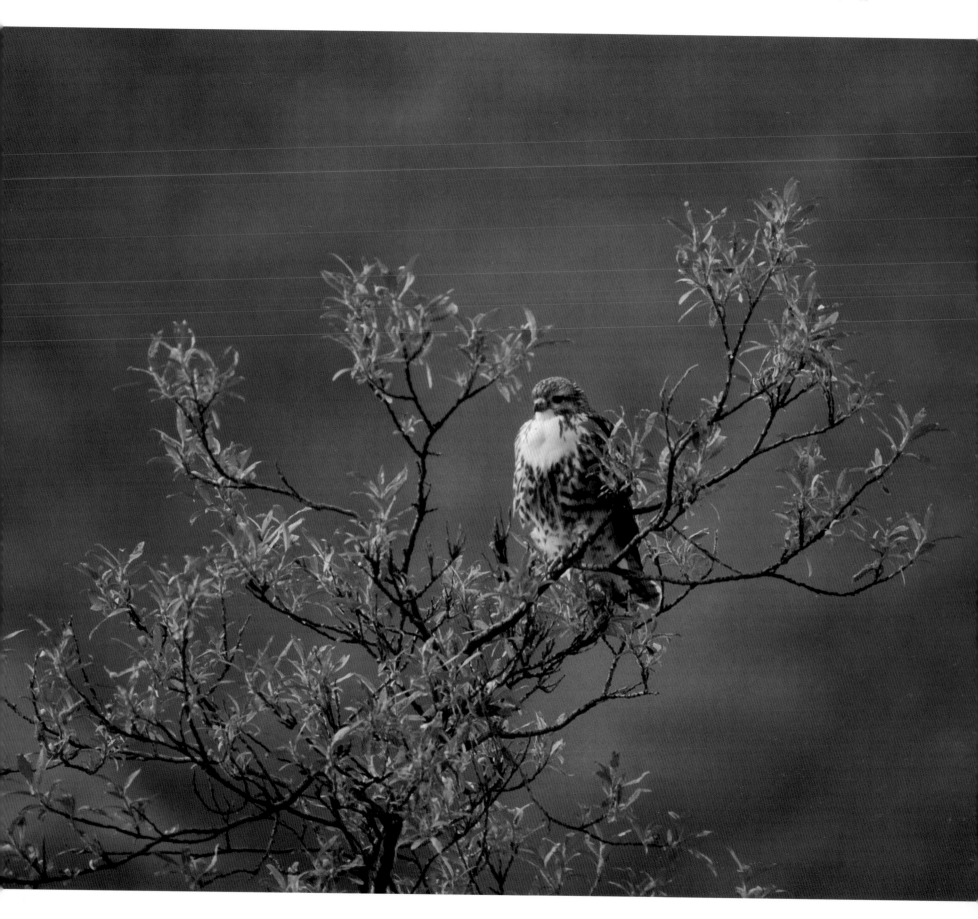

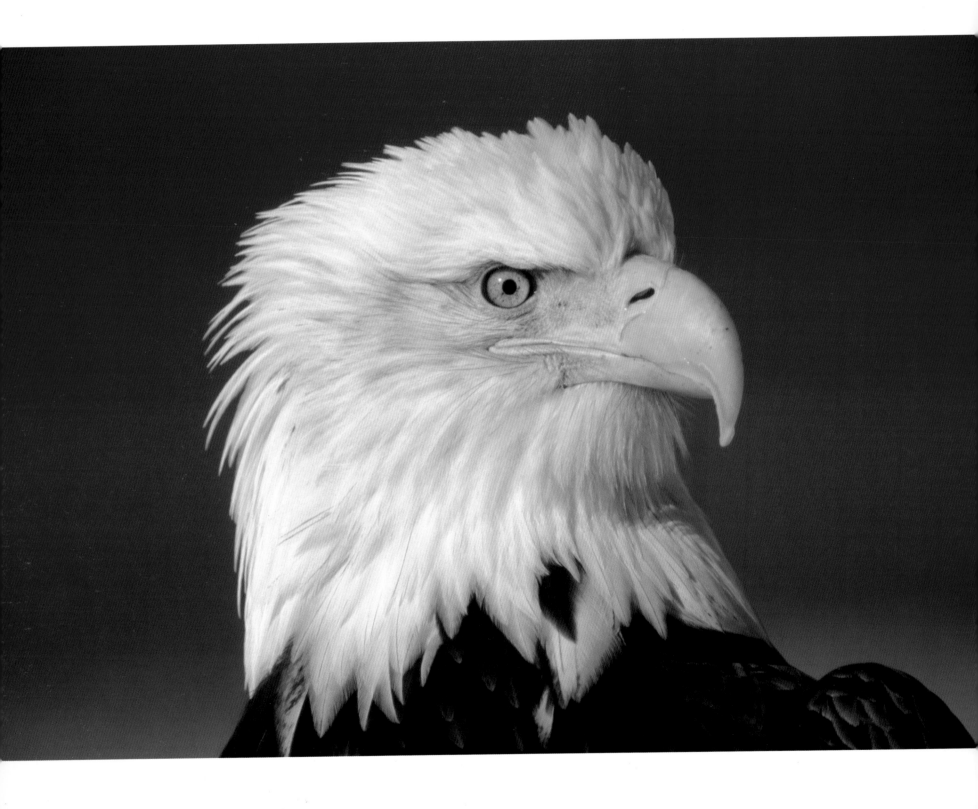

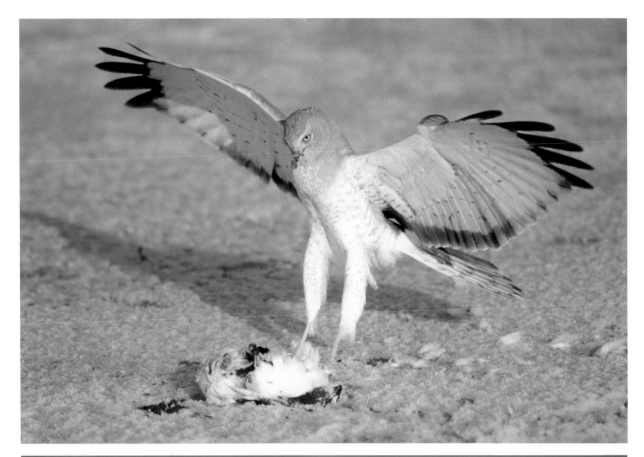

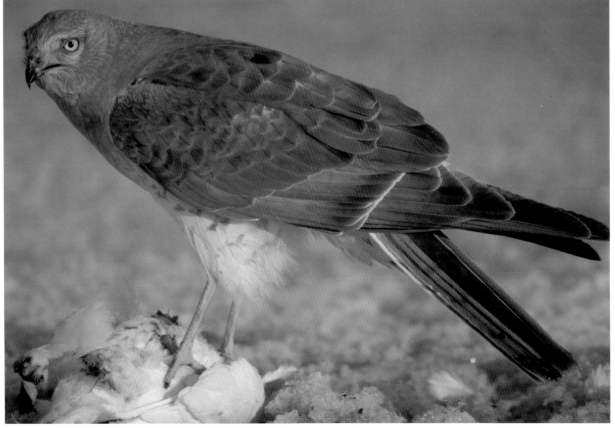

Shorebirds

The restlessness of shorebirds, their kinship with
of their voices down the long coastlines of the
wild creatures. I think of them as birds

STEPHEN BROWN *is the*

director of the Shorebird

Conservation Research

Program at Manomet Center for Conservation

Sciences and has studied shorebirds and their

wetland habitats for twenty years. He received

his doctorate from Cornell University, where he

studied restoration of wetland bird habitats.

Brown is the lead author of "The United States

Shorebird Conservation Plan" as well as more

than twenty peer-reviewed articles on shorebirds

and wetland management. He conducts field

studies on the distribution and abundance of

shorebirds in the Arctic National Wildlife Refuge

and collaborates on other shorebird research

and conservation projects throughout the

country.

Overleaf ▪ Tundra in spring

In early August, the fleeting Arctic summer begins to wane, and the wildlife of the Arctic Refuge coastal plain starts to prepare for another long winter. As the sun begins to set briefly each night for the first time in months, one of the most remarkable feats of migration in the animal world starts to unfold. Many of the adult shorebirds that flew north to breed only a few months earlier have already left their recently hatched young and begun their long journeys south. The juvenile shorebirds, hatched only weeks before on the Arctic tundra, are preparing to follow. They have only recently lost the small tufts of downy feathers they wore upon emerging from their eggs and grown their first full set of flight feathers. After a few short weeks of instruction by their parents in such vital activities as hiding from predators, they must face the world on their own.

These fledglings will now migrate across two continents, without a map or any help from their parents, to a place they have never seen. They will make their way across thousands of miles of unknown landscapes following only their instincts. Remarkably, each generation somehow finds the far-flung wintering grounds unique to their species, ranging from the southern coast of the United States to the South Pacific to the farthest southern tip of South America. They are ambassadors from the Arctic to the rest of the world, and they carry with them clues about the health of the world's ecosystems. Those that manage to survive the arduous migrations will help produce the future generations of Arctic wings, carrying on the cycle of endless movement that has graced the tundra for millennia.

▪ ▪ ▪

The term *shorebird* is applied to a large group of birds that includes the familiar sandpipers and plovers but also includes oystercatchers, avocets, stilts, and jacanas. Many other common birds of the shoreline, such as gulls and terns, are classified in other bird families. There are 222 kinds of shorebirds worldwide; 71 occur regularly in North America, and shorebirds are found in many different habitats throughout the continent. Shorebirds often share similar

the distance and swift seasons, the wistful signal world make them, for me, the most affecting of of the wind, as "wind birds."

Peter Matthiessen, *The Wind Birds*

characteristics such as relatively long bills for probing in wet mud and sand, long legs for standing in water or mud, and long pointed wings for fast flight over long distances.

Most people know shorebirds as demure creatures that follow the coastlines and freshwater edges of the world, quietly going about their business of finding something to eat. Like other birds that fall silent in winter, shorebirds do not vocalize much during migration or on their wintering grounds. But their reputation of silence is misleading, an accident of geography that recalls the famous line about a tree falling in the forest: Shorebirds are little known for their singing because most of us aren't there to hear them when they sing. When they arrive on their Arctic breeding grounds in late May, they burst into song, vividly advertising for mates and staking out their territories. Few bird sounds are as lovely and haunting as the song of a Stilt Sandpiper flying high above its territory while the midnight sun glances off the tundra.

RESTLESS MIGRANTS

Shorebirds complete some of the longest-distance migrations of all animals. Many of the most highly migratory shorebirds use a "long-hop" strategy, with some sections of their journeys completed in long, nonstop flights. Bar-tailed Godwits fly more than 7000 miles from Alaska across the Pacific Ocean to New Zealand without stopping for food, rest, or water. Other species may cover long migration journeys in a series of short flights. Some of the relatively short- and moderate-distance migrants have nonstop flight segments that vary from a few hundred miles to thousands of miles.

Shorebird migration patterns are diverse. Although each species is different, there are three general patterns in North America. Some migration routes connect Alaska with Pacific islands and continents as distant as Australia. Other routes follow the Pacific Coast and western mountain cordilleras of North and South America. Still others connect the Arctic breeding grounds with the Caribbean Basin and northeastern South America, with some of these

passing through central regions of the Lower 48 states and others concentrated in Atlantic coastal regions. Many of the shorebirds that nest in the Arctic Refuge spend the rest of the year in sites all across North America, South America, and Australasia.

∎ ∎ ∎

Why would a Semipalmated Sandpiper, which weighs about as much as a double-A battery, go to all the trouble of flying from South America to the Arctic

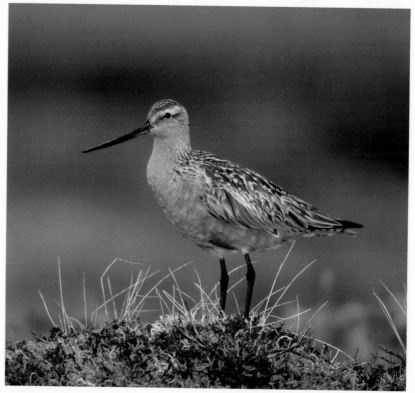

Bar-tailed Godwit

SHOREBIRD BREEDING DISTRIBUTION IN THE ARCTIC NATIONAL WILDLIFE REFUGE

A total of twenty-six shorebird species regularly use the Arctic National Wildlife Refuge during some part of their life cycle, and nine more (Killdeer, Eurasian Dotterel, Black-tailed Godwit, Hudsonian Godwit, Red Knot, Red-necked Stint, Sharp-tailed Sandpiper, Ruff, and Wilson's Phalarope) have been recorded as migrants or visitors. Twenty-three species are known to breed in the refuge, and some breed both on the coastal plain and to the south. Three more species—Solitary Sandpiper, Bar-tailed Godwit, and Western Sandpiper—may breed in the Arctic Refuge, but nesting has not been confirmed.

SHOREBIRDS THAT BREED ON THE ARCTIC REFUGE COASTAL PLAIN

Black-bellied Plover
American Golden-Plover
Semipalmated Plover
Wandering Tattler
Spotted Sandpiper
Upland Sandpiper
Whimbrel
Ruddy Turnstone
Sanderling
Semipalmated Sandpiper
White-rumped Sandpiper
Baird's Sandpiper
Pectoral Sandpiper
Dunlin
Stilt Sandpiper
Buff-breasted Sandpiper
Long-billed Dowitcher
Red-necked Phalarope
Red Phalarope

SHOREBIRDS THAT BREED SOUTH OF THE COASTAL PLAIN

American Golden-Plover
Semipalmated Plover
Lesser Yellowlegs
Wandering Tattler
Spotted Sandpiper
Upland Sandpiper
Whimbrel
Surfbird
Least Sandpiper
Baird's Sandpiper
Wilson's Snipe
Red-necked Phalarope

to reproduce—and then leave the Arctic for the long flight back to its wintering ground? Surprisingly, avoiding the harsh cold of the Arctic winter is probably not the most important reason to migrate south; in fact, several species of birds do manage to overwinter in the refuge. Instead, finding adequate food is probably the most important cause for the round-trip flight. Shorebirds follow the sun, living in the Arctic during the long northern summer days, and traveling south for the northern hemisphere's winter to places where the southern summer is in full swing. This strategy provides two important advantages simultaneously. First, it gives the birds access to the seasonal blooms of invertebrate life that accompany spring and summer in each hemisphere. Second, it gives them long days during which to forage. This is especially important for birds that forage along the coast, where the tides already limit their access to prime feeding areas.

The American Golden-Plover is a favorite among birders for its striking plumage of jet black face and underparts, bold white stripe above the black, and delicately flecked golden and brown upper parts. These birds are a good example of the epic migrations shorebirds undertake and are famous for an unusual twist in their pattern: They pass through North America's interior wet prairies as they head north in the spring but take a different route on the way south in the fall, as though wanting to see more of the countryside than an average shorebird (see map later in this chapter).

After wintering primarily on grasslands and inland wetlands of Argentina, Chile, Paraguay, Uruguay, and southern Bolivia, American Golden-Plovers travel north through the Amazonian regions of South America to arrive on the U.S. gulf coastal plain in March and April. They continue into the North American heartland, where they are commonly seen on farmed fields, before moving on to their Arctic breeding grounds in May to June. But most individuals opt for a fall migration route that is far to the east, taking advantage of summer fruit production along the coast before launching an astonishing 2500-mile nonstop flight over water to South America.

As though not quite up for this extreme migratory challenge, or perhaps just doing their best at finding their way for the first time, many juveniles repeat their parents' spring route in reverse during the fall, taking shorter trips between inland stopover sites on their way south. Only in later years will they somehow learn about the possibility of using the ocean route to fly south. Unfortunately, this species is declining at alarming rates along the eastern coastline of the United States during fall migration. If these declines continue, the species may be in serious jeopardy.

▪ ▪ ▪

So what does it take for a shorebird to succeed at a massive nonstop migration? Fat. While humans often avoid fattening foods and carefully watch their weight, a shorebird getting ready for migration seeks out fats and consumes them at remarkable rates that completely belie the phrase, "to eat like a bird." To imagine eating enough to double your weight in only a month, consider this: An average human male weighing 160 pounds would be required to consume about 560,000 extra calories that month—on top of a normal diet. This is about

the equivalent of eating 1600 cheeseburgers—that's 53 every day for a month! If our man was a vegetarian, he would need to eat 1244 bean burritos laden with cheese and sour cream, or 41 each day all month. In either case, he'd need a lot of antacid.

Even more remarkable is that a fat shorebird can get airborne and fly nonstop for days, consuming all of those fat reserves along the way. A human would have a hard time moving at all, much less walking nonstop to South America. At an average speed of about three miles an hour, walking eight hours a day, our imaginary human migrant would take over a year to make the same trip many shorebirds accomplish in just a few days. In fact, it would take more than a day to travel the distance in a jet airliner, and we would be tired on arrival without having taken a single step. But for shorebirds these marathon flights are commonplace, their link between global habitats in their search for food en route to and from their breeding grounds.

MIXING IT UP ON THE BREEDING GROUNDS

When the first ornithologists watched nesting birds, they assumed there generally were one male and one female per nest, and they sometimes exhorted people to follow these paragons of monogamous virtue—that is, until they started actually marking birds so they could tell them apart and keep track of which ones were doing what. As it turns out, Arctic shorebirds participate in just about every kind of mating strategy one can imagine. While we tend to apply our human values to other creatures, in the struggle for survival in the wild, the most effective mating strategy often is not monogamy.

Some shorebirds use an unusual mating strategy called polyandry, in which more than one male mates with a single female. Particularly enterprising females of some species, including both the Red and Red-necked Phalaropes common in the Arctic Refuge, sometimes finish laying one nest with one male and then move on to start another family with another willing male. Each male is then relegated to raising the chicks alone. On first appearance, it might seem as if the females have it easy, but all this egg laying is a Herculean task in itself. The females engage in the costly behavior of dual nesting only occasionally, perhaps when food is unusually abundant. In producing two complete clutches of four eggs, a female Red-necked Phalarope will have laid about 1.8 ounces of egg in a matter of days—which doesn't seem like much, except that she herself weighs only about 1.2 ounces. Imagine an average human mother of 140 pounds giving birth to nineteen children at perhaps 11 pounds each, and collectively weighing half again as much as the mother, and you'll have some idea of how taxing this might be!

For some shorebirds, such as the Pectoral Sandpiper, males who can manage it occasionally attract multiple females in a mating strategy called polygyny. For ornithologists, polygyny makes counting birds in the field very challenging because it is tough to tell whether a particular male is associated with one or many females. A firm number of pairs is difficult to determine, and so breeding male territories generally are used as an index of population size. Apparently, polygyny is a function either of quality of a territory or female choice. When a

particularly robust male has the strength to maintain a high-quality territory with enough space and food for two females, or otherwise proves attractive due to his great condition, two or more females may decide he's the best choice to father their young. Subsequently, each female lays a nest in his territory rather than that of another nearby male. It makes for a lot of work for the male, because he must constantly fight off other males who try to sneak into his territory and mate with his females. In many bird species, multiple paternity has been determined through genetic analysis, implying that males have a hard time successfully defending territories. But the aggravation apparently is worth the effort, measured in the number of chicks that survive to reproduce and carry on their paternal lineage.

Shorebird chicks have a short childhood. Within a day of hatching, most are able to walk and search for their own food. In the case of Red-necked Phalaropes, the males help chicks stay warm by brooding them, but only for about the first week of life, until their newly grown feathers can maintain their proper temperature. Further parental assistance may include introducing them to foraging areas and perhaps giving a guided tour to the nearby staging areas along the coast, where phalaropes concentrate at the end of the summer. After that, the young chicks are on their own.

HABITAT AND CONSERVATION

Shorebirds, like all other wildlife, need appropriate habitats in which to live: during breeding, during the non-breeding season, and along migration routes. This makes conservation especially challenging, because to ensure the health of their populations, we must protect not only their breeding grounds in the Arctic Refuge but also a great many other key sites that they use throughout the year.

Some species rely heavily upon a small number of strategic migration

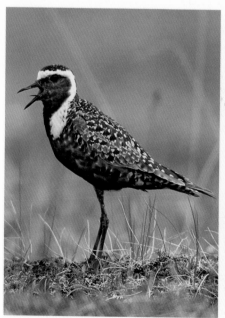
American Golden-Plover

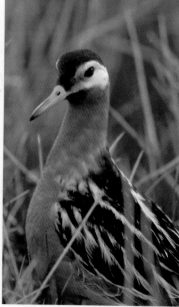
Red Phalarope

stopover sites to successfully complete their migration to and from the Arctic, and because of this a large percentage of a population might be present at a single site at the same time. For example, most of the Red-necked Phalaropes that hatch each year in the Arctic Refuge converge in August along the narrow Arctic coastline. Here, coastal lagoons and intertidal mudflats provide critical habitat as the young birds gain energy stores for their epic migrations to southern oceans. Similarly, between 50 and 80 percent of Red Knots, which are sometimes seen as migrants along the Arctic Refuge coast, stage at Delaware Bay, between Delaware and New Jersey, during their northward movement in spring. And the majority of Buff-breasted Sandpipers, a rare species that nests on the Arctic Refuge coastal plain, were recorded during migration at only ten sites across the United States.

The health of these traditional sites is critical, and disruption at any of the essential sites along the migration corridors could have catastrophic results. Recognition of this special aspect of shorebird biology and the need to devise novel conservation strategies were the major factors that led to the creation of the Western Hemisphere Shorebird Reserve Network, which aims to protect critical shorebird sites in both North and South America.

Seasonal wetlands, which may be available only once every several years, are another key shorebird habitat. These pothole wetlands may hold water one year and be dry the next, which causes great variance in the numbers of shorebirds using these wetlands in any particular year. The value of habitat for migrating shorebirds in areas such as the Prairie Pothole region of the upper Midwest or the Playa Lakes region of the southern U.S. prairies tends to be underestimated since these wetlands typically are small and dispersed, and the numbers of birds using any particular site may be few. But when a complex of

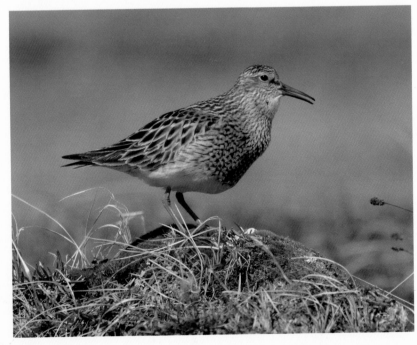

Pectoral Sandpiper

wetlands is considered as a whole, these ephemeral habitats are critical to the survival of many shorebirds that breed in the Arctic Refuge and then travel widely throughout the rest of the hemisphere.

∎ ∎ ∎

Populations of almost all kinds of shorebirds have been affected by loss of essential habitats. Some species have suffered severe habitat loss in both migration and wintering areas. In general, breeding habitat loss has been minimal for boreal and Arctic-breeding shorebirds, but there is growing concern that global warming may change this. The latitude at which shrubs can grow and thrive has been expanding northward due to warmer conditions caused by global climate change, and it is likely that in the coming decades, substantial breeding habitat loss may occur across the North Slope.

Loss of migration habitat already has been extensive for many species. Development and human recreational activities along the coasts have grown enormously since European settlement, reducing intertidal habitats and the diversity and abundance of food eaten by foraging shorebirds. And equally important, coastal development has resulted in the usurping of resting areas used by shorebirds when mudflats and shallow feeding grounds are inundated at high tide. For shorebirds, migration stopover sites play a vital role in their effort to build the reserves they need to fuel the next leg of migration. If they are unsuccessful in gaining the necessary fat, shorebirds don't make it to the next stop, and consequently adult survival rates decline. Because the majority of Arctic breeding shorebirds migrate southward throughout the United States during July to September, they directly compete with humans for coastal space during the peak of summer outdoor recreation season.

THE RACE TO SAVE THE SHOREBIRDS

Each wildlife species attempts to reproduce and replenish its numbers, but its population tends to be limited by some critical factor. For shorebirds, perhaps not enough young hatch each year; many young birds don't survive; adult birds die from contaminants; or they can't return to the breeding grounds because food supplies along the way are too low. But because of the variety of challenges that these birds face, and the difficulty of measuring how important each factor is, we don't yet have a solid grasp of the specific causes for most of the declines that have been observed in shorebird populations. This lack of knowledge means that we must take a precautionary approach and work to protect all of the areas critical to shorebirds, while at the same time making efforts to learn more about the problems they face. A new effort called the Shorebird Research Group of the Americas was recently formed to coordinate hemispheric work on these questions for the species suffering the greatest declines. We hope that the critical information will come in time to help reverse the downward trends.

The oil development proposed for the Arctic Refuge must be weighed in this context, as it represents another potentially large risk for many species that already are in trouble. Direct effects of oil drilling in the refuge include loss of nesting habitat due to construction on the breeding grounds and

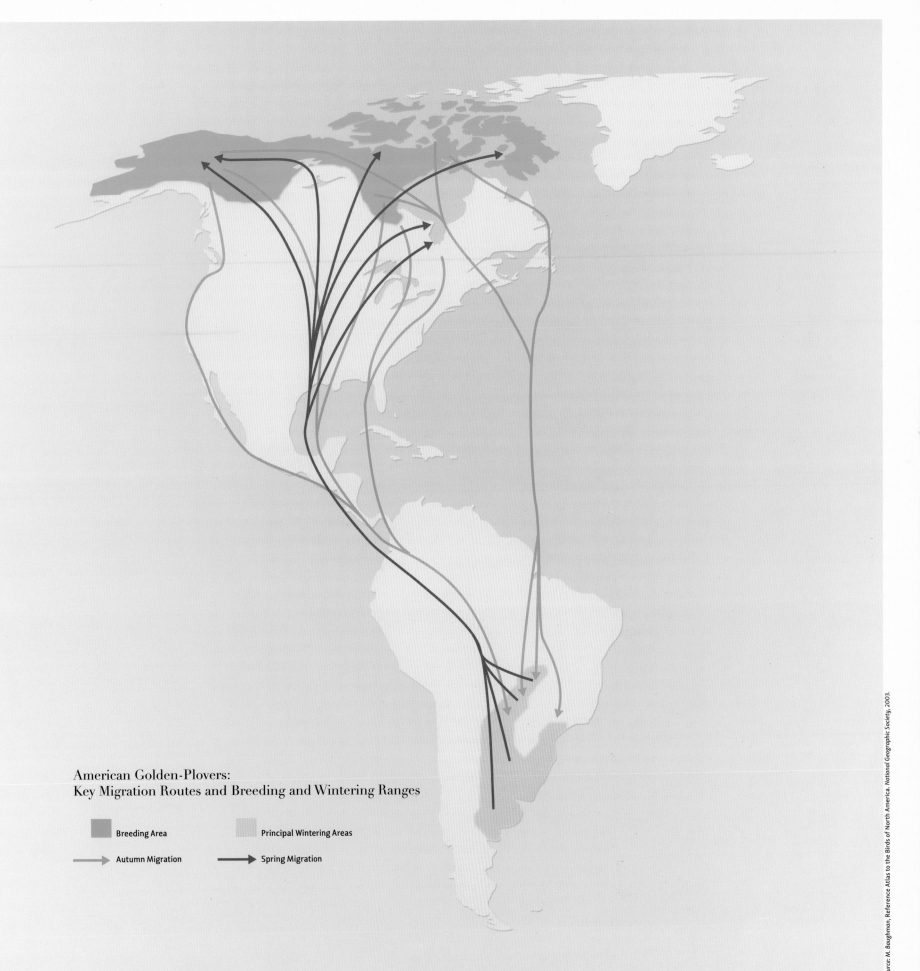

American Golden-Plovers:
Key Migration Routes and Breeding and Wintering Ranges

Breeding Area Principal Wintering Areas

Autumn Migration Spring Migration

Source: M. Baughman, Reference Atlas to the Birds of North America. National Geographic Society, 2003.

SHOREBIRD NESTING HABITAT IN THE ARCTIC NATIONAL WILDLIFE REFUGE

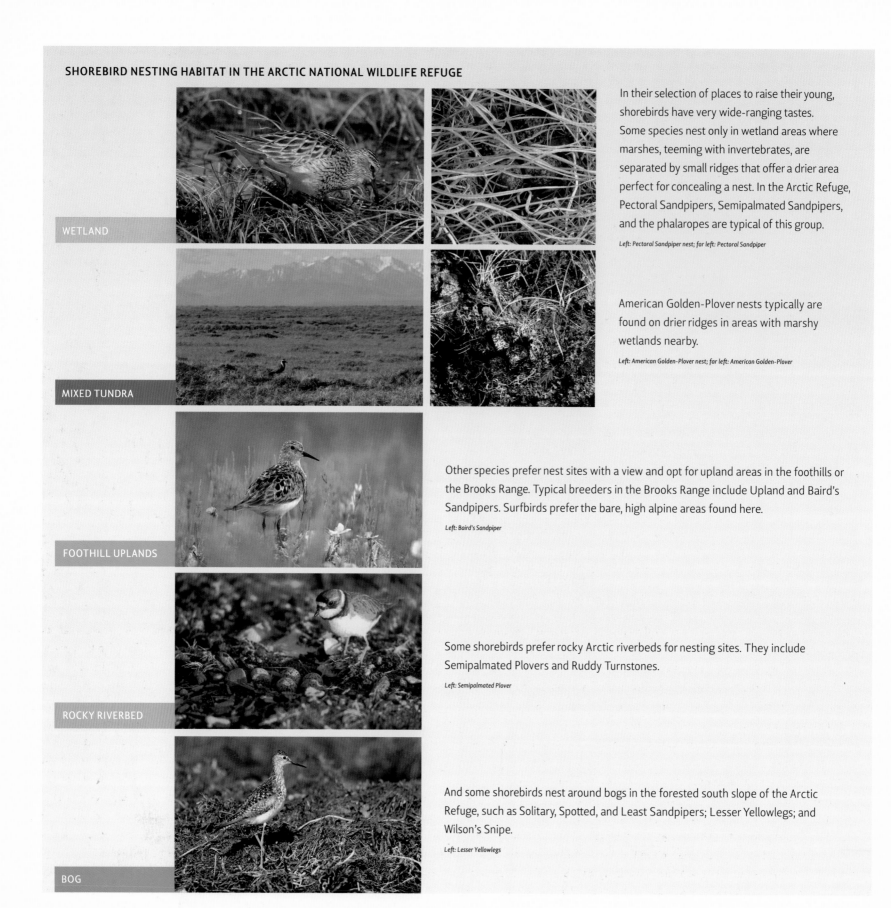

WETLAND

In their selection of places to raise their young, shorebirds have very wide-ranging tastes. Some species nest only in wetland areas where marshes, teeming with invertebrates, are separated by small ridges that offer a drier area perfect for concealing a nest. In the Arctic Refuge, Pectoral Sandpipers, Semipalmated Sandpipers, and the phalaropes are typical of this group.

Left: Pectoral Sandpiper nest; far left: Pectoral Sandpiper

MIXED TUNDRA

American Golden-Plover nests typically are found on drier ridges in areas with marshy wetlands nearby.

Left: American Golden-Plover nest; far left: American Golden-Plover

FOOTHILL UPLANDS

Other species prefer nest sites with a view and opt for upland areas in the foothills or the Brooks Range. Typical breeders in the Brooks Range include Upland and Baird's Sandpipers. Surfbirds prefer the bare, high alpine areas found here.

Left: Baird's Sandpiper

ROCKY RIVERBED

Some shorebirds prefer rocky Arctic riverbeds for nesting sites. They include Semipalmated Plovers and Ruddy Turnstones.

Left: Semipalmated Plover

BOG

And some shorebirds nest around bogs in the forested south slope of the Arctic Refuge, such as Solitary, Spotted, and Least Sandpipers; Lesser Yellowlegs; and Wilson's Snipe.

Left: Lesser Yellowlegs

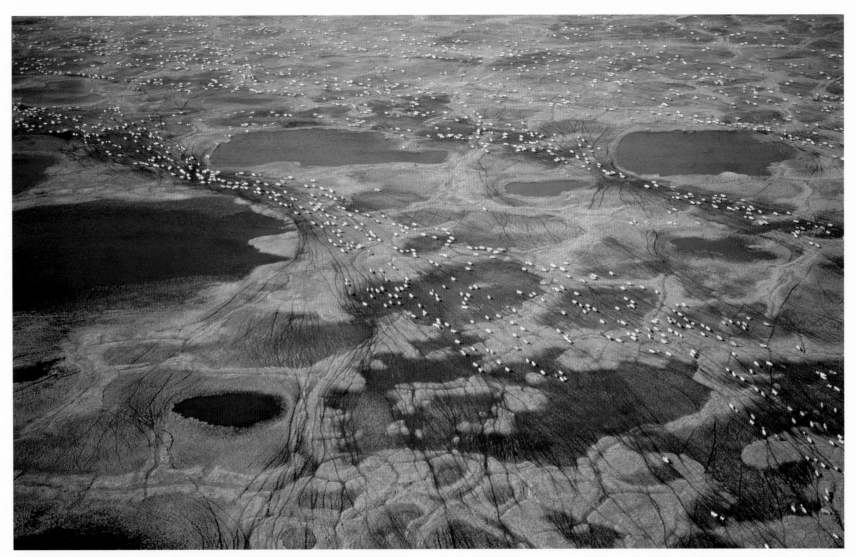

Caribou herd migrates across tundra, habitat used by shorebirds to nest earlier in the season

changes in vegetation from seismic exploration activities. Some indirect effects include oil-spill contamination, which inevitably accompanies oil development; changes in drainage patterns around roads, which can adversely affect habitats; and potential increases in predation rates on shorebird nests by those predators that are drawn to human habitation and refuse. How much impact there might be from these various factors is difficult to predict, but we do know that further declines in already-diminished populations will only make matters worse.

No one knows for certain where oil might be found under the Arctic Refuge coastal plain, but it is likely that the pattern of oil distribution outside the refuge, which is clustered along the coast, may continue under the refuge as well. If oil development is allowed in the refuge, it would certainly take place within the small coastal plain area. Our research in the Arctic Refuge has shown that the coastal plain hosts enough shorebirds to qualify as a Site of International Importance under the Western Hemisphere Shorebird Reserve Network and

as a Wetland of International Importance under the Ramsar Convention on Wetlands. In addition, our work has shown that the coastal wetlands support the greatest numbers and species diversity of Arctic shorebirds—critical habitat needed to ensure that enough young shorebirds hatch each year to replace the adults lost to the risks of long migrations.

Protecting key breeding areas like the Arctic Refuge coastal plain is an essential step toward preserving the populations of these remarkable migrants, who travel to and depend on so many different places scattered throughout the Western Hemisphere to support their long-distance lifestyle. Their travels as ambassadors from the Arctic make clear the connectedness of ecosystems throughout the hemisphere. Considering their death-defying migrations and the long odds they face along the way, the spectacle of shorebird migration is perfectly humbling. Protecting them will require all our diligence and ingenuity. In this process, if shorebird migrations have a lesson to teach us, it might simply be to cast fear and doubt aside, and attempt the seemingly impossible. ■

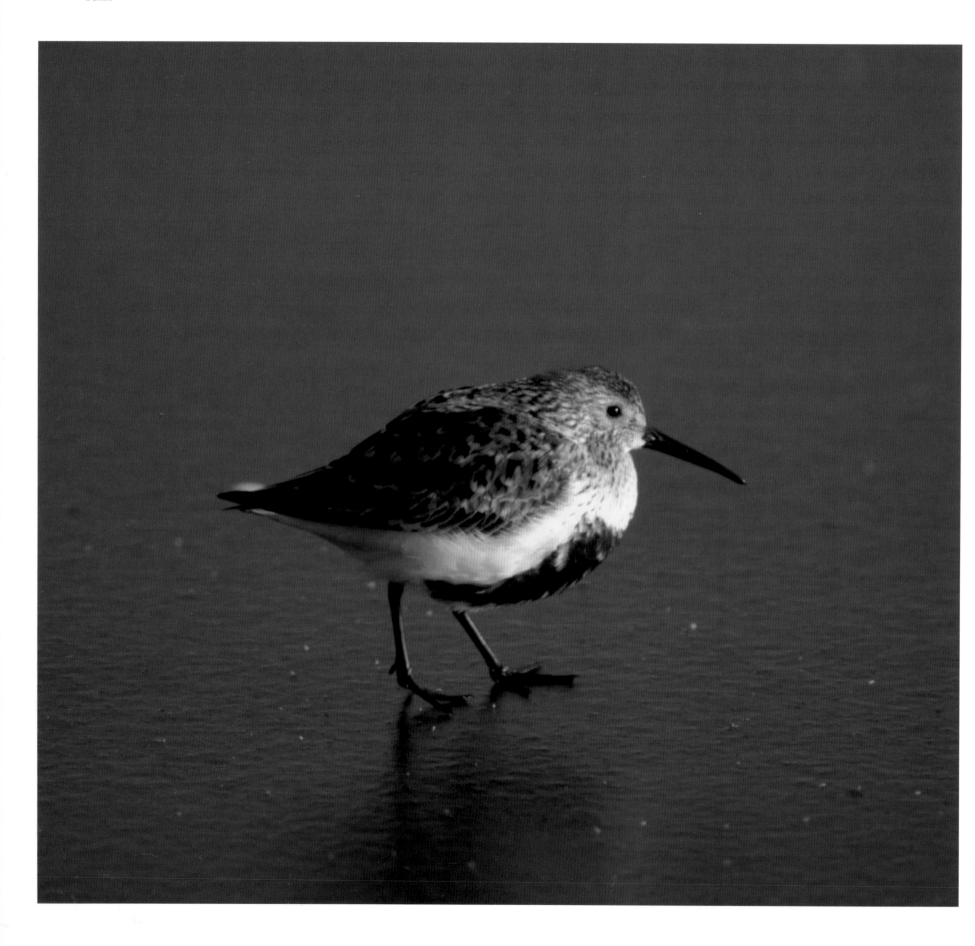

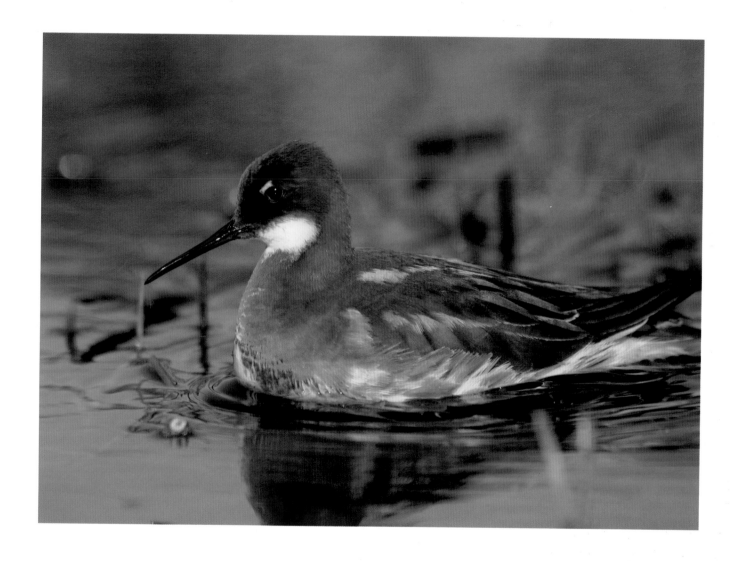

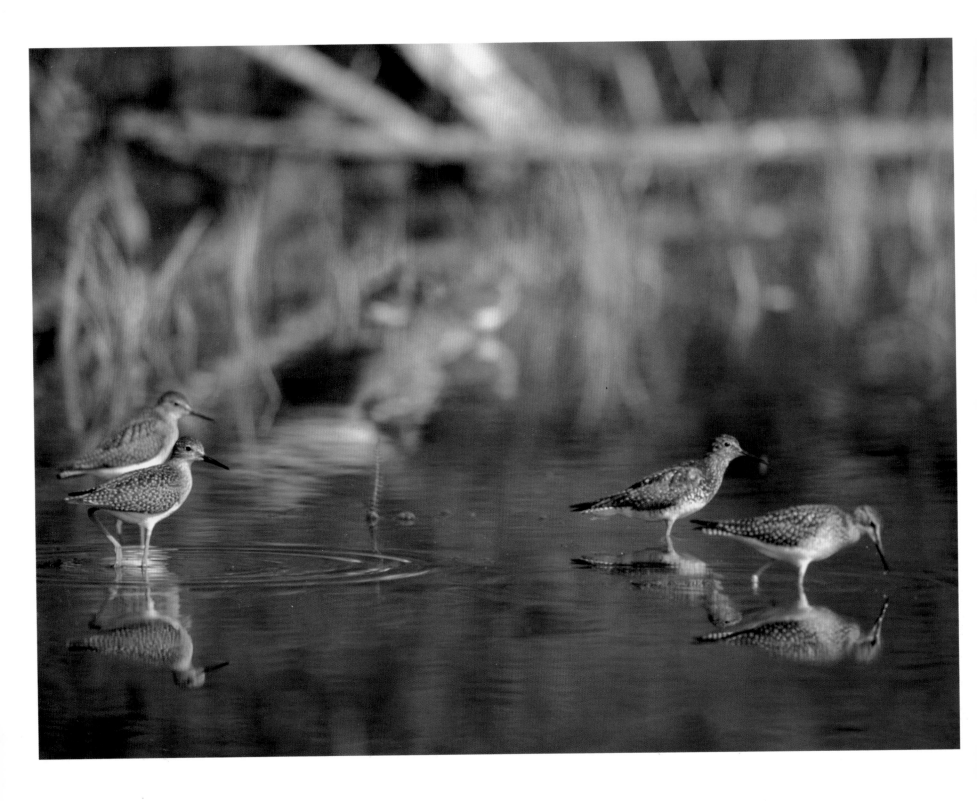

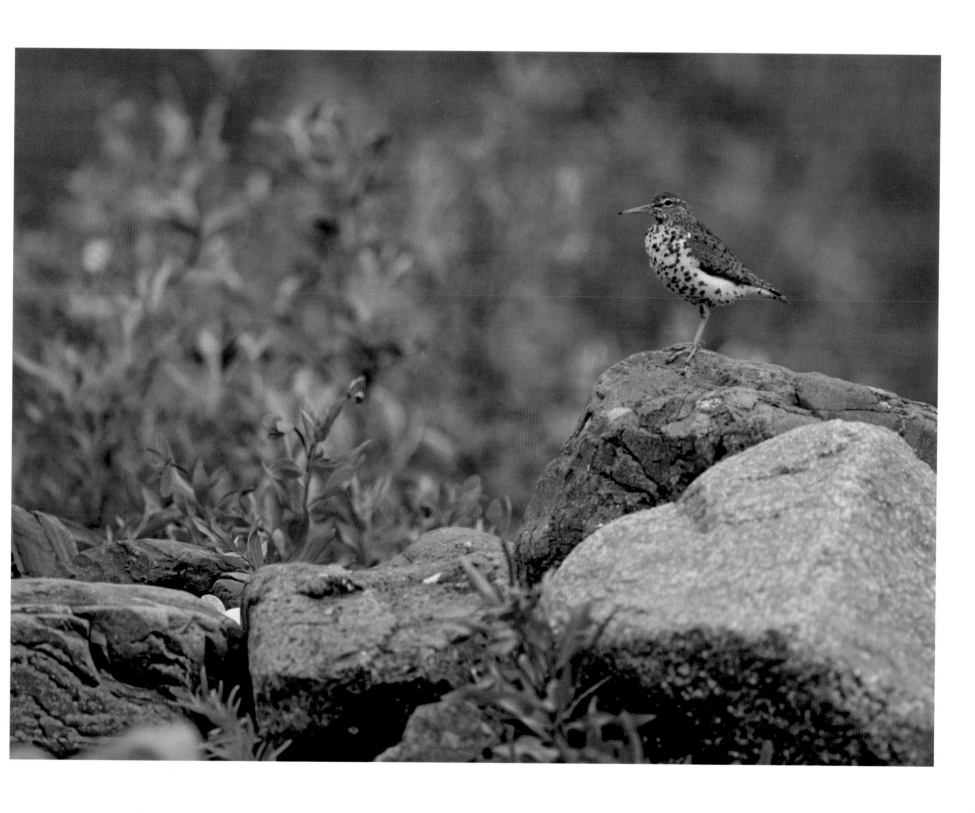

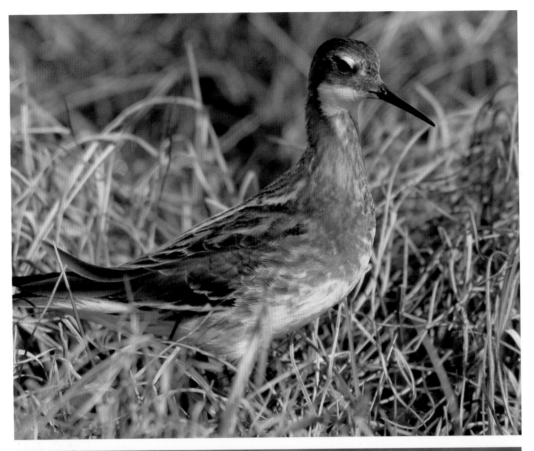

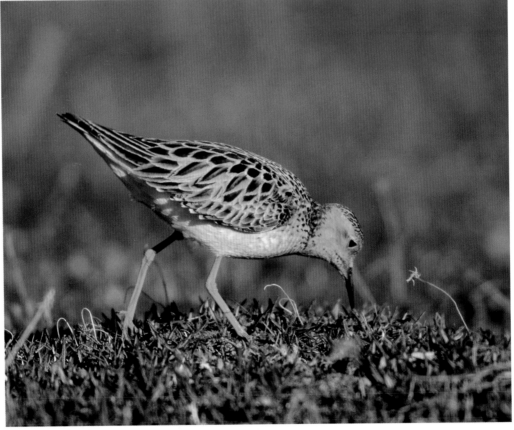

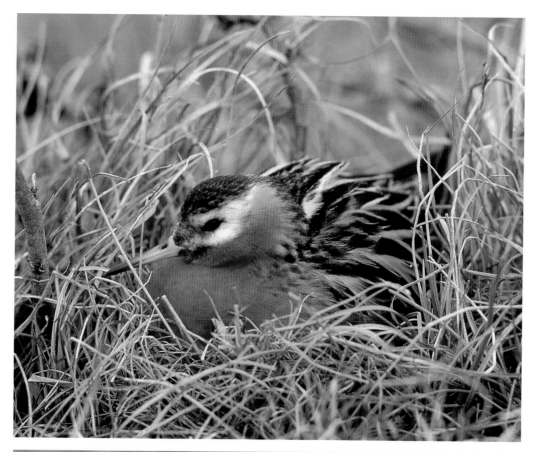

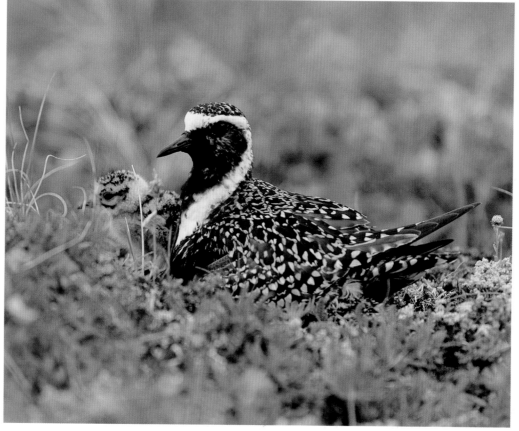

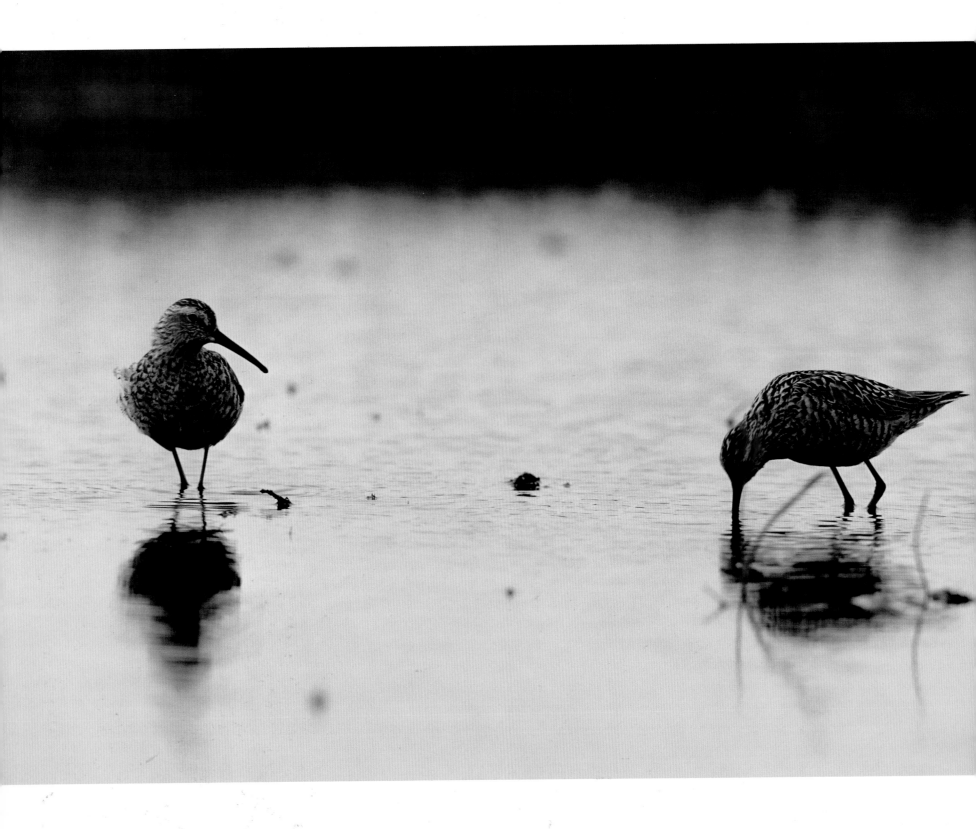

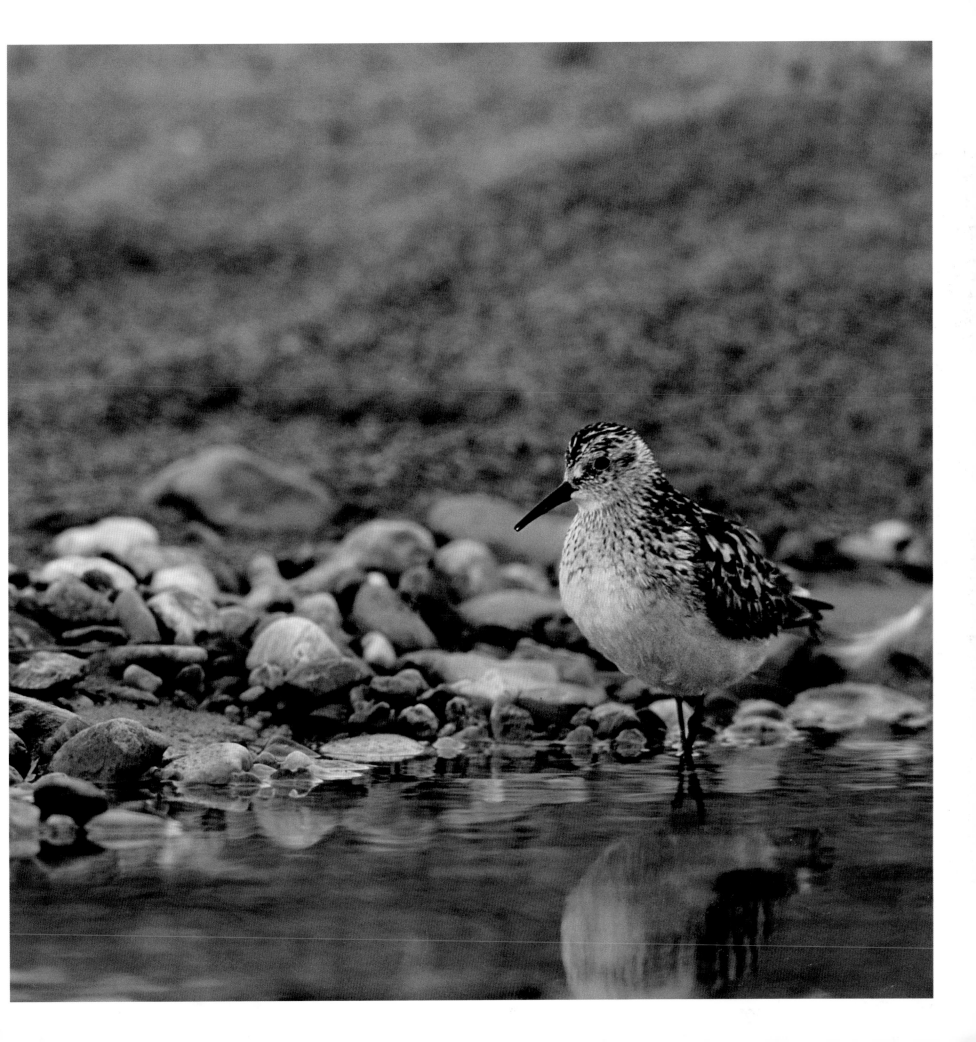

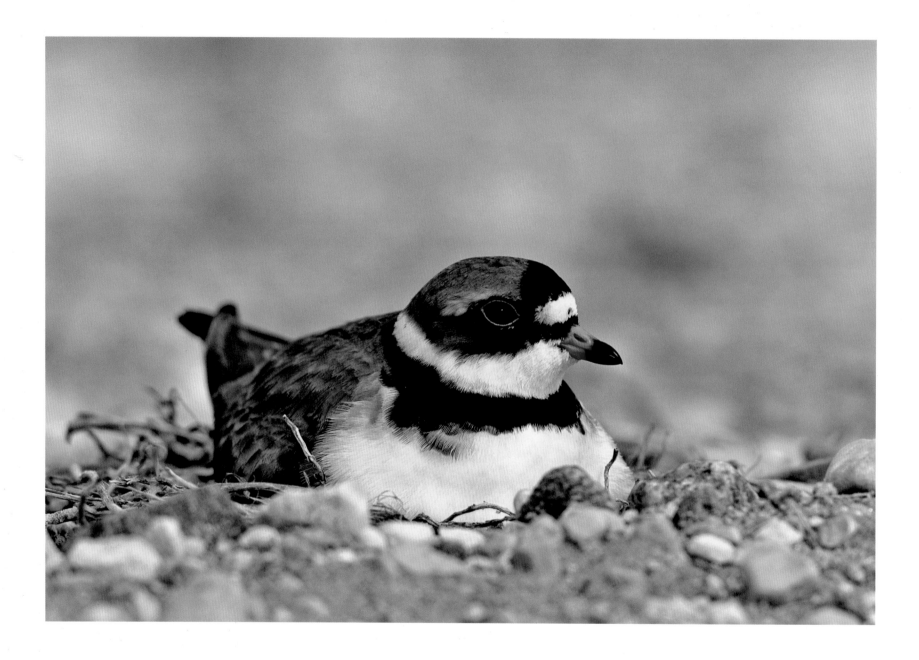

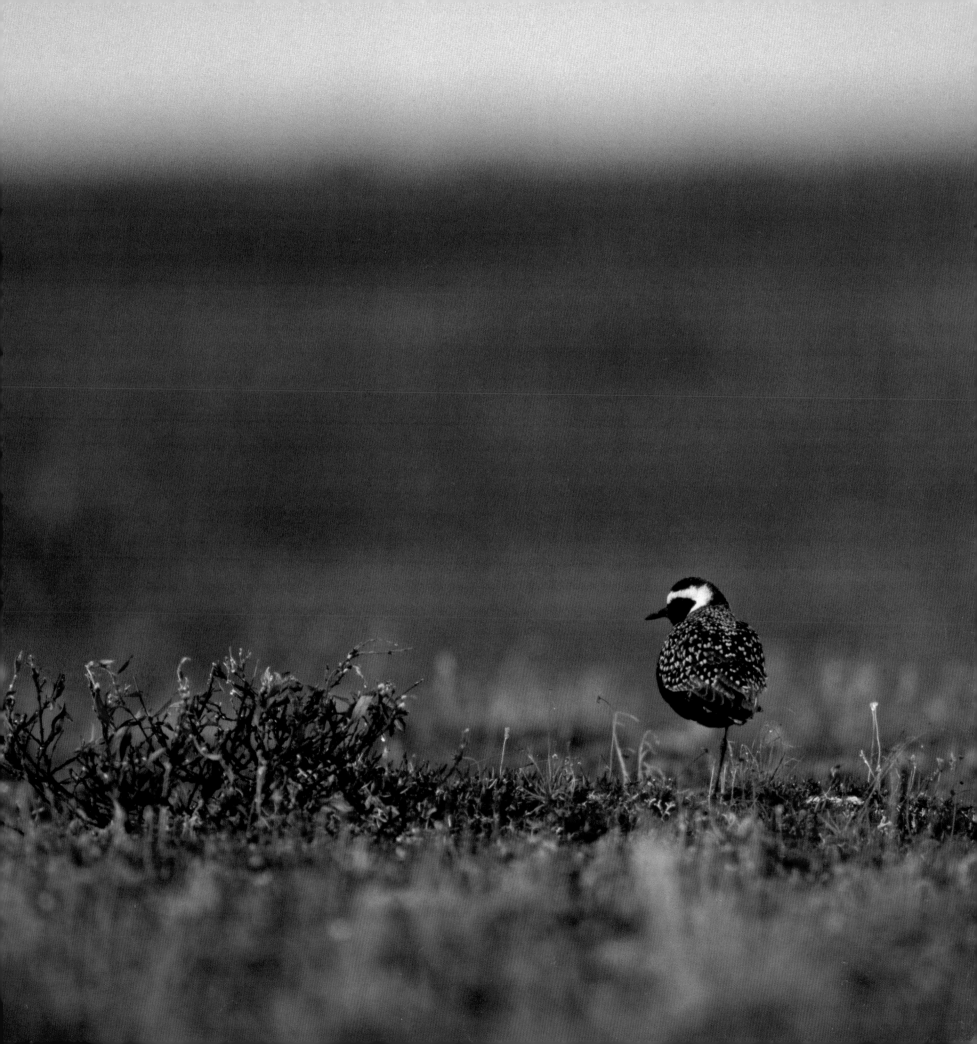

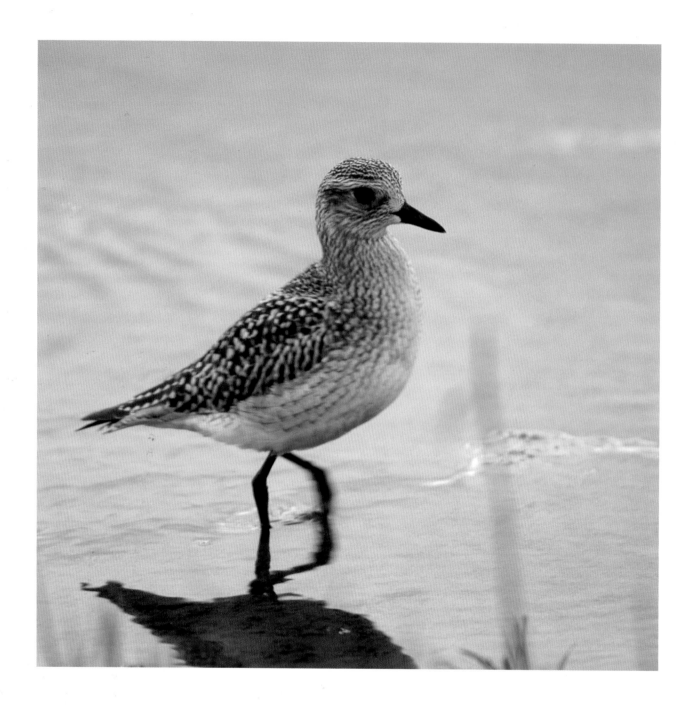

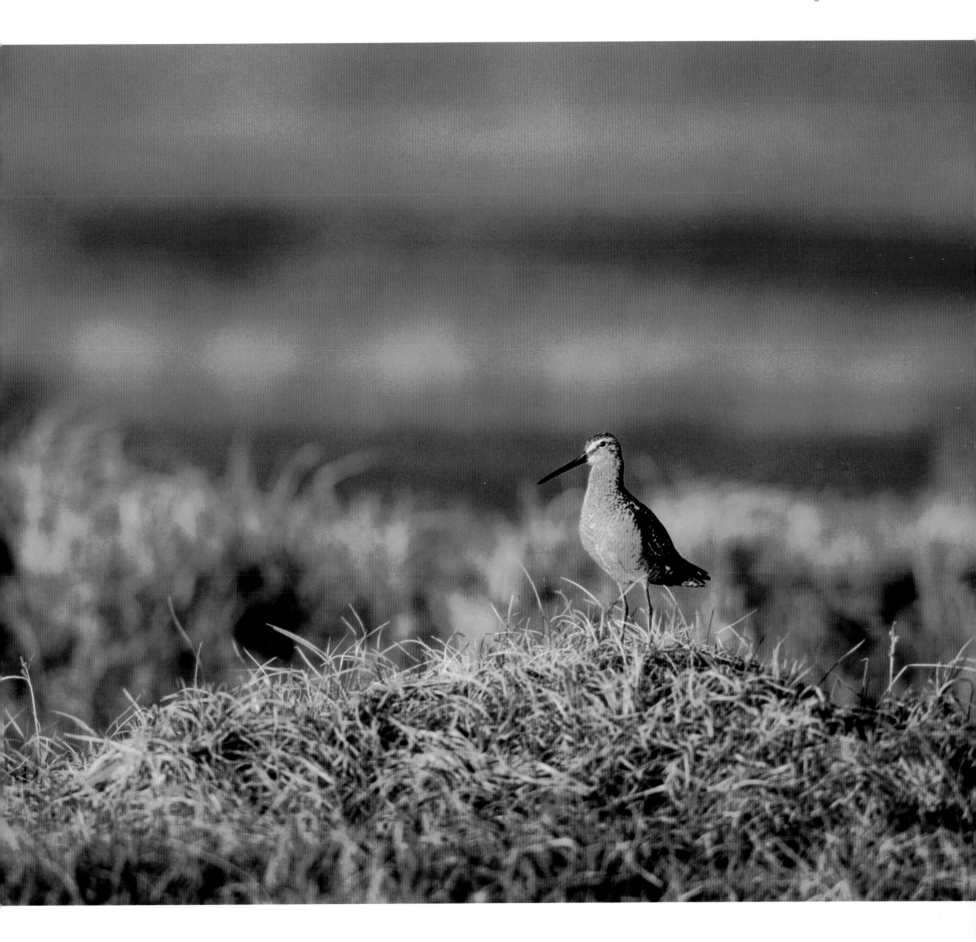

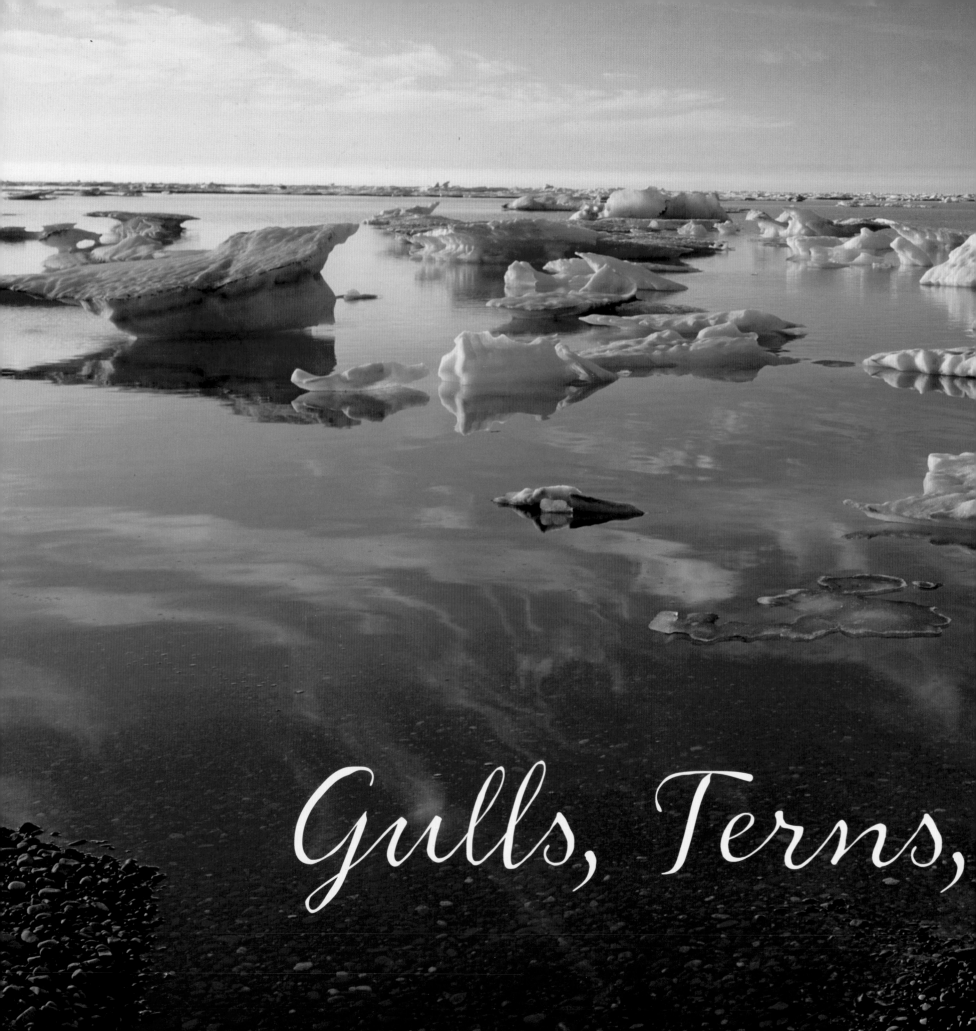

Gulls, Terns,

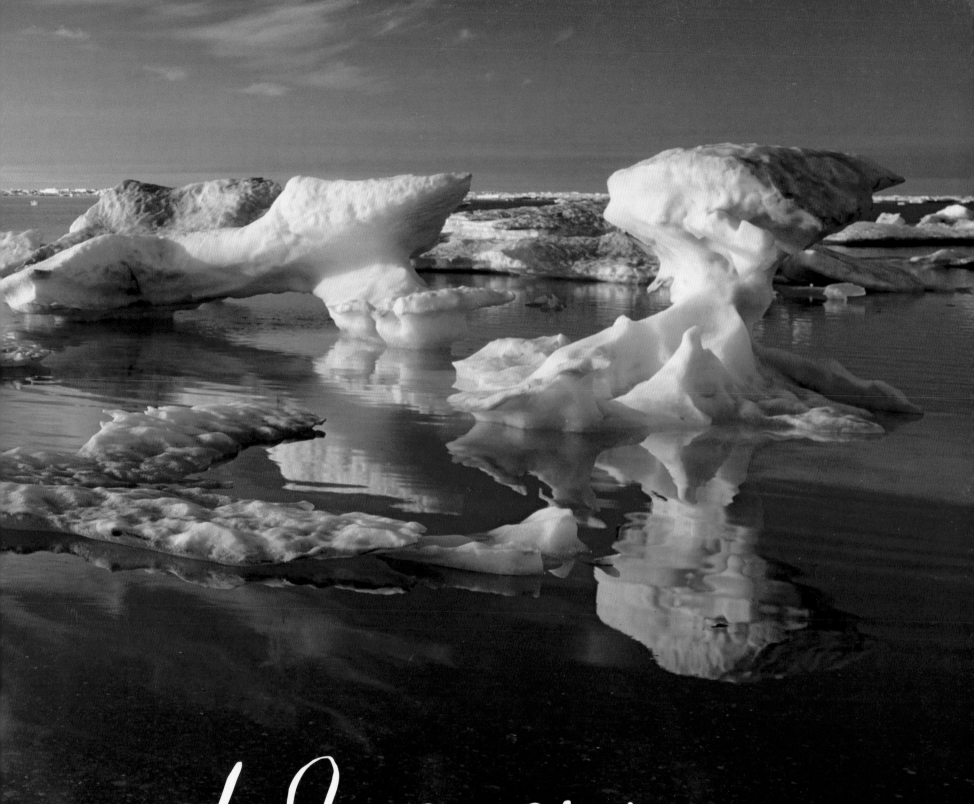

and Jaegers

Photo: John Gibbons

WAYNE R. PETERSEN

is Massachusetts

Audubon's director of

the Massachusetts Important Bird Areas

(IBA) Program and has led international

birding tours, lectured, and conducted birding

workshops across North America for over thirty-

five years. Petersen is a New England Regional

Editor for North American Birds *magazine and*

wrote the National Audubon Society's Pocket

Guide to Songbirds and Familiar Backyard

Birds *(East), coauthored* Birds of Massachusetts

and Birds of New England, *and coedited the*

Massachusetts Breeding Bird Atlas.

Overleaf ■ *Sea ice along the Arctic Refuge coast*

Conspicuous at Alaska's Arctic Refuge during the endless days of early summer, jaegers, Arctic Terns, and gulls of at least two common species are a familiar presence. Living is easy during this season, when food typically is abundant, nesting opportunities are aplenty, and daily survival is not energetically costly. Long-tailed Jaegers, surely one of the planet's most beautiful seabirds, swoop and chase one another with animation and grace, hovering periodically in their quest for hapless lemmings and pausing occasionally on the ground to glean small arthropods or crowberries from the floor of the treeless Arctic coastal plain landscape. Arctic Terns, avian marathoners seemingly ever on a quest for an endless summer, gracefully dip and skim the icy waters of the Beaufort Sea in pursuit of small fish and tiny invertebrates, some of which inevitably will be ferried to downy chicks huddled on a gravel bar somewhere back from the coast.

Sharing the tern's interior nesting retreat is a small colony of Sabine's Gulls, a stunning and diminutive Arctic relative of the widespread and more familiar Herring Gull. The Sabine's Gull, like the Arctic Tern, eventually will travel thousands of miles south to its winter home once its nesting in the Arctic Refuge has been accomplished. Even the hardy and resourceful Glaucous Gull, a familiar sight seen winging its way along the pack ice edges and nesting on tussocks in tundra ponds, will abandon the teeming coastal lowlands before the dark days of winter arrive.

It is well known that certain Arctic-nesting shorebirds make epic flights to wintering quarters as distant as southern South America, Australia, and New Zealand. Yet if one were to follow these itinerant pilgrims to the great coastal estuaries or inland wetlands of South America where many spend the winter, their lifestyles would appear to be relatively unchanged. They continue to probe for invertebrates on intertidal mudflats, seek small mollusks on the *restingas* of Argentina, and pursue insects in the pampas of Patagonia. However, for the jaegers, gulls, and terns of Arctic Alaska, life after breeding becomes a lifestyle apart.

man than the way
build and yet leave a landscape as it was before.

Robert Lynd, *The Blue Lion and Other Essays*

Among the marvels of the avian world is its incredible diversity. This diversity manifests itself in plumage variations, vocalization differences, nesting and foraging behaviors, and migration strategies. Indeed, virtually any trait capable of exhibiting variation does so. Of the regular Arctic Refuge breeding birds, few species undergo seasonal life changes more dramatic than those of the Long-tailed Jaeger, Sabine's Gull, and Arctic Tern. After traveling to Arctic Alaska to lay their eggs and rear their young in a few short weeks each summer, these species promptly head south for the open ocean south of the equator, thousands of miles from their natal home. The pelagic realm becomes their nonbreeding habitat, an environment that is their home for most of their lives. Not surprisingly, this change of habitat is accompanied by some striking modifications in their behavior.

WHAT MAKES SEABIRDS SPECIAL?

Jaegers, gulls, and terns all belong to the large avian order *Charadriiformes,* a group that also includes shorebirds, skimmers, and alcids. These birds all share certain structural and behavioral features in common with other families in the order. Unlike shorebirds, all have webbed feet, although most are as adept at walking on land as they are at sitting on the water and swimming. Jaegers possess beaks with a prominent hook at the tip, a clue to their often-predatory existence. Gulls have bills that are laterally compressed and designed for feeding on a variety of organisms, ranging from fish, mollusks, marine worms, crustaceans, and water-born insect larvae, to eggs, small birds, and carrion. The large, omnivorous Glaucous Gull will just as readily consume human refuse as fish, or the eggs and chicks of shorebirds or other seabirds. In contrast, the dainty Sabine's Gull feeds like a tern, dipping to the water's surface to capture small fish, plankton, and the larvae of aquatic insects when they are available. Terns, in marked contrast to both jaegers and gulls, have slender bills that are sharp, pointed, and well adapted for capturing small fish that they obtain by plunging into the water from flight.

Not surprisingly, the ways in which various prey are obtained are practically as variable as the prey itself. Jaegers are especially creative in capturing prey. While nesting in the Arctic Refuge, Long-tailed Jaegers primarily subsist on lemmings that they capture by hovering overhead and then quickly dropping on them, dispatching them with their powerful hooked beaks. Parasitic Jaegers, unequivocally the swiftest and most adept hunters of all the jaegers, subsist largely on songbirds and shorebirds that they capture on the wing. The largest and less-agile Pomarine Jaegers frequently forage for lemmings on foot, pausing to dig the rodents out of the ground. Although not as dramatic as hunting rodents or songbirds on the wing, Long-tailed Jaegers also frequently walk slowly over the tundra, snapping up small insects or grazing on crowberries.

Kleptoparasitism is perhaps the most interesting and dynamic of the foraging

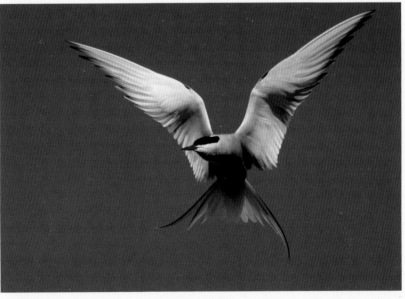

Arctic Tern

strategies regularly employed by jaegers, especially the larger species. This technique is most often employed during the nonbreeding season, when jaegers are at sea. The technique involves stealing food, usually fish, from other foraging seabirds, such as terns or small gulls. With acrobatic precision a jaeger, or sometimes two or three together, actively pursues and harries a tern carrying a fish until the tern drops its prey in an effort to avoid further attack by the pesky pirate. This foraging technique is sufficiently important to the Parasitic

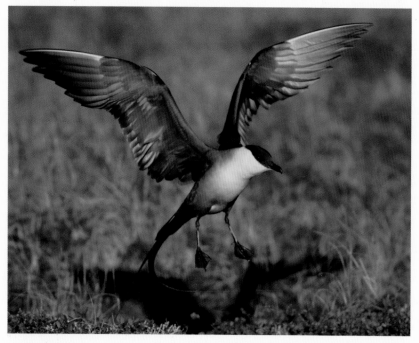

Long-tailed Jaeger

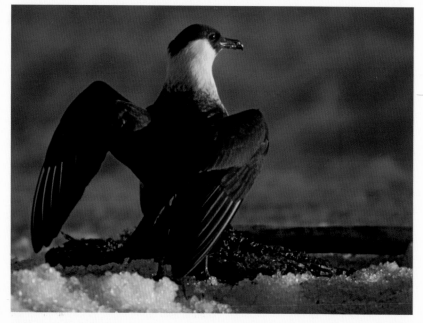

Light morph Pomarine Jaeger

Jaeger that once this species leaves its Arctic breeding grounds, much of its migration is attendant with that of Arctic and other tern species throughout its duration. The Long-tailed Jaeger, no doubt due to its smaller size, is somewhat less inclined to kleptoparasitism than the larger jaegers, often preferring to glean food from the surface of the ocean or attend fishing vessels and scavenge by-catch instead.

A plumage characteristic of jaegers, most notable in Parasitic and Pomarine Jaegers, is the striking degree of color variation found between one individual and another. Such distinct color variation within a species is termed polymorphism. In waterfowl and many songbirds such color variation is gender linked, with males typically exhibiting a more colorful plumage than females. In jaegers, however, such color variation is not linked to gender and may show up anywhere within the breeding range of the species. Studies suggest that plumage polymorphism in jaegers is at least partially tied to geographical distribution, which in turn is associated with the predominant foraging strategy of the birds in a specific region. In areas where jaegers principally forage for rodents over the tundra, such as the Arctic Refuge, light morph individuals tend to predominate. In situations where the majority of foraging is done at seabird colonies, dark morph birds prevail and kleptoparasitism is the primary hunting technique. To further explain these variations, one hypothesis suggests that light morph jaegers are less conspicuous to terrestrial prey when hovering overhead, while dark morph jaegers apparently are less conspicuous to seabirds being parasitized, both near breeding colonies and at sea.

Besides displaying extensive color polymorphism, jaegers, as well as gulls and terns, also exhibit distinctly different immature and adult plumages as well as subtly differing breeding and nonbreeding plumages. In general, the immature plumages of jaegers are even more variable and complex than those of adults, typically featuring differing amounts of dorsal and ventral barring; distinct patterning on the underwings, flanks, and upper-tail coverts; and variability in the extent of overall gray or buff coloration. Because of this great plumage variation, in many cases shape, structure, and flight style are often more useful than plumage characteristics when attempting to identify jaegers in the field, regardless of their age.

Most jaegers require at least three years to attain sexual maturity and full adult plumage, while in gulls this process varies from two years (in, for example, Sabine's Gull) to as many as four years (Glaucous Gull). Most terns are ready to breed by the time they reach three years of age. Despite the variations in these groups, cohorts of the same age are more or less recognizable, even though considerable plumage variation often exists between individuals.

After reaching one year of age, jaegers, gulls, and terns ordinarily molt twice a year, usually a partial molt in the early part of the year and a complete molt that involves the flight feathers in the last half of the year. Sabine's Gull is exceptional in that it undergoes a complete molt in the spring and only a partial molt in the autumn. Also, like Arctic Terns, juvenile Sabine's Gulls do not acquire a black head until they are two years old. Similarly, the adults of

these two species molt most of the black on their heads by winter.

Given that most seabirds do not acquire their adult plumage or attain sexual maturity in a single year, it is not surprising that many of them are long-lived compared to many other bird species. Information obtained from bird banding indicates that some jaegers and gulls may live for more than twenty years, and one Arctic Tern was recorded to have lived for thirty-four years. While this is astounding in itself, when one considers the miles annually traveled by this species during migration, it becomes all the more remarkable.

LIFE BEGINS IN THE ARCTIC

To appreciate the life history of Arctic-breeding seabirds, one needs to visualize the Arctic Refuge in late spring and early summer, the season when jaegers, gulls, and terns return to the tundra to nest. A palette of Arctic wildflowers will soon carpet the otherwise-brown tundra with riotous splashes of color; myriad water-born insects are emerging from recently thawed tundra pools; and everywhere there are the wonderfully weird hoots, trills, and whistles of male shorebirds in aerial display, eager to establish territories and secure the favor of arriving females. With the exception of the ever-hardy Glaucous Gull, most of the breeding seabirds arrive in late May or early June, just in time to exploit the thawing pack ice and the melting tundra snow.

By synchronizing the establishment of their territories and the laying of their eggs with the emergence of microtine rodent populations such as voles and lemmings and the nesting cycle of small songbirds, Long-tailed and Parasitic Jaegers are prepared to nest practically as soon as they reach the Arctic Refuge. Because they tend to occupy the same territory from year to year, jaegers typically mate with the same partner from one year to the next. Biologically this is an advantage, since the abbreviated Arctic summer demands that breeding activities be tightly compressed in order to finish nesting by the time the weather becomes inhospitable.

The larger Pomarine Jaeger differs somewhat from the smaller species in this regard: It acquires a new mate and establishes a new territory each season, thus requiring a longer and more intensive period for courtship and territory establishment. Their breeding is both nomadic and opportunistic. Due to the decidedly cyclical nature of lemming populations from one year to the next, the breeding location and reproductive success of Pomarine Jaegers tends to be highly variable from season to season. In seasons with an extreme lemming shortage, many Pomarine Jaegers will skip an entire breeding season.

The food supply of gulls and terns is more dependable, being comprised primarily of small fish, crustaceans, and aquatic insect larvae. Predictably, the early nesting season behavior of these species follows a pattern of brief courtship accompanied by territory establishment, usually at previously used sites, and egg laying. For first-time breeders the establishment of a territory and the securing of a mate can be more challenging than for older birds, whose previous experiences and strong site fidelity reduces much of the stress and conflict associated with first-time breeders. Breeding males in these groups

tend to arrive on the tundra slightly ahead of the females, thereby allowing them to tie down a territory before the females return. These early nesting behaviors represent adaptations to facilitate successful nesting within a seasonally truncated breeding period.

Once a pair bond is established, nest building is initiated and eggs are laid. For most jaegers, gulls, and terns, a nest is little more than a scrape—a rudimentary depression in the ground—usually with only small amounts of vegetation and debris added as a lining. In most species it is the female that accomplishes nest building, although in Pomarine Jaegers and Glaucous Gulls both sexes participate. Jaegers prefer to nest on low elevations or on the tops of raised hummocks in the open, while Glaucous Gulls nest on small islands in

Lemming

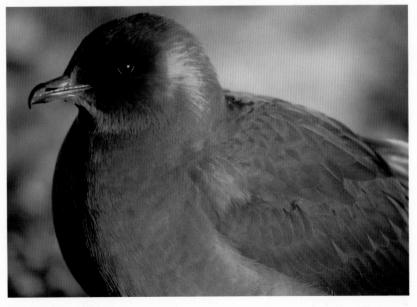

Dark morph Parasitic Jaeger

ponds, coastal barrier islands, and gravel bars in rivers, and they are inclined to create raised nest mounds constructed of grasses, seaweeds, mosses, and sometimes mud. Such structures occasionally reach more than two feet in height and eighteen inches across. Since the nests are used from one year to the next, they tend to increase in size over time. Sabine's Gulls simply make a shallow scrape, usually on the top of a tussock near water and often in the company of Arctic Terns. Arctic Terns simply place their eggs on bare gravel.

Clutch size for most of these seabirds ranges from one to four variously speckled and cryptically colored eggs, with the majority of species usually laying two eggs in most years; only the big Glaucous Gulls ordinarily lay three eggs. If eggs are lost as a result of weather or predation, occasionally a pair will produce another clutch, but more often nesting is forsaken for the season. Incubation responsibilities tend to be shared by both sexes, with a duration that ranges from twenty to twenty-four days in the relatively small Arctic Tern, to twenty-seven to thirty days in the Glaucous Gull. After hatching, the young of all these species are semiprecocial and are covered with a soft and, except for jaegers, speckled down. Shortly after hatching chicks are able to move about, and they generally abandon the immediate nest site, within a few hours in the case of Sabine's Gulls and Arctic Terns and several days for others. Despite being covered with protective down and having the ability to efficiently move around right after hatching, chicks regularly are brooded by their parents while they are small in order to protect them from overexposure to the elements.

Jaegers and terns are very aggressive in defense of their nests and young. Should a predator such as a raven, a fox, or even a human come too close to a nest or brood, it risks being physically attacked. Both Parasitic and Pomarine Jaegers will fly menacingly at the head of an intruder, sometimes actually striking the predator with their feet. Arctic Terns are even bolder, using their sharp, pointed bills and agile flying ability to repeatedly render painful strikes

Glaucous-winged Gull

to an apparent threat. Unlike shorebirds and other ground-nesting birds that routinely use a distraction display to lure predators away from their nest or young, among Arctic Refuge seabirds only the Parasitic Jaeger regularly demonstrates this behavior, and then only if severely pressed. Plaintive calling and spasmodic wing flapping are part of the ruse to lead a predator away from the nest or young.

How the young are fed varies somewhat from one group of seabirds to another. Adult jaegers ordinarily regurgitate food in the presence of their hungry, begging young, with the female typically parceling out tiny bits to the chicks until they are large enough to pick it up for themselves. Should an entire prey item, such as a lemming, be too large for one parent to dismember for the young by itself, both members of the pair may participate in what amounts to a tug-of-war in order to reduce the prey to a manageable size for the chicks. A parent Glaucous Gull will regurgitate food only when a chick pecks at the orange spot located on the lower mandible of the parents' beak. This spot, known as a "releaser," is critical to the feeding of the young: Its appearance triggers the pecking response in the chick, which in turn stimulates the adult to regurgitate food. Arctic Terns are unique among the group in that they carry food in their bills and deliver it whole to the hungry chicks. In extreme cases a food item may be nearly as large as the chick!

Though less dramatic than the fledging and rapid departure of highly precocial juvenile shorebirds, the first flights of most juvenile jaegers, small gulls, and terns generally are accomplished within a month after hatching. The more robust young of the large, cliff-nesting Glaucous Gulls, however, may not attempt their first flight for forty-five to fifty days after hatching. Even after learning to fly, the juveniles of these different species tend to remain with their parents for an additional several weeks and in some cases for as long as two months. During this late-summer period, the young increase their ability to efficiently forage and improve their flying skills, which, by the end of summer, will be essential for the long migratory journey that awaits them.

Breeding, migration, and molt are the most energetically costly activities in a bird's life. The way that Arctic nesting species balance these stressful activities varies considerably. Molt, the process by which birds annually replace their feathers, is especially variable. In long-distance migrants such as jaegers, Sabine's Gulls, and Arctic Terns, little or no molting takes place before the birds leave the tundra at the end of summer; instead, they molt upon reaching their winter quarters in the Southern Hemisphere. This strategy allows long-distance travelers to expend less energy during the time that they are nesting and undergoing the stress of a lengthy migration. Once they reach their wintering grounds, they undergo a more or less complete molt that brings them into either their first-summer plumage (as found in Sabine's Gulls) or their second-winter plumage, the latter variation being a consequence of skipping the partial molt into a first-summer plumage that is demonstrated by most gull and tern species.

Glaucous Gulls, which are not long-distance migrants, exhibit a different

molt strategy: They gradually begin molting in early summer, not completing the molt of their flight feathers until sometime in late fall. Juveniles, on the other hand, hardly molt at all until initiating a complete molt, including their flight feathers, beginning sometime between March and May.

ARCTIC DEPARTURE

By the end of August and early September, most seabirds, with the exception of Glaucous Gulls, have largely abandoned the Arctic Refuge. Now a major transition begins for these species, a transition that ultimately results in changes in their habitat, behavior, feeding ecology, and plumage. Jaegers, Sabine's Gulls, and Arctic Terns are transequitorial migrants that annually leave the Arctic breeding grounds and travel thousands of miles southward for the winter. Although most of this migration takes place over the open sea, the birds' initial departure from Arctic Alaska of necessity follows less pelagic pathways. Due to the vast, circumpolar Arctic breeding distribution of most of these species, the precise exit strategy taken by any given individual cannot be described with absolute certainty.

Some jaegers and Arctic Terns nesting in northern Alaska depart westward along the Arctic Ocean coast and then head southwest into the Chukchi Sea, pass through Bering Strait, and eventually make their way to the offshore waters of the Pacific Coast of North America. Other birds apparently move overland across interior Alaska, reaching the Pacific Coast somewhere between south coastal and southeastern Alaska. Still another important migration route takes birds eastward along the coast of Arctic Canada with at least some individuals passing southward into Hudson's Bay, while others continue east to northern Labrador, then south to the Atlantic Ocean. From the regular occurrence of jaegers in the Great Lakes area as well as at other widely scattered interior locations, it would appear that at least some juveniles regularly take an overland route to reach the coasts of the continental United States. Observations in both Canada and the United States suggest that Sabine's Gulls probably follow similar Arctic departure routes. Interestingly, both Long-tailed Jaegers and Sabine's Gulls are more frequently observed along the Pacific Coast in autumn than on the Atlantic Coast. This may be due to the fact that both species tend to migrate well offshore along the Atlantic continental shelf edge, where few birders get to see them.

The terminal winter destination of most Long-tailed Jaegers and Parasitic Jaegers in the Western Hemisphere is deep in the southern Pacific and Atlantic Oceans, typically between thirty degrees south and fifty degrees south, in the Humboldt Current off western South America, or at similar latitudes at the convergence of the Brazil Current and the Falkland Current off Argentina. Many Pomarine Jaegers also winter north of the equator, ranging at sea in the Pacific Ocean from Southern California to Peru, and in the Atlantic Ocean in the Caribbean Sea and the waters off northern South America. Sabine's Gulls spend their nonbreeding season at sea from southern Baja California to northern Chile, where they concentrate in the food-rich waters of the Humboldt Current off Peru.

Arctic Terns exhibit what is possibly the most dramatic annual migration of any organism on earth: Some individuals may travel more than 30,000 miles a year. Once their young have fledged, the majority of Arctic Terns breeding in Arctic North America move eastward to staging areas in the eastern North Atlantic Ocean, from which they then migrate southward, past western Africa. After crossing the equator, some birds head for South America, although most of the population appears to pass through the offshore waters of southern Africa before continuing south into the Southern Ocean, where the majority of birds will spend the winter at the edge of the Antarctic pack ice. While this migration is seemingly extraordinary, almost as impressive is the way the terns

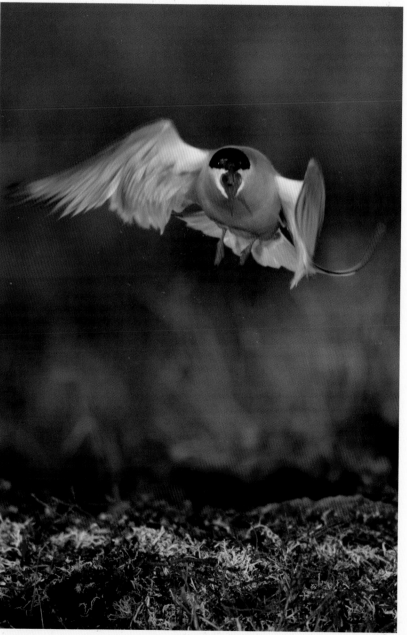

Arctic Tern

utilize the powerful westerly winds—the Roaring Forties—that dominate the Southern Ocean to deflect their migratory path east of southern Africa as they enter Antarctic waters.

Once the terns reach the region of the Antarctic pack ice, they undergo a complete molt, having conserved the much-needed energy required for molting for their lengthy transequatorial journey. Feeding all the while on the abundant Antarctic krill, Arctic Terns gradually follow the seasonally melting pack ice southward until they encounter the powerful easterly winds associated with the South Polar Region. These polar winds eventually drift the terns westward to the vicinity of Antarctica's Weddell Sea. With the gradual return of the austral winter, beginning in March, the birds turn northward and once again take advantage of the same powerful westerly winds in the forty degrees south latitudes that helped them reach Antarctica in the fall. These favoring winds assist the terns as they again make their way back toward southern Africa, where they begin tracking northward toward the equator, ultimately reaching their Arctic nesting grounds sometime in early June.

Arctic Terns in their first summer remain in the Southern Hemisphere and do not return to the Arctic. Because of the inhospitableness of the austral winter season, most of the nonbreeding, immature terns spend their first summer in the food-rich waters of the Humboldt Current off western South America, the same nutritive ocean waters that sustain large numbers of wintering jaegers and Sabine's Gulls.

BEYOND THE ARCTIC: ADAPTATIONS AND MODIFICATIONS
It is during the long non-breeding season spent in the Southern Hemisphere that jaegers, Sabine's Gulls, and Arctic Terns truly become seabirds, employing specialized adaptive strategies different from those utilized during their relatively brief stay on the Arctic Refuge. At this season jaegers forage by gleaning small fish and marine invertebrates from the ocean surface or by becoming more reliant on kleptoparasitism as a way of obtaining sustenance. Sabine's Gulls feed exclusively by surface gleaning, either in ternlike flight or by floating buoyantly on the water and dipping with their bills. They virtually never visit land at this season, and, as with jaegers and Arctic Terns, the ocean becomes their home for nearly nine months of the year. To deal with the excess salt that is daily a major part of their nutritional intake, these birds have highly modified extrarenal organs called salt glands located in their heads above and in front of their eyes. These glands work in concert with their kidneys to filter and concentrate the excess salt in their blood stream, and then excrete it through the nasal cavity and external nares. Indeed, if one had the opportunity to observe many seabirds closely enough, they would appear to continually have runny noses!

A highly evolved and delicate combination of physiological processes, variable foraging techniques, differing migration patterns, anatomical and structural adaptations, and varying molt strategies has given jaegers, gulls, and terns the tools they need in order to seasonally travel from one end of the earth to another—tied at one end to the Alaska tundra for nesting and to the vast oceans of the Southern Hemisphere at the other. It is noteworthy that many portions of Arctic Alaska were beneath thousands of feet of Laurentide ice as recently as 8000 to 10,000 years ago, a circumstance clearly unsuitable for avian occupation in many areas during that period. At least one hypothesis holds that some of these seabirds, such as a number of tundra-nesting shorebirds, may represent hardy colonists (or survivors?) that have successfully adapted themselves to inhospitable Arctic landscapes that likely were exceedingly difficult to inhabit during the Wisconsin glacial period. It is equally plausible to imagine that the migration strategies that we see in these seabirds today may gradually have come about in response to major climate changes during the last glacial epoch. Had these species not been able to undertake such a major shift in global distribution, they probably would not exist today. Although it would seem that these species would hardly have to annually migrate from one end of the earth to another in order to escape the onset of winter these days, it is more than coincidental that so many Arctic nesting birds undertake such epic journeys. Could it be that the long seasonal migrations that we annually observe today actually are a recapitulation of responses to yesterday's ice ages?

WHAT DOES THE FUTURE HOLD?
The cycle eventually comes full circle: Seabirds return to the Arctic Refuge in spring to nest and rear their young in the lingering brilliance of the Arctic summer; they exit the tundra in fall and head for the open sea in order to travel thousands of miles to spend the winter in the Southern Hemisphere; and then they return the following spring. Such is the life of seabirds. Thoughtful reflection on this incredible annual saga inevitably leads to questions about the survival challenges facing these oceanic globetrotters.

Unlike many members of the abundant shorebird fauna of the Arctic Refuge, for the time being most seabirds are adapted in ways that to some degree removes them from severe anthropogenic pressure. Although it is true that indigenous people routinely shoot and kill jaegers while they are accessible to them on the Arctic tundra—and they harvest the eggs of Arctic Terns for their consumption as well—in general these seabirds are spared much of the human contact more often encountered by long-distance migrant shorebirds. Shorebirds, with their finely tuned coastal, interior wetland, and upland grassland habitat needs, are more vulnerable to human disturbance once they depart from the Arctic Refuge than are any of the seabirds. Indeed, perhaps a seabird's greatest survival virtue is its ability to live relatively out of harm's way for much of its life. The open sea is not without hazards, however; oil, chemical pollution, and encounters with commercial fishing activity all represent templates for negative impacts on seabirds during their lives at sea. Yet the mandate for widely separated and highly concentrated specific food resources that punctuates the survival of shorebirds is not the limiting factor for pelagic seabirds that it is for their land-bound relatives. To be sure, in the Arctic Refuge, variations in lemming cycles or the incidence of unseasonable foul weather may be responsible for short-term setbacks to breeding success. In the future, however, it is the specter of significant ecosystem disruption, resulting from efforts to obtain oil from

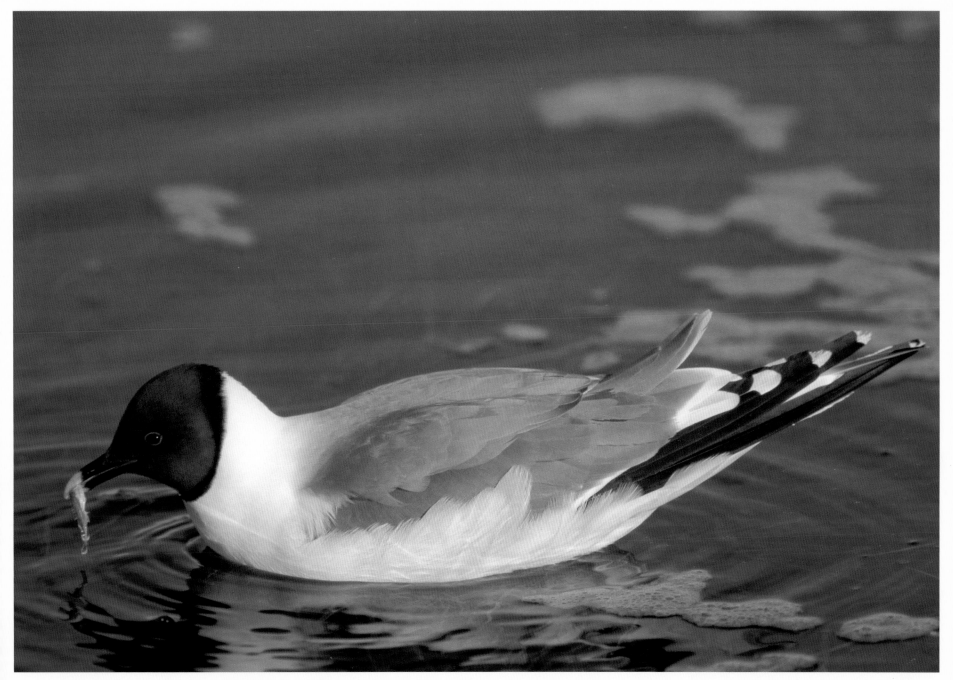

Sabine's Gull

beneath the fragile tundra ecosystem, that represents the greatest threat to the future of Arctic nesting seabirds during the critical land-bound stage in their life cycle. Although it is true that overfishing or cyclic perturbations in marine food abundance at sea could someday critically impact their fortunes, to date these influences do not appear to significantly affect the jaegers, gulls, and terns that nest in the Arctic Refuge.

Threats brought on by global climate change, however, may be more ominous. Parasitic Jaegers, Arctic Terns, and other seabird species nesting at colonies in Europe's North Sea have undergone massive reproductive failures in recent years—failures ultimately traced to warming sea temperatures and an attendant collapse in the abundance of plankton, which sustains the bait fish upon which many seabirds depend. One can hope that these pernicious effects will not increase in the years ahead, thus similarly threatening the seemingly healthy and robust seabird populations that currently nest in the Arctic Refuge. It is unequivocal that humans are the ultimate predators. In their hands alone lies the future of Arctic seabirds, if not of the entire Arctic ecosystem. ◼

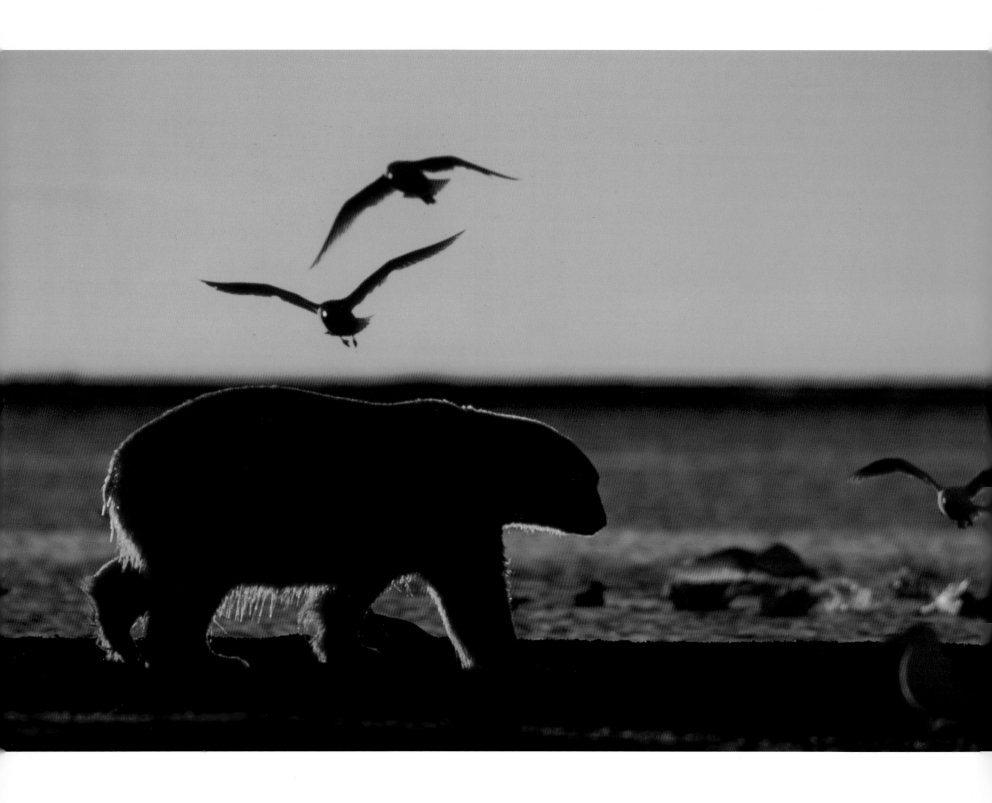

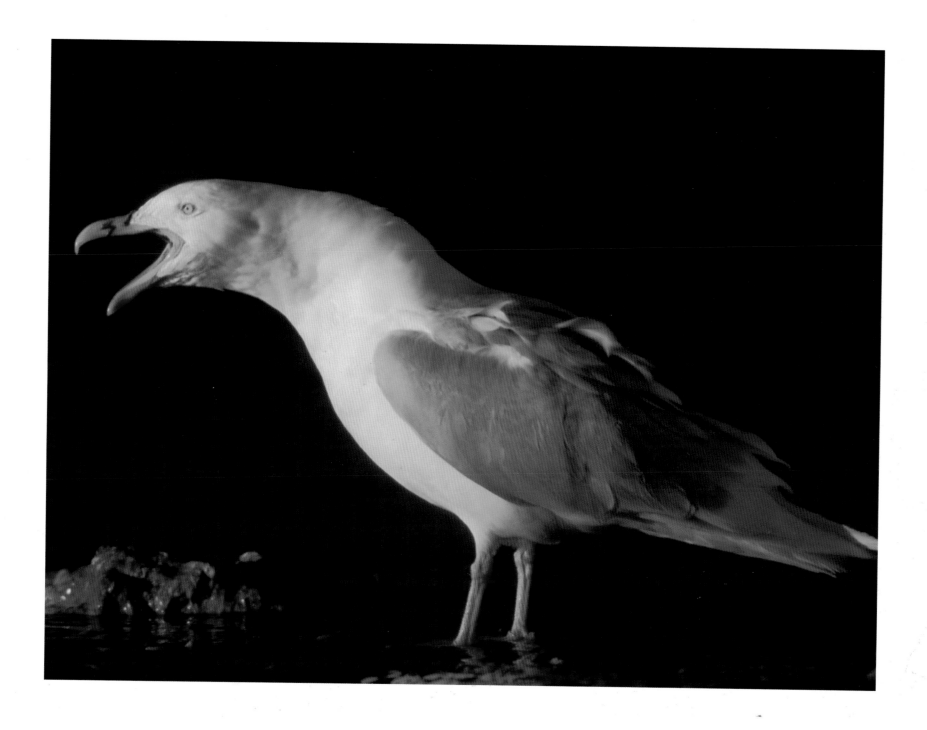

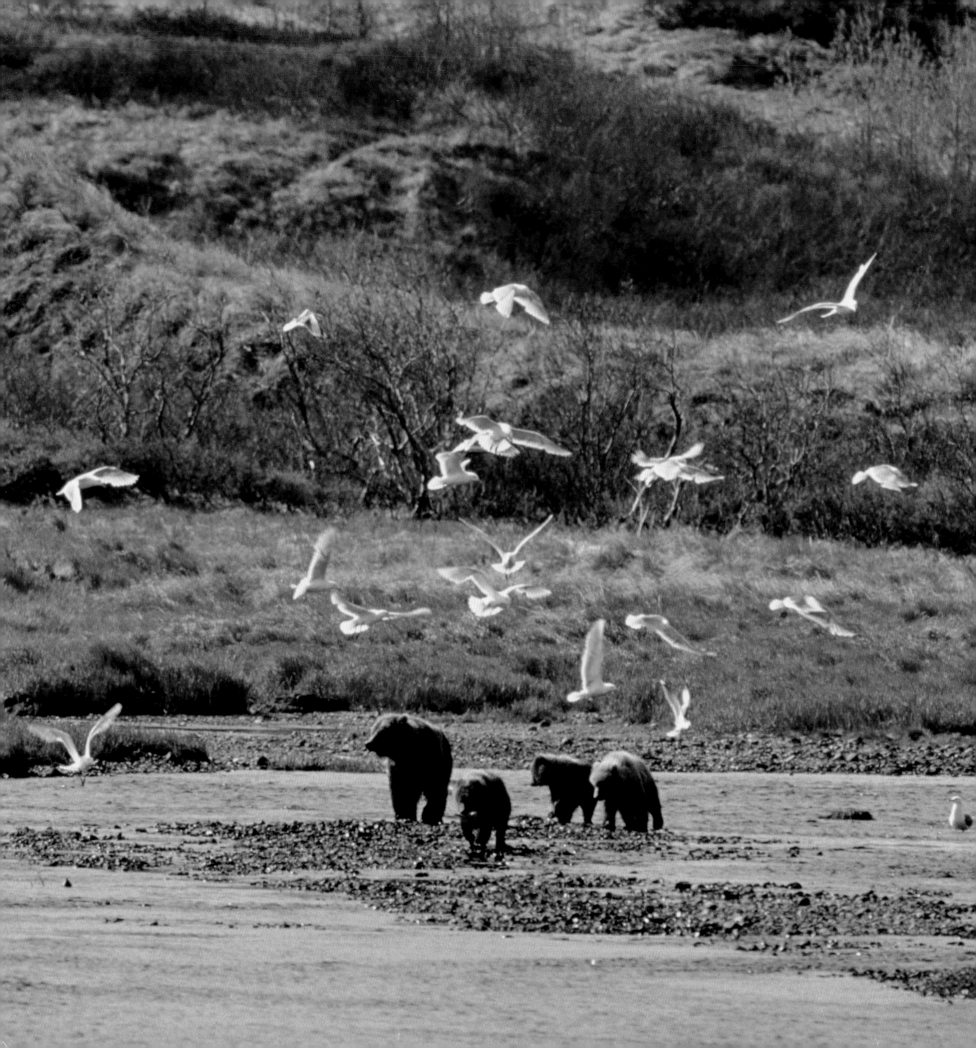

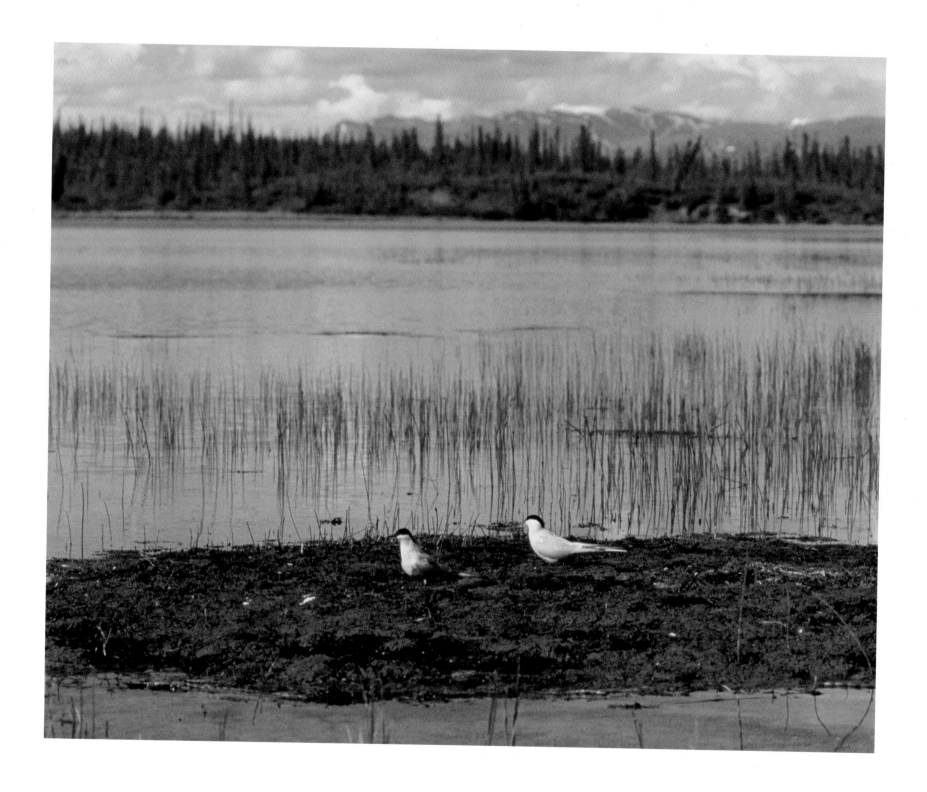

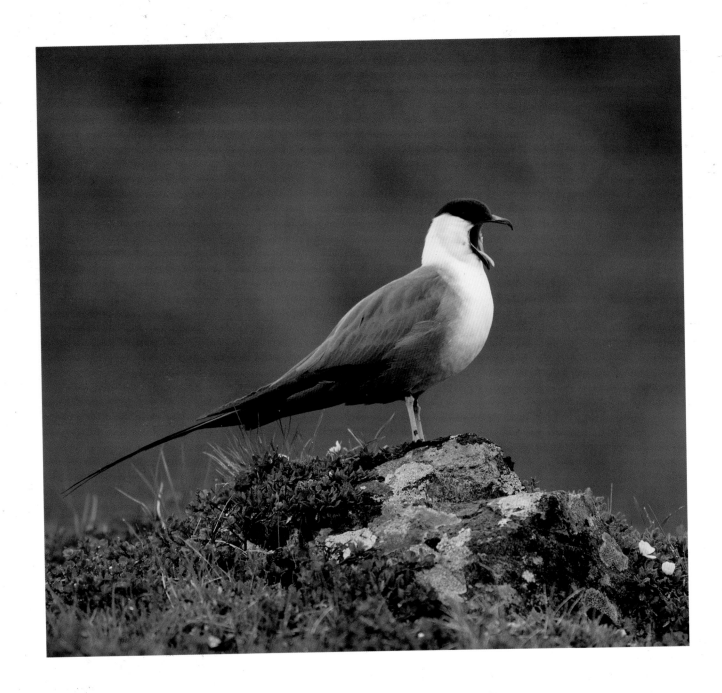

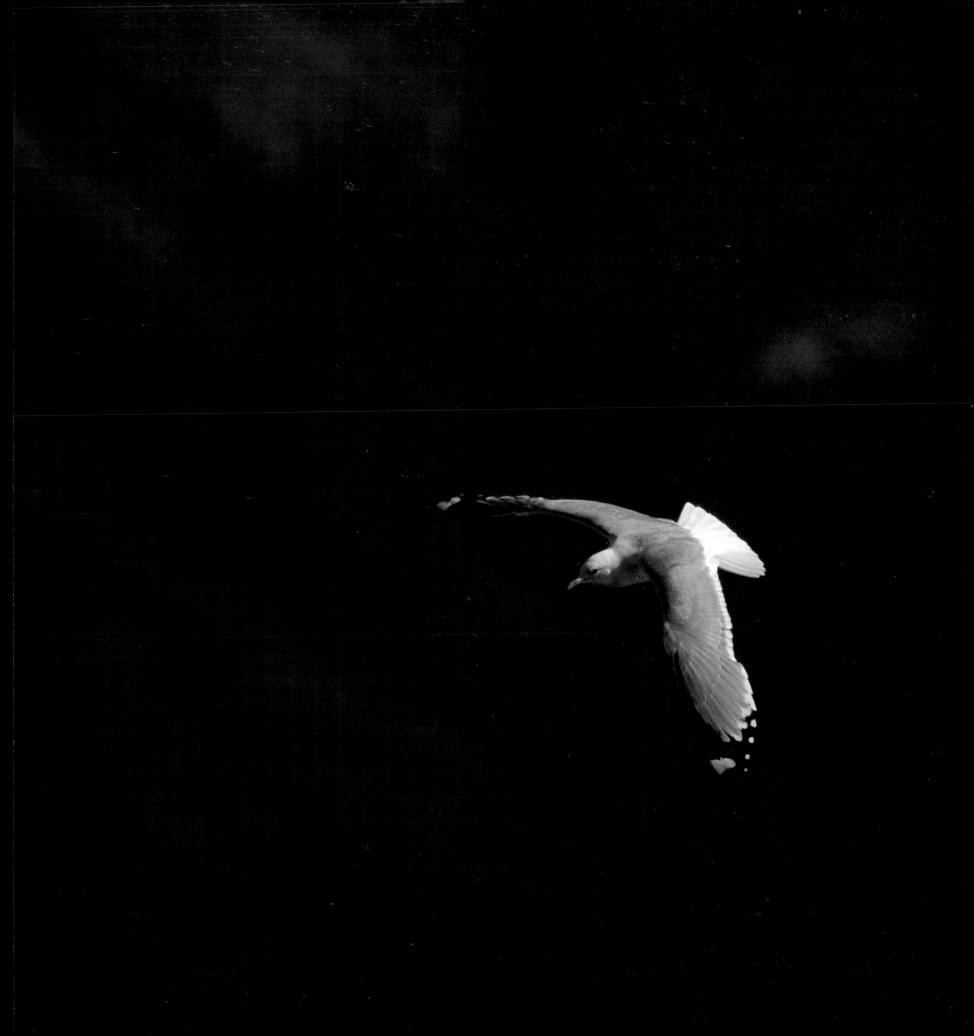

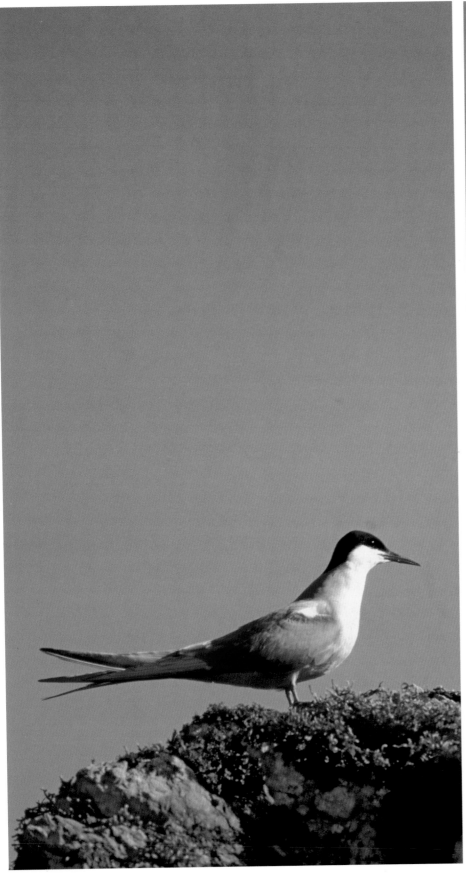

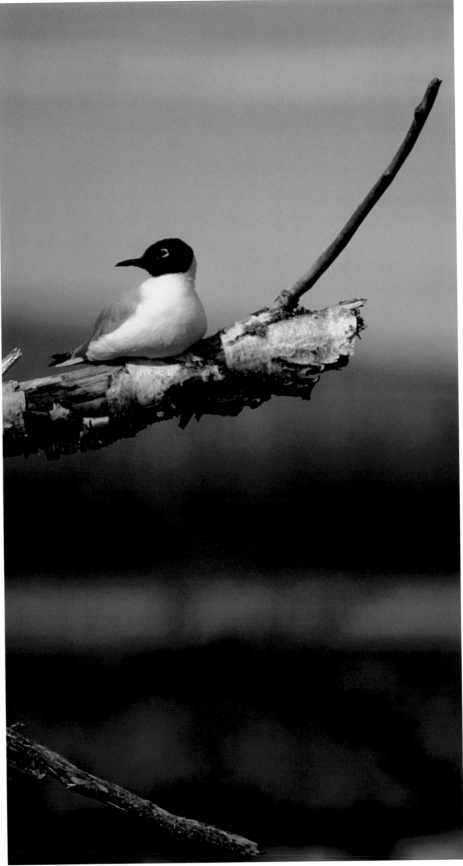

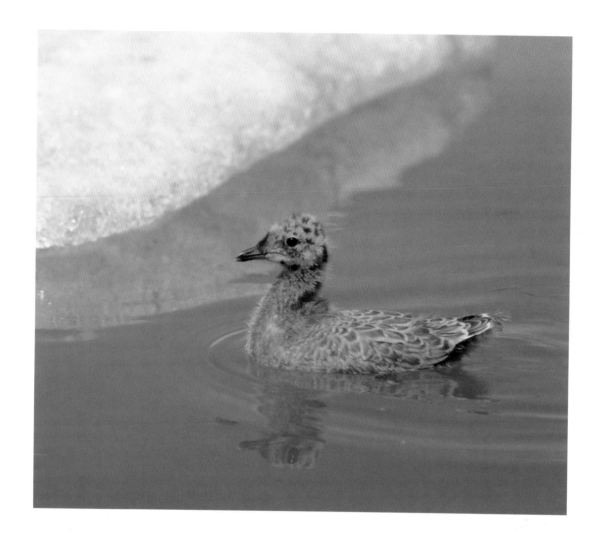

Owls

Photo: Dan Cox, Natural Exposures

DENVER HOLT *is the founder of Montana's Owl Research Institute and Ninepipes Wildlife Research and Education Center. Holt conducts fieldwork on many different species of owls, including Snowy Owls on Alaska's North Slope. His work has been featured on* CNN Science News, Audubon's Up-Close *series,* PBS's Bird Watch, David Attenborough's Life of Birds, *and* National Geographic.

Overleaf ■ *East Fork of the Chandalar River valley*

Not many people live in the Arctic National Wildlife Refuge, and few come to visit this far northern landscape. Like most of you reading this book, I have never been there. But my appreciation for the refuge is no less than those who have been there, and here is why: I have worked on the North Slope of Alaska for fourteen seasons, and the birds I research and enjoy that breed in the refuge could not survive without the full range of habitats—breeding grounds, wintering grounds, and migration stopovers. Arctic ecosystems are uncommon on a world scale; they represent a small percentage of the world's landmass when compared to oceans, forests, grasslands, and deserts. There are few places on earth like the Arctic National Wildlife Refuge and even fewer places like it in North America. That this place exists is what matters: a place where wildlife and wild lands interact naturally, and where animals and landscape receive minimal human influence.

In the 19.5 million acres of Arctic and subarctic ecozones found in the refuge, there are lakes, ponds, marshes, rivers, and the Arctic Ocean. There are trees and forests, too; matted willows sprawl on the tundra, while thickets of taller willow and alder grow along the creeks and rivers. Mature spruce and birch forests are found here as well. Sprinkled within these larger-scale habitats are more delicate plants—wildflowers, lichens, mosses, sedges, and rushes. These landscapes support a diversity of plant and animal life, and it matters not that there are more species in the tropics than the Arctic. It is the landscape that is of uncommon occurrence, and those species that have adapted to this landscape. Perhaps these species are even unique in adapting to such environments. The rarer Arctic landscape and its fewer species could be affected more severely by development, in terms of populations and distribution, than if the same development were to occur in the extensive tropical areas.

As winter falls upon the region, those species that live here face only a few choices for survival: They must tough it out, hibernate, or migrate. Most birds migrate, dispersing to six continents. The owls, the birds I know best, tough it out or migrate.

Through Arctic Eyes by Denver Holt

Taxonomists currently recognize about 205 species of owls in the world. However, this number increases or decreases yearly depending on the techniques used to assign species status. All owls are listed under the order *Strigiformes* and are further divided into two families: *Tytonidae* (Barn and Bay Owls, about 16 species) and *Strigidae* ("typical owls," about 189 species). In the Arctic and subarctic life zones of North America, only the *Strigidae* occur, and only 6 species in total: Great Horned Owl, Snowy Owl, Northern Hawk Owl, Great Gray Owl, Short-eared Owl, and Boreal Owl. Fossil owls date back to the Paleocene epoch, about 55 million to 65 million years ago, and our modern genera can be dated to the Pleistocene epoch, about 3 million to 10,000 years ago.

Owls are one of the most widely recognized groups of animals in the world. Indeed, this group is known on every continent except Antarctica, and owl stories, legends, and myths have been passed down from generation to generation in many native cultures worldwide. This is perhaps the oldest recognized bird species known from prehistoric cave art: An etching of a Snowy Owl family has been identified on a cave wall in France that dates back to the upper Paleolithic Age.

Certainly, owls are among the most appealing looking of the world's animals. Although it's hard to say why, it might lie in the fact that they have a head and face similarly structured to that of humans: Within the flat humanlike face sits a forehead, two forward-facing eyes, a down-curved bill/nose, and a wide mouth. This structure is also similar to some of the higher primates that we also admire. And owl voices are easy to recognize and imitate, adding to the allure.

All owl pairs raise their families with biparental care. Depending on the species, males and females come together in a long-term pair bond or perhaps only for a breeding season. Unlike the sexual color differences (dimorphism) found in male and female peacocks, for example, there are few if any color differences between the sexes of the world's owls. With few exceptions, it is very difficult to tell the differences between males and females in most species. It is possible that color differences are less important to most owl species because they see primarily in black and white, and are either nocturnal or active during times of low light. Because they must hide and sleep during some of the daylight hours, most owl species have evolved cryptic coloration and feather patterning to camouflage themselves within their environments.

Vocalizations are a very important means of sociobiology in this group. Owls possess a diverse vocal repertoire. The onset of owl courtship and breeding is all about hooting, tooting, whistling, and trilling. With some exceptions, the larger species tend to hoot, and the smaller species toot or whistle. Most vocalize from an elevated perch, while some species also engage in aerial courtship displays.

Few species of owls build nests but rather tend to use already-existing

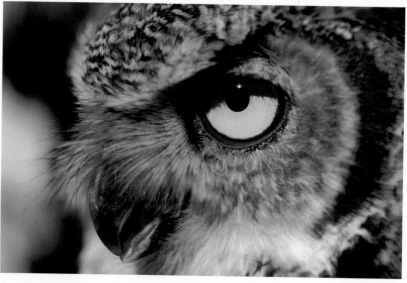

Great Horned Owl

structures. Boreal Owls will use old woodpecker holes, while Great Gray Owls might use an old hawk or raven nest. Those species that construct nests reflect minimal building skills. For example, some Short-eared Owls will construct a small grass or twig bowl directly on the ground, while Snowy Owls will simply dig a hole several inches deep on a mound on the tundra.

Only the female owls develop a brood patch, incubate eggs, and brood nestlings. All owl eggs are white in coloration and spherical in shape. In many species, males defend the nesting females and nestlings and/or provide food for the family during the incubation and early nestling period. As the nestlings age, females may also provide additional food and protection. Some variation occurs among species, however. Females are larger than males in almost all owl species in the world. Called sexual size dimorphism, the reasons for this variation are unknown, although many theories exist. One such theory is based on the ability between the sexes to capture different sizes of food; another is based on the fact that females fast during times of food shortage when breeding and thus may need a larger body mass to compensate.

Most female owls begin incubation with the first egg. This results in asynchronous hatching, in which nestlings hatch according to the order in which the egg was layed. Age differences between nestlings of a week or more have been noted in the same nest. In all *Strigidae* species, nestlings hatch with a wet covering of downy feathers, with eyes closed. These nestlings are altricial—helpless when hatched—and are totally dependent upon the female for warmth, food, and protection for an extended period of time. Owl nestlings have two natal down plumages: The first natal down is white, followed several days later by the onset of a second natal down that generally camouflages them with the color of the habitat in which they live.

Nestlings of ground-nesting owl species generally grow faster than tree-nesting species and tend to leave the nest earlier. For example, ground-nesting Short-eared Owl nestlings will disperse from their nests at about two weeks old, approximately three weeks before they can fly. It seems reasonable to assume that this is an adaptation necessary to reduce predation by terrestrial predators such as foxes. Owls that nest in tree cavities, such as the Northern Hawk Owl, leap from their nests at three to four weeks old, without any prior practice at flying. Large species such as Great Horned Owls, which nest on broken-topped trees or stick platform nests in trees, leave their nests at five to six weeks old, well before they can fly. Although the larger, more powerful owls are less vulnerable to predation, these strategies probably help to reduce predation at the nest site.

Owls use keen vision and hearing to locate and kill prey. In some species, they have evolved feather adaptations that reduce their aerodynamic flight noise. Essentially, this gives some species unusually silent flight to reduce the chance of being detected when trying to capture prey. Depending on the species, either vision or hearing may be more important to aid in hunting; however, both are used in combination. Owls are carnivorous. They eat insects, amphibians, reptiles, birds, and mammals. There are no strict carrion eaters, although many species will feed on carrion during times of food shortages. In the Arctic, the owls primarily are carnivorous, and the diet varies little.

Because of the long summertime daylight hours in the Arctic, the owls here hunt by day during much of the breeding season only to return to a more crepuscular and nocturnal lifestyle during the fall and winter seasons. Many species of owls are known to kill prey and cache it for future use. This may act as a buffer in times of food shortage. During extreme cold, some species of owls are known to "incubate" frozen prey that had been previously cached in order to eat it. This thawing of frozen prey appears to be an adaptation to living in cold environments.

Owls can be year-round residents, migrants, or nomadic. Variation may occur within a species and even among sexes of the same species. Short-eared Owls have been known to board ships 500 miles out to sea during migration. On the other hand, male Boreal Owls may stay on territory throughout the year, while some Boreal Owl females and young migrate or disperse. Some species of northern owls are known to respond to natural variation in food availability and will on occasion irrupt, or move in great numbers, to more southerly wintering grounds. Although irruptions generally have been assumed to be a response to food shortages, there may also be other factors involved, such as deep snows that prevent prey from being captured, or extreme cold, or a combination of other factors. In the winter of 2004–2005, for example, one of the greatest irruptions of northern owls occurred in south-central Canada and the north-central and Great Lakes regions of the United States. Great Gray Owls, Northern Hawk Owls, Boreal Owls, and a few other species moved into the area by the thousands. It was estimated that in St. Louis County, Minnesota, where normally few owls remain during winter, over 1700 Great Grays, 400 Boreals, and 300 Northern Hawk Owls wintered there.

Natural causes of death in most owl species usually include starvation and predation. That aside, most other causes of death are human induced and include shooting, automobile accidents, and collisions with other manmade objects. Conservation of all owl species is a habitat issue, however. If we provide the habitats, the owls will go about their lives and reproduce successfully.

GREAT HORNED OWL

The Great Horned Owl, a large and powerful predator, is probably the most widely distributed and most often observed of all the North American owl species. It is an uncommon permanent resident on the south side of the Arctic Refuge, where it may breed. The Great Horned Owl is distinguished outwardly from the other owls in this chapter by the tall tufts of feathers that arise from the sides of its forehead.

While its tufts stand tall, its very large, bright yellow eyes and black bill give it a fierce appearance. There is some color variation in this species; those of the northern and grassland and desert regions generally are lighter in color than those of the southern and more forested regions. This species is probably more closely related to the Snowy Owl than any other species of North American owl. It is second in size only to the Snowy Owl in the United States and Canada,

with females weighing about three and a half pounds and males about two and a half pounds.

The deep, two-part hoots of the Great Horned Owl can be heard almost any time of year. It is during the onset of the breeding season, however, that the frequency of their song increases as the males and females hoot back and forth, presumably solidifying the pair bond for another breeding season. They will roost together during the day and hoot together during the night. Males provide the females with food, and copulations can begin as early as December in some northern latitudes. Males and females often maintain long-term pair bonds until death.

Great Horned Owls nest in a wide variety of places: in large stick nests made by other raptors or corvids, on broken-off tops of large trees, in holes in cliffs, on manmade platform nests constructed for Osprey and Canada Geese, and, rarely, on the ground. Females lay one to four eggs but most often two, and incubation lasts thirty to thirty-five days. The young leave the nest at about six weeks of age and begin their first flights at about seven weeks. The young are believed to become independent of adults by early fall; however, they will beg for food into late fall and early winter, four to five months after hatching.

The Great Horned Owl has one of the most diverse diets of all owls: It will eat just about anything. Although much of its diet is made up of small mammals, Great Horned Owls have been recorded to eat insects, fish, birds the size of ducks and grebes, mammals the size of ground squirrels, and rabbits. They are even known to kill striped skunks.

The Great Horned Owl is a good example of a species that shows several lifestyle strategies. In the northern part of its range it can either migrate or reside, while in the southern portion of its range it can be a year-round resident. Because of its adaptability, there appears to be little threat to Great Horned Owl populations. They have fared well in human-altered habitats and have been shown to expand into habitats previously unoccupied by Great Horned Owls.

SNOWY OWL

The Snowy Owl is one of the most recognizable and magnificent of the world's birds of prey. An uncommon to common permanent resident and occasional rare breeder on the Arctic Refuge coastal plain, reliable population estimates are unknown. Across the north slope of Alaska, Snowy Owls nest where abundant food resources can be found. Despite its size, power, and ability to kill such large species as the arctic fox and Greater White-fronted Geese, these owls cannot breed unless the two-ounce small rodents called lemmings are abundant. This owl is so specialized that on the North Slope it relies almost entirely on one lemming species—the brown lemming. In fact, of approximately 30,000 prey eaten by Snowy Owls breeding in the Barrow, Alaska, region from 1992 to 2004, 97 percent were of this one species.

Adult males can be pure white or nearly so. In fact this owl's plumage is so brilliant white that it can be seen for more than a mile across the tundra landscape. These three- to four-pound males take at least three years to reach

adult plumage. The larger females can weigh in at four to six and a half pounds and are speckled brown on white. The very large, brightly colored yellow eyes and black bill give this owl an impressive facial stare.

A closer look at this species reveals sleek yet thick plumage, long and densely packed feathers around the bill, and thickly feathered legs and toes—no doubt all adaptations to staying warm in the Arctic environment.

Some Snowy Owls spend entire winters on the Arctic coastal plain or out on the pack ice. The insulative value of their plumage protects them from winter Arctic temperatures. In fact, the Snowy Owl's feathers have been shown in laboratory experiments to protect the owls to ambient temperatures reaching minus forty degrees F. This value appears to be as warm as that of the arctic fox and Dall sheep. In spite of everything we do know, there still are some things scientists don't know, such as what the owls eat during these long, dark, and cold winter months.

As daylight increases and temperatures start to warm, the Snowy Owl breeding season begins. Whether migrating north or wandering in the vicinity of a northern wintering site, the Snowy Owl begins to move to the breeding habitats, evaluate the food resources, and make decisions about whether to breed or keep moving and evaluate the options elsewhere. Eventually, however, the owls will settle for the short Arctic summer, whether they breed or not.

Because of the constant daylight in the Arctic, and the fact that these owls nest on the ground, many aspects of their breeding biology are easily observed. Males catch lemmings and present these nuptial gifts to females. Males will hoot and engage in low courtship flights and conduct courtship displays on the ground to entice females to mate with them. If the male can supply adequate

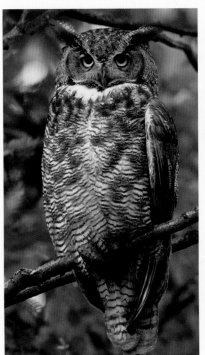

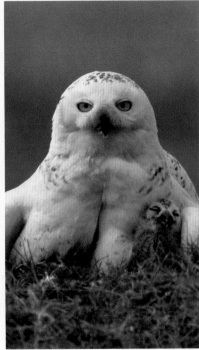

Great Horned Owl Snowy Owl

resources, in this case lemmings, then the pair will breed. In this species, it is not known if long-term pair bonds exist. The owls select a nest that has some height advantage over the surrounding landscape. Here females can watch over the tundra and keep an eye out for potential threats to the eggs and chicks—polar and grizzly bears, wolves, wolverines, arctic foxes, perhaps Golden Eagles, an occasional Pomarine Jaeger, and humans.

Although influenced by a variety of factors, the average number of eggs laid is usually five; however, three to ten have been recorded. Females incubate the eggs for thirty to thirty-three days, and the eggs usually hatch in the order in which they were laid. In very large clutches, there can be ten or more days in age difference between the oldest and youngest nestlings. Life in the Arctic can be harsh, however, and despite the large number of eggs laid, in most nests several chicks die. Starvation is usually the cause. Often these dead nestlings are fed to the surviving chicks; occasionally the dead chicks are eaten by the brooding female. Rarely do all chicks from a single nest fledge.

At about twenty days of age, the large nestlings begin to leave the nest on foot. They will wander and hide in the nooks and crannies of the tundra landscape for another two to three weeks before they make their first flights. Until that time, the parents provide food and protection, with the males contributing the most parental care. Even when they are fledged, the young are still dependent upon the adults for food. By October or November the young owls are on their own to hunt and survive their first winter.

Although somewhat restricted to hunting lemmings and voles during the breeding season, the Snowy Owl diet outside of breeding can be rather varied. Where small mammals are abundant and accessible, the owls will eat

them. However, they are also capable of killing ducks, upland game birds, and mammals as large as muskrats.

The occurrence of Snowy Owls in coastal and prairie regions of Canada and the northern United States confirms their migration behavior. Recent satellite tracking studies have also revealed an east-to-west winter movement and over-wintering at northern latitudes. Arctic-breeding Snowy Owls have also been tracked traveling from the United States to Russia, back to the United States, and then to Canada and back to the United States. Conservation of this species is thus an international effort to protect Arctic habitats among all the circumpolar countries. It is a forgiving species and can coexist to some degree with certain types of development. For example, in Barrow, Alaska, the owls seem to tolerate structures associated with the gas pipeline, an airport, a gravel pit, communication towers, and roads, if available habitat is nearby and disturbance is minimal. They do less well at nests that are located near human habitation, especially when these nests are visited regularly by people wanting to observe, photograph, or take chicks. Most killing of the owls also takes place near human habitation. Thus, increased access to nests by people because of development is a problem.

NORTHERN HAWK OWL

The Northern Hawk Owl may be the most easily recognized of all the North American owl species. An uncommon permanent resident on the south side of the Arctic Refuge, it is often seen across its range perched high atop a spiked spruce tree. A quick flier with athletic maneuverability, this owl flies through northern forests with the speed and power to capture a wide range of prey that includes mammals and birds. It is also known to irrupt or invade southern latitudes during times of food shortages.

Its wide shoulders, large chest, tapered waist, relatively short wings, and long tail give it the appearance of an *Accipiter* hawk or a falcon from the distance, thus its common name, hawk-owl. On closer inspection, however, it is clearly an owl. It is a rather long-looking owl and measures about sixteen inches from its head to the tip of its tail. It does not have a well-defined facial disc, and its yellow eyes and bill give it a stoic stare. Males and females look alike, with females being slightly larger. Males weigh about ten ounces and females about twelve ounces.

The hawk-owl announces the onset of the breeding season with a long, fast trill given in flight or when perched. Males will entice females to a potential nest by vocalizing near the site and presenting nuptial gifts of food.

Hawk-owls usually nest in cavities of large-diameter trees. Most often these cavities have been created through decay or fire, or where branches have broken off. Sometimes large woodpecker cavities and, more rarely, stick nests made by other species of birds are used.

Females lay three to thirteen eggs; however, seven is the average. The incubation period is twenty-five to thirty days, and the eggs hatch asynchronously. Nestling growth is rapid, and the flightless nestlings leap out of their nests at three to four weeks of age. Then they use their bills and feet

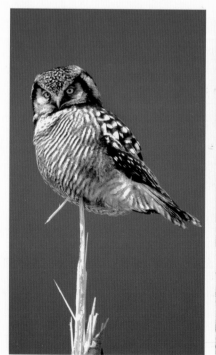

Northern Hawk Owl

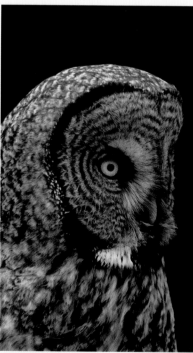

Great Gray Owl

to climb leaning vegetation and return to the trees, fluttering, jumping, and walking from branch to branch. They give food-begging calls, and both adults continue to feed them. As the young age, the adult females participate less in parenting. The age at which the young become independent is not known, but it is suspected to occur between ten and twelve weeks.

Food consists mostly of small- and medium-size mammals and birds. Of the small mammals, voles are the most important during the breeding season. However, some studies indicate a higher percentage of snowshoe hares in the diet. Although the hawk-owl kills a wide variety of birds, they do not appear to be an important prey source except during winter. Northern Hawk Owls are known to cache prey in crotches or cavities of trees for future use.

This owl prefers moderately dense forests with openings near meadows, marshes, creeks, and logged areas. It sometimes moves into forests recently burned by fires. Overall, there is very little information known about this species in North America. Forest management practices that affect nest sites are likely to have a negative impact on this species.

GREAT GRAY OWL

The Great Gray Owl is a forest species and is another of the most recognized and admired of the world's northern owl species. It is likely a rare permanent resident on the south side of the Arctic Refuge, where it may breed. Often referred to as the phantom of the boreal forest, it is hard to believe that this huge species can so easily be overlooked. Despite its size, it is often seen perched gingerly atop tiny spiral-shaped evergreen trees or small dead branches, often close to the ground. It is among a few species of owls that are highly dependent upon hearing for hunting success. In fact, its asymmetrical ear positions enable this owl to locate prey under several inches of snow. It then plunges down through the snow to capture its prey.

Its huge round head, distinct facial disc with concentric rings, small yellow eyes, yellow bill, and overall gray plumage make identification rather straightforward for this species. A close look at the owl's face reveals a white "bow tie" appearance of white and dark feathers around the midneck region. The long, loose feathers that cover the Great Gray Owl's body help keep it warm during the long winter nights of the north country. Its head-to-tail and wingtip-to-wingtip measurements make this species the largest by length and breadth of any North American owl species. However, its body mass is less than that of the Snowy and Great Horned Owls. The males and females of the species look much alike, but females weigh about two and a half pounds while males weigh about two pounds.

The breeding season is preceded by a descending series of low-frequency hoots vocalized by both sexes. There are no elaborate courtship flights. When pairs roost together, they often engage in mutual preening of each other's body feathers. Great Gray Owls nest on already-existing large stick platform-type nests built by other species such as hawks and ravens. Great Gray Owls will also use old squirrel dreys or, rarely, clumps of mistletoe for nests. Large-diameter broken-topped trees (snags) are important nest sites in some areas. Females lay

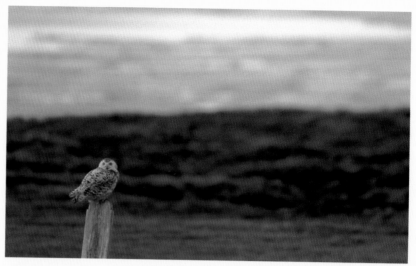

Immature Snowy Owl on wooden headstone

three to five eggs and incubate these eggs for about thirty days. Males provide food and can be very aggressive in defense of the young. The nestlings grow rather quickly, and when they are three to four weeks of age they disperse from their nest and roost in nearby trees. They first fly between five and six weeks of age. They are dependent on the adults for food and protection until they are about three months old, and the adult males do most of the food provisioning during these later stages. Great Gray Owls are known to live ten or more years in the wild.

Despite its large appearance, it eats predominately small mammals, particularly voles, and pocket gophers in some areas. Larger mammal and bird prey are killed less frequently. Great Gray Owls hunt from perches close to the ground and use acoustical cues to help locate prey. When hovering over a spot in the snow, the owl will dive face first toward the snow surface, only to quickly place its feet where its face has just been and plunge through a foot or more of soft snow to capture prey moving beneath. The plunge hole in the snow, and the wing and feather prints on each side of it, is evidence of this hunting technique.

This owl is known to make long-distance movements in relation to snow depths and fluctuating food resources. Some individuals have been known to travel over 300 miles during winter movements, from north to south. In irruption years, thousands may move south in search of food. In more southerly populations, adults may remain on territories throughout the year.

Forests are important to Great Gray Owls, and consequently forest logging practices can have negative or beneficial effects on this species. Great Gray Owls need large, mature forests for nesting and cover for protection of the young at an early age. However, Great Gray Owls will hunt clear-cuts and roadsides and are thus adaptable to some forestry practices.

SHORT-EARED OWL

The Short-eared Owl is one of the world's most widely distributed owl species. It is an uncommon to common breeder on the Arctic Refuge coastal plain; it

is common in the Brooks Range; and it is a rare summer visitor on the south side of the refuge, where it may breed. This owl's distinctive buoyant flight is often referred to as being "mothlike." The Short-eared Owl can be active day or night, and, when hunting, it courses low over the ground, quartering fields in a manner reminiscent of Northern Harrier hawks. One of the most aerial and consequently easily observed owls, this species has been know to simply show up in areas where small mammal populations are abundant.

As its name implies, the Short-eared Owl has small tufts located centrally just above the forehead. These usually are only seen when the owls appear to be trying to hide. Its eyes are deep yellow, and its bill is black. The sexes are similar in coloration: They are somewhat tawny brown or golden brown with vertical streaks on the breast. Females are darker overall. The larger females weigh about fourteen ounces, and males weigh slightly over ten ounces. A distinctive dark brown carpal or wrist mark is evident on the underwing of both sexes during flight. The function of this mark is unknown.

If food is abundant, Short-eared Owls will establish territories and engage in aerial courtship flights, rare among the world's owls and rarely seen by human observers. One of the most aerially acrobatic of all owl species, male Short-eared Owls initiate their courtship flights by flying in circles until a desired height is reached. Very often this can be 500 feet or more above the ground, but often it is considerably lower. Once in position, the males will glide or flap and glide over a specific area. Down below in the grass or perched atop a rock or mound, a female waits. Males utter a rapid series of ten to fifteen low-frequency hoots. They may vocalize this series several times before falling into a shallow, short dive and then bring their wings under the trunk of their bodies, clapping them

together to produce a unique popping sound. They will quickly pull up, regain some altitude, and then at some point repeat the performance. This is called sky dancing, and it is males that perform for females. Add into the negotiations a good territory and plenty of food, and a female will accept the male. Somewhere beneath this sky dancing display a ground nest will be placed.

Short-eared Owls need more ground cover than Snowy Owls in order to conceal themselves. The nest is placed near a bush or clump of grass or within tall grasses. Sometimes no nesting materials are used, while other times a small amount of grass and twigs appears to be arranged in a circle around the nesting female.

The average clutch size is about six, but Short-eared Owls are known to have clutches of ten and even thirteen eggs. The incubation period is about thirty days, and the eggs hatch asynchronously, usually in the order laid. Nestlings develop very quickly, and by the time they are about fifteen days old, they leave the nest on foot and hide in the surrounding vegetation. Here they scream for food during the night and are fed by the adults. Body-mass growth and feather development advance quickly, and the first flights are achieved between four to five weeks of age. Probably by late summer or early fall, the young are independent of adults.

With few exceptions, this species needs abundant small mammals to trigger its breeding activity, in most cases lemmings or voles, depending on the latitude. It is rare for this species to kill prey the size of a rabbit. However, in some coastal areas more birds occur in the diet, including terns and shorebirds. Some island populations of Short-eared Owls, such as in the Galapagos, will eat predominantly seabirds.

Known to be highly migratory and even nomadic, this species is not restricted to the Arctic. The Short-eared Owl's distribution extends from the Arctic to areas of South America and the Galapagos and Hawaiian Islands. Population declines have been noted in areas where grasslands and shrub habitat have been converted or developed from their original state. (This is the case with many grassland species of animals.) In some areas, this species has benefited from restoration projects such as converting old mining areas to grasslands. As with the Snowy Owl, large areas of open lands may need to be protected to accommodate the migration and nomadic tendencies of this species.

BOREAL OWL

The tooting trill of the Boreal Owl is one of the most pleasant of all the owl songs in North America. It is likely a rare permanent resident on the south side of the Arctic Refuge, where it may breed. Cold winter nights mark the onset of the breeding season, and male Boreal Owls, tucked away in the trees, start their courtship songs. Snow covers the ground, and on the clearest and coldest of nights, their soothing songs reverberate throughout the northern forest. This setting is often accompanied by clear views of the constellations and an occasional aurora borealis.

One would not think that this loud, clear trill comes from an owl that stands only ten inches tall and weighs just four and six ounces, depending on the sex. Boreal Owls are rather easy to recognize, with their large squarish heads,

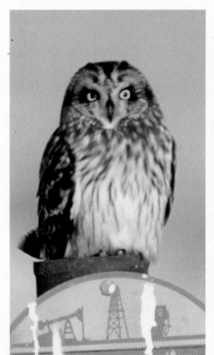

Short-eared Owl

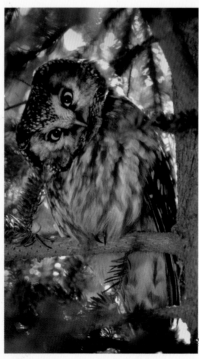

Boreal Owl

light yellow eyes, and light-colored bills. In Europe this species is known as Tengmalm's Owl and is one of the most well-studied owls in the world.

The Boreal Owl is a cavity nester and utilizes either natural holes in trees or holes excavated by woodpeckers. In areas where there are no cavities, they will readily accept manmade nest boxes. Males will often sing from a cavity entrance, presumably trying to entice the females or show them that this is a good place to nest. It is unclear which sex makes the nest site selection decision. Once a decision has been made, the females will lay eggs in the selected cavity with no additional nesting material needed.

Females lay three to five eggs. Only the females incubate their eggs, for twenty-six to thirty-two days. Males provide most of the food during this time, but females may begin hunting again when the young are about three weeks old. Young leap from the cavity when they are about thirty days old—their first flight—and flutter to a nearby branch or the ground. From the ground, they use downed vegetation such as leaning trees to crawl their way back into the higher canopy. They remain in the vicinity of the nest and are fed by the adults for another three to six weeks. They are assumed to be independent of adult care by early fall.

Unlike the owls mentioned earlier in this chapter—which are active during morning, day, evening, and night—this species hunts mostly during the night (when night occurs) but will extend this to daylight hours during winter. Food consists mainly of a few species of small forest mammals, mostly voles and mice weighing less than two ounces. They also eat a small number of birds, more often in winter than other times of the year.

Because Boreal Owls require nest cavities, forest management practices that maintain mature and old-growth forest are critical, because they support the woodpeckers on which Boreal Owls depend.

■ ■ ■

Our history and experiences as a human society have clearly shown that we can impact wildlife and wildlands in a variety of ways. In North America alone, our impact has caused the extinction of several species, including the Heath Hen, Passenger Pigeon, Labrador Duck, Steller's Sea Cow, and Sea Mink. At the other end of the scale, we have helped restore species such as the American bison, Bald Eagle, elk, grizzly bear, and wolf. While some wildlife species can coexist with humans and development, catastrophic environmental accidents that damage ecosystems can affect some of the most hardy species. And, even if those threats are reduced or eliminated, the results of increased human presence and access to the more pristine and wilder parts of the land will have an effect. That is, the process will be the same as that found in any habitat: Some species of wildlife will move farther from human presence, and as the presence spreads—as it always does—wildlife will retreat even farther until it's again left with smaller populations isolated within small islands of habitat. Increasingly, we must travel to refuges, management areas, conservation areas, and private lands to encounter many species of wildlife. We should preserve the few wildlife havens we have set aside and let our society be credited as thinkers ahead of our time, as surely we will be evaluated by future generations. ■

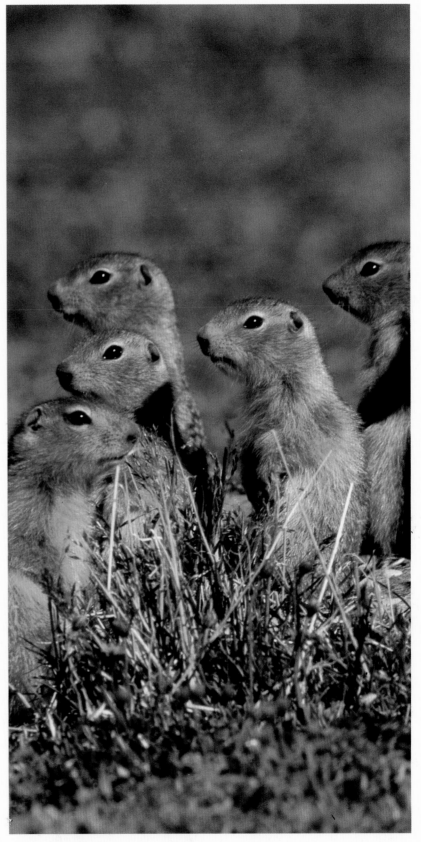

Arctic ground squirrels

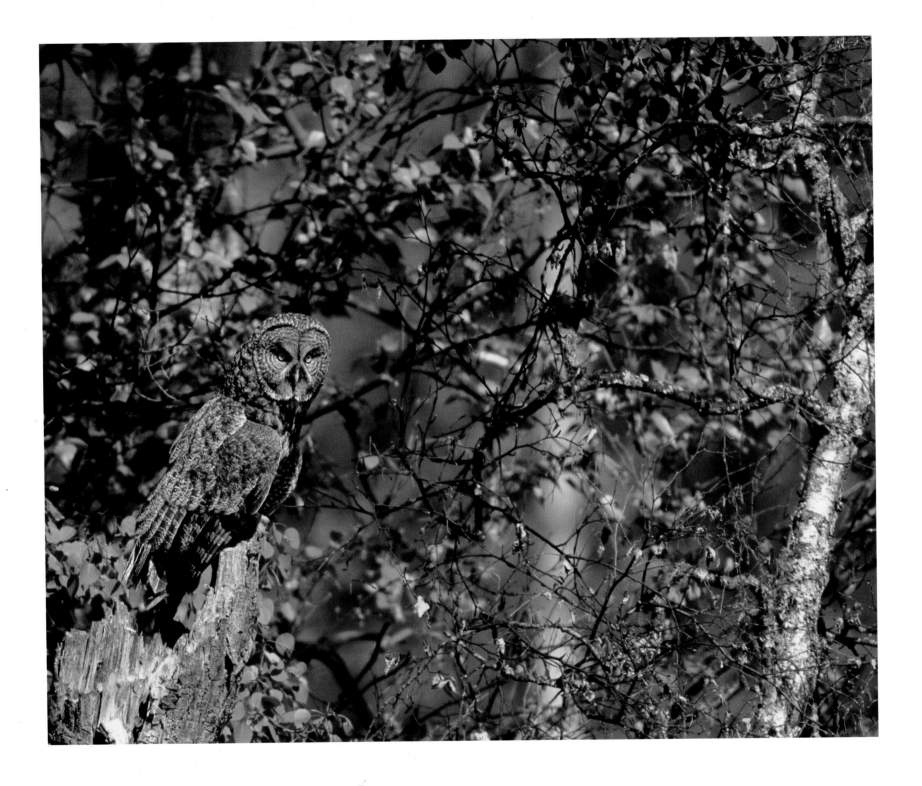

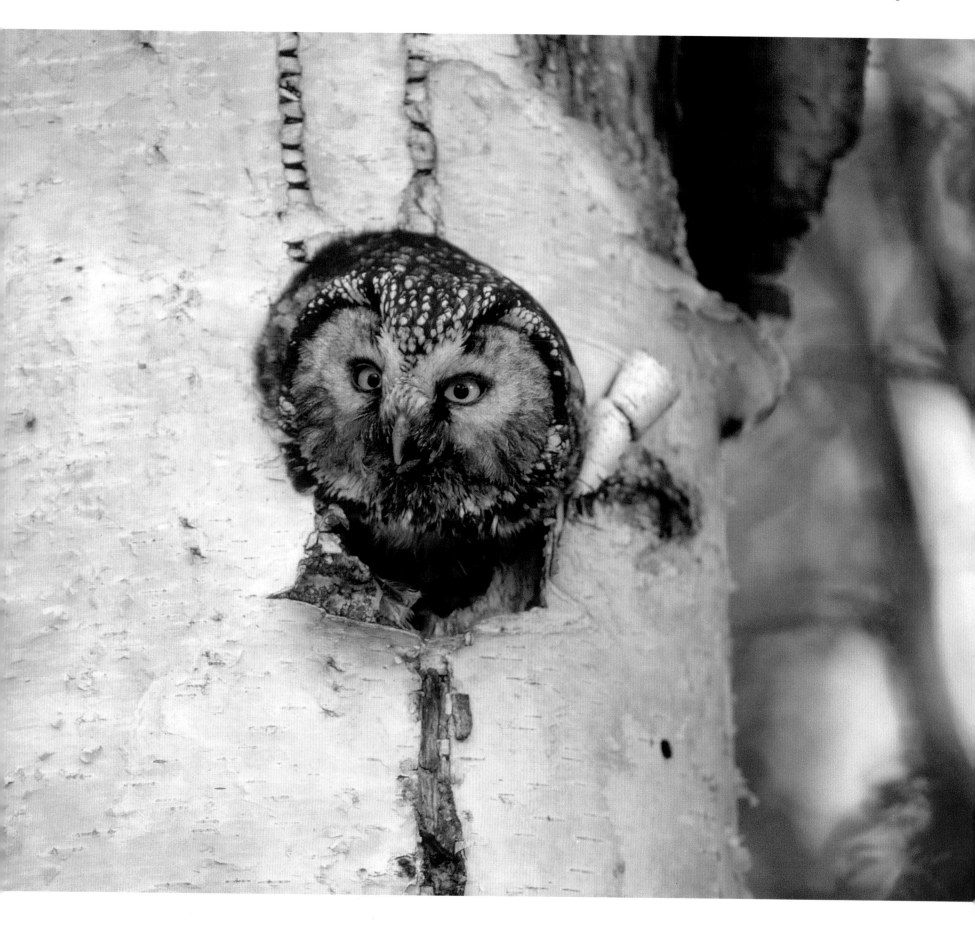

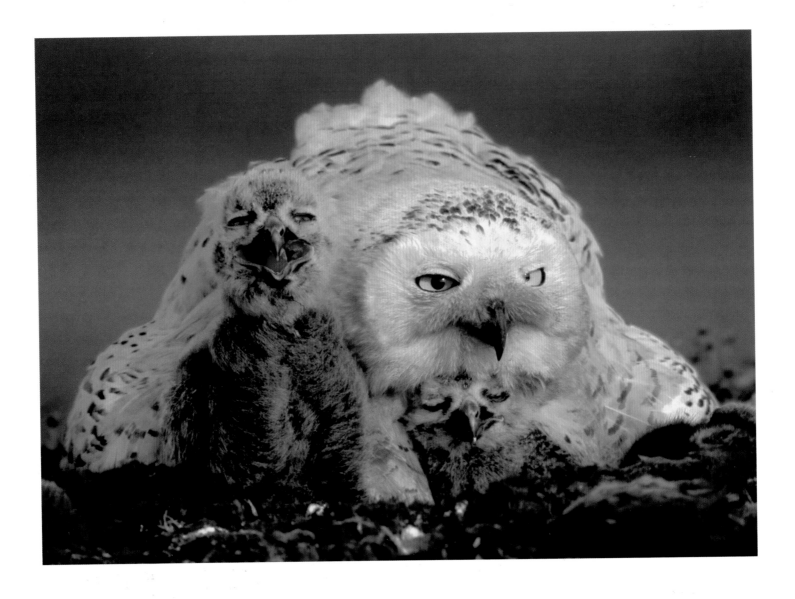

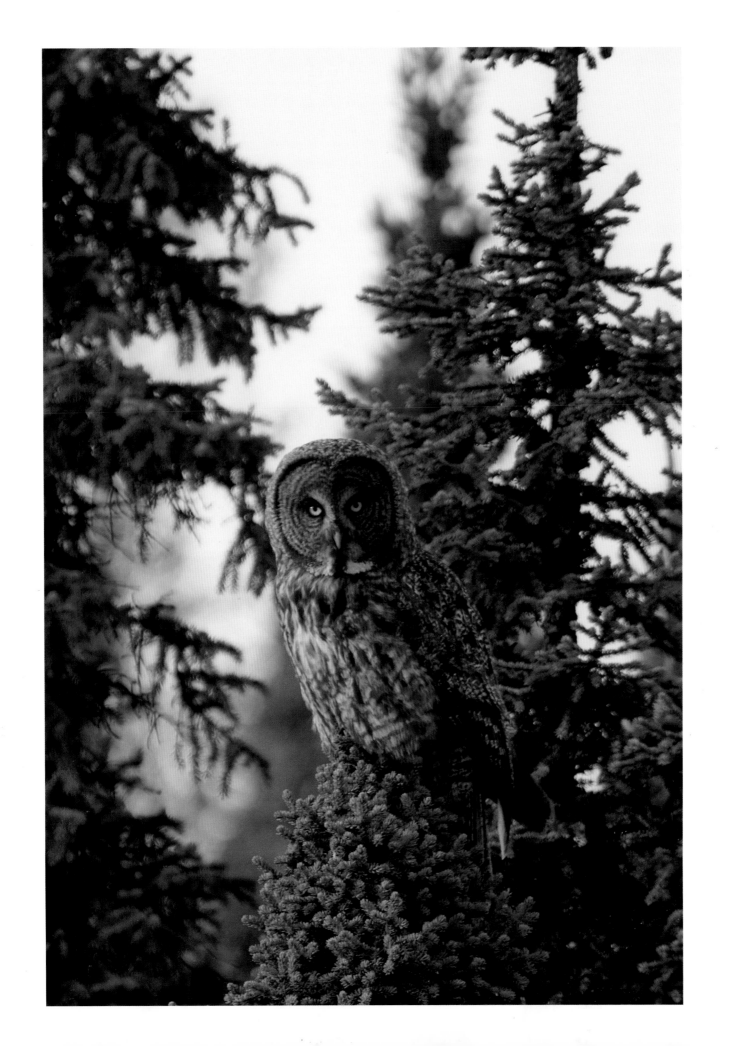

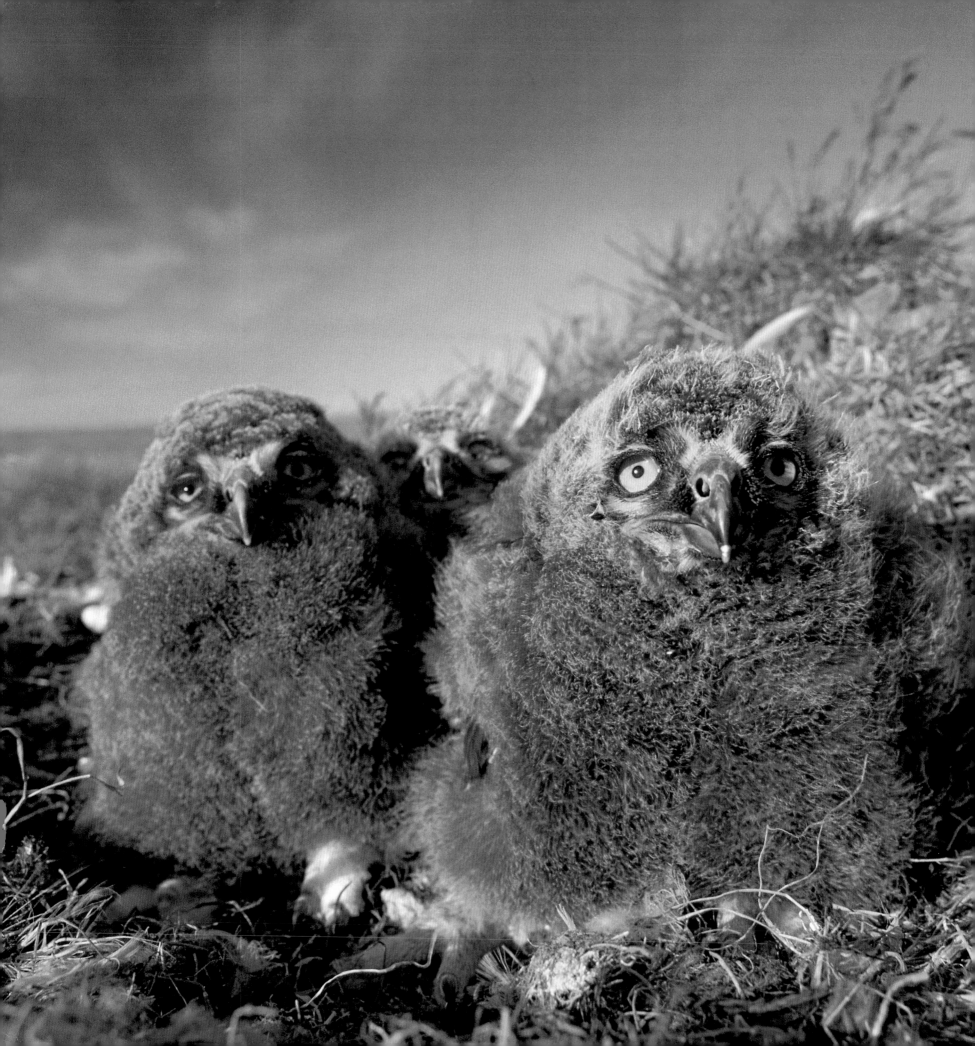

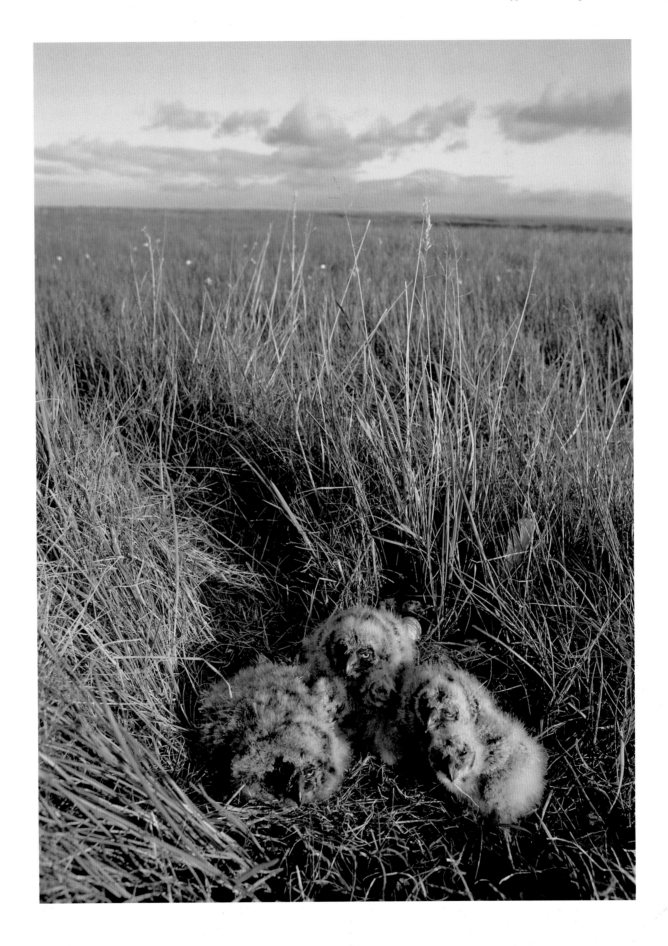

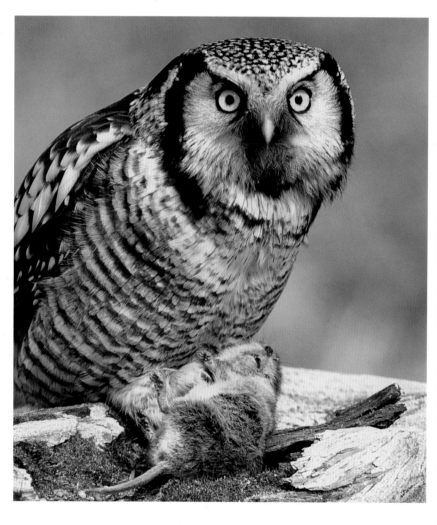

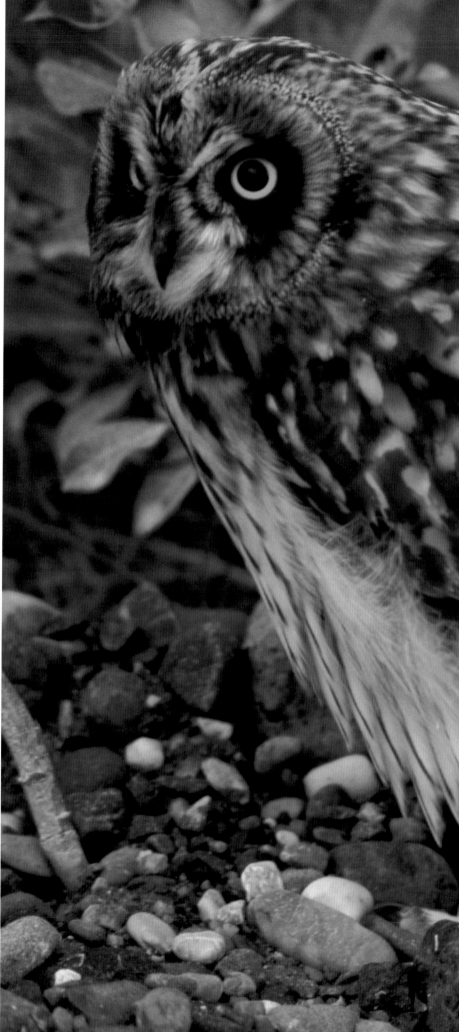

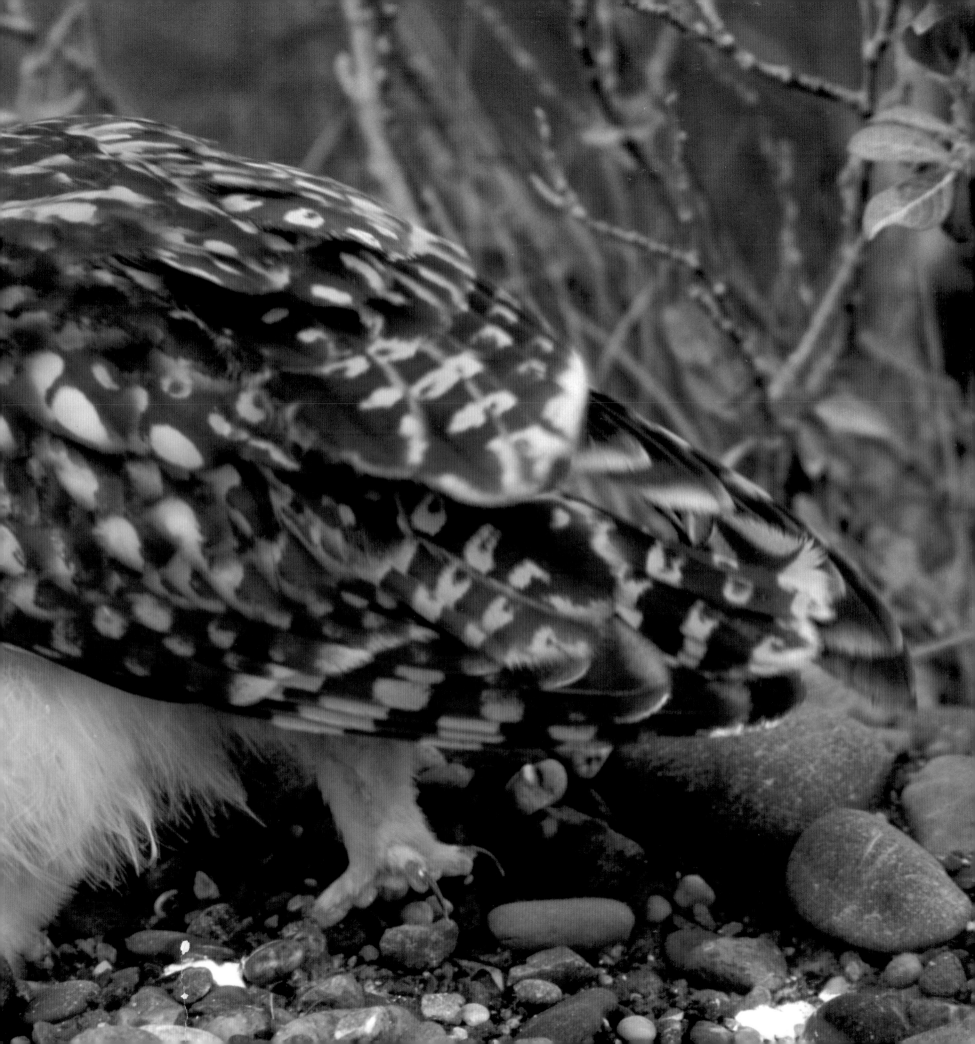

Land Birds

Photo: Annie Caulfield

DEBBIE MILLER *is a*

thirty-year Alaska resident

who has extensively

explored and studied the natural history of

the Arctic National Wildlife Refuge. She is

the author of several books about the refuge,

including Midnight Wilderness: Journeys in

Alaska's Arctic National Wildlife Refuge; *she also*

was a contributing essayist for Arctic National

Wildlife Refuge: Seasons of Life and Land. *Miller*

is the author of ten nature books for children.

Her recent book, Arctic Lights, Arctic Nights,

received the 2003 John Burroughs Nature Book

for Young Readers award. Miller lives near the

wilderness in Fairbanks with her husband and

their two daughters.

Overleaf ■ *Kongakut River valley, foothills of the Brooks Range in the background*

Along the Arctic Refuge Coast, we are hemmed in by fog with a gusting wind in our faces. It's nearing midnight on June 9 as we walk along the fringe of tundra that forms the northern edge of America. Snow patches and windswept drifts still prevail, yet the soft, woolly fingers of lousewort are popping up from the ground, some beginning to show their delicate pink blossoms. Beyond the mist-shrouded tundra, a sliver of beach separates us from the ice-mantled Beaufort Sea. My friend Annie Caulfield and I are just outside the Inupiat community of Kaktovik.

With hoods up and wool gloves on, I scan the shoreline and spot the tracks of an arctic fox woven into the sand with those of sandpipers and gulls. The fog begins to lift a bit, and the wind softens. In the distance I look for polar bears near a bowhead whalebone pile that lies near the sea ice. On past trips I've been lucky enough to see these magnificent animals wander near the coast, sometimes scavenging on the remains of whales harvested by Inupiat hunters. There is no sign of bears this evening, but we do hear the beautiful songs of birds.

Two male Lapland Longspurs are singing melodious songs, establishing their territories on the open, spongy terrain. They wing their way high in the sky, hover and pause for a moment, and then descend, with wings outstretched, ever so gracefully to the tundra. While angling down they sing a liquid, cheery tune that complements their flight pattern. Named for the elongated claw on their hind toe, these hefty sparrows are striking in their breeding plumage. The male longspur's head and breast are velvet black, framed by a bright, white stripe that arcs behind the eyes. His reddish brown nape is the finishing touch that cloaks him in beauty.

■ ■ ■

As an Alaskan, I've always felt lucky to live in a region that serves as a birthplace for many species of migratory songbirds. While most species visit the Arctic Refuge for only a few spring and summer months each year, this is their critical window for reproduction. During the nesting time, northerners are fortunate

journeys defies belief.

Scott Weidensaul, *Living on the Wind: Across the Hemisphere with Migratory Birds*

to see species in their beautiful breeding colors, singing unique songs to attract mates and establish territories. Such songs warm the heart and soul even on an arctic day when temperatures hover around freezing.

Those living in the central United States have likely seen these seed- and insect-eating sparrows. The heart of the Lapland Longspur's winter range is the Great Plains, where they often feed on waste grain in agricultural fields. Some flocks have been estimated to be as large as 4 million birds. In April, as daylight increases, these huge flocks grow restless and begin their journey north. Their extensive breeding range covers most of Alaska and northern Canada.

Dr. Laurence Irving, a well-known Alaska scientist, studied the migration of Lapland Longspurs in the early 1960s. For a number of years he chartered their spring movements through northern British Columbia, the Yukon Territory, and Alaska. He observed flocks as large as 2000 funneling through several passes in the Brooks Range en route to the Arctic coastal plain. Irving calculated that longspurs traveled an average of fifty-five miles per day, and that May 17 was the average date for movement through the central Brooks Range.

In the mid-1970s, while teaching school in Arctic Village, on the south slope of the Brooks Range, I marveled at the arrival of these great flocks. Waves of Snow Buntings and Lapland Longspurs would suddenly appear out our backdoor, peppering the snow-covered tundra. The chattering voices of thousands of birds filled the spring air. Pausing to feed on last year's seeds or berries, the flocks were soon off, traveling farther north to their breeding territories.

From the Great Plains to the Arctic coastal plain beneath our feet, the Lapland Longspurs depend on open, grassy habitat. Of the 194 bird species recorded in the Arctic Refuge, the Lapland Longspur is the most abundant breeder on the coastal plain. Found in both hemispheres, it may also be the most wide-spread and numerous Arctic-nesting terrestrial bird in the world: There are an estimated 40 million longspurs in North America alone. Fossil records suggest that these birds have a long relationship with the Arctic. In the northernmost

part of Greenland, a 6000- to 8000-year-old longspur feather was discovered in a bed of peat moss.

Lapland Longspurs commonly build well-camouflaged nests beneath cottongrass tussocks that can be nearly impossible to spot. The few times I've located nests have been cases when I accidentally ventured too close to the site, and the startled parent flew away. I am always struck by the miracle of a delicate nest of eggs tucked carefully beneath a tuft of grasses. Studies by the U.S. Fish and Wildlife Service show a breeding density of approximately twenty Lapland Longspur nests per square kilometer near the Canning River delta. Such activity suggests that more than 300,000 longspurs might be nesting on the Arctic Refuge coastal plain.

Their nests of woven grasses often face south to maximize the sun's warmth

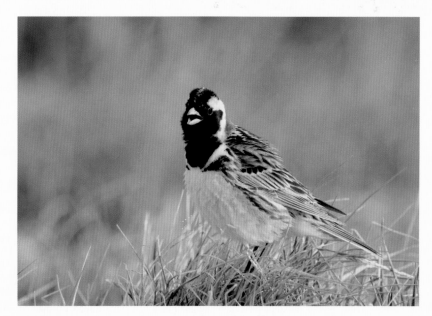

Lapland Longspur

and to avoid prevailing winds. Longspurs typically lay five or six greenish, brown-speckled eggs the size of an oval-shaped dime. After two weeks of incubation, the chicks enter a world that is usually bursting with insect life. With unlimited daylight, both parents actively snatch insects around the clock to feed their brood. If the parents are successful, and the weather cooperates, the hatching of the eggs and explosion of insect life are in perfect synchrony.

∎ ∎ ∎

We continue to watch the two male longspurs as they suddenly become rivals. A female longspur has appeared on the tundra, and the chase is on. One male pursues the female in flight, and then the second male joins in. They circle us several times, darting after the female, flights interspersed with singing. Back and forth they zigzag around us, the female showing no immediate preference. We continue on across the windblown tundra, wondering who might be the lucky suitor.

Walking back to Kaktovik, we constantly hear Snow Buntings singing their welcoming songs, perched on light posts and rooftops. Their musical warbling makes me smile. I reflect on my first trip to Kaktovik, thirty years ago, when the friendly faces of Inupiat children surrounded our tent. I've always associated the happy song of these striking white and black birds with those smiling youngsters. The Inupiat call the Snow Bunting *amauliigaaluk,* which means snowbird. The male Snow Buntings are the first migratory songbirds to arrive in the far north; the female buntings follow three or four weeks later. While snow still blankets the land, they sing their hearts out, establishing their territories, heralding spring.

∎ ∎ ∎

A few days later, Annie and I are in the Sadlerochit Mountains, the northernmost extension of the Brooks Range. We are just south of the Section 1002 coastal plain area and have begun a fifty-five–mile trek near Sunset Pass. I've chosen this area because of its great diversity of songbird habitats. We hope to see and hear many of the regular breeding songbirds that make annual journeys

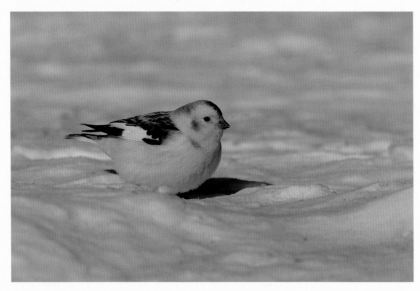

Snow Bunting

to the northern region of the Arctic Refuge. Over the course of two weeks, our route will explore mountain and cliff zones, rivers and flood plains, riparian and cottonwood groves, lowland and upland tundra, and perennial springs.

The soft-spoken warbling of a Northern Wheatear awakens me. He is just outside the thin membrane of our tent. I poke my head out the door and see him perched on a limestone pinnacle. His posture is regal, his black-masked head striking. Surrounding the wheatear is a cluster of tors and spires that rise up around us. The weathered tors are of all shapes and sizes: rectangular slabs, pinnacles fingering the sky, scattered chunks of mountain that look like chess pieces—all reminiscent of the canyon lands of the Southwest. Our tent is situated on a sloping perch that faces a formation we nickname "the keyhole."

We are camped on top of a collapsed mountain that has spilled across the valley of Weller Creek. The creek, which runs along a fault line, has gradually cut through the rocky debris to form a beautiful gorge below our campsite. This elevated, dry landscape, with its spires, precipices, and rock rubble, is ideal nesting habitat for the Northern Wheatear. Wheatears like to build their nests in crevices, under rocks, and amidst piles of stones. As cavity nesters, they have a strong fidelity to their breeding sites, and they may bond with the same partner for successive years. The female typically chooses the nesting site, and some sites are used repeatedly.

The Northern Wheatear's migration is a remarkable 13,000-mile journey that stuns the imagination. The wheatear now perched by my tent may have wintered with elephants or zebras in East Africa. They are drawn to the short-grassy acacia steppe of Kenya and Tanzania. Like the Arctic, the steppe lands have abundant insects, and wheatears can be seen hopping and pecking at beetles, caterpillars, spiders, and other invertebrates. In January they may feed in the company of zebras and lions, and in June they may nest by neighbors such as caribou, grizzly bears, or Dall sheep.

Of the nearly two dozen species of wheatears on Earth, the Northern Wheatear is the only species born in the New World, yet it doesn't forget its Old World heritage. For a moment, visualize the astounding migration: Sometime in late winter or early spring, the wheatears leave the herds of elephants, flying often at night, alone or in flocks. They fly beyond Kenya and Ethiopia, and across the Red Sea. They may pass over the oilfields of Saudi Arabia, war-torn Iraq, and Iran, beyond the mountains of Afghanistan, onward across the vast interior of Siberia. Following its ancestral route, the Northern Wheatear knows of no political boundaries. It is one of the world's most diplomatic birds.

In mid-May, Northern Wheatears begin to arrive on the Seward Peninsula after crossing two continents and Bering Strait. When these beautiful thrushes first arrive, the insects have yet to explode, so a large portion of their diet consists of last year's frozen-fresh berries. The wheatear near my tent has chosen the Sadlerochit Mountains of the Arctic Refuge for his breeding territory, an additional 600 miles of flying from Bering Strait. Accomplishing such a migration once, given the severity of weather conditions and the distance factor, would seem a miracle.

We later climb up on a ledge that is matted in vegetation. Yellow cinquefoil

brightly covers the narrow perch, and we find several clusters of scat from Dall sheep and marmots. We sit on the ledge gazing at the rock formations and the peaceful greening valley that is cradled by Mount Weller and the surrounding 4000-foot-high ridges. It is spectacular—a hidden valley framed by this unusual collection of tors.

Suddenly we again hear the beautiful, varied song of the wheatear. The complex song resonates within itself, as though it is carrying on a conversation. A male is perched just below us on a prominent boulder. Not far away, a female wheatear answers quietly, and the two of them begin singing back and forth, up and down, a soft melody with notes rising and falling. Some notes are throaty and almost swallowed. Others are flutelike. The two birds are about thirty yards apart.

I later discover through research that we had the good fortune of hearing the "conversational song" of the Northern Wheatear. This quiet, musical song is sung by the male when in close contact with the female. The female may respond with a soft, indistinct warbling, referred to as the "quiet subsong." Interestingly, the wheatear's song sometimes includes the mimicry of other species. In one study, a Northern Wheatear was said to mimic the songs and calls of thirty-eight other species and races.

Perhaps this is why the wheatear song sounds so complex and varied—it is as though the bird is conversing in a number of foreign languages. Given the scope of the wheatear's range and migration, perhaps the learning of other songs relates to the bird's exposure to so many Old and New World species on three different continents. In addition to being a diplomatic bird, we might also think of the wheatear as a natural-born linguist.

Beyond the pair of wheatears, I hear the *fee-beeee* call of a Say's Phoebe. The plaintive call, which sounds much like the bird's name, echoes off the canyon walls. At first the phoebe's call might be mistaken for some kind of hawk. Then comes the short, lilting phrase at the end of his identifiable song, as though the bird is saying *C'mere, c'mere, c'mere, won't ya please?*

We spot the cinnamon-bellied phoebe flying around the tors, investigating the surroundings, snatching insects near the ground. Then it takes off, flies across the stream, and disappears behind a large rock formation. Among the flycatchers, the Say's Phoebe has the northernmost breeding range. Like the wheatears, it prefers nesting habitat that provides protection from the elements. Phoebes like to have a ceiling of rock over their heads, often building their nests beneath a ledge, or in the crevice of a canyon wall.

Annie and I ponder over the fact that we are likely seeing a number of songbird species at the maximum extent of their breeding range. Is this the most northern phoebe, we wonder? In the winter you might see this phoebe catching insects in California and the Southwest, and as far south as Oaxaca.

Later in the day we hear the cries of another cliff dweller. Beyond the gorge we spot a pair of Gyrfalcons. We watch them fly, soar, and scan for prey along the rocky slopes. Using binoculars, we locate their fuzzy-white nestlings tucked on a ledge within a crevice of a towering limestone wall, several hundred vertical feet above the ground. The parents are actively hunting in the vicinity of their young. The gyrs fly swiftly a few feet above the rocky slopes in an effort to surprise unsuspecting prey, like low-level fighter planes cruising below radar detection. While we don't witness a strike, we do recall the white, feathery patches of ptarmigan remains that we saw along the Weller Creek valley floor. Perhaps these gyrs had snatched them from the tundra.

After a long stretch of flying, these distinctive hunters land on top of the sheer wall above their young. Gyrfalcons are elegant birds. They look like royal guards perched on the edge of a castle fortress. Annie and I become so entranced with the Gyrfalcons that we quietly perch ourselves on a ridge and watch them for several hours. As the shadows grow longer, Annie studies the valley and notices several caribou wandering below us. They stop to graze on fresh green shoots that are poking up through last year's dried grasses. From our perch we feel honored to be in the presence of Gyrfalcons and caribou, of Northern Wheatears and Say's Phoebes, all in one glorious view of this valley of tors.

■ ■ ■

It is a dreamlike sound that awakens me. We are camped near Sunset Pass, and I hear the spiraling voice of one of my favorite singers, the Horned Lark. I'm sore and stiff from backpacking several miles across the tussock-studded tundra, but the Horned Lark pulls me from the tent.

In the bright morning light I'm struck by the vastness of this place, and the beauty. We face the beautiful Romanzof Mountains, to the southeast, and the Franklin Mountains, to the southwest. To the north, the coastal plain rolls out before us, endless, it seems, because of the unrestricted visibility. The view is so grand, so big, that the eye cannot contain it. My eyes can only follow

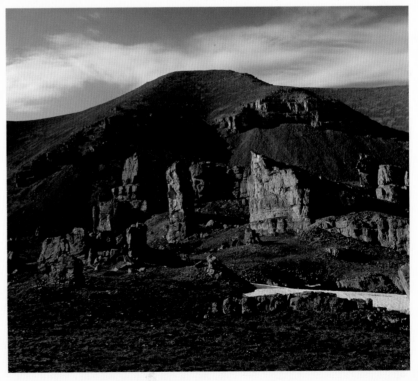

Limestone formations, Sadlerochit Mountains

and study the graceful ridge lines and snow-mantled peaks, the far-reaching braided rivers, the miles upon miles of greening tundra and valleys, the dome of clear blue sky, and the tiny delicate wildflowers that abound. It all takes my breath away. And then the Horned Lark sings again.

I walk over the ridge and discover an alpine tundra slope specked with white dryas, Lapland rosebay, and yellow cinquefoil. The thin layer of grassy

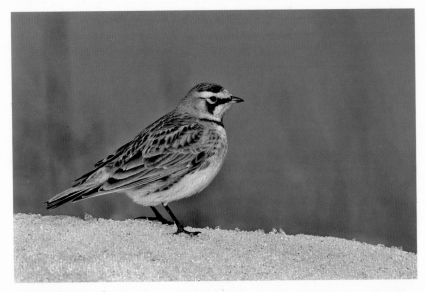

Horned Lark

American Tree Sparrow

vegetation is growing on an open patch of compressed shale. I scan the slope for birds while sitting on tundra the texture of a well-groomed putting green. A male Horned Lark soon appears with his distinctive yellowish face, black bib, and characteristic "horns"—feathery tufts that sweep above his head. This Horned Lark is busy snatching small insects off the tundra, covering his territory in a circular pattern around me.

Another lark begins twittering his wonderful ascending series of notes. I love the way the Horned Lark sings a couple of warm-up notes in succession, then their voice delivers a rising, quick-paced twitter, ending high, as if the bird has just reached the top of a peak. In reality, Horned Larks often glide to the ground when singing. With wings and tail outstretched, the bird descends while the song climbs the musical scale. The uplifting song seems to reflect the bird's love of high, open country where the views are most extraordinary.

Later in the day we watch a lone caribou walk up the valley and a Snowy Owl explore the tundra. The huge owl pumps his broad wings slowly, deliberately. Their wings look distinctively stiff and sturdy, as though they are reinforced with struts. The majestic owl soars across the tundra, hovering and diving, searching for prey. We see him perch on the tundra, his roundish head erect and pronounced. Like white clouds upon a steel-blue sky, the Snowy Owl stands out against a sea of greening tundra.

The next evening the fog rolled in from the Arctic coast, thick and damp, penetrating to the bone. The temperature dropped quickly, the wind increased, and the songbirds grew quiet. We inhaled our hot chocolate before it cooled off, then retreated to the tent. Our extra clothing was put to the test: long underwear, wool hats and gloves, down vest and fleece pullover, jacket and wind shirt, extra-thick wool socks. We wear them all.

By morning the tent has stopped flapping, and another bird's voice awakens me. Today it is the American Tree Sparrow singing his short, liquid song in a willow bush near our tent. His voice pure and clear, he heralds the morning as if to say *the day is here, get up, get going.* An abundant bird, this rusty-capped sparrow breeds across much of Alaska and northern Canada, building its nest on the ground, usually near tree line. Many Americans see these sparrows during the winter. They are attracted to bird feeders and can be found in parts of every state with the exception of Florida. The center for activity is on the Great Plains, where the sparrows thrive on weed seeds. They are known to beat weeds with their wings and then retrieve the seeds that fall upon snow-covered fields.

We expect to be fogged in, unable to see across the valley. To the contrary, we are greeted by overcast skies and warming temperatures, our first gift on this day of surprises. Our second surprise comes after half a mile of hiking, when we reach a drainage with a distinctive forked tributary. We check the map and realize that we are much farther along than we expected—one drainage closer to our destination, Sadlerochit Springs. Due to weariness from yesterday's long slog across the spongy tussocks, we had miscalculated the number of river crossings and had walked two miles farther than we estimated.

We contour along the expansive valley slopes above the Sadlerochit River.

Along the way we spot a couple of moose on distant gravel bars and hear birdsong in willow thickets along the streams: chattering redpolls, cheerful White-crowned Sparrows, and American Tree Sparrows. At first, the hiking is easy going on well-drained, upland tundra. Then we drop down to the valley floor and encounter more strenuous trudging. We plod through a 200-yard stretch of soft, wet moss in the lowlands. The mossy zone swallows each footstep as though we are walking across a mattress with bad box springs. Fortunately it is short-lived, and we soon escape the area. We climb up a gentle slope until we reach a spot where we can see into the next valley.

Annie is a few steps ahead and catches the first glimpse of the distant grizzly bear. She turns and lets me know we have a third surprise. The good-size dark bear is a mile or more away, foraging on roots and plants on the other side of the valley. We are a comfortable distance from the bear, so we decide to break for lunch, give the bear a lot of space, and watch his movements.

While we eat pilot bread and peanut butter, a female Eastern Yellow Wagtail appears on the tundra, faithfully wagging her tail. She is busy gathering pieces of grass for her nest. There is no sign of the male, but the female passes us several times with grass dangling from her bill. We sit quietly and find it amazing that we can observe this long-distance migrant from southeast Asia while watching a grizzly bear forage in the background.

Eastern Yellow Wagtails breed on both sides of Bering Strait. In Alaska they are only found on the western and northern fringes of the state, typically in coastal upland regions such as the swath of tundra surrounding us. In August this wagtail will begin her extraordinary migration, traveling west beyond the coastal plain, crossing the Chukchi or Bering Seas, then flying south, following the scribble of Asian coastline. While the extent of the yellow wagtail's winter range is unknown, they have been observed in Taiwan, Indonesia, and Australia.

In Tom Harrisson's book, *World Within: A Borneo Story*, he describes how yellow wagtails have helped the Kelabit people of Borneo. Wedged between mountains and the South China Sea, the Plain of Bah in northern Borneo can be cloud covered for days on end. The sun and stars may be unseen for long periods. As a result, the Kelabit adopted an unusual bird calendar that is oriented around the arrival and departure of the yellow wagtails.

For the Kelabit, the most important crop is rice, and it must be planted and harvested at the right time of year, during a three-month window. If the Kelabit plant the rice too late, they risk losing the crop to Dusky Munias, a finchlike bird. These munias can essentially devour and devastate an entire rice crop if the planting is untimely. It so happens that the yellow wagtails begin arriving on the island at the proper planting time. For centuries, the return of the yellow wagtails has signaled the Kelabit to plant their rice. The Kelabit calendar revolves around the planting month, known as *Sensulit mad'ting*, meaning the month of the yellow wagtail's arrival.

I marvel at this story, which connects an Arctic-born bird to the indigenous people of Borneo, showing the cultural significance of the wagtail's dramatic migration. Over the centuries, yellow wagtails have certainly had no mission to help the Kelabit plant their rice, but isn't it such a wondrous coincidence that

the timing of their migration has provided the perfect clock for the Kelabit, without the need for sundials, watches, or wall calendars?

The bear has disappeared over the next ridge, and we decide to walk a slightly different route, following the creek that flows into the Sadlerochit River, to avoid any close encounter with the bear. As we make our way down the valley, there is another surprise. Not far in front of us, a large gray and white wolf pops up from a ravine. The wolf takes a quick glance at us and then lopes away, climbing up the slope. On the ridge line he pauses, head held high and alert, fur rising slightly with the breeze. His proud stance etches the sky. After studying us with a brief, bold stare, he continues trotting along the ridge in the same direction as the bear.

Moving down the valley, I walk with visions of the yellow wagtail, bear, and wolf in my mind, all encountered in the span of an hour. We approach a small cottonwood stand as we near the floor of the Sadlerochit valley. At first I think I'm mistaken; then, listening closely, there is certainty. Through the distant gurgling stream, we hear the flutelike notes and beautiful phrasing of a Hermit Thrush. Not far from the thrush an American Robin is singing as well. This incredible duet makes us drop our packs and investigate the grove of cottonwoods.

The Hermit Thrush's repertoire of varied songs is extraordinary. Through the avian bioacoustic work of Donald Kroodsma and others, we know that the Hermit Thrush's heavenly two-second song might draw from more than a hundred notes, with as many as fifty changes in pitch. Kroodsma's book, *The Singing Life of Birds*, is filled with sonograms and charts that reveal one Hermit Thrush's ability to sing as many as seventy-five different and successive songs. As we listen to this beautiful singer, he begins each liquid song with a

Grizzly bear

single-note whistle that always varies in pitch. A creative composer, the Hermit Thrush never repeats the same beginning note, as though he loves working through the musical scale of major and minor notes.

Could this be the northernmost Hermit Thrush? Perhaps this forest bird is just an accidental, a wanderer who will never find a mate because he is so far beyond his defined breeding range. How long will this thrush sing his exquisite song, announcing that one of America's northernmost cottonwood groves is now *his* territory? Is there a remote chance that a female might hear him? While I've seen nesting robins in the Arctic over the years, the Hermit Thrush is a first. Annie and I will always remember this hiking day as our day of surprises: from the yellow wagtail and Hermit Thrush to the wolf and grizzly bear.

■ ■ ■

The rush of water lulls us to sleep. There is something wonderfully soothing about sleeping in a tent with the constant sound of perennial springs only a few feet from our door. We are perched on a small bench of grass next to Sadlerochit Springs, on the coastal plain. These springs gush from the mountains year round, creating a unique biodiverse habitat. Through the long Arctic winter, the steady rush of fifty-degree water keeps the meandering stream open and flowing for a good five miles below the springs.

Once again I awaken to beautiful birdsong, this time mixed with sounds of the splashing and gurgling springs. This new voice is lively and gregarious. An American Dipper is singing his whimsical song. This male sounds like a young child who has just discovered percussion instruments and plays each one briefly, then runs to the next. A lot of whistles, bell-like notes, and varied phrases make it difficult to define a distinct tune—but what a playful song!

Eastern Yellow Wagtail

Growing up in northern California, I enjoyed watching sooty-gray dippers in the rivers of the Sierra Nevada. Flying just above the rush of water, they would alight and dunk beneath the surface, in search of aquatic insects and larvae. These skinny-legged, drenched birds were a marvel, constantly dipping in and out of the water, comically bobbing with their perpetual knee bends and twitching heads. Naturalist John Muir was very fond of the American Dipper, referring to his favorite swimmer as the "water ouzel." Muir considered the dipper and stream inseparable, and eloquently described its song in his book, *The Mountains of California*

> His music is that of the streams refined and spiritualized. The deep booming notes of the falls are in it, the trills of the rapids, the gurgling of margin eddies, the low whispering of level reaches, and the sweet tinkle of separate drops oozing from the ends of mosses and falling into tranquil pools. The ouzel never sings in chorus with other birds, nor with his kind, but only with the streams. . . .

In watching and listening to the dippers outside our tent, it appears that these birds are truly married to the fast-moving stream. The only aquatic songbird in the world, dippers are well adapted to the rush of rivers. For added insulation, dippers have more contour feathers than other passerines of similar size—approximately 4200 feathers compared with 3000 or fewer in other birds. They also have a heavy layer of down between their feather tracts, and their eyelids are covered by tiny wisps of feathers. Dippers have a metabolic rate that is 35 percent lower than other passerines of the same size, so they can function well at very low temperatures.

What defies belief is that these water birds live year round on the coastal plain of the Arctic Refuge, at Sadlerochit Springs and a few other river locations where there is open water in winter. If there is an ice-free channel with an adequate food supply, they can survive. It seems impossible that these robin-size birds will swim in the Arctic on a sunless January day, when air temperatures might plunge to fifty and sixty below zero. Yet Robert Thompson, an Inupiat resident of Kaktovik and a wilderness guide, has not only seen dippers in the heart of winter, he's actually heard them singing. The only other songbirds known to survive the coastal plain on a year-round, regular basis are the Common Raven and the Hoary Redpoll.

Along the stream we spot a dipper with wet insects draping from its stuffed beak. We watch the dipper fly to a moss-covered rock, and then its head briefly disappears out of view. Soon it's evident the dipper is feeding a chick. We are amazed that this camouflaged dipper nest looks like one of the many mossy rocks that are scattered in the streambed. Without the noticeable feeding behavior, we never would have recognized this emerald green hut as a nest sheltering three chicks.

In the midnight sun light, we later witness the chicks taking their first few steps beyond the nest. They teeter on slippery, algae-covered rocks, hopping from one boulder to another. The radiant, low-angle light illuminates their orange beaks and pale legs. One chick stretches his small wings and begins fly-hopping short

distances between the rocks. First a few inches, then a few feet, and finally, like a miracle, this fledgling is able to fly a few yards across the rush of water.

Annie and I are glued to the dippers. Over the course of two days we witness the bold first flights of three chicks as they venture from the nest. One chick hops along the rocks near the edge of the stream and finds itself stranded below a large boulder. For a good half hour, the chick studies the wall of rock that is blocking its path back to the nest. He walks in circles, teetering on the slippery rocks, studying the wall of stone up and down, looking very indecisive and stranded.

Finally the chick makes a bold decision that surprises us. After several up-and-down looks at the Iron Curtain, the chick gazes across a relatively wide channel of white water and appears to ponder. After several minutes the chick decides to go for it, as if it might be thinking, *I'm stuck. I'm not getting over this thing, so this is it—my only alternative.* Instead of retracing its steps along the stream's bank, his rapid little wings carry him just a few inches above the rushing stream, and he successfully lands on a cluster of rocks. Inch by inch, the chick zigzags from rock to rock, covering new stream territory, and somehow finds its way back to the splash-laced nest. To us, it all seems like an extraordinary feat.

The most humorous daredevil crossing occurs the next day. A parent and chick are a good fifty yards below the nest, near the edge of the stream. The parent flies off, following the stream to one of its favorite feeding areas, presumably to gather a beakful of insects for the chick. The chick apparently grows tired of waiting and decides to cross a relatively wide stretch of the stream, perhaps to find its parent. This is the longest flight we witness—a good twenty-five yards. It is nearly a crash-and-splash. About halfway across, the chick's small wing touches the water for a millisecond; there is a momentary loss of control; and then the little one flies on, wings pumping frantically. The chick makes it.

A few minutes later, the parent returns to the same spot where the chick had stood waiting. The parent characteristically dips and turns its head, dips and turns. I sense a little parental panic as the dipper looks for its chick. Then suddenly the parent spots the chick on the other side of the river, flies across and feeds it, and truly looks surprised that the chick has managed to cross this major waterway. Again, we witness what seems like another feat.

■ ■ ■

Annie and I eventually pull ourselves away from the dipper family to explore the stream environment below the gushing springs. We marvel at the diversity of plant, bird, and insect life associated with these perennial springs. Along the willow-fringed stream we spot both the Yellow Warbler and the black-capped Wilson's Warbler. These beautiful warblers appear as bright as yellow lemons amidst the brown tangle of willow. Both of these small, sweet-singing birds have incredible migrations. The Yellow Warbler, a bird that weighs about as much as nine paper clips, may migrate as far south as Brazil and northern Bolivia. The slightly smaller Wilson's Warbler winters largely in Mexico and Central America. These wisps of life are so weightless that you could mail three of them across America with a thirty-nine–cent stamp.

Along the quiet, meandering stream we also see a family of Red-breasted Mergansers, a Spotted Sandpiper, and another frequent flyer, the Wandering Tattler. This solitary shorebird, with its heavily barred breast, might wander as far south as New Zealand and Australia. During the winter, tattlers are commonly seen on South Pacific Islands such as Fiji, Samoa, and Tonga.

We ponder the biodiverse nature of the Sadlerochit Springs area as well as the many habitats we have encountered in the mountains and valleys, and on the coastal plain. Each precious ecosystem offers special niches for these incredible birds that begin their lives here. It is a wonder that so many states and countries are connected to the Arctic Refuge through the birth of birds, their unique songs, and their ancestral migration routes that thread the world.

Each thread, each bird, each song, holds the world together without political boundaries. Birdsong is a universal language that we all can enjoy whether we live in America, Australia, Canada, Siberia, France, Kenya, Iraq, Bolivia, Oaxaca, or Borneo. Through the millennia, it is the songbirds that make us stop, listen, and smile. It is the songbirds that give us hope for the future. ■

American Dipper chick

American Dipper at nest

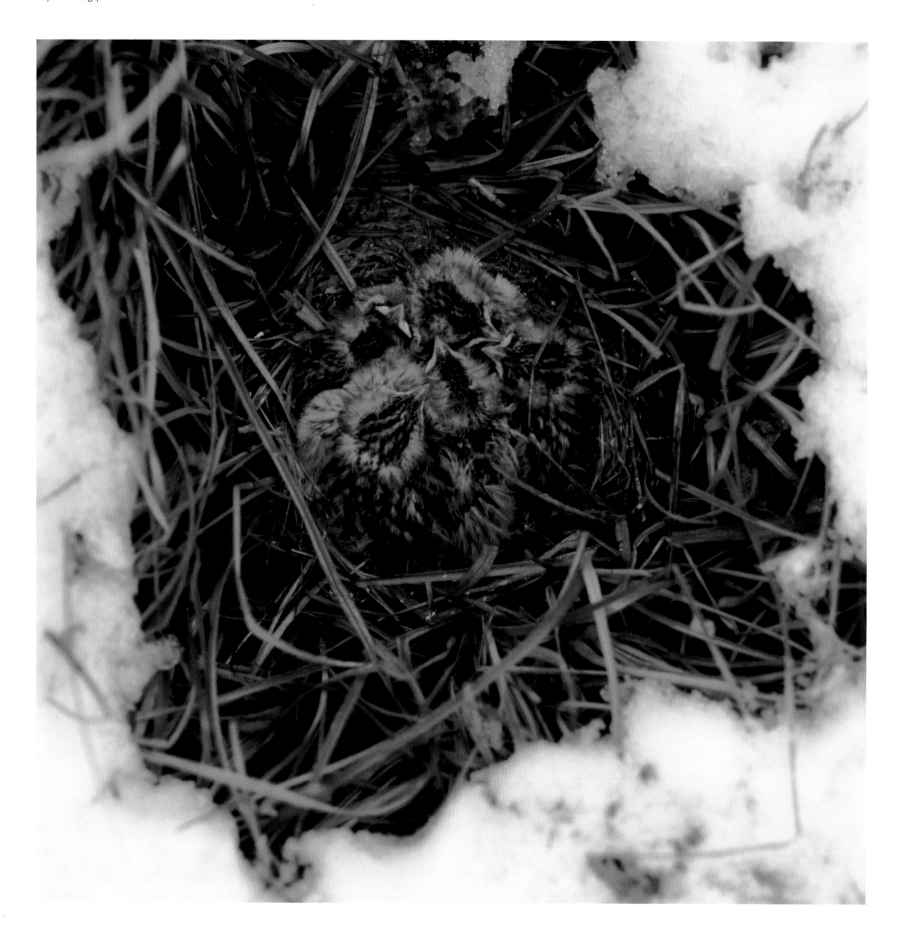

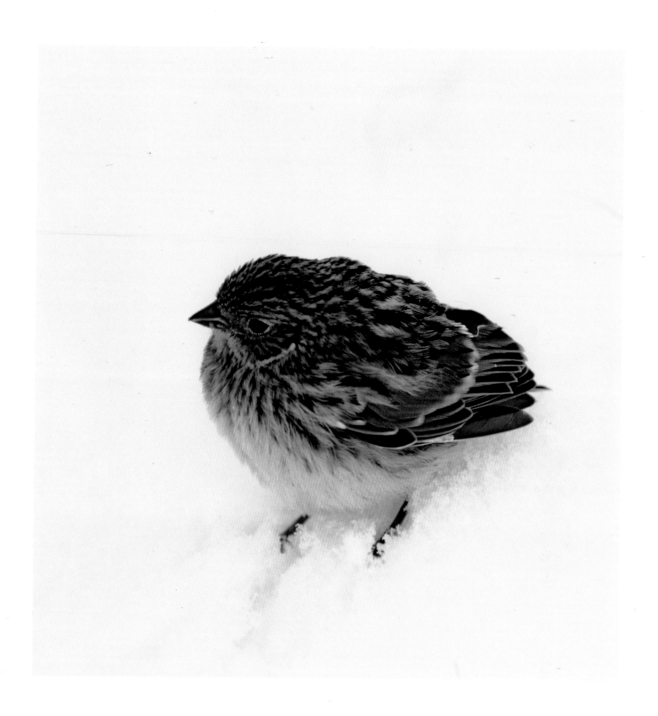

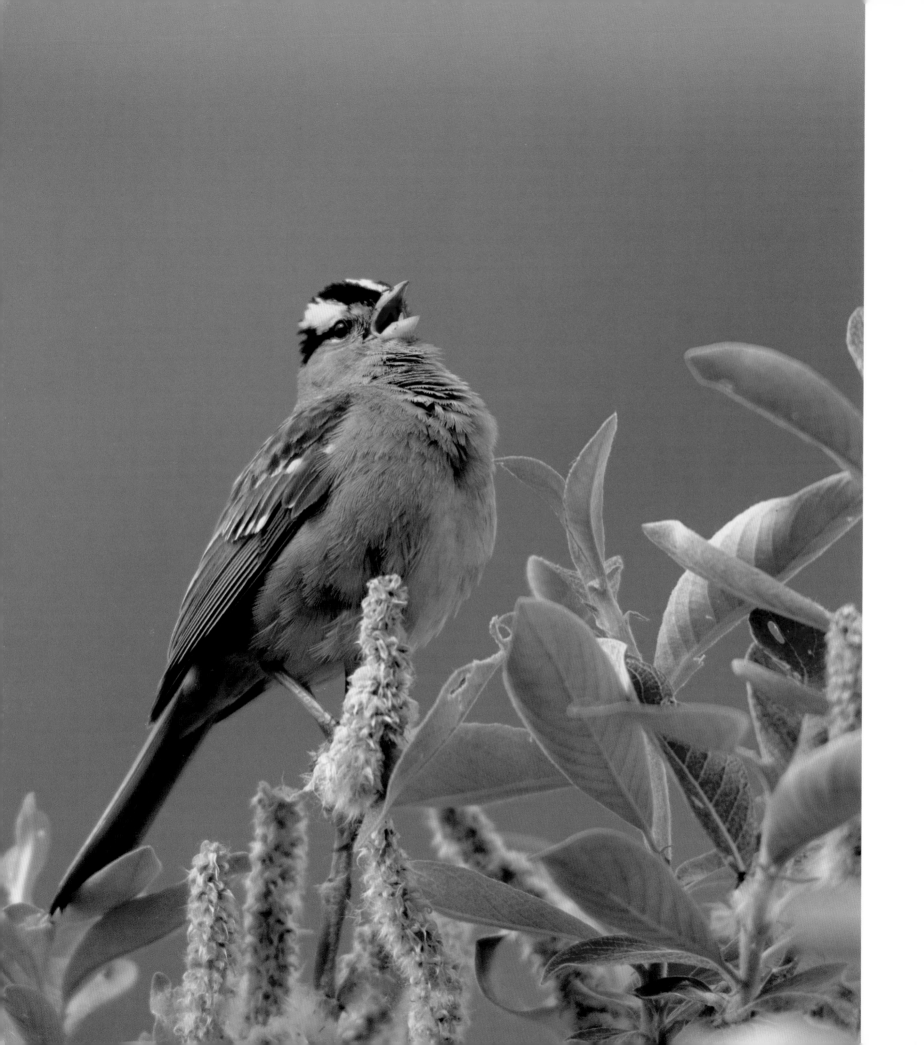

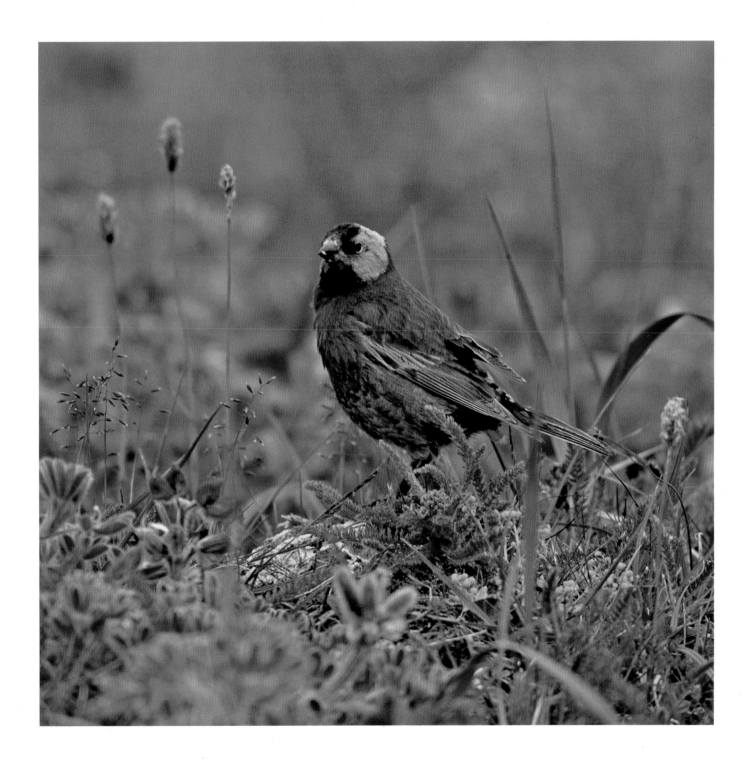

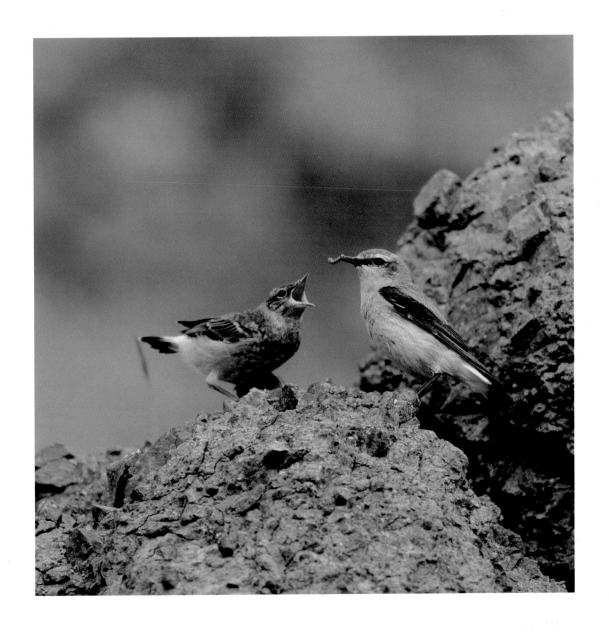

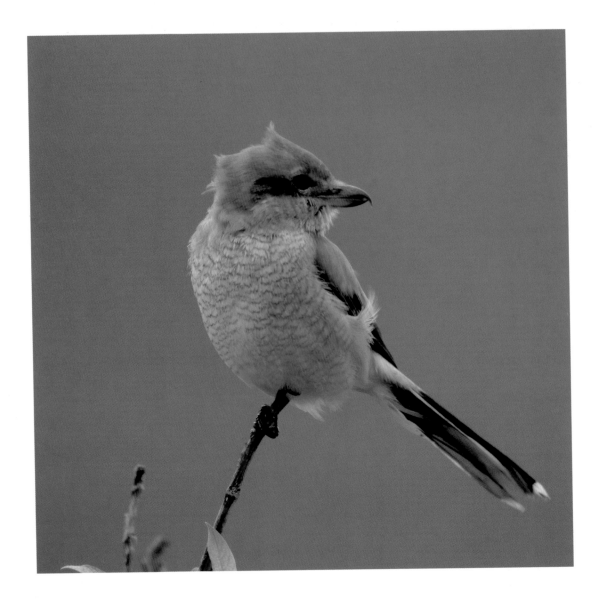

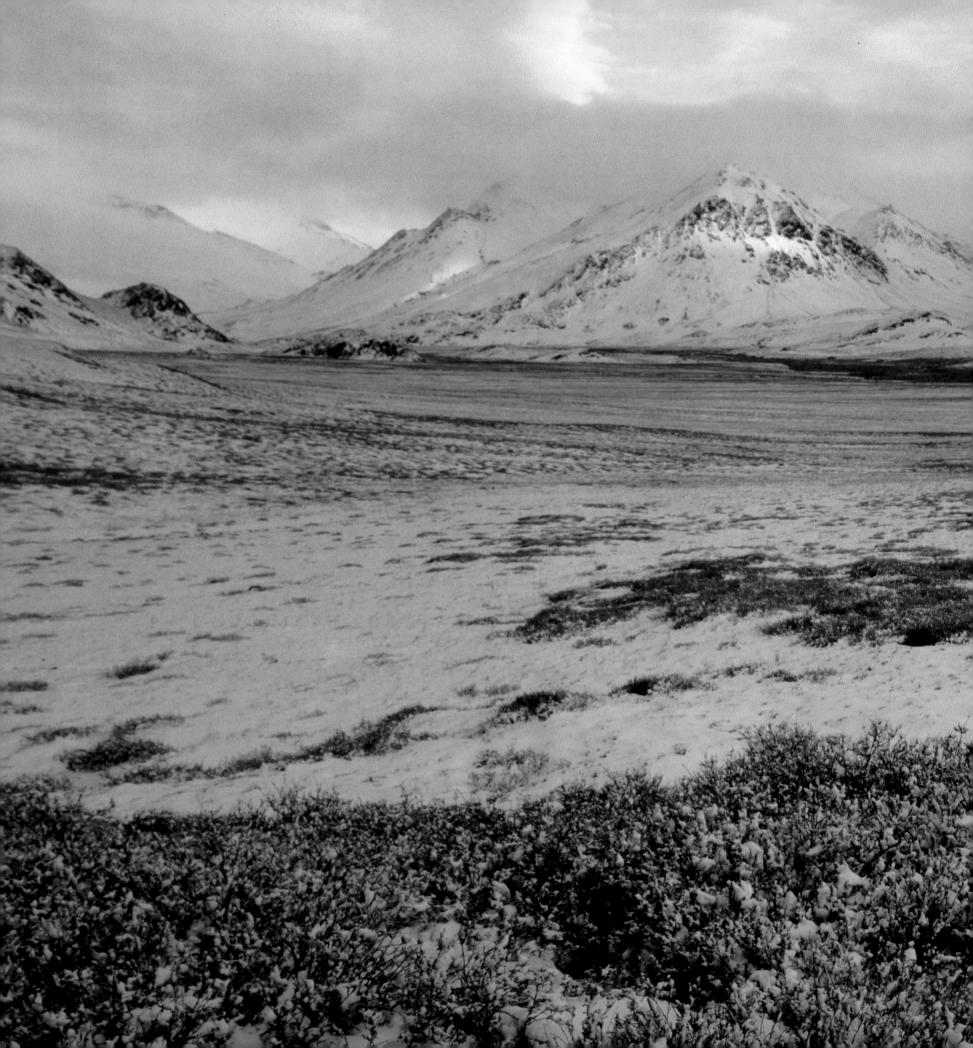

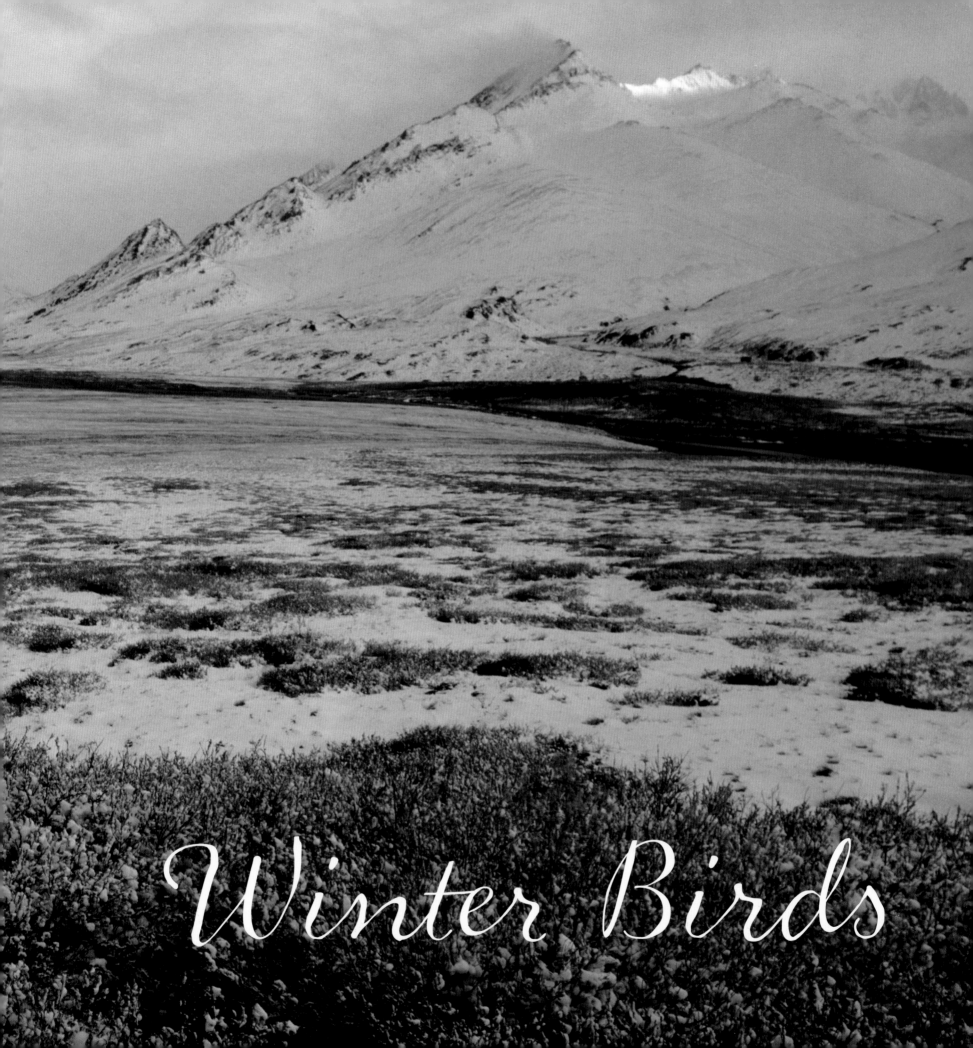

Winter Birds

FRANK KEIM *is a retired*

high school teacher who

taught for twenty-one years

in four Yupik villages in the Lower Yukon School

District in Southwest Alaska, at the mouth of

the Yukon River. He lived for many years in

Latin America, where he was a Peace Corps

Volunteer and an anthropology instructor

at the University of Cuenca. Keim is on the

Alaska State Board of Trustees of the National

Audubon Society and regularly contributes

articles to local and regional publications. He

is a nature poet and wood-carver. He learned

his love of birds and walking from his father

when he was very young, and he hopes his own

children and grandchildren will learn the same

from him.

Overleaf ■ *Okpilak River valley*

The strangest thing happened to me before I started writing this essay. I was on a week-long kayak trip in Prince William Sound when, one cool, windy night, I had a dream about the winter birds of the Arctic National Wildlife Refuge. I warn you, it was a bizarre dream. Let me try to remember.

All the birds that reside in the Arctic Refuge during the winter were gathered around a campfire in the nocturnal dark of the boreal forest. There was deep snow on the ground, and a wall of black-green spruce surrounded this confraternity of birds. Both predators and prey were present, but they all seemed to be getting along; in fact, they were downright sociable with one another. The yellow flames of the fire flickered off their feathers and beaked faces, and not a scowl or a smirk or a suspicious glint could be seen in any of their eyes.

Glancing around the fire, I counted twenty-six species: Starting with Common Raven, who seemed to be the ringleader, there was his cousin, Gray Jay; then American Dipper, Boreal Chickadee, and her two cousins, Black-capped and Gray-headed Chickadees. Next to them were five of the grouse family: Rock and Willow Ptarmigan, and Spruce, Sharp-tailed, and Ruffed Grouse. In a quiet huddle were four woodpeckers: American Three-toed, Downy, Hairy, and Black-backed. Then there were five owls deep in serious conversation: Boreal Owl, Northern Hawk Owl, Snowy Owl, Great Gray Owl, and Great Horned Owl. Gyrfalcon was next, chatting with his neighbor, Northern Goshawk. Completing the circle were the four colorful winter finches: White-winged Crossbill, Pine Grosbeak, and Hoary and Common Redpolls. The last three were glancing at their neighbor, Common Raven, and gesturing at their suitcases. They were getting ready to move to Fairbanks if the temperatures plummeted any lower.

It was a motley group, to be sure, but they were well adapted for this harsh Arctic environment in ways that their insect-eating cousins were not. Raven began to speak about a story that was being written about them, one that told readers why they stayed in the Arctic Refuge during winter while their cousins

Everyone is born with a bird in his heart.

Frank M. Chapman

flew south to warmer climates. I listened and heard words from the other side of the fire ask, "But what makes us winter birds, anyway?" Then suddenly my dream ended in a noisy crash.

What had happened, I wondered? Had a tree fallen, or had a bear come into camp? I peered out of my tent and saw an overturned cooking pot next to a Gray Jay. I rubbed my eyes and asked myself, "Am I still dreaming?"

I wished I were, because I wanted to hear what the birds had to say about what constituted a winter bird. I tried going back to sleep to continue the dream, but finally I gave up, deciding in any case that this would be a good place to begin my story.

. . ▪

In the context of the Arctic National Wildlife Refuge, a winter bird is any species that remains within the boundaries of the refuge in significant numbers for twelve months of the year. During some frigid winters there may be exceptions, such as the three species of finch in my dream that sometimes move a little farther south at this time. With the present warmer trends in weather, these finches undoubtedly will begin to stay year round in the southern corner of the refuge.

There are also birds that remain in certain parts of the refuge that normally would not do so except under unusual circumstances. Heimo Korth, a friend and astute birder who has lived along the upper Coleen River in the refuge for almost three decades, told me he had observed Mallards even in the dead of winter on the headwaters of the Old Crow River. There is open water there, he said, and if ducks can eat there all year, they'll stick around. He also told me a story about a White-crowned Sparrow that somehow failed to migrate and hung around his cabin until midwinter. It hid under the cabin at night and would come out to feed during the short daylight hours. Heimo had killed a grizzly bear and left the carcass in the snow nearby, and every morning he would watch the fluffy-feathered bird emerge from the hole under the cabin, alight on the carcass, and eat the fat from the meat. One day, though, he didn't

see the little sparrow, and he understood why when he investigated and found weasel tracks entering the hole.

The refuge stretches from the Beaufort Sea to well south of the Porcupine River. This span in latitude, encompassing a broad variety of habitats and six distinct ecoregions, influences which species can survive and even flourish here during the winter, and it boils down to what food is available for them

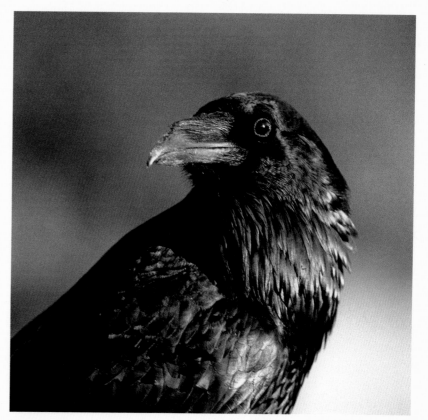

Common Raven

under the difficult weather conditions with which they must contend. Since the northern portion of the refuge, including the coastal plain and the mountainous regions, is subject to the harshest weather and has virtually no tall trees, it has the fewest number of both species and individual birds that overwinter. The southern part of the refuge, however, is more benign, with less wind and more tree cover. There are more winter birds here as a result and, if my dream is any indication, more firewood for avian campfires.

Since many of the twenty-six winter species in my dream are covered elsewhere in this book, I've selected ten to discuss here that I regard as especially interesting or with which I've had personal encounters.

CHICKADEES

I'll begin with a wee bird I saw for the first time in June of 2004, on a rafting trip on the Marsh Fork of the Canning River in the northwest corner of the refuge. Our charter was late bringing in our raft, so I suggested to two friends that we take a short walk downriver to a heavily willowed outwash punctuated in places with sparse stands of cottonwood. I'd heard that Gray-headed Chickadees often nested in the cottonwoods and thought we might be lucky enough to spot one of these elusive birds.

We thrashed through thick willows for more than an hour and were just about to give up when I heard the definite *spish* of a chickadee. It was slower than that of Black-capped and Boreal Chickadees, but a chickadee it was. So I *spished* back and immediately spied it in the willows, poking around for insect tidbits. I glassed it to inspect its topknot and face, comparing it to the pictures of the chickadees in my bird guide. It did, in fact, have a grayer head than any of the Boreals I'd ever seen, and its white cheek patch was larger than that of the Boreal or Black-capped Chickadees. Finally, after hearing so much about this bird for so long, I was able to observe it up close and personal. When I *spished* again, it flew down right in front of me and ogled me as though I might have something to offer it.

Another began calling nearby. Its slow and easy *spish* was identical to the one I was trailing through the willows. Unfortunately, I couldn't spend all day following them; it was hot in that breezeless jungle, and I didn't want to alienate my friends with my enthusiasm. As I pushed through the willows onto the open tundra, I stopped to listen to the chickadees one last time. *Tsiti ti ti jeew . . . jeew jeew.* Then they stopped, and that was the last time I heard their call.

This hardy bird is the rarest and least understood of our North American chickadees. It is an Old World bird, known as the Siberian Tit in northern Russia and Europe, that crossed the Bering Strait during one of the last glaciations and established itself in the northern part of the continent to as far east as the Mackenzie River valley in Canada. It is a permanent resident found at or north of the tree line where stunted spruces, cottonwoods, and willows grow along remote Arctic creeks and rivers such as the Canning, Kongakut, and Clarence Rivers. Like other chickadee species, it feeds in small family groups on insects, larvae, spiders, seeds, and the fat of dead animals. Its foraging strategies, too, are similar to those of other chickadees, including the storage of food for later retrieval.

Once mated, Gray-headed Chickadees remain together all year on a large permanent territory that may be shared by one other mated pair. They nest in tree cavities, usually in dead or dying spruce or cottonwood trees. The nest, built by the female, is made of grass, moss, and animal hair. The male feeds the female as part of their mating ritual and continues to do so throughout the incubation period and until the nestlings are about half-grown. Between four and eleven white, reddish brown spotted eggs are laid, and incubation is done totally by the female, for fourteen to eighteen days. After the eggs hatch, the female broods the young most of the time at first while the male brings food. Later both parents share these duties. The young leave the nest when they are about twenty days old. Heimo and I both think it's likely that pairs that nest on the north side of the Brooks Range migrate along with their offspring to the more heavily wooded southern side of the mountains during the cold winter months.

Of the Gray-headed Chickadee's two cousins, the Black-capped and Boreal Chickadees, the Boreal Chickadee is probably the most common of all the winter birds in the refuge, especially where there are spruce trees.

Until I met the Gray-headed Chickadees, I always thought of boreals as country cousins of black-caps. Compared to the calls of black-caps and others that range far to the south, the slow, almost drawling *spish* of a boreal is a fascination. I love to listen to them in the forest, and when I *spish* back they immediately come over to investigate. In the fall I've had a dozen of them surround me, wondering where the noise was coming from.

Like other chickadee species, boreals feed on insects, spiders, seeds, and animal fat. They are monogamous, possibly mate for life, and remain together in the same general area all year. Their mating ritual usually starts in the top of a spruce: The male chases the female in a downward spiral around the tree. Mating occurs after sweet solicitation calls by the female during which she also asks for food from the male.

Boreals nest in the holes of trees, usually in either a natural cavity or one hacked out by woodpeckers, although they also will dig their own. Both male and female help with the excavation, but only the female builds the nest inside, using moss, feathers, animal hair, and plant down. As many as nine white, reddish brown dotted eggs are laid, and only the female incubates them. During the eleven- to sixteen-day incubation period the male feeds his mate. After the eggs hatch, the female stays home to brood the young while her mate works very hard to bring home the bacon. Both adults feed the nestlings as they grow larger until finally, at about eighteen days, the young fledge and learn to provide for themselves, foraging for food rich in carbohydrates and storing much of it for retrieval during the winter.

But winter nights are so long in the Arctic Refuge that boreals and other chickadee species have to do more than simply get fat on rich foods in order to survive. To get through those frigid, foodless nights they roost in tree cavities in a state of "regulated hypothermia," in which their body temperature drops as much as twenty degrees F below their normal daytime body temperature. As a result, they don't have to expend as much energy, stored in fat reserves, to heat their bodies. They also have other cold-weather adaptations: By shivering their

muscles, they use stored fat reserves to generate heat and to regulate their body temperature when cooling down at night. They also have denser plumage than southern birds their size, a trait that doesn't make for the most graceful flying but provides the insulation they need to successfully survive Arctic winters.

CROSSBILLS

According to my friend Heimo, the next most common winter bird in his part of the refuge is the White-winged Crossbill. But this northern crossbill has been known to leave the area on a moment's notice. In fact, if the spruce and tamarack cone seed crop upon which they feed is not abundant, they will wander, often in large flocks, throughout the boreal zones of the Northern Hemisphere in search of trees heavily laden with cones. They may even travel far into Canada or south to Fairbanks, as they did a few years ago. When they find such crops they may settle in the area for a while, even building nests and raising young in the middle of winter.

Crossbills have one of the most unusual beaks in the bird world. Ogle the beak through your binocs and it appears almost deformed. But watch a crossbill perform up at the top of a tree with a spruce or tamarack cone in its grasp and you'll see that the beak is perfectly adapted to pry open the cones, allowing it to extract the seeds with its dexterous tongue.

No matter the time of year, if the seed crop is particularly good, a flock of these tough little birds may collectively decide to go into nesting mode. You'll be able to tell by a change in their behavior and the sound of their song. In their courtship flight, the male changes his tone from a sharp, metallic *cheet* to a continuous sweet twitter similar to that of a redpoll. He beats his wings slowly as he circles above the female, sometimes chasing her in the air. The pair may perch close together, touching beaks, and the male often feeds his mate. They nest high up on the horizontal limbs of spruces, and the nest is an open cup of twigs and grass, lined with moss, hair, and soft plant fiber. It is built by the female, although the male may help by bringing nesting materials. Four spotted, pale bluish green to white eggs are laid, and the female incubates them for about two weeks while her mate provides her with regurgitated seeds. After feeding her, he occasionally will give a flight-song display. When the eggs hatch, the female broods the young while the male brings food, this time in the form of a regurgitant of milky seed pulp. As the nestlings grow bigger, both parents feed them until about a fortnight after hatching, when they leave the nest. If the female begins another brood, her mate will attend the first batch of fledglings until they're totally on their own.

An important adaptation that allows crossbills to survive the severe refuge winters is an enlarged crop known as a gular pouch. They store extra seeds in the gular pouch as they eat, especially toward nightfall and at the onset of inclement weather. This "lunch box" of extra food will carry the birds through the night and the cold by allowing them to slowly digest while resting in a sheltered spot. Another way they cope with the Arctic cold is by growing more down feathers in the fall and fluffing up these feathers as they remain completely still in their snow-enclosed spruce shelters.

PTARMIGAN

Two much larger birds that prepare themselves for winter in the refuge with similar adaptations are members of the grouse family: Rock and Willow Ptarmigan. These birds not only grow very thick, downy body plumage to hold in warmth, but their feet are also heavily feathered to the tips of their sharp claws and act as snowshoes to allow them to walk more easily on the surface of the snow. On cold winter nights they burrow into the snow to sleep, allowing the insulating value of the snow to keep them warm. Like crossbills and other winter finches, they, too, have a gular pouch in which they store food for digestion during the night or a winter snowstorm.

Inupiat Eskimos who live on the edge of the refuge call Willow and Rock Ptarmigan *Kadgivik* and *Niksaktongik*, respectively. The name *Kadgivik* refers to the red comb over the eyes of the Willow Ptarmigan male that is raised conspicuously during courtship display. *Niksaktongik* relates to the loud belching noise the Rock Ptarmigan makes when he is disturbed. I've surprised these birds on the tundra and mistaken the belch for the growl of a grizzly bear. You can imagine my reaction.

As the names of the birds indicate, they occupy somewhat different habitats in the Arctic Refuge. While Rock Ptarmigan prefer the tundra of the coastal plain and the alpine zone of the Brooks Range, Willow Ptarmigan—well, they really do prefer the willows. However, there is much overlap, especially on the coastal plain, where I've seen both species nesting near each other on the Okerokovik River, not far from the Beaufort Sea.

These two ptarmigan species subsist on similar diets of buds, leaves, and seeds of willows, alder, and dwarf birch. They also eat crowberries, blueberries, and cranberries, plus insects and spiders. When the chicks are young they at first feed heavily on insects, gradually eating more and more plant material.

It's a real treat to watch the male birds of these species perform during the mating season. Sometimes it's hard to tell whether their behavior is intended to frighten away other males or to attract females. The way they raise their nuptial

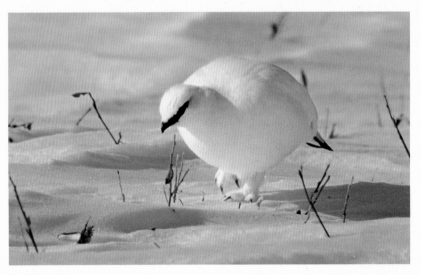

Rock Ptarmigan

eyebrows, throw their heads back, fan their tails, and strut proudly around their nesting ground is a sight to behold. And that's not all; they follow this activity by taking flight, rapidly flapping their wings, gliding, then fluttering back down to the ground as they utter their own macho version of a guttural croak.

The two species build their nests on the ground in a similar manner, although Rock Ptarmigan prefer a somewhat more open and, yes, rocky area. The females of both species build these nests in a shallow depression and line them with grass, leaves, moss, and feathers. They each often lay more than a dozen pale brown-splotched eggs and incubate them alone for about three weeks. Unlike other species of ptarmigan, the male Willow Ptarmigan remains close to the female throughout the incubation period. Hiding in a thicket near the nest, he will do whatever it takes to defend his mate from attacks by gulls and jaegers, even knocking them over to prevent them from getting the eggs. One male was documented to even have attacked a grizzly bear that stumbled into his mate's nest.

All of the eggs of the two species hatch at roughly the same time, and within just a few hours the downy chicks leave the nest with their mother and begin foraging on their own. The female tends the young and broods them while they are still small, but within two weeks the young can fly well enough to escape land predators, and by the end of the summer they are independent of their parents.

Because winter winds and temperatures are so harsh on the coastal plain of the refuge, both species gather in large flocks and move lower on the mountains and somewhat south of their breeding range at that time, although they normally do not go beyond the tree line.

SPRUCE GROUSE

Another hardy member of the grouse family that spends the winter in the Arctic Refuge is the Spruce Grouse. Somewhat uncommon, they are resident only on the south side of the refuge. A few years ago I was skiing in the forest

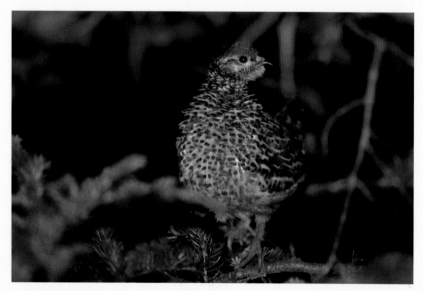

Immature Spruce Grouse

during late winter and noticed a spruce branch that appeared ragged and torn. On closer inspection I found the branch almost totally denuded of its needles. "Aha, Spruce Grouse," I thought, because spruce needles and buds are what these grouse eat in winter. This grouse has many other English names: Canada Grouse, Black Grouse, Cedar Partridge, Spotted Grouse, Spruce Partridge, Swamp Partridge, Wood Grouse, Wood Partridge, Spruce Hen, and Fool Hen. The last name comes from their habit of "freezing" on a low spruce tree limb as they are approached by humans. This makes them an easy target, and they have become a tasty supplement to the menu of Athabascan Indians living in the boreal forest near the Arctic Refuge.

I've found three scientific names for this bird. As with all species, only one scientific name is the "correct" one at any given time, although they are changed occasionally. The American Ornithologist's Union currently lists the scientific name as *Falcipennis canadensis*, although the one I prefer is *Canachites canadensis*, meaning "Canadian noisemaker." This refers to the noise the male makes during his territorial and mating displays in spring. On his nesting ground in the boreal forest of the refuge, usually alongside a fallen tree that has been used over many years for shelter, the male Spruce Grouse rapidly beats his wings together above his back while rising in the air and landing on the ground. As the female watches nearby, the male spreads his handsome, orange-tipped tail feathers, raises his bright red eyebrow combs, and makes a low hooting sound, trying his hardest to command her attention in the mating game.

Once mated, the female scratches out a shallow depression on the ground under dense cover; lines it with a few needles, grasses, and leaf litter; and then lays up to ten brown-blotched, buff- to olive-colored eggs. As with her ptarmigan cousins, she alone incubates the eggs, and after they hatch three weeks later, she also cares for the young. The chicks are precocial and leave the nest soon after they hatch. The downy hatchlings are immediately able to feed themselves, but at night and in cool weather their mother broods them to keep them warm. Within just a week the young are able to flutter up from the ground to low tree branches to escape predators such as foxes. To distract these predators, the mother bird performs a "broken-wing act," which almost always works.

WOODPECKERS

Among the huddle of winter birds around the campfire in my dream were four woodpeckers. Of these, the one most commonly found in the boreal forest of the Arctic Refuge is the American Three-toed Woodpecker. When my friend Heimo Korth and I were comparing notes on this bird, we both discovered we had often been able to coax them closer to us by tapping a twig against a tree trunk. Once, one landed so near and peered at me so intently that I could see a little spark of light reflecting from his left eyeball.

You'll find this woodpecker mostly in areas of the forest that have recently been burned by a forest fire. Big infestations of wood-boring insects concentrate in these areas, and three-toeds take full advantage of the bonanza. In healthy parts of the forest where there has been a population explosion of the spruce

bark beetle, they often provide the most effective control of that major forest pest. Why they and their cousins, Black-backed Woodpeckers, have only three toes instead of the usual four that other birds have is a puzzle, but it certainly doesn't impede their chances of survival even in the harsh environment of the southern part of the Arctic Refuge. Heimo says both species of three-toed are present year round where he lives.

One of the survival strategies of the American Three-toed is a strong pair bond that lasts all year and sometimes continues over successive years. The male also assists the female in the excavation of the nest cavity, takes his turn with incubation (mostly at night), and helps feed and tend the nestlings after they hatch until well beyond the fledging period.

The nesting season begins with much tree drumming by the male, which both attracts females and informs other males of his territorial dominance. He also does a lot of head swaying and calls more loudly than usual. This usually does the trick, and it isn't long before four white eggs are laid in the nest. In two weeks these eggs hatch, and, since the chicks are altricial, it is more than three weeks until they hesitantly take their first flight from the nest cavity. It is another four to eight weeks before they are totally on their own.

Both species of three-toed woodpeckers found in the refuge probably evolved from the same original species because so many of their behaviors are the same or similar. And although their ranges overlap, they may have hostile exchanges where they meet. For this reason, one or the other predominates. In the boreal forest of the Arctic Refuge, it seems the American Three-toed Woodpecker is the more prevalent.

GRAY JAY

I was surprised when Heimo told me the Gray Jay was rather rare in his area. Nevertheless, it is present; a few years ago I even saw a young one out on the refuge coastal plain. The jay was probably just being his teenage self and exploring, but it was a long way for a forest bird to roam.

The Gray Jay is variously called Canada Jay, camp robber, Cinerous Crow, and Whiskey Jack, among other common names. The last name comes from the Cree Indian word *whiska-zhon-shish,* meaning "the little one that works at a fire," and relates to the jay's propensity to visit campfires for an easy handout. Cinerous comes from the Latin word *cinereus,* which means "ashes," referring to the black and gray plumage of the jay.

As a member of the Corvid, or crow, family, Gray Jays have one of the largest brains per body size in the animal world. They have long, soft, and silky plumage, especially in winter, which keeps them warm when temperatures plummet to sixty degrees below zero. Gray Jays cache large quantities of food during the warmer months for use in winter, using their gluey saliva to help stick pieces of food in bark crevices and other hiding places. They can even carry food with their feet, a trait rare among songbirds.

Like so many of their Corvid cousins, Gray Jays are monogamous, and mated pairs stay together year round and defend permanent territories. You might see them in winter, often accompanied by their most dominant young. The parents

drive this young bird away in early spring, however, when the urge to nest takes over. Since they are permanently bonded, Gray Jays don't have much of a courting ritual, and usually all you'll see is some feeding of the female by the male. As soon as you spot this courtship feeding, you know the pair is building a nest somewhere on the branch of a dense spruce close to the trunk. The nest is a bulky cup made of sticks, grass, and moss fastened together with spider silk. It is well insulated with fur and feather down to accommodate the pair's tendency to nest when there is still much snow on the ground and temperatures are as low as thirty degrees below zero.

After laying three or four grayish white eggs, the female alone does the incubation while her mate provides her with food. In three weeks the eggs hatch, and the mother bird broods the young while the male brings food to the

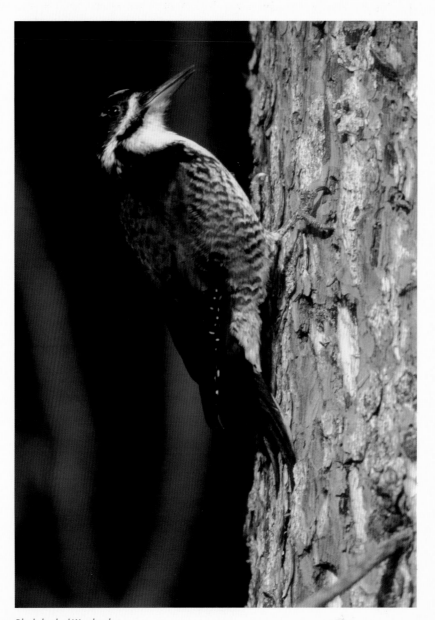

Black-backed Woodpecker

nest for everyone. Later, when the young have a few more feathers and are less vulnerable to the cold, both parents will forage for food and bring it back to the nestlings. After another three weeks or so the young are ready to take their first flight, but they remain with their parents for at least another month to learn a few more survival strategies. Then they are on their own, although, as I mentioned, the most dominant of the offspring usually hangs around all winter with its parents. This may be so that at least one of the young learns all of the tricks of survival its parents know to help survive this very harsh climate.

Gray Jays learn things so well that some Alaska Native cultures once believed they had special powers of perception and that they were even conscious of the world around them in the sense that many of their actions were intentional or premeditated. No wonder, for a bird with such a large brain.

COMMON RAVEN

Closely related to the Gray Jay, the Common Raven is the bird regarded as the most conscious of them all by Native people everywhere in Alaska. But don't let its moniker fool you; this is no common bird. As our largest passerine, it is thought to be perhaps the most intelligent and socially adept bird on earth. In addition to having more than two hundred different vocalizations and many dialects, it has been described as crafty, resourceful, and quick to learn and profit from experience. Among southern Yupik Eskimos, it was once believed ravens possessed a much higher quality of awareness, referred to as *cella*, relating them to *Cellamyua*, meaning "Great Spirit." Northern Inupiat Eskimos and Gwich'in people who live near the refuge also once held them in greater esteem.

For a bird that sometimes establishes lifelong ties with its mate, the raven

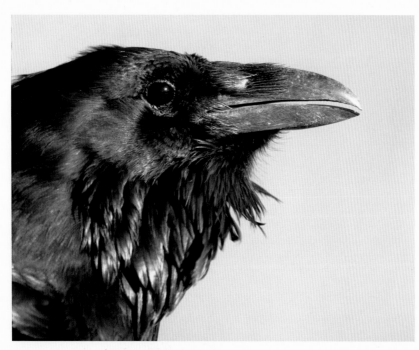

Common Raven / Opposite ■ Bird print in snow

goes through some elaborate courtship rituals. Watch carefully in early spring and you'll see the male fly wingtip-to-wingtip with the female and then peel off and dive like a Peregrine Falcon, often tumbling over and over in the air, not unlike humans who "fall head over heels in love." When perched on a limb, raven couples touch shoulders, preen each other's feathers, and touch bills as though kissing.

After the ritual aerobatics comes the serious business of nest building, often beginning even while there is still much snow on the ground and it is quite cold. Both sexes help construct the nest, which they build high on a sheltered cliff ledge or in a tall tree. The nests are made of broken branches lined with leaves, grass, moss, fur, and feathers, in that order. After laying four or five green brown-spotted eggs, the female alone incubates them while her mate feeds her on the nest. About three weeks later the eggs hatch and both parents fetch food and water for the nestlings, although the mother broods them at night and when it's cold. Since they are such large birds, raven young take a long time to grow to the point where they are ready to take wing. But finally, after five or six weeks, they stand on the verge of the cliff ledge where they were born and, with a little coaxing from their parents, take their first tentative flight.

Even when they're all safely out of the nest and in the air, these altricial young still must depend upon their elders for both food and the life skills that will allow them to live long lives. For a bird that can live as long as twenty-five years, they have much to learn, including how to forage, scavenge, and hunt cooperatively in groups; how to cache food, wheel and tumble in the air, court their mates, play with their peers, be sociable in their communal roosts, and even *quork* and *bell-croak* in their peculiar Arctic Refuge dialect. They must also learn to contend with the intense cold of Arctic Refuge winters. As with other northern birds that have to cope with these frigid temperatures, ravens, too, have adaptive equipment that allows them to do this efficiently. In autumn they grow more down feathers, which they fluff up to add even more insulation. They put on additional body fat, are equipped with that lunch box called a gular pouch, and are blessed with an extraordinary circulatory system, which, along with muscle twitching and their signature cold-weather crouch, guarantees their lanky legs and feet will be around to see the light of another very short day. I can't help but think that the soft murmurings I've heard at their winter nocturnal roosts, much like the commiserations of humans, also help them get through these bitterly cold nights.

■ ■ ■

When I close my eyes to conjure up again the images of my campfire dream and the yellow flames flickering off the feathers and beaks of that motley crew of winter birds huddled around the fire, I am struck by the extraordinary differences in size, shape, color, behavior, and song. Although this may be so, they are every one kindred in their remarkable ability to survive in a climate where scant numbers of people have ever chosen to make their own home. Except for small groups of hardy Native Americans and a few non-Natives such as Heimo Korth, humans have not made much of a mark on the lives of the birds in what is now the Arctic National Wildlife Refuge. I fervently hope we never will. ■

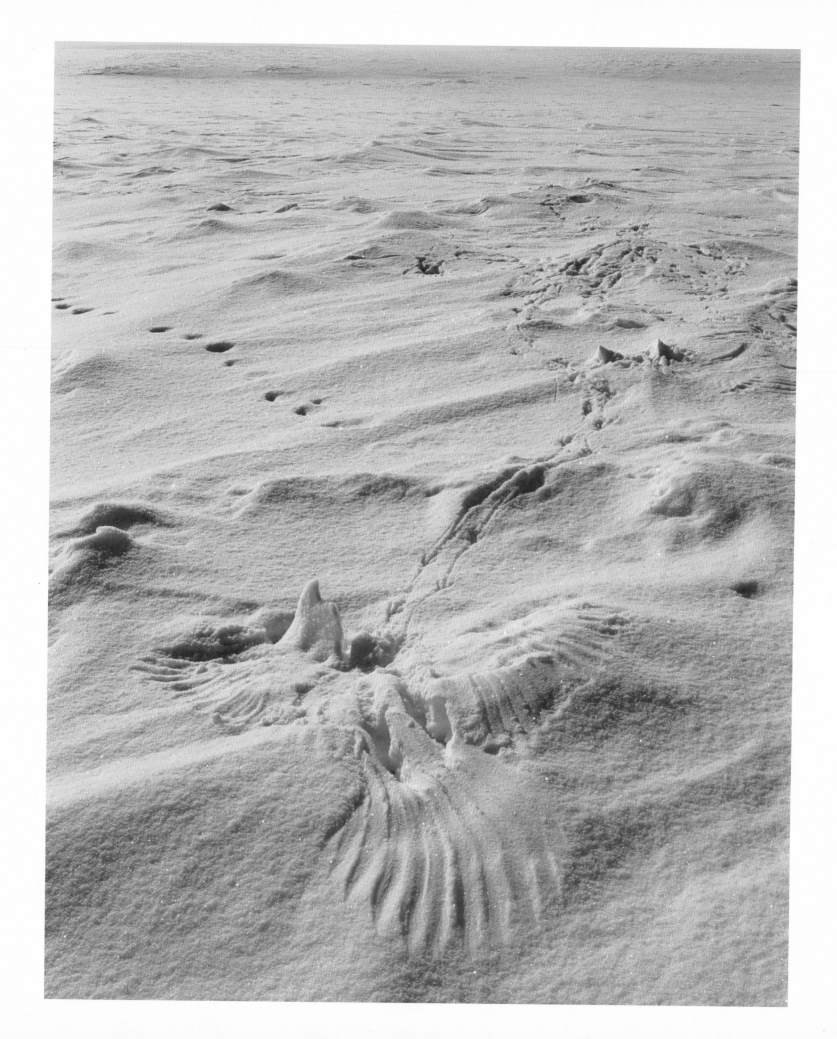

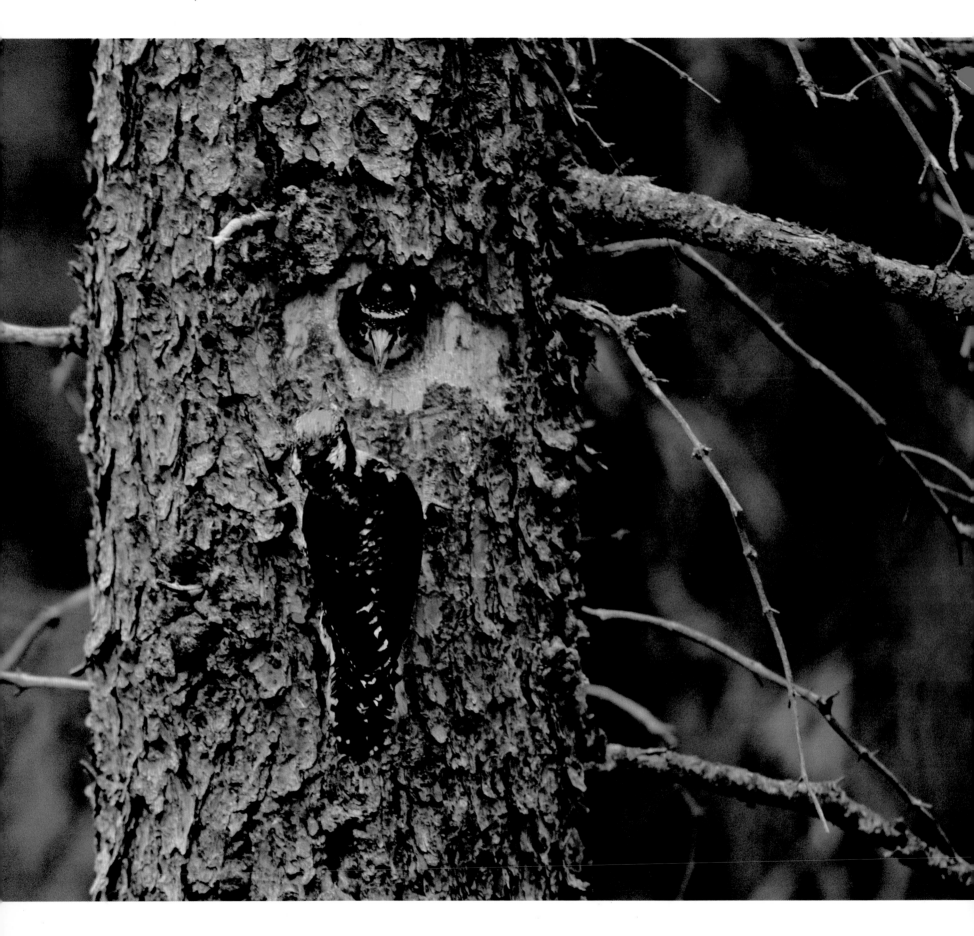

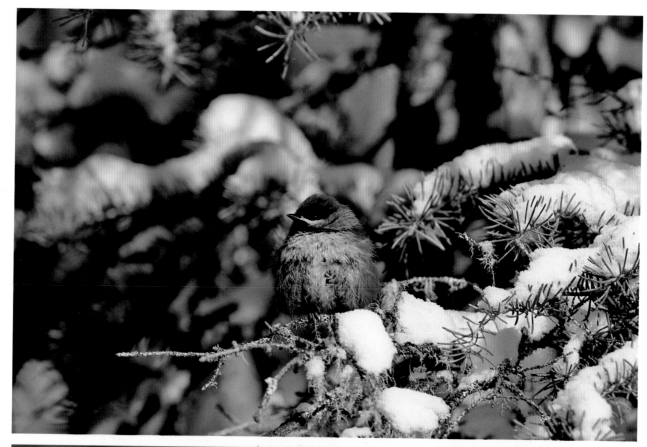

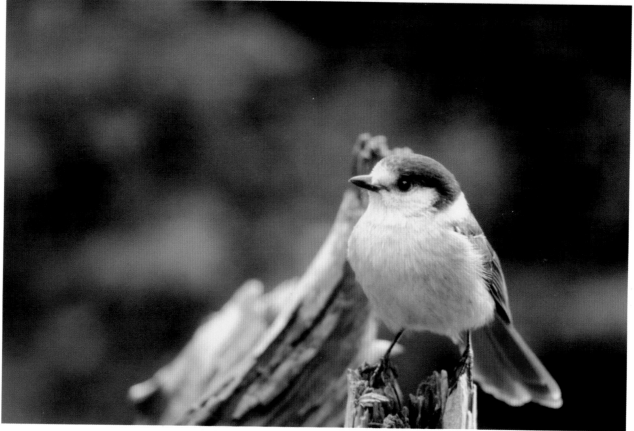

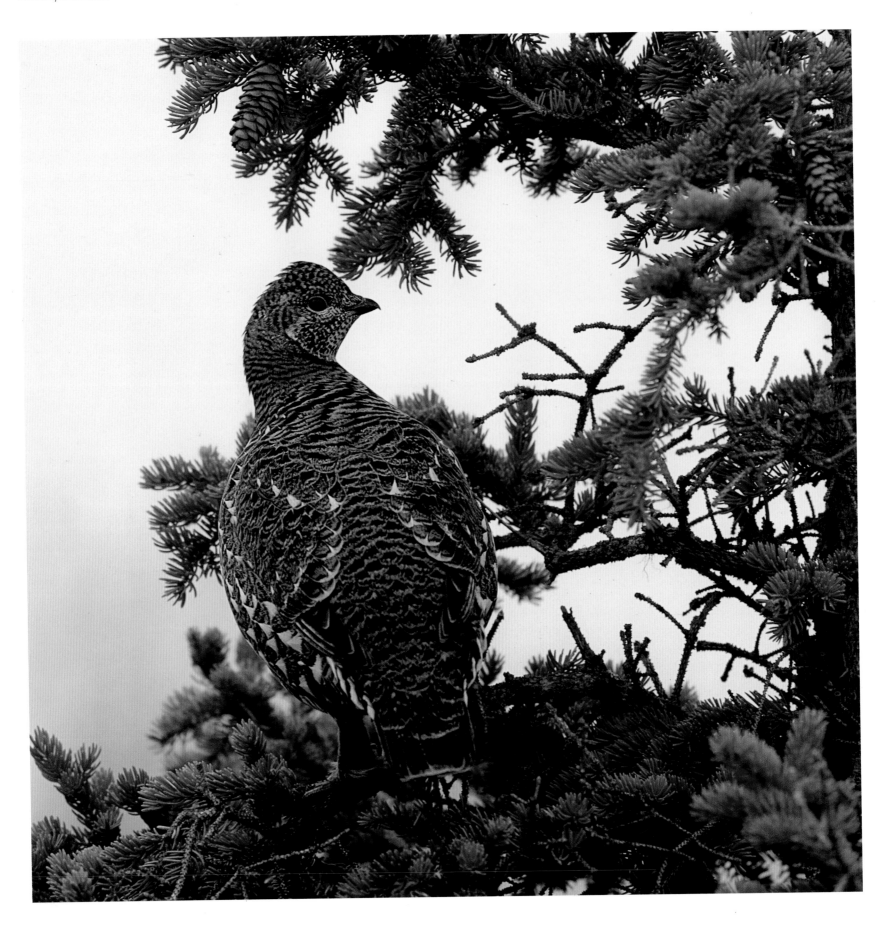

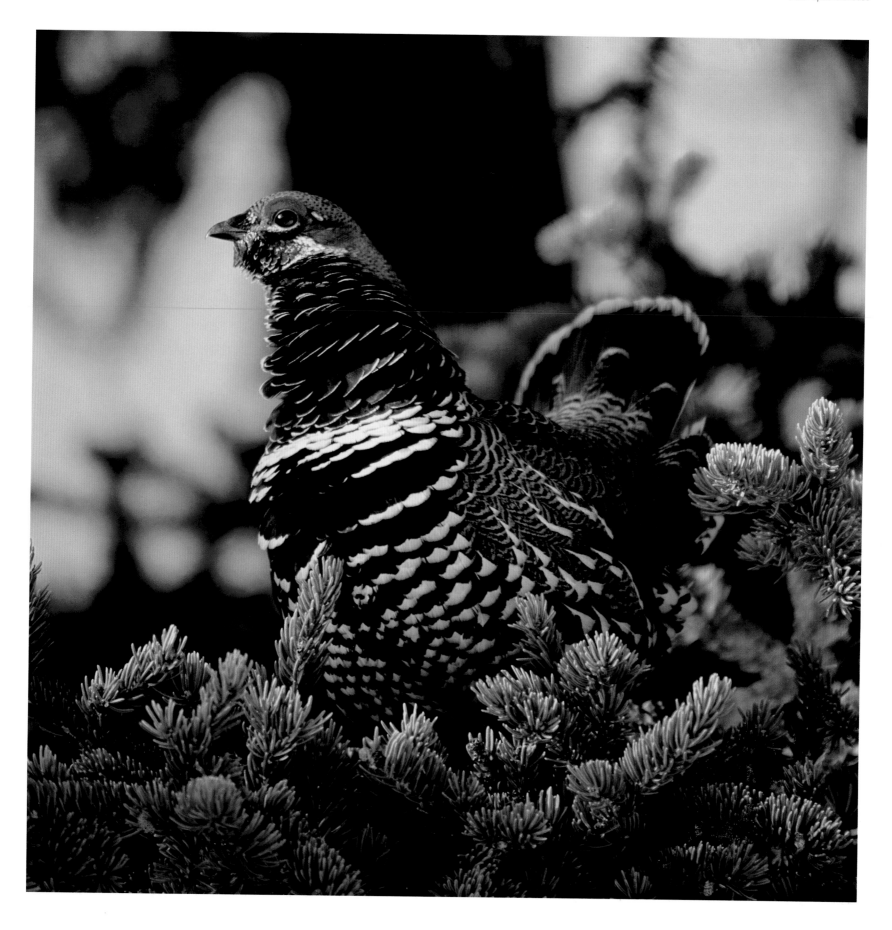

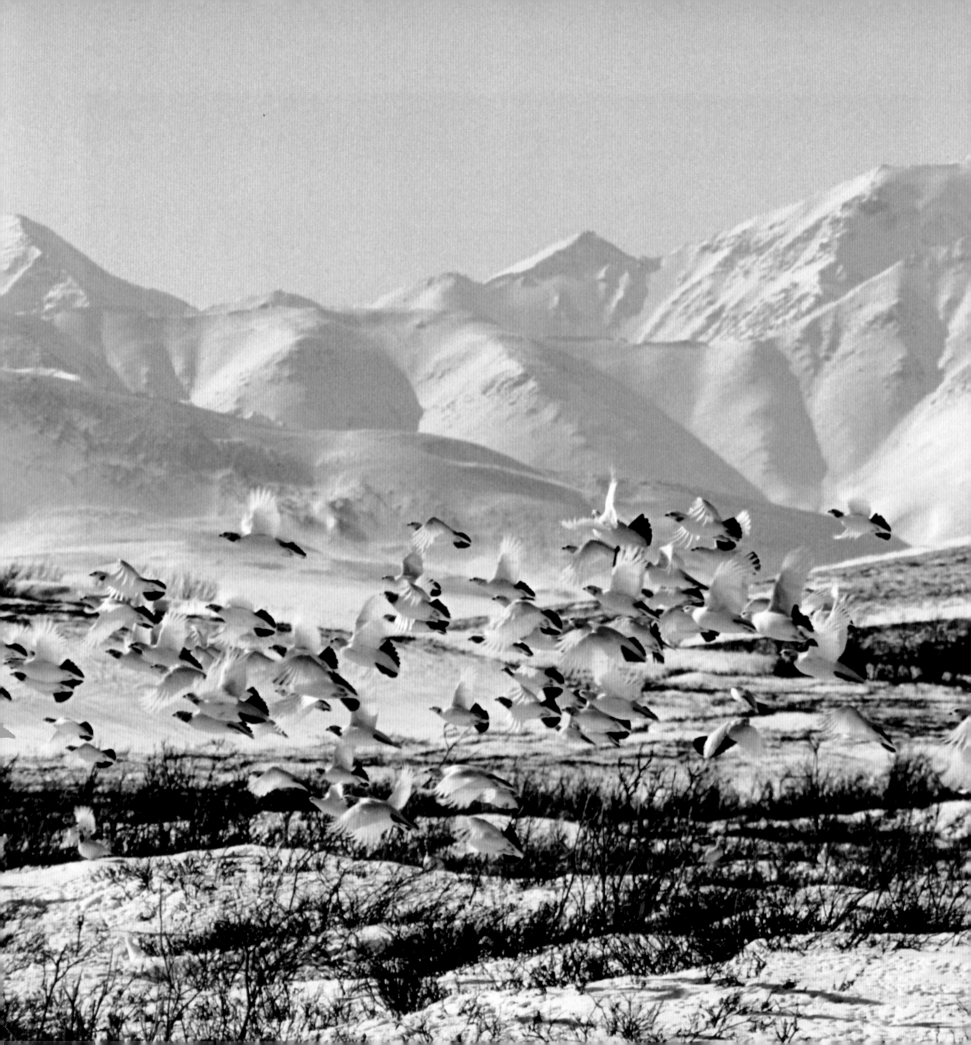

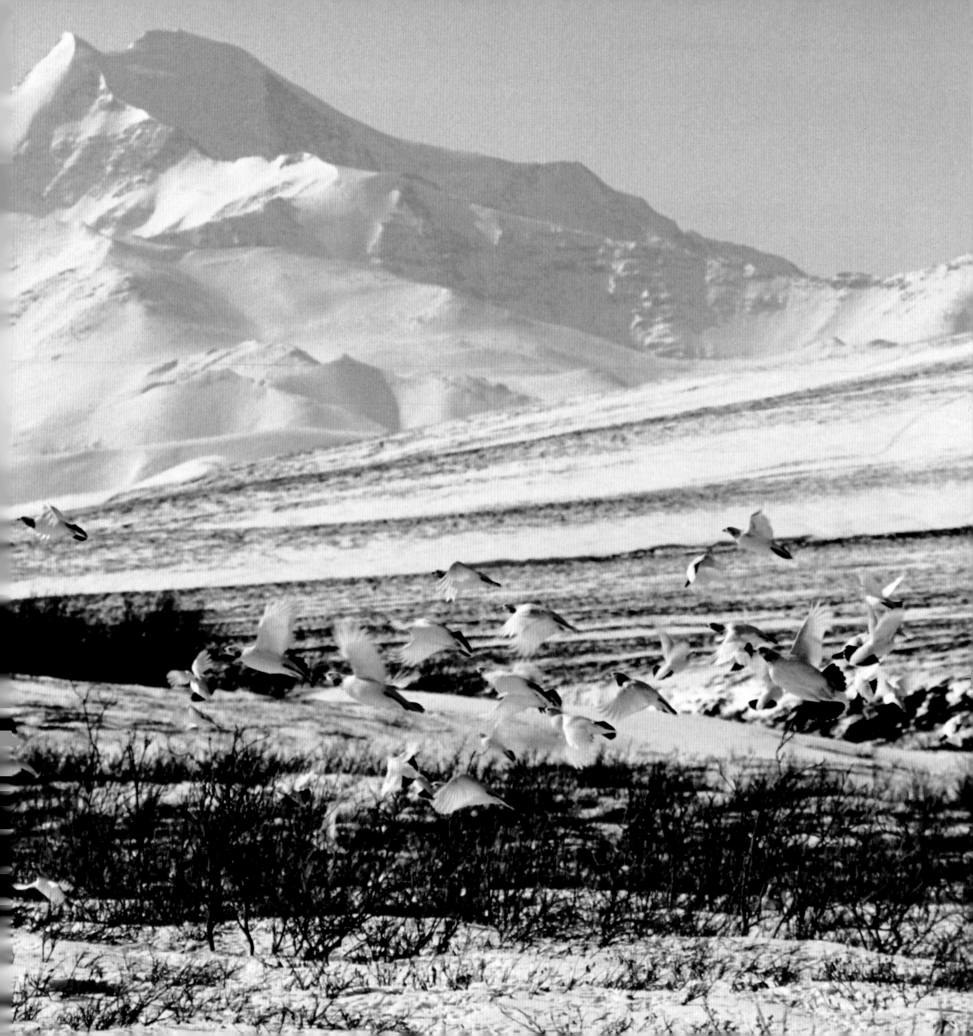

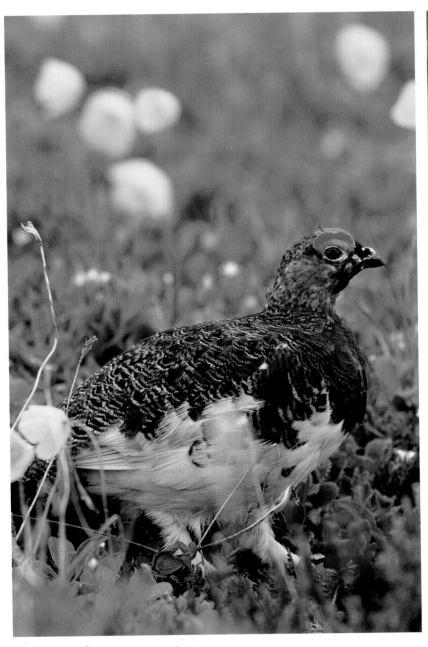
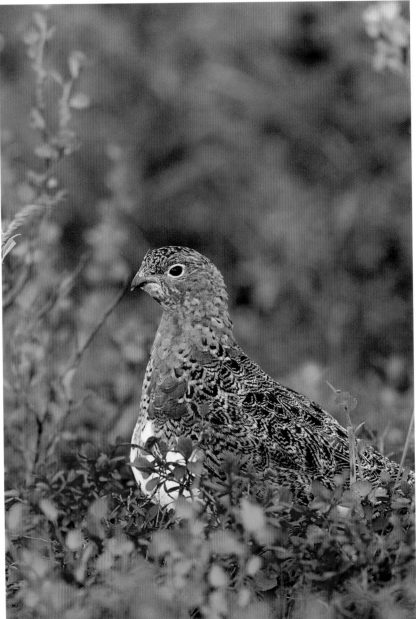

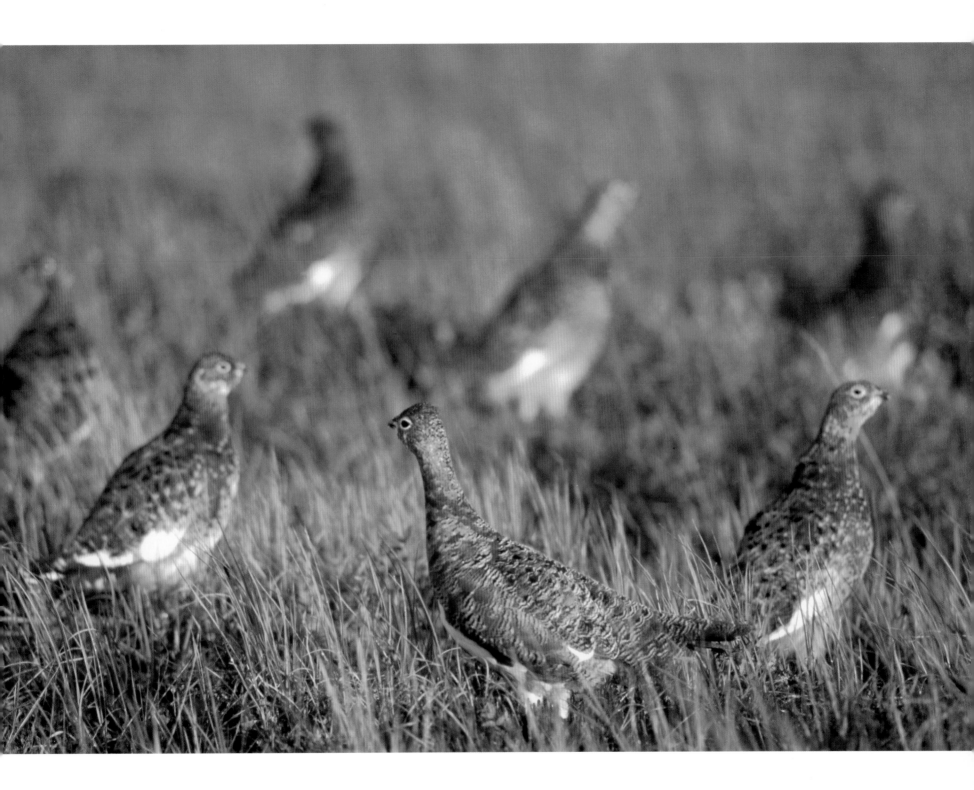

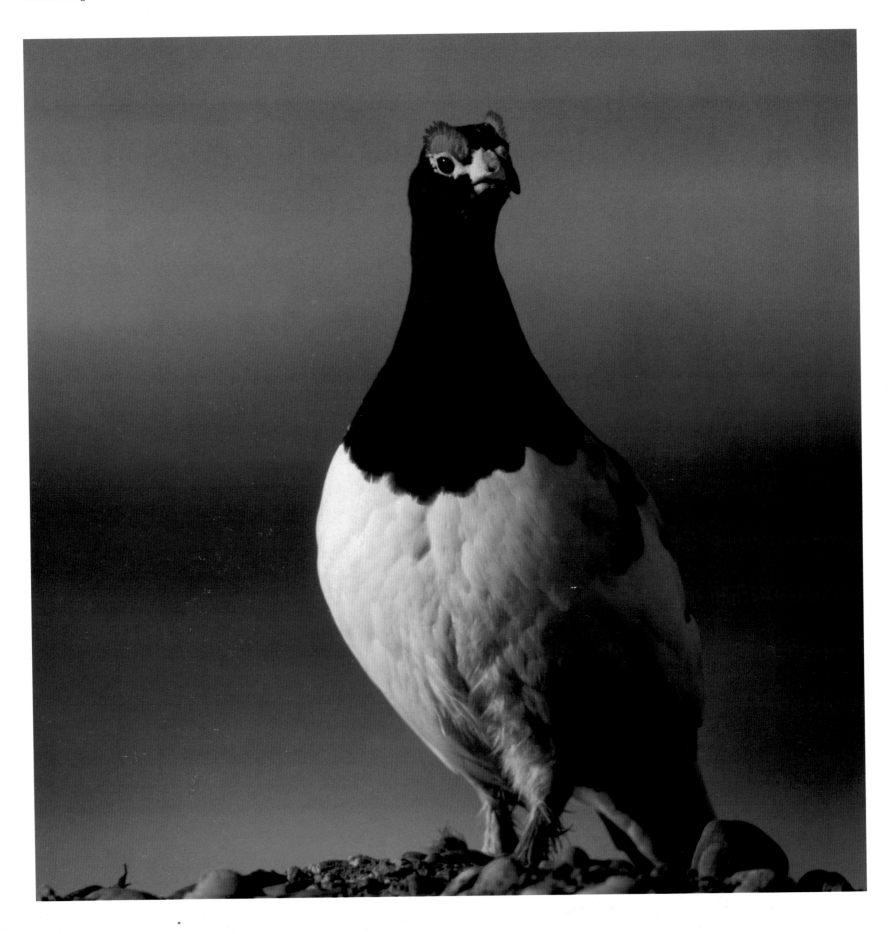

Autumn Bird Research in the Arctic Refuge by Robin Hunnewell

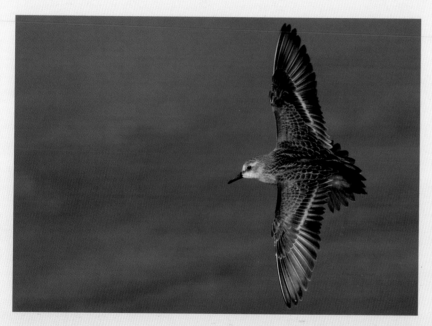

Semipalmated Sandpiper

*T*he Okpilak River flows north across the Arctic coastal plain and empties into the Beaufort Sea. At its mouth it joins with the Hulahula River and forms a wide delta of swift channels that braid over tidal flats to a lagoon. Far to the south, in the Romanzof Mountains, is the Okpilak Glacier and moraine. From here a flour of sediment infuses the Okpilak so that its outflow carries plumes the color of milk chocolate far out to sea.

It is late summer, and the polar days have begun to admit an hour or two of twilight, foreshadowing the coming of winter. At this time of year the river deltas are habitat for shorebirds that will soon migrate to wintering grounds in the Southern Hemisphere. Their layover here is timed to coincide with blooms of invertebrate life on the tidal flats, staging for flights that follow the curvature of the earth over two continents. As a strategy for survival, it seems as improbable as any in the natural world, but it is fueled by full-blown necessity.

By comparison, fieldwork in the Arctic is unadventurous. Our team is here to conduct research on the post-breeding movements of shorebirds in the Arctic Refuge. We are stationed on the delta of the Okpilak River, and our study plans include spatial monitoring of birds moving within and among river deltas of the Arctic coast. The goal: to track how shorebirds make use of the time and space given to them as they prepare for their southward migrations. In order to follow them we must catch, band, and fit radios to the birds, and then listen for their signals. Catching shorebirds means finding them in large enough gatherings to make our light mist nets effective.

We set upright mist nets on the flats in opportune areas where birds are foraging into the wind. We wait. When it is calm, the quiet is complete except for the restless calls of shorebirds. Now and then there is the low boom of ice shifting outside the lagoon. When there is wind, the air shakes with the roar of surf, and the weather changes rapidly. We are warm and enveloped in insects one moment and then plunged into fog and bitter cold the next.

When a parade of young Semipalmated Sandpipers appears in the sunlit fog before us, we watch intently. They thrust their bills to the hilt in the watery mud and are lost in a dazzling blur. If our proximity is not tolerated, a quick lift of the wings will take them banking away.

A shout goes up, announcing a capture! We sprint to the net and carefully extract a sandpiper from the soft mesh. We band the bird, measure it, equip it with a small radio, and then release it. As a tiny beacon of information, it will now relay valuable clues about itself, its species, and the Arctic Refuge, helping us to preserve its habitats—and its future. ■

Sometimes we hear the Snow Buntings—what we call snowbirds—before we see them. The snowbird's arrival in Kaktovik signals the first day of spring. After a long winter they are so welcome; this species is one of the few songbirds of the Arctic. To hear a snowbird singing perched upon your canvas-wall tent when you wake up adds much cheer to your day. To hear the song of the snowbird from inside your house as it comes down through the *kinguk*—the ventilation system—is an uplifting experience.

I live on the edge of the Arctic Ocean on Barter Island, within the boundaries of the Arctic National Wildlife Refuge. There are 300 residents in my village of Kaktovik; I believe it is the most remote village in the United States. Birds have a significant place in the culture of the Inupiat, my people. Birds are a source of food, to be sure, but other aspects of their existence bring us enjoyment as well.

Shortly after the snowbirds return, we anticipate the return of the various birds we hunt. The winters here are long and at times very severe. Outside activities are reduced because of the short days and extreme weather conditions. With the arrival of the geese, people come alive, and there is a flurry of activity as people prepare to go to the spring hunting camps. This is an event that we look forward to all winter. It is a time for the renewal of cultural activities. Camping and hunting are family affairs, and young people are introduced to this part of our culture, which brings families together.

Inupiat spring camp in the Hulahula River valley

Hunting is an activity that we have depended on for our existence for thousands of years. It is part of what defines us as a people. In these modern times, much of our culture has changed. Hunting activities are a part of our culture that holds our community together.

When a young person makes his first catch of each animal or bird, traditionally it is taken to an elder, who praises the young person and lets the youngster know how important he or she is to the community. In this way our culture continues and self-esteem is reinforced. If the first catch happens in the spring hunting camp, it is a happy occasion.

The birds of winter add much to the winter scene. The land can be so quiet without them. They are not many in species but they are truly remarkable. The raven has to be the toughest bird in the world. When we go out after winter storms, he is there to greet us. I think he is like us; he truly loves this land, as he could surely choose to fly to a less-harsh land. And to see ptarmigan in the hundreds of thousands in the willow patches makes the land feel full of life. Later, in May, seeing breeding pairs across the North Slope with the alpenglow of the midnight sun turning them pink is an experience to remember.

The birds come from here, the Arctic, our home, because this is where they are born. In this age we are able to learn where our birds go when they leave us. I call them our birds, but they are the birds of the whole world. They go to six continents and all the states. Each bird is unique. The flight of the Arctic Tern is amazing; it flies all the way to Antarctica and back again. The American Golden-Plover migrates to Argentina, the Yellow-billed Loon to Russia, the Eastern Yellow Wagtail to Indonesia.

All is not well with our birds. Will the Eskimo Curlew return? Is it still of this earth? Can the Buff-breasted Sandpiper continue to exist with its habitat marginalized? Our birds live in places around the world during the rest of the year. Will the chemicals that pollute those areas affect the birds that return to us—and will this in turn affect us because of the birds we eat?

The habitat of our birds must be protected. The birds need this area—the Arctic Refuge—to continue their existence. They have no voice, so we must look out for them. They depend on us. We have lived with these birds for thousands of years; our culture is entwined with them. Will the quest for oil overpower their need for habitat in which to breed? In the places our birds migrate to, will those people take care of them? We must do all that we can to assure their protection.

Time goes on. Someday, I will be the elder. Perhaps a young person will bring me a bird, his first catch, and I will be so happy. Our culture will continue, perhaps for thousands of years more. We can hope.

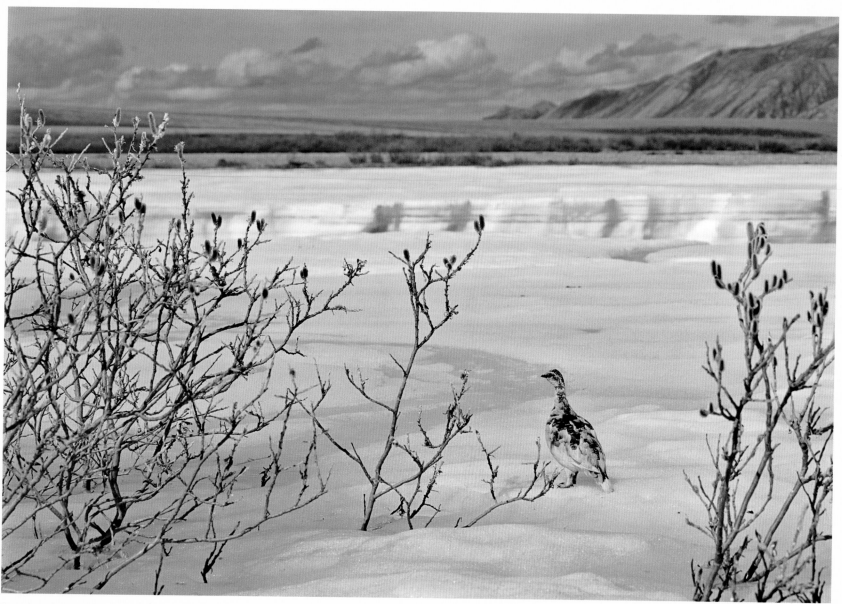

Ptarmigan changing plumage at winter's end

ROBERT THOMPSON *is an Inupiat Eskimo wildlife guide who lives on Barter Island, beyond the coastal plain of the Arctic National Wildlife Refuge. In addition to guiding, he enjoys hunting, dog mushing, carving ivory, and wood crafts. He is also an excellent camp cook and a storyteller of local history. Thompson has been invited to speak across the nation about the Arctic National Wildlife Refuge.* ■

The Gwich'in believe everything is related: Every species has a responsibility to the earth in order for it to be complete. We don't single out only one bird's responsibility or one animal's responsibility. Around the globe, all indigenous people see things this way: All things are related. To harm one part of creation puts all of creation out of balance. This is why I drum—to help educate others in the ways of our culture and to bring awareness to others that we must save the birds and the caribou and all the creatures that live in the Arctic in order to keep the balance in the natural world.

■ ■ ■

When a sparrow sings, it says, "This is my church." He's talking about everything around him, the landscape, the environment—that's his church. He reminds us to appreciate what God prepares for us. In springtime when birds start coming back to our part of the Arctic to nest, the kids say, "Did you hear that one yet? Did you hear?" It's the church bird. When we hear him, it reminds us of how important the environment is around us.

The Yellow Warbler—what we call yellowbird—comes to our area, but he is here for a very short time. We look for yellowbird in the spring, but it's hard to find the bird or its nest. It's like what they say about the hummingbird down south: If you see one, it's good luck. His nest is so small, and his eggs are so small, I think it doesn't take very long for them to hatch. He comes in July and he leaves in July; they come and then they go. That's why it's so special to see one. Yellowbird has always been around. This bird is part of our life, part of our culture. We say to each other in springtime, "Have you seen yellowbird yet?"

When we do find a nest, we don't bother it. If I pick up a stick and take a feather from the nest, the bird will stay; but if I touch the nest, he leaves it, so we never touch a nest. That's the way it is with all the birds. We believe that if you touch the eggs with your skin, they don't hatch. But if I touch the eggs with a stick they'll still hatch. So you can't pick up an egg and put it back; the bird won't take care of the eggs, and the eggs won't hatch. This shows us that the natural world lives best when we leave it alone; it can die if humans leave their mark on it.

I learned these things when I was growing up. We kids would tell each other things, and then we would confirm them with our mothers. "Is this true?" we'd ask. Our parents were very important in telling us how to behave the right way. We were taught by our parents that birds are good and that we shouldn't hurt them, because they take care of the insects and are part of the natural cycle of the earth. We could take a bird for food if we needed to eat, because we are part of this cycle, too; but we should only take the life of a bird or an animal if there is a purpose to it.

Daí—the sandpiper—hangs around the lakeshore. It's very hard to find his nest, but when we come near he makes a lot of noise. When humans are nearby, the *daí* is very loud. He alerts the others in the animal world of human danger. He's a tattletale, telling the other birds and animals that the people are coming. The indigenous peoples of Hawaii, New Zealand, the South Pacific all have the same story. Around the world, the birds know of some humans' reputation for destruction.

The raven is in our fables and legends. He has control over people; he fools people. That's how the story usually ends—the people are foolish, and the raven is smart. When the Creator first made the raven, the Creator said, "You're raven now, and this is your responsibility: You can't prey on live food, you must eat the leftovers and keep the earth clean. That's your responsibility." Raven is a scavenger. People think scavengers are the lowest things, eating roadkill and trash. We never think to honor it for keeping the earth clean. The reason we have these stories is to teach us to see his great responsibility and be grateful for his place on earth. That's what the legends are for, so that we can learn. We must do our part, too. Just because animals can't talk doesn't make us better than they are. They are here to teach us respect and honor, to show us how things work if only we will take the time to see.

Everything in the natural world is related. Each animal has its own responsibility, and each animal should be respected. Some people think birds are a nuisance, but they were created for a purpose. They must have room to live; this is why the Arctic is important. We must respect the birds and animals, because they all have a part in keeping the earth healthy.

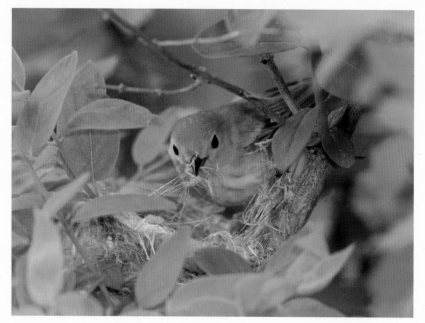

Yellow Warbler

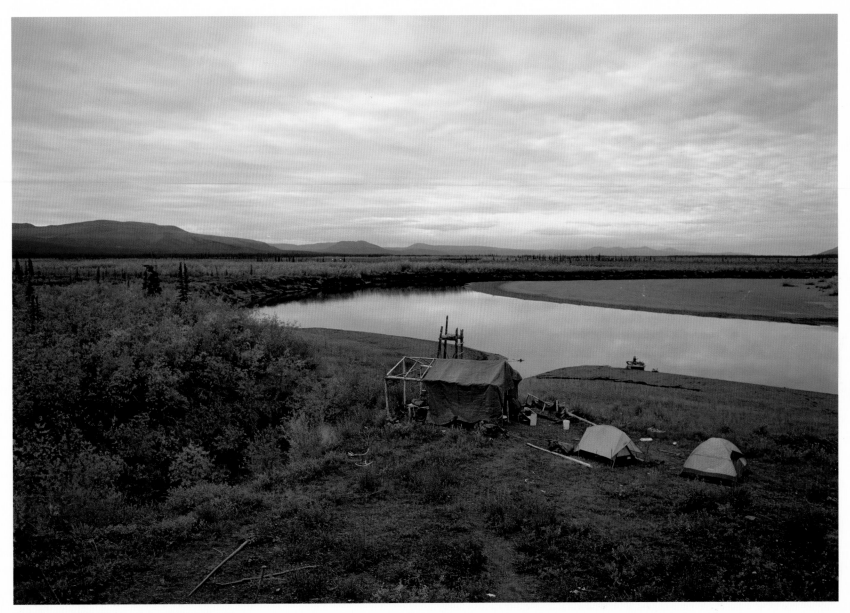

Gwich'in camp along the East Fork of the Chandalar River

Photo: Subhankar Banerjee

SARAH JAMES *is a Gwich'in activist who lives in Arctic Village, just south of the Arctic National Wildlife Refuge. She has spoken across the country against development in the refuge and spent three months in 2005 at a vigil in Washington, D.C., drumming, singing, dancing, and praying with other Native Americans to educate the public about human rights issues in the refuge. In 2002 James was co-winner of the prestigious Goldman Environmental Award with two other Gwich'in elders.* ■

Between the time of British explorations for a Northwest Passage in the 1800s and 1968, when oil was discovered at Prudhoe Bay, Alaska's North Slope was largely a land left to its few thousand native Inupiat Eskimo inhabitants. To be sure, there was activity by scientists, the military, and a few hardy recreationists and sportsmen, but this Minnesota-size land was essentially one large wilderness with endless vistas and a nearly full complement of native wildlife, and the harsh-but-glorious forces of nature dominated the landscape. Much has now changed, and images of the earth at night, taken from space, reveal concentrations of light at Prudhoe Bay in the central Arctic that rival large cities in brightness and extent.

To understand the birdlife of the Arctic National Wildlife Refuge and the epic conservation opportunity this refuge represents, one must first place the refuge in the context of the North Slope environment and the expanding, pervasive influence of the petroleum industry in America's Arctic.

NORTH SLOPE ECOREGIONS

Alaska's North Slope can be divided into three ecoregions: the high mountains of the Brooks Range, the Arctic foothills, and the Arctic coastal plain. At any given longitudinal slice, these ecoregions vary in their relative proportions—and how they are laid out has everything to do with what makes the Arctic Refuge unique and so valuable.

In the vast western Arctic, the Brooks Range lies far to the south. At Barrow, for example, the low, coastal plain extends more than a hundred miles to the south, and the austere high country of the Brooks Range lies a full 200 miles away. In between, there is a broad band of relatively dry, rolling upland foothills. As one travels from west to east, the Brooks Range arcs to the north and east, and the bands of coastal plain and foothills become more narrow. But even at Prudhoe Bay, about sixty miles west of the western boundary of the Arctic Refuge, the coastal plain is still about eighty miles wide.

Once inside the Arctic Refuge, however, the picture is dramatically different. The coastal plain—which is the biological heart of the refuge—is very narrow, only fifteen to forty miles wide. And the band of foothills is even more narrow, before the Brooks Range rises abruptly to heights of more than 9000 feet.

The importance of this geomorphology is simple: Within the boundaries of the Arctic Refuge, there is a largely intact ecosystem. Starting at the Arctic Circle, south of the Brooks Range, this ecosystem encompasses all of the habitats and landforms from the boreal forest north to the crest of the Brooks Range and on to the foothills, the coastal plain, the barrier islands, and, finally, the Beaufort Sea. Nowhere else in America's Arctic is there the opportunity to preserve in one protected area an intact ecosystem with an unbroken continuum of habitats and a full complement of native flora and fauna.

PETROLEUM LEASING

Even today, with millennia of use by Inupiat Eskimos and decades of activity by the oil industry and the military—with the significant exception of Prudhoe Bay, the adjacent central Arctic oilfields, and a handful of scattered communities—the character of the North Slope is overwhelmingly wild. This is changing rapidly, however, as both the federal and state governments aggressively promote petroleum development where there is any oil or gas potential.

Right now, outside of that small portion of the Arctic Refuge that has been designated by Congress as Wilderness, there are no permanently and fully protected conservation areas on the North Slope. And only a tiny sliver of the Arctic Refuge Wilderness, in the extreme northeast corner, is in the wildlife-rich Arctic coastal plain ecoregion. To the west, the coastal plain and foothills of the central Arctic are entirely committed to oil and gas activities. West of the Colville River—in the National Petroleum Reserve-Alaska (NPR-A)—the federal government has an aggressive leasing program and has rolled back administrative protections now in force at such places as Teshekpuk Lake, which provides critical habitat for molting Brant and other geese.

At Prudhoe Bay, the petroleum industry already has moved offshore, primarily into the near-shore waters owned by the state. As is true on land across the North Slope, however, the state and federal governments are moving aggressively to open most of the Beaufort Sea to oil and gas activity starting offshore of the Arctic Refuge and moving west all the way to the Chukchi Sea.

It is entirely possible that in less than a decade nearly 100 percent of the coastal plain and adjacent offshore submerged lands will be under lease for petroleum exploration and development. It also is entirely possible that within the next twenty-five years, an interconnecting oilfield infrastructure will span the entire Arctic coast, both on- and offshore.

INDUSTRIAL OILFIELDS

Anyone who has driven across the Great Plains of North America knows how grain elevators appear in the distance, and there are nodes of trees and buildings that are towns and small nodes of trees and buildings that are farm sites. Everything is connected by roads and powerlines, and there are airstrips scattered throughout. Take the same mental image, apply it to the flat, treeless coastal plain in Arctic Alaska, and you can quickly get a sense of how oilfields lie and appear on the land.

It is unavoidable that industrial-scale oilfields require a huge and extensive infrastructure. According to the National Research Council, development and production of oil in the central Arctic, starting with the original field at Prudhoe Bay, has resulted in 115 gravel drill sites or pads, 20 pads with processing facilities, 115 pads with other support facilities (for example, power stations, camps, and staging pads), 91 exploration sites, 13 offshore exploration

islands, 4 offshore production islands, 16 airstrips, 4 exploration airstrips, 1395 culverts, 596 miles of roads and permanent trails, 1690 miles of pipe, and 210 miles of transmission lines. All told, more than 17,000 acres are directly affected, and these acreages are spread across parts of about a thousand square miles of land.

To be fair, as the technologies for oil exploration, development, and production have improved, the industry's "footprint" on the land has been reduced. For example, the Alpine complex of drill sites, just west of the Colville River, is a state-of-the-art facility, not presently connected by roads to other central Arctic oilfields. Currently, two drill pads, connected by a road, occupy less than 200 acres. However, the industry now proposes at least five more drill pads, and possibly many more will follow. All of these must be linked by some combination of roads and pipelines, with accompanying airstrips and other facilities. The inevitable result is a spiderweb of infrastructure that sprawls across the landscape in a configuration dictated by geology and economics, not by birds and the environment.

In 2001, proponents of drilling for oil in the Arctic Refuge tried a new ploy, which was to say that the footprint of oil development in the coastal plain would be limited to 2000 acres. Even 2000 acres would be too much for those who believe that the Arctic Refuge coastal plain should be completely free of development. Unfortunately, the so-called 2000-acre limit is a cynical myth. As first proposed in the U.S. House of Representatives, the 2000 acres would only include areas directly covered by gravel, not including roads and pipelines. Only the vertical support members holding up the pipeline would count against the 2000-acre cap. And the borrow sites from which the gravel would be mined also would not be included.

Most significantly, there would be no requirement that the 2000 acres of oilfields must be in a contiguous block. In other words, there could be multiple Alpine-like sites connected by roads, pipelines, and powerlines scattered across the coastal plain of the Arctic Refuge. This would destroy the coastal plain's wilderness qualities and, recalling that the influence of oilfields and all the associated activities extend far beyond the immediate gravel footprint, have a profound impact on its birds and other wildlife.

IMPACT ON BIRDS

Direct losses of bird habitat due to development of oilfield infrastructure may alter bird distributions. There is no evidence that displaced birds simply nest elsewhere, nor are there good data on the population-level effects of these habitat losses on individual bird species. One study estimated reductions of 5 to 18 percent in numbers of shorebirds nesting within the perimeter of the Prudhoe Bay oilfield, but this work did not address the question of their fate or the ultimate impact, if any, on their populations. Another study indicated that

nests of Tundra Swans are located farther from oilfield infrastructure than the nests of other waterfowl.

One key difference between the Prudhoe Bay/central Arctic oilfield area and the Arctic Refuge is that there is much less coastal plain habitat in the Arctic Refuge. Hence, for birds dependent on low, wet habitats, there is less available in the way of alternative habitats. On the other hand, if oil and gas infrastructure is specifically placed on drier terrain to avoid wetlands, there could be disproportionate effects on birds, such as Buff-breasted Sandpipers, that prefer drier habitats.

Unfortunately, the effects of oilfield infrastructure extend far beyond the immediate footprint of the facilities. For example, dust from roads can speed snowmelt in the spring, which may encourage early nesting by small birds, possibly to their detriment. Roads and placement of gravel pads on the tundra can alter the flow of water and create ponds or deeper water, which then affect birds in and around those habitats.

Most importantly, placement of oilfield facilities ultimately fragments what had been extensive, unbroken blocks of habitat for wildlife. From the standpoint of birds, two of the most conspicuous examples of this extended influence are the human activity associated with oilfields and enhanced predator populations.

■ ■ ■

Industrial oilfields are bustling with activity by people, trucks, airplanes, helicopters, barges, and boats. Different species of birds react differently to

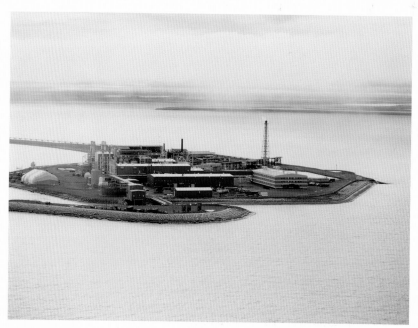

Offshore oilfield

disturbance, depending on the nature of the disturbance, specific circumstances, and season of occurrence, and there is some ability to habituate to disturbance in some situations. For example, a Pacific Loon may be comfortable with truck traffic passing the tundra lake on which it nests, while a group of workers on foot at the wrong time and place might well cause it to abandon its nest, especially in early stages of breeding activity.

One of the most pervasive and unavoidable disturbances around oilfields is aircraft, both fixed wing and helicopters. The more remote a site, the greater the reliance is on aircraft to monitor pipelines and to move people and materials, especially in the summer months. Sometimes the level of activity by aircraft is very high. For example, between June 1 and July 15, 2000, during the height of the bird-nesting season, there were nearly 2000 airplane and helicopter take-offs and landings from the Alpine airstrip. As with other types of disturbance, there is some ability to habituate to aircraft, but conditions vary widely. For example, the noise of a low-flying helicopter on a day with low ceilings can wreak havoc, while a high-flying fixed-wing airplane on a sunny day may warrant hardly a glance from a bird on the ground.

Molting waterfowl, such as the Brant and other geese that gather north of Teshekpuk Lake each summer, are highly vulnerable to disturbance, especially by aircraft. Within the Arctic Refuge, there is major concern about the hundreds of thousands of Snow Geese that gather on the coastal plain each fall to graze on cottongrass and build fat reserves for their migration to wintering grounds in the southern United States and Mexico. Like the molting geese, these staging birds are highly sensitive to disturbance, and birds that are displaced from prime feeding habitat or are frequently flushed may be less fit for migration

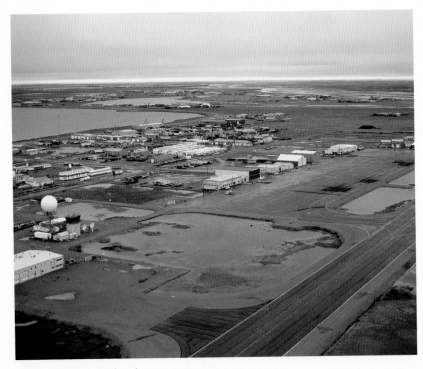

Development on wetland tundra

and experience reduced winter survival. The U.S. Department of the Interior estimates that oil development could displace Snow Geese from as much as 45 percent of their preferred feeding habitat within that portion of the Arctic Refuge that is proposed for oil development.

Human food wastes and structures attract predators such as Common Ravens, Glaucous Gulls, arctic foxes, and grizzly bears and may enhance their populations through increased survival. In turn, these predators may have an impact on nesting birds and their eggs and young. There are few hard data on predator populations or their impact on birds in North Slope oilfields and even fewer baseline, pre-oilfield data with which to compare.

In the case of ravens, we know that they were relatively rare on the North Slope prior to oil development, and Audubon Christmas Bird Counts document a dramatic increase in numbers of wintering birds since counts began at Prudhoe Bay in 1987. Typically, ravens nest in trees or on cliffs and in rocky areas, but not out on open, low ground. Oilfield facilities, however, have provided structures on which to place nests and have given ravens access to food and warmth during the cold winters.

According to the National Research Council, increased predation is the most apparent effect of oil development on birds that nest in oilfields. For example, at Howe Island, near the Endicott Causeway northeast of Prudhoe Bay, predation by foxes and bears appears to be responsible for low nest success and even complete failures in a colony of Snow Geese from 1991 through 2001.

Currently there is research underway at several sites across the North Slope looking at predation on nesting shorebirds. Only preliminary results are available, but this study should yield valuable data on predation levels in and around oilfields versus sites where there presently is no oilfield infrastructure.

OIL SPILLS

On average, there are more than 400 spills of oil and other toxic substances in and around North Slope oilfields annually. Most of these are small, but some are quite large. In April 2001, for example, more than 92,000 gallons of crude oil and saltwater were spilled onto the tundra in the Kuparuk oilfield, west of Prudhoe Bay. These spills can degrade bird habitats, and there is concern about the persistence of toxins released through spills and emissions into the air.

Oil is toxic to birds. Even small amounts of oil will destroy the insulating capacity of feathers, and birds or embryos (in eggs) that come into contact with oil usually die.

The greatest risk to birds in the Arctic Refuge due to oil is from a spill reaching coastal lagoons or near-shore waters. This might occur due to an accident with a supply barge or the rupture of a pipeline crossing one of the many rivers that run north from the Brooks Range and empty into the Beaufort Sea. As an example of the potential magnitude of such a spill, in 1979 the Trans-Alaska Pipeline ruptured and spilled 63,000 gallons of crude oil into the Atigun River.

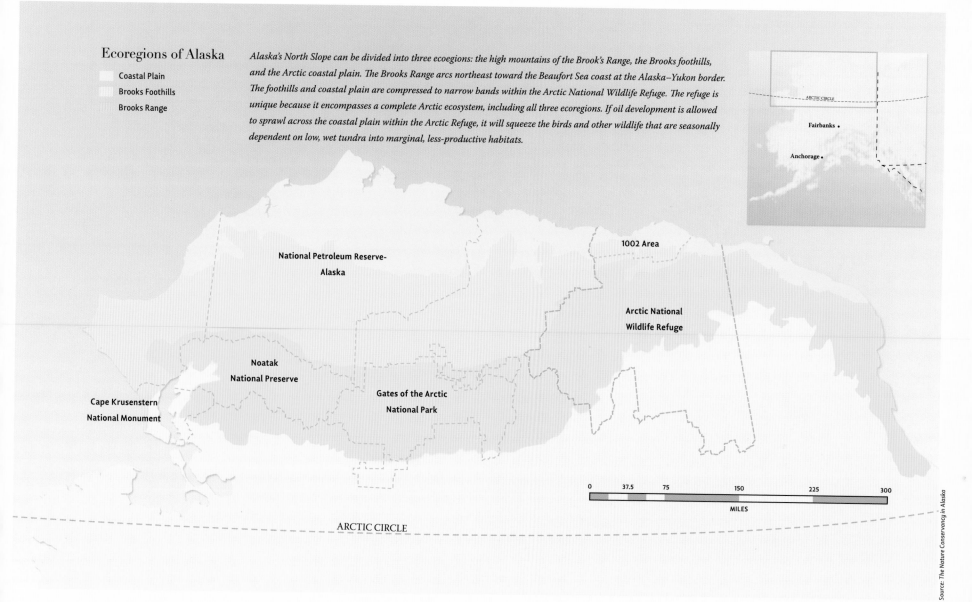

Ecoregions of Alaska

Coastal Plain
Brooks Foothills
Brooks Range

Alaska's North Slope can be divided into three ecoegions: the high mountains of the Brook's Range, the Brooks foothills, and the Arctic coastal plain. The Brooks Range arcs northeast toward the Beaufort Sea coast at the Alaska–Yukon border. The foothills and coastal plain are compressed to narrow bands within the Arctic National Wildlife Refuge. The refuge is unique because it encompasses a complete Arctic ecosystem, including all three ecoregions. If oil development is allowed to sprawl across the coastal plain within the Arctic Refuge, it will squeeze the birds and other wildlife that are seasonally dependent on low, wet tundra into marginal, less-productive habitats.

Fairbanks

Anchorage

1002 Area

National Petroleum Reserve-
Alaska

Arctic National
Wildlife Refuge

Noatak
National Preserve

Gates of the Arctic
National Park

Cape Krusenstern
National Monument

| 0 | 37.5 | 75 | 150 | 225 | 300 |

MILES

ARCTIC CIRCLE

Source: The Nature Conservancy in Alaska

If crude oil were to reach the coast at the wrong time at such places as Camden Bay or Beaufort Lagoon, tens of thousands of molting Long-tailed Ducks, King Eiders, and other water birds would be at risk. In addition, the deltas of the Canning and other rivers, and various coastal marshes and meadows, are areas of concentration for thousands of migrant shorebirds, which would be highly vulnerable to spilled oil, especially if driven by strong winds.

The *Exxon Valdez* oil spill in 1989 killed more than 250,000 marine birds, including many waterfowl and loons such as those that use the Arctic Refuge. The *Exxon Valdez* oil spill and its impacts on birds and other wildlife will stand forever as an example of what can happen when we rely on promises and technology to protect the environment. We cannot afford to make this same mistake in the Arctic Refuge.

CUMULATIVE EFFECTS AND CLIMATE CHANGE

Over time, the impacts of development don't occur in isolation from each other nor from the environment. This tendency for impacts to accumulate and interact with each other and with the effects of natural change in the environment is called "cumulative impacts." There is much concern about cumulative impacts with respect to oil and gas development across the North Slope. One example would be the construction of a road, which has very immediate impacts on the environment, such as covering the tundra with gravel and reducing habitat available for nesting birds. Over time, however, changes in the area's hydrology and snowmelt patterns result in changes in the distribution of water and the composition of vegetation, which, in turn, result in changes to small-mammal and bird populations. In the end, the impacts are far greater and more prolonged than those of the road itself.

By far the greatest long-term concern about cumulative impacts on the North Slope is the interaction of global warming and oil and gas activities. It is widely recognized that the effects of global warming—due in large measure to the burning of fossil hydrocarbon fuels—are becoming evident most quickly and obviously in the Arctic. Rising temperatures are resulting in rising sea levels, retreating Arctic pack ice, and thawing permafrost. Impacts on wildlife

and their habitats are not entirely certain, but for the wildlife of the Arctic coastal plain, the changes cannot be good.

A primary concern as it relates to interactions between global warming and petroleum development is shifting vegetation zones. Rising temperatures encourage the growth of taller, denser, woody vegetation. Boreal forests will extend north, and areas that are now vegetated by fine grasses and sedges will be invaded by willows. This is a fundamental problem for the birds that nest, molt, and stage on the open tundra of the Arctic coastal plain. Taller, woody vegetation conceals predators, reduces the extent of nesting habitats, and may change the composition and availability of insects and other foods. At the same time, the physical extent of the coastal plain may simply shrink due to coastal erosion from the rise in sea level.

If vast oilfield complexes are superimposed on this already-changing landscape, whether in the Arctic Refuge or in the NPR-A to the west, it is easy to foresee that habitat available for the birds of the coastal plain will shrink and be degraded. Birds with more specialized habitat requirements, such as molting geese in the area north of Teshekpuk Lake, will suffer the most. Reduced populations and conceivably the extinction of some species whose populations already are small may follow.

PROTECTED AREAS

Given the certainty of North Slope ecological change induced by global warming and the continued expansion of the petroleum development, there is a need to identify ways to avoid, reduce, or mitigate negative effects. Planning for ecological change, however, requires an understanding of the sources and nature of the changes, which is complicated by the lack of a system of scientific control areas—free or largely free of the influence of petroleum development—across the North Slope. It will be difficult, if not impossible, to tease apart the effects of global warming and the petroleum industry when there are no sizeable areas free of oil and gas activity.

At present, there is a single Long Term Ecological Research site established by the National Science Foundation at Toolik Lake, which is in the foothills of the Brooks Range more than a hundred miles south of Prudhoe Bay. In its 2003 assessment, "The Cumulative Environmental Effects of Oil and Gas Activities on Alaska's North Slope," the National Research Council recommended establishment of similar protected areas in comparable areas within and outside industrial zones across the North Slope.

The possibility of seeing oilfield infrastructure across the entire North Slope coast, both on- and offshore, underscores the fact that there is no strategy in place for a network of even representative protected control areas—to say nothing of large-scale wilderness—in the Arctic. It also underscores the paramount importance of the opportunity for landscape-scale conservation in the Arctic Refuge and its coastal plain. The coastal plain of the Arctic Refuge—most of which is proposed for leasing by the Bush Administration—may be the best, if not the only, chance to preserve a significant portion of this ecoregion and to do so as part of a larger, wild Arctic ecosystem.

Common Ravens and nest

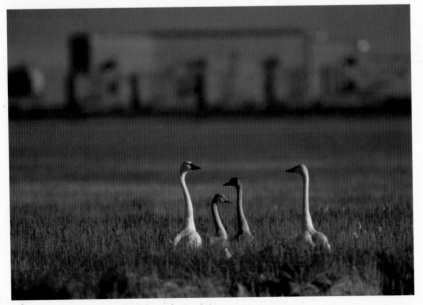

Tundra Swans, Prudhoe Bay / Opposite ■ Industrial infrastructure on coastal tundra, Prudhoe Bay

Photo: John Schoen

STAN SENNER *is executive director and vice president of Audubon Alaska. He has more than thirty years of experience in ornithology and in the fields of natural resources and wildlife conservation policy. Senner served as the science coordinator for the Anchorage-based* Exxon Valdez *Oil Spill Trustee Council.* ■

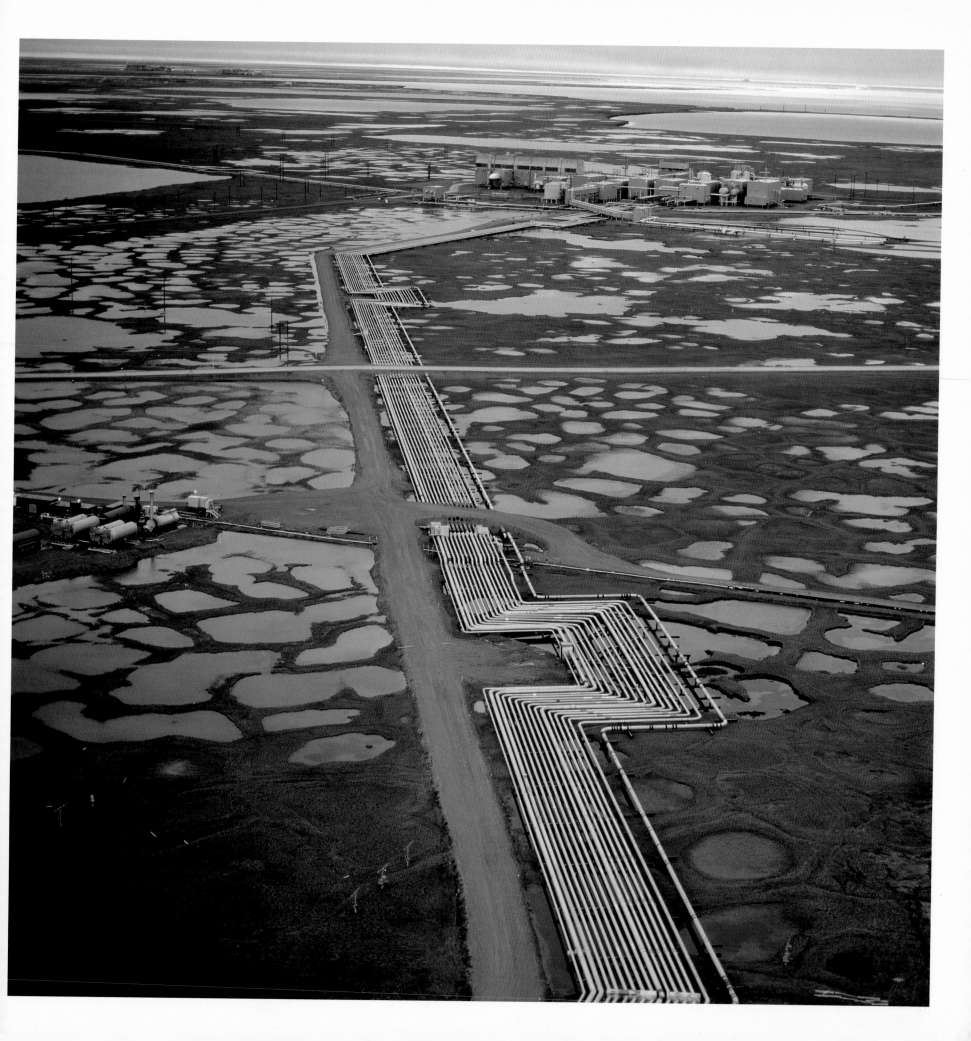

There's a certain look to the sky here, a brightness above the horizon that reflects the nearness of water. It would tell me (if I didn't know already) that just beyond this low rise, just out of sight, is the edge of the sea. I had seen this kind of light this summer on the coastal plain of the Arctic National Wildlife Refuge, but that's not where I am now. The wheel of the seasons has made a quarter-turn from summer; it is September, and I am far to the east and south of the Arctic Refuge, on a barrier beach in the Carolinas.

In making this shift in geography, I am not alone. Out on the open flat in front of me are three Buff-breasted Sandpipers, exquisite small birds with soft colors and subtle feather patterns, walking about with quick, delicate steps. They are migrants, probably just arrived from nesting grounds far above the Arctic Circle. I might have seen the parents of these very birds when I was in the Arctic Refuge in June. But not these individuals: At that time, they were not yet alive. The crisp feather edgings of these sandpipers show that they are juveniles, hatched just this summer. These birds first saw daylight less than three months ago, tested their wings and took their first tentative flights less than two months ago, and now they have already picked up and flown at least 3000 miles to the east and south. What's more, this is only a temporary stopover on their journey. They still have more than 4000 miles to go before they reach their winter quarters on the pampas of southern South America.

To anyone not versed in bird lore, it seems unbelievable that such travels should be undertaken by these small creatures that weigh only a couple of ounces each and that have seen fewer than a hundred days so far. To me, the most remarkable thing about this phenomenon is that it is not at all unusual. Every Buff-breasted Sandpiper in the world is engaged in this same journey right now, and so are major populations of a score of other shorebird species. Today on the Carolina coast I have seen Pectoral Sandpipers, Stilt Sandpipers, Lesser Yellowlegs, White-rumped Sandpipers, American Golden-Plovers, and a variety of others that have come from the high Arctic. Hundreds of thousands of individual birds follow this route that spans the length of the Americas. They fly east across Canada and then turn southward to cross the eastern United States or the open waters of the Atlantic, and then the dark jungles of the Amazon Basin, arrowing south to the temperate climates of southern South America. During what would be the northern winter, every wet meadow and coastal flat in Argentina hosts a reunion of birds from the Arctic.

. . .

I don't know if those wintering shorebirds ever dream of the Arctic when they are half a world away, but I can't help but think about the forces that will pull them back north in the spring. Their journey is a pragmatic one. They leave in fall because they could not survive the Arctic winter, and they return in spring to partake of the explosion of life in the Arctic summer. The Arctic coastal plain in summer is overflowing with life, an abundance that makes it fully worth the effort for these sandpipers and plovers to fly 8000 miles to be able to raise their young there. On the Arctic coastal plain, anyone interested in the real world gives thanks for the nonstop daylight in summer that makes it possible to try to take it all in: the countless small flowers of the tundra, the butterflies and bumblebees and myriad lesser insects, the lemmings and foxes and caribou, the ducks and loons on every pond, the song-flights of birds overhead, the feverish activity of life racing to create another generation while summer lasts.

Yes, this is the same scene that a few politicians have referred to as a "wasteland." But we know better.

It's September now, and that peak of summer activity is past. Birds that were neighbors on the Arctic Refuge in June are now dispersing to the four winds. To be sure, many other sandpipers and plovers are paralleling the journey of the Buff-breasted Sandpipers that I am watching now. Some of them will wind up at the same Argentinian destinations. But others will be scattered from the coasts of the United States right down to Tierra del Fuego.

The Snowy Owls that shared the tundra with these sandpipers probably have not even left the refuge yet; some of these big, ghostly predators will wander the Arctic coastal plain all winter, gliding in silence over the white wilderness, while others will drift over remote regions of central Alaska and Canada. Among the smaller birds, Snow Buntings and redpolls may stay through the winter but a little farther south in Alaska. Lapland Longspurs, those musical little buntings of the tundra, will move east and then south, congregating in winter in flocks of thousands that swirl over plowed fields on the Great Plains.

Swimming birds must leave the Arctic Refuge for the winter to find open water. Loons and scoters and Brants will be moving by now, mostly heading to coastal or offshore waters farther south. Some of the geese and ducks, such as Greater White-fronted Geese and Northern Pintails, are now on their way south through prairie regions in the center of the continent to winter in coastal marshes of Texas and Louisiana. But the King Eiders—stocky, hardy, incredibly tough sea ducks—may simply move far offshore instead of moving south, their flocks congregating in narrow open leads in the shifting pack ice of the Bering Sea.

Other birds that have moved out to sea may be heading south beyond the equator. Phalaropes, those nonconformist little swimming sandpipers, have now traded in their richly colored breeding plumage for soft winter shades of blue-gray and have disappeared out over the waves. They may be aiming for the Humboldt Current, off the west coast of South America. Jaegers have gone back to practicing their piracy on the high seas, and while some Pomarine Jaegers and Parasitic Jaegers may tarry offshore from California,

the Long-tailed Jaegers will have headed for deep midocean waters of the Southern Hemisphere.

Thus, during the off-season, birds from the Arctic Refuge may be dispersed over half the globe, from the pack ice of the Bering Sea to the pampas of Argentina, from open plains of Kansas to ocean currents south of Africa. When all those birds return next spring, the tundra will be crowded. The Arctic may look vast on a map, but it is a finite landscape after all, and during the spectacular burst of summer activity it seems that every acre is crucial, every acre is filled to the brim with life.

Unfortunately, many of those acres are under siege. Underneath this land there may be deposits of petroleum, built up over millions of years. Powerful interests want to extract it—at great expense and with massive destruction at the surface—so that it can be burned up in a few minutes in ostentatious suburban trucks, jet skis, riding lawnmowers, race cars that run endlessly around circular tracks, and other devices of similarly dubious value. Extracting the oil will mean temporary profits for a few, attended by habitat destruction that will take centuries to heal, even longer. In today's world, dollars often speak louder than sense, so those of us who oppose this mindless destruction are often under attack from those who hope to profit from it. When big government and big business are aligned together against the natural world, it can be terrifying for mere citizens to stand up and speak the truth.

I am thinking about this as I stand on this coastal strand, far from the Arctic Refuge, marveling at these sandpipers that already have traveled thousands of miles through the September sky. They seem so matter-of-fact as they forage among the beach grass, as if they are oblivious to the magnitude of their journey. It's just their fate: They simply must fly or die. From the Arctic to Argentina, then back again next spring, it is a round trip they must repeat every year until their strength falters and they perish. If we tried to think of their travel in human terms it would become unfathomable, a challenge of monstrous proportions, requiring impossible levels of stamina, strength, commitment, even courage and faith. I find myself wondering if I could ever be strong enough or brave enough to be one of these little sandpipers; wondering, too, what will happen when these birds return to the Arctic next spring.

Will there be a place for them? Will they perform this impossible feat of migration, surmount the challenges, survive the dangers, and then come back to find that there is no room for them to nest because their refuge has been violated and the tundra has been destroyed? Or will we succeed in protecting the Arctic National Wildlife Refuge from desecration? We face challenges, it's true, but they hardly compare to the challenges overcome by the birds in their migrations. If we know the truth, we have a responsibility to fight for the land that these birds need for their survival.

Common Redpoll

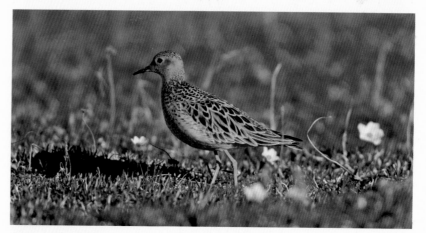

Buff-breasted Sandpiper

Photo: Kimberly Kaufman

KENN KAUFMAN, *best known for his* Focus *series of bird guides, is one of the most popular birding authors in the country. He is field editor for* Audubon *magazine and a regular contributor to numerous birding magazines. A devoted conservationist, he works vigorously to promote the appreciation and protection of nature. Other books in his field guide series include the* Kaufman Focus Guide to Butterflies *and the* Kaufman Focus Guide to Mammals. *He also wrote the* Peterson Field Guide to Advanced Birding, Kingbird Highway, *and* Lives of North American Birds. ◼

Birders in the Scope by Cynthia D. Shogan

Twenty-three years later I still vividly remember her tall body swirling into the Sierra Club's Washington, D.C., office bearing homemade pound cake and greeting each of us with a squeal of southern-drenched glee. Hailing from Auburn, Alabama, Carolyn Carr frequently found herself drawn to Capitol Hill like a moth to the flame to lobby her congressional delegation, to testify on wilderness legislation, and to mentor Sierra Club activists who were experiencing Washington, D.C., for the first time.

When I first met Carolyn, her kind face seemed familiar. I learned that Carolyn was one of the hundreds of volunteers from across the country who worked tirelessly on what became the most comprehensive conservation bill ever enacted into law—a wildly successful law that yet reflected difficult compromises, including placing the coastal plain of the Arctic Refuge in political limbo: the Alaska National Interest Lands and Conservation Act. Carolyn gave all she had and whatever was asked to the campaign to pass the Alaska Lands Act: endless hours of phoning, recruiting activists, and, perhaps most memorably, lending an uncharacteristically calm presence on a television talk show in Jason, Alabama—sandwiched between a belly dancer and a revival preacher.

Carolyn's interest in the outdoors flourished while she attended college in Tucson. Her landlords, who were local Audubon officers, had observed early on how much time she spent hiking around Tucson, and for her birthday they presented her with her first birding guidebook—the *Peterson Field Guide to Western Birds*. She dutifully toted it around with her and gradually became aware of the world of birds. Between classes and volunteering for the Southern Arizona Hiking Club, she was coerced into taking a local Girl Scout troop on a week-long camping trip in the Chiricahua Wilderness. On the fifth morning she awoke from her light sleep to the agitated sounds of strange adult voices nearby. Remembering that there had been sign of bears along the hike, she catapulted out of the tent and sprinted to the small crowd of adults. Panting, she asked, "Is there a problem?"

"Nothing is wrong," they said. Then they pointed to a huge patch of wild Missouri iris, where a bird was flitting about. Carolyn couldn't believe that the bird, which she could easily make out without binoculars, was a hummingbird. The bird watchers showed Carolyn, and later all her Girl Scouts, their first Magnificent Hummingbird.

. . .

Jack Biscoe's name is mentioned almost synonymously with that of former Senator Cohen and now the current senators from the Pine Tree State. For many years—almost as long as Americans have been fighting to keep oil development out of the coastal plain of the Arctic National Wildlife Refuge—Jack has been quietly, unassumingly, and consistently pressuring the senators of Maine to protect the Arctic.

Jack is an old-fashioned letter writer. Has been writing to his senators since 1989 and hasn't seen any reason to stop. In 1980, he and a few volunteers created the Alaska Coalition of Maine. There were just a few folks at first, many of whom didn't have computers, and many of whom he still hasn't met. Jack would call them up to give them the latest political update on the status of the Arctic Refuge, and then they, too, would write letters to their senators. He has a friend who helps him type their newsletter. Jack's list of letter writers now numbers in the hundreds. The senators from Maine know and respect Jack. He has become a pen pal with portfolio.

In college, a friend of one of Jack's professors invited students to Southeast Alaska to tag and count salmon. Jack was literally and figuratively hooked. As he tells it, Alaska became "part of his blood." Every few years he managed to return to Alaska through summer assignments with the Fish and Wildlife Service or working on his friends' trawler.

When the *Exxon Valdez* ran aground in March of 1989, Jack's life changed forever. He frantically called around to his contacts in Alaska and the Lower 48 wanting to assist in the cleanup. The first week his friends told him to wait; the community couldn't handle the 500 volunteers. The second week, there were a thousand. Finally, in September of 1989, Jack was able to lend his hand to the recovery effort.

Jack was shocked by what he saw. He couldn't believe the devastation wrought by the horrific accident—the foolishness of it, and the death of wildlife and birds. Hundreds of thousands of marine birds were killed—murres, Marbled Murrelets, Harlequin Ducks, scoters, goldeneyes, cormorants, and so many others. An Alaska Native elder observed that they "would never had thought it was possible for the water to die."

Back at home, Jack still couldn't believe what he had seen, and it moved him to become politically engaged. He wrote his first letter to Senators Snowe and Cohen urging them to prevent future tragedies by requiring that the companies use double-hulled tankers. Then Jack had an "aha" moment. "It was all about what was at the other end of the pipeline—the Arctic. That's how I got involved," he explained.

. . .

Both Jack and Carolyn laugh when asked how much time they devote to protecting the Arctic. Jack suggests that I "ask his wife and she'll say twenty-four

hours a day." Jack claims he has the time because he's retired but fails to mention that he and his wife also own and run an antique business. Carolyn acknowledged that she was able to devote countless hours to the cause only after she quit her job at Auburn University and opened her own consulting business. Both began their volunteer work modestly and on their home turf—Jack cranking out the weekly if not daily letters, Carolyn testifying at local hearings to protect a favorite wilderness spot in Arizona.

Carolyn said, "Once you've done one thing, you realize that you don't drop dead and can really do these things." One experience leads to another. Sierra Club leaders saw the potential for volunteer leadership and gently pushed Jack to do more; Carolyn never needed an invitation to be at the center of the action. In 1977, a woman named Pam Ridge called Carolyn up and asked her to volunteer "a year or two" to work on the Alaska Lands Act. The act was signed into law three years later. When environmental lobbyists in D.C. realized that the senators from Maine would only speak to Jack and no one else, he was invited to D.C. to participate in numerous Arctic Wilderness Weeks. These twice-yearly events train eighty activists from around the country on the political nuances of the Arctic campaign and how to lobby their representative and senators. The "Mainers" always welcomed Jack, and all the activists learned from Jack's example that one person can make a difference.

Perhaps environmentalists and birders are "by nature" optimists or at least adept at learning from life experiences. Reflecting on the low point of his Arctic activism, Jack believes his worst moment was also his highest. By experiencing the devastation from the *Valdez* oil spill, Jack literally was shocked into activism. It was a life-changing experience. Neither Jack, nor anyone else, as it turned out, could ever permanently remove the stinking, oozing oil from the beach at Bligh Reef, but he could do something to prevent future tragedies in sensitive areas such as the coastal plain of the Arctic National Wildlife Refuge. The "low point was seeing the oil—same time it tipped me off dead-center. I had never written to my congressman at all—never had—and I came home and wrote my senators and have been doing it ever since."

It was with great trepidation that Carolyn entered the office of the Dean of the Alabama delegation, the Cardinal of the Public Works Committee Representative Tom Bevill. They had locked horns over the largest pork-filled water project, the infamous Tennessee-Tombigbee. Bevill politely said, "If you promise not to beat me up, I would be happy to talk to you." Carolyn meekly replied that she wouldn't, and they had a very frank and revealing conversation. Congressman Bevill said that he was very interested in the Alaska Lands Act, and that Representative Don Young, from Alaska, had spoken to him repeatedly about the legislation. But, honestly, he had not heard from one single constituent from his congressional district about the issue. This might

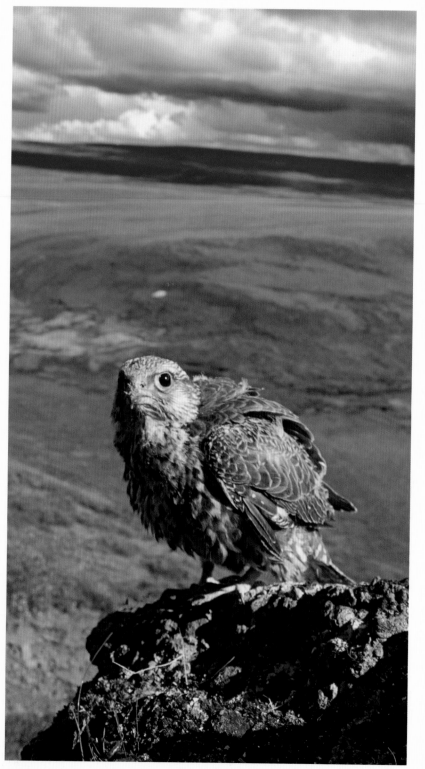

Gyrfalcon

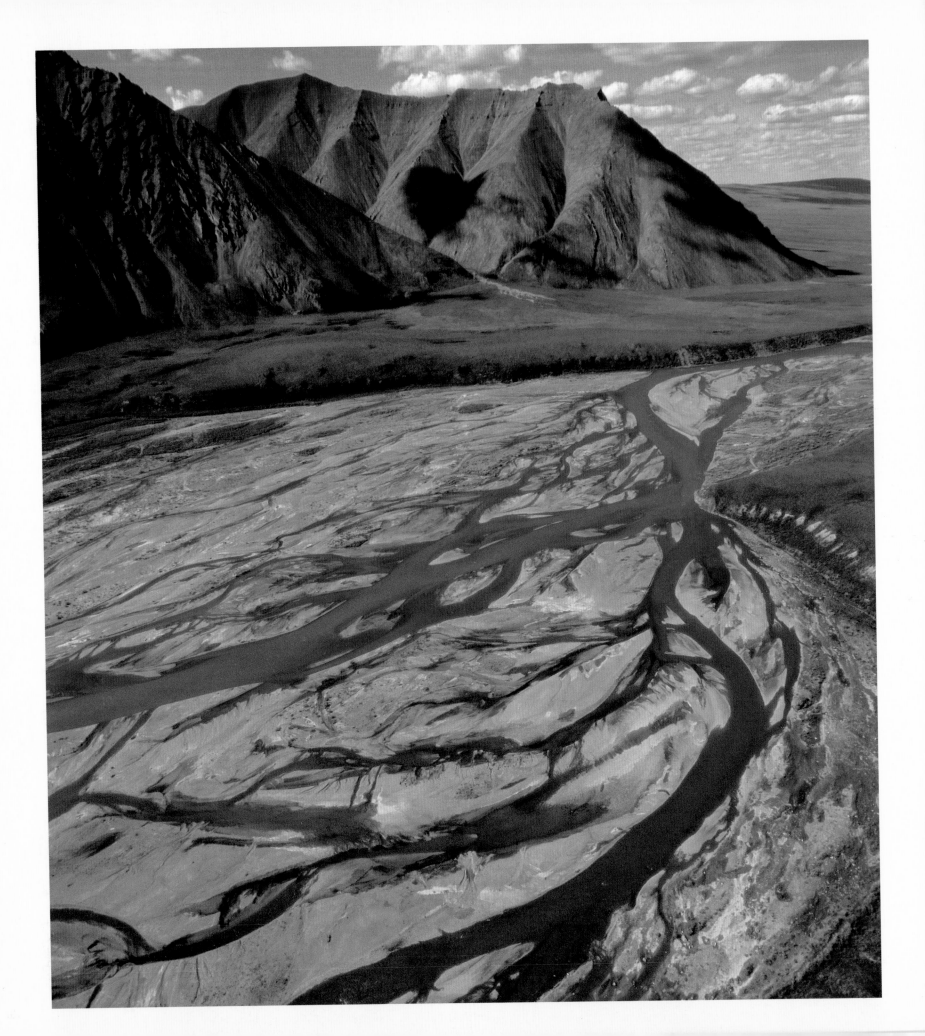

have been a low point—it certainly was a tense one—but Carolyn left her meeting with Congressman Bevill thinking, "Oh, wow—I can really use this in the future. It helps me understand how to organize and that it is never too early to organize." Carolyn immediately contacted all ten of the Sierra Club members in Representative Bevill's district and held a workshop on how to lobby, and devised a phone-tree to generate calls and letters in support of the Alaska Lands Act.

According to Carolyn, the connection between being a bird watcher and working to protect the Arctic is the easiest connection in the world to make. The most obvious connection is that a majority of the birds people love to watch are migratory. The next connection is the realization of the importance of protecting the Arctic habitat for these precious summer residents. In describing the importance of the Alaska Lands Act, all Carolyn had to do was show folks pictures of the Copper River Delta and the birds that fly there. As Carolyn says, in her endearing southern accent, "It really becomes very immediate, even though it's far away." And, she continued, you know that "birders are always talking about where the birds are going or coming from." Carolyn even knows a local Republican politician whose bird watching led to getting involved in protecting the environment. The politician became disappointed in her party's lack of conservation ethic, so she switched parties and became a Democrat.

Another connection that Carolyn has observed over the years is one between protecting the distant Arctic habitat to becoming actively involved in saving habitat locally—perhaps a reverse NIMBY (Not in My Backyard). Birders who devote their time and energy to protecting the distant habitat in the Arctic Refuge for the migrating birds may become even more committed to ensuring that the local stopping grounds also remain pristine. One of Carolyn's relatives, an avid birder, has become increasingly active over the years. "Can you picture it," Carolyn asks, "a grandmamma in her sixties leading a picketing group regarding a local land-use problem?" She never would have gotten involved if she hadn't been a birder.

■ ■ ■

All bird watchers, regardless of age, size, or field marks, have the necessary skills to be effective Arctic activists. It's a simple and logical step to extend birding skills to the campaign to protect the coastal plain of the Arctic National Wildlife Refuge.

Patience: Birders can wait indefinitely for that one unique warbler. Activists patiently apply endless pressure as they urge decision makers to vote to protect the Arctic.

Keen sense of observation: Birders observe the broader landscape for signs of potential bird activity, and they observe minute details of each bird to determine the species. Activists observe the political landscape for each member of Congress and observe what influences each member of Congress in choosing how to vote.

Listener: Birders can identify a bird by song. Activists listen and learn from their opponents.

Committed: Once they get started, birders are committed throughout their lifetime to getting up early, going where necessary, and doing what it takes to see that unique bird. Activists are committed to doing all it takes, from making phone calls to traveling to Washington, D.C., to protect the Arctic.

Flock together: Birders tend to bird in flocks, and birders flock together when a special bird is spotted. Activists know that in order to win the campaign to protect the Arctic, the flock has to grow.

■ ■ ■

As a bird lover and watcher, you already are an Arctic activist. Now take the next step: Contact your local conservation group and join up with the thousands of Americans who work to protect the Arctic National Wildlife Refuge.

CYNTHIA D. SHOGAN *is the executive director of the Alaska Wilderness League, which works to further the protection of Alaska's incomparable natural endowment through legislative and administrative activities, public education, and grass roots activism. In 2002 the Alaska Wilderness League was one of seven organizations to receive the inaugural Leadership Award from the Natural Resources Council of America for the environmental community's campaign to protect the Arctic National Wildlife Refuge. Shogan received the Wilburforce Foundation's Conservation Leadership Award in 2003.* ■

Opposite ■ *Canning River, Arctic National Wildlife Refuge*

We hope that this book has inspired you to take action on behalf of the birds of the Arctic National Wildlife Refuge. As threats to this last remaining Arctic wilderness continue to mount, your voice is increasingly important. While many other wildlife species have been the subject of much discussion, the birds of the Arctic Refuge have not been given the attention they deserve. You can help change this.

The organizations listed below are advocates for the protection of the Arctic National Wildlife Refuge. You can assist these organizations in many ways. Most depend on membership donations to support their work, and joining any of these groups will help protect the refuge. Most of these groups also depend on volunteers, and participating in this way can be extremely rewarding. Contact these groups to find out how you can help keep Arctic wings flying.

Alaska Coalition
122 C Street NW, Suite 240
Washington, DC 20001
Phone (202) 628-1843
www.alaskacoalition.org

Alaska Conservation Foundation
441 West 5th Avenue, Suite 402
Anchorage, AK 99501
Phone (907) 276-1917
www.akcf.org

Alaska Wilderness League
122 C Street Northwest, Suite 240
Washington, DC 20001
Phone (202) 544-5205
www.alaskawild.org

Audubon Alaska
715 L Street, Suite 200
Anchorage, AK 99501
Phone (907) 276-7034

Defenders of Wildlife
1101 14th Street Northwest,
 No. 1400
Washington, DC 20005
Phone (202) 682-9400
www.savearcticrefuge.org

Gwich'in Steering Committee
122 First Avenue, Box 2
Fairbanks, AK 99701
Phone (907) 458-8264
www.gwichinsteeringcommittee.org

National Wildlife Federation
11100 Wildlife Center Drive
Reston, VA 20190-5362
Phone (703) 438-6000
www.nwf.org/arcticrefuge/

Natural Resources Defense Council
1200 New York Avenue Northwest,
 Suite 400
Washington, DC 20005
Phone (202) 289-6868
www.savebiogems.org/arctic

Northern Alaska Environmental Center
830 College Road
Fairbanks, AK 99701
Phone (907) 452-5021
northern.org/artman/publish/

Sierra Club
85 Second Street, Second Floor
San Francisco, CA 94105
Phone (415) 977-5500
www.sierraclub.org/wildlands/arctic/

The Wilderness Society
1615 M Street Northwest
Washington, DC 20036
Phone (202) 833-2300
 (800) THE-WILD
www.tws.org/ourissues/arctic

The Wildlife Conservation Society
2300 Southern Boulevard
Bronx, NY 10460
Phone (718) 220-5111
www.wcs.org

U.S. PIRG
218 D Street Southeast
Washington, DC 20003
Phone (202) 546-9707
www.SaveTheArctic.org

FOR MORE INFORMATION ON THE ARCTIC REFUGE

Arctic National Wildlife Refuge
101 12th Avenue, Room 236, Box 20
Fairbanks, AK 99701
Phone (907) 456-0250
arctic.fws.gov

Manomet Center for Conservation Sciences
P.O. Box 1770
Manomet, MA 02345
Phone (508) 224-6521
www.manomet.org
www.shorebirdworld.org

National Wildlife Refuge Association
1010 Wisconsin Avenue NW, Suite 200
Washington, DC 20007
Phone (202) 333-9075
www.refugenet.org/

ACIA. *Arctic Climate Impact Assessment.* New York: Cambridge University Press, 2005, *www.acia.uaf.edu/pages/scientific.html.*

Baicich, P. J., and C. J. O. Harrison. *Nests, Eggs, and Nestlings of North American Birds.* 2d ed. Princeton, NJ: Princeton University Press, 2005.

Banerjee, S. *Arctic National Wildlife Refuge: Seasons of Life and Land.* Seattle: The Mountaineers Books, 2003.

Brackney, A. W. "Abundance and Productivity of Tundra Swans in the Coastal Plain of the Arctic NWR." In *Annual Wildlife Inventories: 1002 Area—Arctic NWR Annual Progress Report 1989,* edited by T. R. McCabe. Anchorage: U.S. Fish and Wildlife Service, 1990.

———. "Distribution, Abundance, and Productivity of Fall Staging Snow Geese on the Coastal Plain of the Arctic NWR." In *Annual Wildlife Inventories: 1002 Area—Arctic NWR Annual Progress Report 1989,* edited by T. R. McCabe. Anchorage: U.S. Fish and Wildlife Service, 1990.

Brower, K. *Earth and the Great Weather: The Brooks Range.* Friends of the Earth. New York: McCall Publishing Company, 1973.

Brown, S., C. Hickey, B. Harrington, and R. Gill, eds. *The U.S. Shorebird Conservation Plan.* Manomet, MA: Manomet Center for Conservation Sciences, 2001.

Cogwell, M. T. *Arctic National Wildlife Refuge.* Hauppauge, NY: Nova Science Publishers, Inc., 2002.

Douglas, D. C., P. E. Reynolds, and E. B. Rhode, eds. *Arctic Refuge Coastal Plain Terrestrial Wildlife Research Summaries.* U.S. Geological Survey, Biological Resources Division, Biological Science Report, 2002.

Garner, G. W., and P. E. Reynolds. *Final Report—Baseline Study of the Fish, Wildlife, and Their Habitats, Arctic National Wildlife Refuge Coastal Plain Resource Assessment.* Anchorage: U.S. Department of the Interior, Fish and Wildlife Service, 1986.

Hupp, J. W., and D. G. Robertson. "Potential Impacts of Petroleum Development on Lesser Snow Geese Staging on the Arctic Coastal Plain." In T. R. McCabe, ed., *Annual Wildlife Inventories: 1002 Area—Arctic NWR Annual Progress Report 1989.* Anchorage: U.S. Fish and Wildlife Service, 1990.

Johnson, S. R., and D. R. Herter. *The Birds of the Beaufort Sea.* Anchorage: BP Exploration (Alaska) Inc., 1989.

Kauffmann, J. M. *Alaska's Brooks Range: The Ultimate Mountains.* Seattle: The Mountaineers Books, 1992.

Kaufman, K. *Kaufman Field Guide to Birds of North America.* Boston: Houghton Mifflin Co., 2000.

———. *Lives of North American Birds.* Boston: Houghton Mifflin Co., 1996.

Lentfer, H., and C. Servid, comp. *Arctic Refuge: A Circle of Testimony.* Minneapolis: Milkweed Editions, 2001.

Lopez, B. *Arctic Dreams: Imagination and Desire in a Northern Landscape.* New York: Vintage Books, 2001.

Matthiessen, P. (text), Clem, R. V. (paintings). *The Shorebirds of North America.* New York: Viking, 1967.

Miller, D. S. *Flight of the Golden Plover: The Amazing Migration Between Hawaii and Alaska.* Anchorage: Alaska Northwest Books, 1996, *www.debbiemilleralaska.com.*

———. *Midnight Wilderness: Journeys in Alaska's Arctic National Wildlife Refuge.* Portland, OR: Alaska Northwest Books, 2000, *www.debbiemilleralaska.com.*

Morris, A. *Shorebirds: Beautiful Beachcombers.* Minocqua, WI: North Word Press, Inc., 1996.

Murie, M. E. *Two in the Far North.* Portland: Alaska Northwest Books, 1997.

National Research Council. *Cumulative Environmental Effects of Oil and Gas Activities on Alaska's North Slope.* Washington, DC: The National Academies Press, 2003.

Pielou, E. C. *A Naturalist's Guide to the Arctic.* Chicago: University of Chicago Press, 1994.

Rennick, P., ed. *Arctic National Wildlife Refuge.* Anchorage: Alaska Geographic Society, 1993.

Sibley, D. A. *The Sibley Guide to Bird Life and Behavior.* New York: Knopf, 2001.

———. *The Sibley Guide to Birds.* New York: Knopf, 2000.

Stap, D. *Birdsong: A Natural History.* New York: Scribner, 2005.

Truett, J. C., and S. R. Johnson, eds. *The Natural History of an Arctic Oil Field.* San Diego: Academic Press, 2000.

Weidensaul, S. *Living on the Wind: Across the Hemisphere with Migratory Birds.* New York: North Point Press, 2000.

———. *Return to Wild America: A Yearlong Search for the Continent's Natural Soul.* New York: North Point Press, 2005.

Williams, T. T. *The Open Space of Democracy.* Great Barrington, MA: The Orion Society, 2004.

Wohlforth, C. *The Whale and the Supercomputer: On the Northern Front of Climate Change.* New York: North Point Press, 2004.

All photographs were taken in the Arctic National Wildlife Refuge except as noted in parentheses.

Born in India in 1967, SUBHANKAR BANERJEE received his bachelor's degree in engineering before moving to the United States, where he obtained master's degrees in physics and computer science. Before starting his career in photography, Banerjee worked in the scientific fields for six years, with Los Alamos National Lab in New Mexico and Boeing in Seattle. His first professional photographic project culminated in a book, *Arctic National Wildlife Refuge: Seasons of Life and Land,* published by The Mountaineers Books. Solo exhibits of Banerjee's Arctic Refuge photographs have been on display at the Smithsonian National Museum of Natural History in Washington, American Museum of Natural History in New York, California Academy of Sciences in San Francisco, The Field Museum in Chicago, Burke Museum of Natural History and Culture in Seattle, Grand Rapids Art Museum in Grand Rapids, Museum of Utah Art and History in Salt Lake City, Gerald Peters Gallery in New York and Santa Fe, Wilding Art Museum in California, and other venues. Banerjee's photographs are represented exclusively by the Gerald Peters Gallery, Santa Fe–New York.

Photo credits: back cover and pages 8, 9, 19 (lower), 24–25, 28, 35, 41, 42 (lower), 53 (lower), 56–57, 59, 61, 64, 65 (left and right), 84 (lower), 86, 87, 91, 92–93, 107, 110–111, 128–129, 148–149, 153, 162–163, 168, 171, 173, 174, 176 (upper), 177, 179 (lower)

Growing up the son of an ice cream store owner and a schoolteacher in Valley Stream, New York, STEVE KAZLOWSKI craved a life pursuing nature. After earning a degree in marine biology from Towson University in Baltimore, he worked briefly for a marine lab before setting aside a microscope and picking up his camera. He headed to Alaska to become a wildlife photographer, initially working construction jobs and on fishing boats to support his dream. Kazlowski now works full time as an independent photographer. His images have been featured in *Audubon, Backpacking, Canadian National Geographic,* and *Time* magazines. Three books exclusively feature his photography: *Alaska Wildlife Impressions* (Farcountry Press, 2004), *Alaska Wildlife of the North* (Hancock House Publishing, 2005), and *Alaska Bears of the North* (Hancock House Publishing, 2005). He produces and distributes his own postcards and other print photographs, including via his website: *www.lefteyepro.com.* He resides in Seattle, Washington, in the winter and travels Alaska and the northeast throughout the year.

Photo credits: pages 1, 2–3 (central Arctic coast), 7, 12, 34, 36, 37, 39 (central Arctic coast), 42 (upper), 43, 44 (Interior Alaska), 46 (central Arctic coast), 47 (central Arctic coast), 49, 50 (left and right), 51, 52 (central Arctic coast), 53 (upper), 55, 62 (central Arctic coast), 67 (Denali National Park, Alaska), 68 (Kachemak Bay, south-central Alaska), 69 (upper and lower; both central Arctic coast), 78 (Semipalmated Plover), 80, 82 (Yukon, Canada), 83 (Wrangell-St. Elias National Park, Alaska), 88, 89, 90 (central Arctic coast), 96 (lower), 97 (lower), 101 (central Arctic coast), 102, 103, 108 (left and right), 109 (Kenai Fjords National Park, Alaska), 113 (Anchorage), 117, 118 (left; central Arctic coast), 126–127 (central Arctic coast), 138, 139, 144 (Denali National Park, Alaska), 146, 147 (left), 151, 153, 154 (Kenai Peninsula), 155 (Kenai Peninsula), 159 (lower), 165, 166, 176 (lower; Prudhoe Bay, Deadhorse, Alaska), 181

MICHIO HOSHINO was born in Ichikawa City, Japan, in 1952. At the age of seventeen, a photo of an Eskimo village on the northwest coast of Alaska in a National Geographic magazine inspired him to explore the vast wilderness. During the summer of 1972 he traveled to Shishmaref, Alaska, to live with the town's mayor. Hoshino returned to Japan and went on to major in economics at Keio University. In 1978 he left his native Japan to live in Alaska, where he studied wildlife management at the University of Alaska. His professional career as a photographer began with the publication of *Grizzly* (Chronicle Books, 1986), which won an Anima award for distinguished wildlife photography. Other books of his photographic work include *Moose* (Chronicle Books, 1988) and *The Grizzly Bear Family Book* (North-South, 1994), a work for children. His photographs have been published in numerous American and international magazines. On August 6, 1996, at the age of 44, Hoshino was killed by a brown bear while sleeping in his tent during a photo expedition on the Kamchatka Peninsula, in eastern Russia. He is survived by his wife, Naoko, and his son, Shoma.

Photo credits: front cover and pages 45, 70–71, 79, 104, 115 (right), 121, 124, 125. All photographs © Michio Hoshino/Minden Pictures.

Photo: Marsh Polin / Birds as Art

With more than 20,000 of his images in publication, ARTHUR MORRIS is widely recognized as the world's premier bird photographer. For eight seasons he counted shorebirds at Jamaica Bay Wildlife Refuge, Queens, New York for the International Shorebird Surveys. *Shorebirds: Beautiful Beachcombers* was his first book, and his book *The Art of Bird Photography* is the classic how-to work on the subject. He is a popular *Photography* magazine columnist. Morris has been a Canon contract photographer for the past nine years. He currently travels, photographs, teaches, and speaks his way across North America while leading more than a dozen Birds as Art instructional photo tours each year.

Photo credits: pages 29 (Jamaica Bay Wildlife Refuge, New York), 31 (Nome, Alaska), 40 (Bosque Del Apache National Wildlife Refuge, New Mexico), 54 (Bosque Del Apache National Wildlife Refuge, New Mexico), 73 (Nome, Alaska), 75 (right; Barrow, Alaska), 95 (Nome, Alaska), 96 (upper; Nome, Alaska), 98 (Katmai National Park, Alaska), 99 (Nome, Alaska), 126 (left; Nome, Alaska), 131 (Nome, Alaska), 132 (lower; Churchill, Manitoba, Canada), 134 (upper; Churchill, Manitoba, Canada), 167 (Jamaica Bay Wildlife Refuge, New York), 170 (Point Pelee National Park, Ontario, Canada)

Photo: Lynn Bowers

HUGH ROSE received his bachelor's and master's degrees in geology from the University of Vermont, and after a ten-year career in geology that included teaching and geologic mapping, he moved to Alaska to explore and photograph the Arctic wilderness. He worked as a naturalist guide in Denali National Park for six years and since then has guided natural history trips from Alaska to Antarctica and places in between. Hugh's travels have taken him to the Arctic National Wildlife Refuge in all seasons of the year, and the refuge remains one of the most remarkable places he has ever visited. "Of all the places I have visited on earth, the Arctic National Wildlife Refuge is the most special to me and continues to draw me back, time and again," says Rose. "I hope we can have enough foresight to not squander this valuable wilderness resource for the sake of six months' worth of oil. The wilderness value of the refuge far exceeds its oil value in the twenty-first century, where solitude and natural beauty are more rare than oil deposits."

Photo credits: pages 11, 20 (left and right), 30, 38, 63 (Brooks Range), 66, 75 (left), 78 (Lesser Yellowlegs), 85 (lower), 106, 115 (left; just outside the refuge), 116 (right), 120, 123, 132, 134, 140 (also CD image), 141, 143, 145, 147 (right), 156, 157, 158, 159 (upper), 160, 161, 164 (left and right), 169

MARK WILSON loves to travel in the wilderness by canoe because, as a photographer, he's inclined to bring a lot of heavy photo gear on trips. Wilson has returned to the Arctic over and over again, drawn by the amazing light, the incredible birds, and its great sense of space and time. He and his wife, Marcia, both naturalists and avid birders, offer slide programs about the Arctic that include bringing a Snowy Owl to audiences in New England. Wilson, who once took second place in a World Press competition for a photo of a Great Gray Owl, is a staff photographer at the *Boston Globe*, where he has worked for twenty years.

Photo credits: pages 15 (Arctic Alaska), 17 (all), 19 (upper), 21, 22, 23, 48, 60 (upper and lower), 78 (Baird's Sandpiper), 85 (upper), 116 (left), 118 (right), 119, 122, 136, 142, 179 (upper), 182

The Arctic National Wildlife Refuge is a vast and isolated landscape where birdlife has been largely unphotographed. Important gaps in documentation for Arctic Wings *were filled by contributors who took photographs while in the refuge for research or exploration. We are grateful for the use of their images.*

STEPHEN BROWN: pages 78 (Pectoral Sandpiper), 84 (upper), 97 (upper)
ROBIN HUNNEWELL: page 78 (American Golden-Plover)
DEBBIE MILLER: pages 33, 105, 133, 137 (upper and lower)
BRAD WINN: 76, 78 (Pectoral Sandpiper nest, American Golden-Plover nest), 81, 135

Birds of the Arctic National Wildlife Refuge

Courtesy of Steve Kendall, Wildlife Biologist, U.S. Fish and Wildlife Service, Arctic National Wildlife Refuge

There are currently 194 bird species officially documented as occurring in the Arctic National Wildlife Refuge. This list was compiled over decades by refuge biologists and dedicated volunteers. Because many areas of the refuge are rarely or infrequently visited, information about the occurrence, distribution, and breeding status of birds is incomplete. The list of species changes continuously as more birders and scientists visit the refuge and report on the birds using the area. This list is organized following the standard taxonomic order used in most bird guides. In the Breeding Status column, *B* indicates that the species has been documented to breed in the refuge, and *P* indicates that the species is a probable breeder in the refuge. Those species without a letter indicator in this column do not breed here but depend to some degree on the refuge for part of their life cycle, such as stopping over during migration between breeding and wintering areas.

—*Stephen Brown*

Common Name	Scientific Name	Breeding Status
Greater White-fronted Goose	Anser albifrons	B
Snow Goose	Chen caerulescens	
Ross's Goose	Chen rossii	
Brant	Branta bernicla	B
Cackling Goose (Taverner's)	Branta hutchinsii	B
Canada Goose (Lesser)	Branta canadensis	B
Trumpeter Swan	Cygnus buccinator	B
Tundra Swan	Cygnus columbianus	B
Gadwall	Anas strepera	
Eurasian Wigeon	Anas penelope	
American Wigeon	Anas americana	B
Mallard	Anas platyrhynchos	B
Northern Shoveler	Anas clypeata	P
Northern Pintail	Anas acuta	B
Green-winged Teal	Anas crecca	B
Canvasback	Aythya valisineria	
Redhead	Aythya americana	
Ring-necked Duck	Aythya collaris	
Greater Scaup	Aythya marila	B
Lesser Scaup	Aythya affinis	B
Steller's Eider	Polysticta stelleri	
Spectacled Eider	Somateria fischeri	B
King Eider	Somateria spectabilis	B
Common Eider	Somateria mollissima	B
Harlequin Duck	Histrionicus histrionicus	B
Surf Scoter	Melanitta perspicillata	P
White-winged Scoter	Melanitta fusca	P
Black Scoter	Melanitta nigra	
Long-tailed Duck	Clangula hyemalis	B
Bufflehead	Bucephala albeola	
Common Goldeneye	Bucephala clangula	P
Barrow's Goldeneye	Bucephala islandica	
Smew	Mergellus albellus	
Common Merganser	Mergus merganser	
Red-breasted Merganser	Mergus serrator	B
Ruffed Grouse	Bonasa umbellus	P
Spruce Grouse	Falcipennis canadensis	P
Willow Ptarmigan	Lagopus lagopus	B
Rock Ptarmigan	Lagopus muta	B
Sharp-tailed Grouse	Tympanuchus phasianellus	P
Red-throated Loon	Gavia stellata	B
Pacific Loon	Gavia pacifica	B
Common Loon	Gavia immer	
Yellow-billed Loon	Gavia adamsii	
Horned Grebe	Podiceps auritus	P
Red-necked Grebe	Podiceps grisegena	P
Northern Fulmar	Fulmarus glacialis	
Short-tailed Shearwater	Puffinus tenuirostris	
Osprey	Pandion haliaetus	
Bald Eagle	Haliaeetus leucocephalus	B
Northern Harrier	Circus cyaneus	B
Sharp-shinned Hawk	Accipiter striatus	P
Northern Goshawk	Accipiter gentilis	B
Swainson's Hawk	Buteo swainsoni	B
Red-tailed Hawk	Buteo jamaicensis	
Rough-legged Hawk	Buteo lagopus	B
Golden Eagle	Aquila chrysaetos	B
American Kestrel	Falco sparverius	B
Merlin	Falco columbarius	P
Gyrfalcon	Falco rusticolus	B
Peregrine Falcon	Falco peregrinus	B
American Coot	Fulica americana	
Sandhill Crane	Grus canadensis	B
Black-bellied Plover	Pluvialis squatarola	B
American Golden-Plover	Pluvialis dominica	B
Semipalmated Plover	Charadrius semipalmatus	B
Killdeer	Charadrius vociferus	
Eurasian Dotterel	Charadrius morinellus	
Lesser Yellowlegs	Tringa flavipes	B
Solitary Sandpiper	Tringa solitaria	P
Wandering Tattler	Heteroscelus incanus	B
Spotted Sandpiper	Actitis macularius	B
Upland Sandpiper	Bartramia longicauda	B
Whimbrel	Numenius phaeopus	B
Black-tailed Godwit	Limosa limosa	
Hudsonian Godwit	Limosa haemastica	
Bar-tailed Godwit	Limosa lapponica	P
Ruddy Turnstone	Arenaria interpres	B
Surfbird	Aphriza virgata	B
Red Knot	Calidris canutus	
Sanderling	Calidris alba	B
Semipalmated Sandpiper	Calidris pusilla	B
Western Sandpiper	Calidris mauri	P
Red-necked Stint	Calidris ruficollis	
Least Sandpiper	Calidris minutilla	B
White-rumped Sandpiper	Calidris fuscicollis	B
Baird's Sandpiper	Calidris bairdii	B
Pectoral Sandpiper	Calidris melanotos	B
Sharp-tailed Sandpiper	Calidris acuminata	
Dunlin	Calidris alpina	B
Stilt Sandpiper	Calidris himantopus	B
Buff-breasted Sandpiper	Tryngites subruficollis	B
Ruff	Philomachus pugnax	
Long-billed Dowitcher	Limnodromus scolopaceus	B
Wilson's Snipe	Gallinago delicata	B
Wilson's Phalarope	Phalaropus tricolor	
Red-necked Phalarope	Phalaropus lobatus	B
Red Phalarope	Phalaropus fulicarius	B
Pomarine Jaeger	Stercorarius pomarinus	B
Parasitic Jaeger	Stercorarius parasiticus	B
Long-tailed Jaeger	Stercorarius longicaudus	B
Bonaparte's Gull	Larus philadelphia	
Mew Gull	Larus canus	B
Herring Gull	Larus argentatus	B
Thayer's Gull	Larus thayeri	
Slaty-backed Gull	Larus schistisagus	
Glaucous-winged Gull	Larus glaucescens	
Glaucous Gull	Larus hyperboreus	B
Sabine's Gull	Xema sabini	B
Black-legged Kittiwake	Rissa tridactyla	
Ross's Gull	Rhodostethia rosea	
Ivory Gull	Pagophila eburnea	
Arctic Tern	Sterna paradisaea	B
Thick-billed Murre	Uria lomvia	
Black Guillemot	Cepphus grylle	B
Least Auklet	Aethia pusilla	
Horned Puffin	Fratercula corniculata	
Great Horned Owl	Bubo virginianus	
Snowy Owl	Bubo scandiacus	B
Northern Hawk Owl	Surnia ulula	B
Great Gray Owl	Strix nebulosa	P
Short-eared Owl	Asio flammeus	B
Boreal Owl	Aegolius funereus	P
Common Nighthawk	Chordeiles minor	
Ruby-throated Hummingbird	Archilochus colubris	
Rufous Hummingbird	Selasphorus rufus	
Belted Kingfisher	Ceryle alcyon	P
Downy Woodpecker	Picoides pubescens	P
Hairy Woodpecker	Picoides villosus	P
American Three-toed Woodpecker	Picoides dorsalis	B
Black-backed Woodpecker	Picoides arcticus	P
Northern Flicker	Colaptes auratus	B
Olive-sided Flycatcher	Contopus cooperi	
Alder Flycatcher	Empidonax alnorum	P
Hammond's Flycatcher	Empidonax hammondii	P
Eastern Phoebe	Sayornis phoebe	
Say's Phoebe	Sayornis saya	B
Eastern Kingbird	Tyrannus tyrannus	
Northern Shrike	Lanius excubitor	
Gray Jay	Perisoreus canadensis	B
Common Raven	Corvus corax	B
Horned Lark	Eremophila alpestris	B
Tree Swallow	Tachycineta bicolor	
Violet-green Swallow	Tachycineta thalassina	B
Bank Swallow	Riparia riparia	P
Cliff Swallow	Petrochelidon pyrrhonota	B
Barn Swallow	Hirundo rustica	
Black-capped Chickadee	Poecile atricapillus	
Boreal Chickadee	Poecile hudsonica	B
Gray-headed Chickadee	Poecile cincta	B
Red-breasted Nuthatch	Sitta canadensis	
American Dipper	Cinclus mexicanus	B
Ruby-crowned Kinglet	Regulus calendula	B
Arctic Warbler	Phylloscopus borealis	B
Bluethroat	Luscinia svecica	B
Northern Wheatear	Oenanthe oenanthe	B
Townsend's Solitaire	Myadestes townsendi	
Gray-cheeked Thrush	Catharus minimus	B
Swainson's Thrush	Catharus ustulatus	P
Hermit Thrush	Catharus guttatus	
American Robin	Turdus migratorius	B
Varied Thrush	Ixoreus naevius	B
Eastern Yellow Wagtail	Motacilla tschutschensis	B
American Pipit	Anthus rubescens	B
Bohemian Waxwing	Bombycilla garrulus	
Cedar Waxwing	Bombycilla cedrorum	
Orange-crowned Warbler	Vermivora celata	B
Yellow Warbler	Dendroica petechia	B
Yellow-rumped Warbler	Dendroica coronata	B
Blackpoll Warbler	Dendroica striata	B
Northern Waterthrush	Seiurus noveboracensis	P
Wilson's Warbler	Wilsonia pusilla	B
American Tree Sparrow	Spizella arborea	B
Chipping Sparrow	Spizella passerina	
Clay-colored Sparrow	Spizella pallida	
Savannah Sparrow	Passerculus sandwichensis	B
Fox Sparrow	Passerella iliaca	B
Lincoln's Sparrow	Melospiza lincolnii	
White-throated Sparrow	Zonotrichia albicollis	
White-crowned Sparrow	Zonotrichia leucophrys	B
Golden-crowned Sparrow	Zonotrichia atricapilla	B
Dark-eyed Junco	Junco hyemalis	B
Lapland Longspur	Calcarius lapponicus	B
Smith's Longspur	Calcarius pictus	B
Snow Bunting	Plectrophenax nivalis	B
Red-winged Blackbird	Agelaius phoeniceus	
Rusty Blackbird	Euphagus carolinus	B
Brown-headed Cowbird	Molothrus ater	
Gray-crowned Rosy-Finch	Leucosticte tephrocotis	B
Pine Grosbeak	Pinicola enucleator	B
White-winged Crossbill	Loxia leucoptera	B
Common Redpoll	Carduelis flammea	B
Hoary Redpoll	Carduelis hornemanni	B
Pine Siskin	Carduelis pinus	

Bird Index

Bold-faced page numbers indicate photographs

Bluethroat 16, 21

Brant 33, 172, 174, 178; Black Brant 27, **45**

Bunting, Snow 9, 131, **132,** 168, 178

Chickadee, Black-capped 11, 152; Boreal 150, 152, **159;** Gray-headed 16, 20, 150, 152

Crane, Sandhill **12,** 15

Crossbill, White-winged 150, 153

Dipper, American 11, 16, 19, 20, 136, **137,** 150

Dotterel, Eurasian 74

Dowitcher, Long-billed 23, 74, **91**

Duck, Harlequin 27, **38;** Long-tailed 13, 23, 26, 29, 32, 33, 175

Dunlin 10, 29, 74, **80**

Eagle, Bald 60, **68,** 119; Golden 11, 16, 20, 21, 58–60, 62, **63,** 116

Eider, Common 27, **50, 51;** King 27, 32, **52,** 175, 178; Spectacled 29, 32; Steller's **151**

Falcon, Peregrine 16, 20, 21, 22, 29, 32, **61,** 62–63, 156

Godwit, Bar-tailed 73, 74; Black-tailed **73,** 74; Hudsonian 74

Golden-Plover, American 10, 11, 74, **75,** 77, **78, 85, 90,** 168, 178

Goose, Cackling (Taverner's) 31; Canada (Lesser) 13, 26, **29,** 31, 32, **34,** 115; Greater White-fronted 27, 31, 32, 33, **34, 39,** 115, 178; Snow **4,** 27, **28,** 32, **40, 41,** 174

Goshawk, Northern 61, 150

Grosbeak, Pine 150

Grouse, Ruffed 150; Sharp-tailed 150; Spruce 150, **154, 160, 161**

Gull, Bonaparte's **108;** Glaucous 15, 22, 32, 94, 95, 96, 97, 98, 99, **102, 103,** 174; Glaucous-winged **98;** Herring 94, **109;** Mew 19, **107;** Sabine's 94, 95, 96, 98, 99, 100, **101**

Gyrfalcon 9, 16, 20, 33, 61–**62,** 63, **64, 65,** 133, 150, **181**

Harrier, Northern 21, 61, **69,** 118

Hawk, Red-tailed 60; Rough-legged 20, 60–61, **67;** Sharp-shinned 61; Swainson's 60–61

Jaeger, Long-tailed **6–7,** 22, 94, 95, 96, **97,** 99, **106,** 179; Parasitic 95, 96, **97,** 98, 99, 101, 178; Pomarine 95, **96,** 97, 98, 99, 116, 178

Jay, Gray 19, 150, 151, 155–156, **159**

Killdeer 74

Knot, Red 74, 76

Lark, Horned 133–**134**

Longspur, Lapland 11, 23, 29, 130, **131**–132, **138, 139,** 178; Smith's 9, 21, **147**

Loon, Pacific **9,** 23, 27, 30, 31, 32, **46, 47,** 174; Red-throated 11, 26, 27, 30, **31,** 32; Yellow-billed 16, **22,** 30, **48, 49,** 168

Mallard 151

Merganser, Red-breasted 29, 33, **35, 53,** 137

Merlin **66**

Nuthatch, Red-breasted 13

Osprey 115

Owl, Boreal 113, 114, **118**–119, **121,** 150; Great Gray 113, 114, **116,** 117, **120, 123,** 150; Great Horned 63, **113,** 114–**115,** 117, 150; Northern Hawk 113, 114, **116**–117, **126,** 150; Short-eared 21, 33, 113, 114, 117–**118, 125, 126–127;** Snowy 12, 16, 112, 113, 114, **115**–116, **117,** 118, **122, 124,** 134, 150, 178

Phalarope, Red **75, 85;** Red-necked 21, 23, 24, 74, 75, 76, **81, 84;** Wilson's 74

Phoebe, Say's 20, 21, 133

Pintail, Northern 32, **36, 37,** 178

Pipit, American **20**

Plover, Black-bellied 74; Semipalmated 10, 11, 19, 75, **78, 88**

Ptarmigan, Rock 59, 150, **153**–154; Willow 11, 150, 153–154, **162–163, 164, 165, 166**

Raven, Common 19, 136, 150, **151, 156,** 168, 170, 174, **176**

Redpoll, Common 16, 19, 150, **179;** Hoary 136, 150

Robin, American 19, 20, 135, **142**

Rosy-Finch, Gray-crowned **141**

Ruff 74

Sanderling 74

Sandpiper, Baird's **19,** 20, 74, **78, 87;** Buff-breasted 9, 15, 16, 74, 76, **84,** 168, 173, 178, **179;** Least 74, 78; Pectoral 12, 13, 15, 23, 74, 75, **76, 78,** 178; Semipalmated 9, 10, 12, 23, 73, 74, 78, **167;** Sharp-tailed 74; Solitary 74, 78; Spotted 19, 74, 78, **83,** 137; Stilt **23,** 73, 74, **86,** 178; Upland 20, 74, 78; Western 74; White-rumped 74, 178

Scoter, Surf 33, **53;** White-winged 33

Shoveler, Northern 29, **54, 55**

Shrike, Northern 19, **144, 145**

Snipe, Wilson's 74, 78

Sparrow, American Tree 19, 20, 21, **134,** 135; Savannah **20,** 21, **147;** White-crowned 19, 135, **140,** 151

Stint, Red-necked 74

Surfbird 74, 78

Swallow, Cliff 20, 63

Swan, Tundra **1, 2–3,** 26, 27, 29, **42, 44,** 173, **176**

Tattler, Wandering 16, 19, 20, 74, 137

Tern, Arctic 12, 15, 20, 27, 94, **95,** 96, 97, 98, **99,** 100, 101, **105, 108**

Thrush, Hermit 135, 136

Turnstone, Ruddy 10, 74, 78

Wagtail, Eastern Yellow 11, 16, 21, 135, **136,** 168

Warbler, Wilson's 137; Yellow 11, 137, **170**

Wheatear, Northern **11,** 16, 132, 133, **143, 146**

Whimbrel 74

Woodpecker, American Three-toed 150, 154–155, **158;** Black-backed 150, **155;** Downy 150; Hairy 150

Yellowlegs, Lesser 20, 74, **78, 82,** 178

Africa 11, 60, 99, 100, 132, 179
Aichilik River 10
Alabama 180, 181
Alaska National Interest
 Lands Conservation
 Act (ANILCA) 180
American Ornithologist's
 Union 154
Andes 58
Antarctica 12, 99, 100, 113, 168
Arctic char 60
Arctic Village 9, 17, 131, 171
Argentina 11, 15, 61, 74,
 94, 99, 168, 178, 179
Arizona 181
Atigun River 174
aurora borealis 32, 33, 118
Australia 73, 94, 135, 137
barrier islands 27, 29,
 33, 58, 98, 172
Barter Island 32, 168, 169
Bay of Fundy 12
bear, grizzly 17, 19, 59, **104,**
 116, 119, **135**–136, 151,
 154, 174; polar 32, 33, **102**
Beaufort Sea 16, 17, 27, 32, 94,
 130, 151, 153, 167, 172, 174
Bering Sea 135, 178, 179
biodiversity 10
Bolivia 74, 137
Brazil 137
Brazil Current 99
Brooks Range 16, 17, 22, 27, **28,**
 62, 78, 118, **128**–**129,** 131,
 132, 152, 153, 172, 174, 176
California 99, 133, 136, 178
Canada 12, 13, 32, 33,
 99, 114, 116, 131, 134,
 137, 152, 153, 178
Canning River 16, **17,** 19,
 20, 152, 153, 173, **182;**
 delta 22, 26, 31, 131
Caribbean Sea 99
caribou 9, 11, 16, 21, 22,
 27, 29, 32, 58, **59**–**60,** 63,
 79, 132, 134, 170, 178

Carson, Rachel 62
Chandalar River, East
 Fork **110**–**111, 171**
Chesapeake Bay 27
Chihuahua 33
Chile 74, 99
Clarence River 152
climate change 76, 100, 101, 175
coastal plain 9, 10, 13, 16, 22,
 23, **28,** 29, 30, 31, 32, **33,**
 41, 59, 60, 72, 74, 76, 79,
 94, 114, 115, 117, 131, 132,
 134, 135, 136, 137, 152, 153,
 154, 155, 167, 169, 172, 173,
 174, 176, 178, 180, 181, 183
Colville River 172, 173
cottongrass 16, 27, 30,
 32, 131, 174
crustaceans 95, 97
Cygnus 33
Dall sheep 59, 115, 132, 133
Dalton Highway (Haul
 Road) 16, 17
dark morph 96, 97
Deadhorse 16–17
Delaware Bay 76
Denali National Park 60
ecological zones 16, 18
Endangered Species Act 29
Europe 101, 119, 152
Exxon Valdez 175, 176, 180, 181
Fairbanks 17, 151, 153
Falkland Current 99
fish 16, 58, 60, 94, 95, 96,
 97, 100, 101, 115
fox, arctic 15, 16, 22, 29, 32, 115,
 116, 130, 174; red **39, 63**
Franklin Mountains **17, 19,** 134
Georgia 11
global warming 76, 175, 176
Great Lakes 99
Great Plains 58, 61, 131,
 134, 172, 178
ground squirrel 19, 22,
 59, **60,** 115, **119**
gular pouch 153, 156

Gwich'in Athabascan Indians
 9, 156, 170, **171**
Hawaii 118, 170
Hudson's Bay 99
Hulahula River 16, **24**–**25,**
 32, 167, **168**
Humboldt Current 99, 100, 178
Ignek Creek 21
Inupiat Eskimos 9, 27, 32, 130,
 132, 136, 153, 156, **168,** 172
Jeffers, Robinson 31
Kaktovik 9, 16, 30, 32, 33,
 130, 132, 136, 168
Kansas 179
Karen Creek **162**–**63**
kleptoparasitism 95, 96, 100
Kongakut River **58,** 152
Korth, Heimo 151, 152,
 153, 154, 155, 156
Labrador 99
larvae 12, 95, 97, 136, 152
lemming 23, 29, 32, **60,**
 61, 94, 95, **97,** 98, 100,
 115, 116, 118, 178
light morph 96
loss of habitat 10, 33
Louisiana 178
Lower 48 15, 73, 180
Maine 180, 181
mating 9, 12, 30, 73, 75,
 97, 115, 131, 136, 152,
 153, 154, 155, 156
Matthiessen, Peter 9, 10, 73
Mexico 13, 15, 27, 58,
 61, 137, 174
migration, bird 10, 11, 12, 13,
 14, 15, 29, 31, 32, 33, 72, 73–
 75, 76, 77, 79, 95, 96, 97, 98,
 99–100, 112, 114, 116, 118,
 131, 132, 133, 135, 137, 167,
 174, 178, 188; caribou 9, 79
Minnesota 114
moose 16, **19,** 21, 58, 135
mosquito 12, 20, 21, 22, 32
Mount Chamberlin
 30, **162**–**163**
Mount Kilimanjaro 11

Mount Michelson 30
Murie, Margaret (Mardy) 63
Murie, Olaus 62, 63
muskox 16, 21, 29, 58
National Academy of
 Sciences 31
National Petroleum Reserve-
 Alaska (NPR-A) 172, 175, 176
National Research Council
 172, 174, 176
National Science
 Foundation 176
nesting grounds, 12, 73, 74, 75,
 76, 96, 99, 100, 112, 178
New Jersey 76
New Zealand 73, 94, 137, 170
North Slope 16, 22, 60,
 62, 76, 112, 115, 168,
 172, 174, 175, 176
northern lights. *See*
 aurora borealis
Nova Scotia 12
Ohio 15
Okerokovik River 153
Okpilak River **24**–**25,**
 148–**149,** 167
Old Crow Flats 62
Paraguay 74
Patagonia 10, 94
Peru 99
Philip Smith Mountains 17
pipeline 10, 15, 16, 17,
 116, 173, 174, 180
Plunge Creek 20
polyandry 75
polygyny 75
polymorphism 96
Porcupine River 59,
 60, 62, 63, 151
Prudhoe Bay 172, 173,
 174, **176, 177**
Ramsar Convention
 of Wetlands 76
releaser 98
research 10, 23, 26, 27, 60,
 76, 79, 112, 133, 167, 174

Rilke, Maria 10
Roaring Forties 100
Rocky Mountains 58
Romanzof Mountains 134, 167
Russia 116, 152, 168
Ryder, Albert Pinkham 10
Sadlerochit Mountains 27, 30,
 33, 132, **133;** River 32, 134,
 135; Springs 134, 136, 137
saxifrage 16, 29, 32
Section 1002 10, 16,
 22, 31, 117, 132
Shorebird Research Group
 of the Americas 76
Siberia 11, 27, 133, 137
Site of International
 Importance 76
songbirds 9, 13, 95, 96,
 97, 130, 132, 133, 134,
 136, 137, 155, 168
South America 10, 12, 13,
 15, 61, 72, 73, 74, 75, 76,
 94, 99, 100, 118, 178
South Dakota 61
South Pacific 72, 137, 170
Southern Ocean 99, 100
Teshekpuk Lake 172, 174, 176
Texas 27, 58, 61, 178
Uruguay 74
voles 60, 61, 97, 116,
 117, 118, 119
Weddell Sea 100
West Indies 13
Western Hemisphere Shorebird
 Reserve Network 76
Wetland of International
 Importance 76
whale 32, 33, 130
Williams, Terry Tempest 9, 33
wintering grounds 9, 10,
 13, 33, 72, 73, 74, 98,
 112, 114, 167, 174
wolf 21, 22, 119, 135, 136
wolverine 16, 22, 116
Yukon Territory 61, 131
Yupik Eskimo 150, 156

THE MOUNTAINEERS, founded in 1906, is a nonprofit outdoor activity and conservation club with twelve thousand members, whose mission is to "explore, study, preserve, and enjoy the natural beauty of the outdoors." The club sponsors many classes and year-round activities in the Pacific Northwest and supports environmental causes through educational activities, sponsoring legislations, and presenting programs.

THE MOUNTAINEERS BOOKS supports the Club's mission by publishing works on conservation and history, as well as travel and natural history guides and instructional texts.

THE MOUNTAINEERS FOUNDATION is a public foundation established in 1986 to promote the study of the mountains, forests, and streams of the Pacific Northwest, and to contribute to the preservation of its natural beauty and ecological integrity. The Mountaineers Foundation gratefully welcomes financial contributions to continue and extend its vital conservation work. Because The Mountaineers Foundation is a 501(c)(3) charitable organization, contributions are tax deductible to the extent allowed by law.

 Send or call for our catalog of more than 450 outdoor titles:
The Mountaineers Books
1001 SW Klickitat Way, Suite 201
Seattle, WA 98134
800-553-4453
mbooks@mountaineersbooks.org
www.mountaineersbooks.org

MANOMET CENTER FOR CONSERVATION SCIENCES is one of the nation's oldest independent environmental research organizations. Manomet promotes a cooperative, science-based approach to environmental stewardship guided by the premise that a healthy economy and a sustainable environment are mutually compatible and urgent goals. Our scientists conduct original research on natural systems and bring people together to develop sustainability strategies that integrate ecological goals with the social and economic objectives of our partners.

Manomet has carried out a variety of programs where our scientific expertise can lead to meaningful and lasting conservation change for a diverse, hemisphere-wide constituency. These programs include:

Shorebird Research and Conservation Western Hemisphere Shorebird Reserve Network Landbird Research and Conservation
Wildlife and Agriculture Forest Conservation Management Regional Conservation Planning Marine Fisheries Conservation

To learn more about Manomet's work and accomplishments, please visit our website: *www.manomet.org.*

Birds of the Arctic National Wildlife Refuge

All sounds recorded in the Arctic National Wildlife Refuge

naturesound.org

By Martyn Stewart

www.naturesound.org

60 minutes of continual play. This recording includes individual species tracks in the foreground over layers of true Arctic National Wildlife Refuge ambient background sounds. You can listen to the CD as a single, sixty-minute ambient recording or search for your favorite birds by numbered track.

ABOUT BIRDS OF THE ARCTIC NATIONAL WILDLIFE REFUGE

This CD was recorded in the Arctic Refuge along the Kongukut River and was two years in the making. Stewart made his recordings in June, during the height of breeding season, and had this to say about the experience:

"When the peace and quiet resumed after the bush plane departed, I realized that I had been placed into the most fantastic cacophony of sounds . . . the White-crowned Sparrows sing at any given hour, Lapland Longspurs fill the air with song, and a million birds join the chorus in this never-ending theater of light. I had found recordist's paradise—no manmade noise pollution, no cars, no trucks or urban sprawl!

"I used specialty microphones to try to replicate what I was hearing. On the enclosed CD you will hear the gentle transitions from the Arctic foothills out to the coastal plain with multiple calls of individual species mingling throughout. The haunting calls of loons echo through the refuge; sandpipers, gulls, ducks, and many other species litter the soundscape. This is nature's musical passage with amazing progressions from one song to another, a soundprint of the living voices of these ecosystems."

Born in the United Kingdom in 1955, MARTYN STEWART's love of nature began at an early age and led him to complete a degree in horticulture. He has recorded bird and animal sounds for over thirty-five years, and his personal library consists of over 200,000 recordings. He has been commissioned to work for radio, television, and film, contributing to such diverse sources as BBC and NPR radio; the London, San Diego, Melbourne, and Glasgow zoo exhibitions; conservation groups for surveying sounds; and birding reference tapes and compact disks. Stewart monitors national parks to protect the natural soundscapes.

TRACK # / BIRD	SOUND	TIME
1. Kongakut River	Ambient	00:08
2. White-crowned Sparrow	Song	00:04
3. Lapland Longspur	Song	00:09
4. Dunlin	Song	00:06
5. Long-tailed Jaeger	Call	00:12
6. Yellow Warbler	Song	00:04
7. Ambient	Song	00:08
8. Yellow Warbler	Song	00:08
9. Willow Ptarmigan	Call	00:25
10. Trumpeter Swan	Call	00:13
11. Rough-legged Hawk	Call	00:30
12. Dunlin	Call	00:08
13. Common Redpoll	Song	00:19
14. Common Raven	Call	00:13
15. Willow Ptarmigan	Call	00:17
16. Savannah Sparrow	Song	00:04
17. Pacific Loon	Song	00:08
18. Long-tailed Duck	Call	00:12
19. Pacific Loon	Song	00:12
20. Ambient	Song	00:05
21. Rough-legged Hawk	Call	00:29
22. American Dipper	Song	00:18
23. Lapland Longspur	Song	00:27
24. Greater White-fronted Goose	Call	00:48
25. Common Snipe	Song	00:34
26. Brant	Call	01:07
27. Glaucous Gull	Call	00:57
28. Greater White-fronted Goose	Call	01:17
29. White-winged crossbill	Song	00:20
30. Trumpeter Swan	Call	07:12
31. Pacific Loon	Call	00:13
32. Ambient	Song	00:50
33. Long-tailed Jaeger	Song	00:27
34. Northern Wheatear	Song	00:15
35. Glaucous Gull	Call	00:14
36. Pomarine Jaeger	Call	00:26
37. Yellow-billed Loon	Call	00:35
38. Yellow-billed Loon	Yodel	00:15
39. Long-tailed Duck	Call	00:32
40. Alder Flycatcher	Song	00:28
41. Common Raven	Call	00:47
42. Smith's Longspur	Song	00:38
43. Yellow Warbler	Song	00:42
44. Yellow Wagtail	Song	00:40
45. Northern Wheatear	Song	01:22
46. Rough-legged Hawk	Call	00:38
47. Ambient	Song	00:48
48. Long-tailed Jaeger	Call	01:21
49. Long-tailed Duck	Song	00:30
50. Northern Wheatear	Song	01:31
51. White-winged Crossbill	Song	00:43
52. Common Redpoll	Song	00:17
53. Savannah Sparrow	Song	00:18
54. Yellow Wagtail	Song	00:59
55. Common Redpoll	Song	00:34
56. Pomarine Jaeger	Call	00:08
57. Willow Ptarmigan	Call	00:10
58. Pacific Loon	Call	04:07
59. Ambient	Song	00:17
60. Willow Ptarmigan	Peeps	00:18
61. American Dipper	Song	01:05
62. Long-tailed Jaeger	Call	00:11
63. Ambient	Song	00:21
64. Alder Flycatcher	Song	04:12
65. Yellow Wagtail	Song	00:37
66. Smith's Longspur	Song	01:05
67. Arctic Refuge birds	Ambient	14:18